MARXISM AND
COMMUNICATION
STUDIES

Sut Jhally & Justin Lewis
General Editors

Vol. 8

PETER LANG
New York • Washington, D.C./Baltimore • Bern
Frankfurt am Main • Berlin • Brussels • Vienna • Oxford

MARXISM AND COMMUNICATION STUDIES

The Point Is to Change It

EDITED BY

Lee Artz, Steve Macek, and Dana L. Cloud

PETER LANG
New York • Washington, D.C./Baltimore • Bern
Frankfurt am Main • Berlin • Brussels • Vienna • Oxford

Library of Congress Cataloging-in-Publication Data

Marxism and communication studies: the point is to change it /
[edited by] Lee Artz, Steve Macek, Dana L. Cloud.
p. cm. — (Media and culture; v. 8)
Includes bibliographical references and index.
1. Socialism and culture. 2. Socialism and society. 3. Communication—
Social aspects. 4. Communication—Political aspects. 5. Mass media—Social
aspects. 6. Mass media—Political aspects. 7. Dialectical materialism.
I. Artz, Lee. II. Macek, Steve. III. Cloud, Dana L.
IV. Series: Media & culture (New York, N.Y.); v. 8.
HX523.M3765 302.2—dc22 2006015426
0-8204-8825-9 (case bound)
ISBN 0-8204-8126-2 (paper back)
ISSN 1098-4208

Bibliographic information published by **Die Deutsche Bibliothek**.
Die Deutsche Bibliothek lists this publication in the "Deutsche
Nationalbibliografie"; detailed bibliographic data is available
on the Internet at http://dnb.ddb.de/.

The editors gratefully acknowledge a
University Cooperative Society Subvention Grant
awarded by the University of Texas.

Cover design by Lisa Barfield
Cover image: Los Angeles anti-immigrant law march of millions.
Reprinted courtesy of Marcus Africanus and www.indymedia.com

The paper in this book meets the guidelines for permanence and durability
of the Committee on Production Guidelines for Book Longevity
of the Council of Library Resources.

© 2006 Peter Lang Publishing, Inc., New York
29 Broadway, New York, NY 10006
www.peterlang.com

Printed in the United States of America

·CONTENTS·

We may seem a long way from those days of political paranoia following World War II, when reds were thought to be hiding in every crawlspace in every house in every subdivision north of the Mason-Dixon line, stealing milk bottles from the front porch before mom and dad woke up and plotting to indoctrinate the local workers in dad's toy factory. And while in many ways we are very much removed from those McCarthy-era stereotypes of Marxists and communists switching suitcases at the Greyhound bus depot's shoeshine stall, in other ways we are not as removed as we would like to think, especially when it comes to creating scapegoats for our national insecurity.

For both graduate and undergraduate students in United States, Marxism is likely to be seen as an irredeemably antiquated political doctrine whose storied agitprop rarely reverberates with any intensity in our present time. For many the term itself encroaches on the notion of a seriously flawed and dangerous political ideology inevitably leading to a totalitarian police state buttressed by ideological and political barriers that were as unbreachable as Ronald Reagan's hairline until capitalism's inevitable victory finally put an end to that drooling specter that had haunted the globe for nearly a century.

There is no question that the collapse of socialism represented a major historical defeat for the left worldwide that will surely impact the shape and character of revolutions to come. But what that struggle meant for the liberation of aggrieved populations throughout the globe has been distorted most violently by those who bragged the most about putting an end to the age of ideology. It is one of the great tragedies of today that not only has the issue of class largely been displaced by that of culture in scholarly fields within the humanities and social sciences. But worse is the way today's highly motivated historical amnesia and crudely calculated misperception of both Marxism and the history of class struggle obfuscates any clear boundary between Marxism as a critique of capitalism and a means of challenging the dehumanizing impact of capitalist social relations and Marxism as an anti-capitalist ideology viewed largely through the prism of post-Cold War Western propagandists.

Since 9/11, the reactionary acumen and unmatched preternatural gifts of pro-capitalist propagandists have been successful in taking advantage of this newly interactive world and created another Hobbesean us-against-them universe of free market democracy versus its menacing underside. This time the threat does not come from Red Army generals hidden inside an underground bunker in some far-off Eastern Bloc dystopia, or their domestic collaborators such as the Wobblies organizing the coal mines of West Virginia or Hollywood screen writers or news broadcasters defending freedom of speech. Today, the threat is from worshippers at the neighborhood mosque or the ever-present, swarthy-looking bystanders lurking around public buildings, stalking subway stations or video-taping popular tourist attractions, concealing God knows what underneath their oversized grey flannel suits. The U.S. is in no danger of giving up its belief that control of the world's oil supplies stipulates the necessity of an American empire—at least anytime in the foreseeable future. And with that empire comes the necessity of providing the public with a rationale for its defense.

While Marxists have been replaced as the capitalist boogeyman by would-be Middle Eastern terrorists, there is still an ideological reversibility at work, an endless echo of the past, which loops through the mind of many Americans relaying a false equivalence between the Marxists of yesteryear and the jihadists and Islamic Svengalis of today.

Hence, in such sloganizing times, there is a dire need for a book that not only lays out some of the bedrock characteristics of Marxist critique as well

as perspectives that have a long pedigree in Marxist theory but that also puts such a critique in the service of understanding the current crisis of capitalism. This means raising the question of how we have come to view democracy as necessarily married to capitalism, and also the question of how we have come to understand democracy as antithetical to the class struggle as articulated by Marx, to an equitable access to the social surplus and to the commitment to making equality an indispensable virtue of democratic sovereignty. That students rarely look to the work of Marx for insights into the struggle for democracy and social and economic justice is another great tragedy of scholarship in institutions of higher education in the United States.

To a sober reader of world history or any perceptive observer of world events today (those crowded behind police lines and beneath a barrage of tear gas at World Trade Organization protests have a special vantage point), capitalism's claim to provide the only bedrock for democracy is specious at best. Yet anti-corporate attacks on the excesses of democracy by liberal critics or social-movement rallies that fail to challenge the very roots of the capitalist system offer a stunted array of explanations for understanding—not to mention altering—the world-historical impact of capitalism and its implication in the world of human communication.

Enter this timely new volume edited by Lee Artz, Steve Macek and Dana Cloud. The contributors to this important work—important for communication students and scholars to be sure but also for those in related disciplines and sub-disciplines—are refreshingly hesitant to apply shopworn formula to the current political moment, and at the same time they are unwilling to give up the central goal of Marx's critique of political economy— to move beyond analysis to the domain of social transformation (a sentiment echoed in the subtitle of this volume).

Offering an important alternative to the reigning orthodoxy of postmodernism's soi-disant rebels with their textual brigandism that undermines the certainty of conventional meanings while challenging the esurient character of corporate life, the essays that make up *Marxism and Communication Studies* strike a collective blow against the jugular vein of the labor/capital dialectic itself.

Not only does this volume provide a compelling case for a Marxist analysis of communication studies, it promises to refocus the debate on communication as a discipline from those who support the piecemeal

complacency of post-Marxists to those who advance a post-Marx Marxism of revolutionary praxis. What is especially compelling about this volume is the way in which many of the authors are able to creatively apply insights and methods of historical materialism to problems within the study of communication and to contemporary discussions of materialist dialectics and media practices. But what impresses me the most is how some of the authors are able to ally themselves with a view of class struggle that is not the reverse mirror image of the struggle for democracy but its fulfillment.

In this way *Marxism and Communication Studies* offers a Marxism for these times, one that calls for creativity, experimentation and risk-taking and a critique and set of socialist practices that are not rooted in some abstract utopian longing but grounded in the concrete struggles of the here and now.

Peter McLaren
Graduate School of Education and Information Studies
University of California, Los Angeles

·INTRODUCTION: TOWARD CONDITIONS OF OUR OWN MAKING·

Lee Artz, Steve Macek, and Dana L. Cloud

There is a timely and urgent need for a reasoned dialogue reassessing how Marxism can advance the study and transformation of human communication and the social world in which it is embedded. Indeed, ongoing world-historical events, including the vigorously organized market globalization, the corresponding insurgent global anticorporate movement, the conflicts engendered by the U.S. invasion of Iraq, as well as the rebound of interest in socialist policies and working class perspectives, from Venezuela, Brazil, and Argentina to Great Britain, Australia, and eastern Europe, have underscored the importance of a thorough critique of global capitalism and its telecommunication technologies and communication practices.

Marxism's relationship to communication as a discipline has long been marked by a profound ambivalence. As in other disciplines, scholars and students in communication approach existing knowledge under conditions not of our own making. While notions derived from Marxist theory—ideology, hegemony, reification, commodification, social class, dialectics, cultural imperialism, and so on—are regularly deployed in the pages of communication journals and are foundational for entire subfields such as cultural studies, many accounts of these theoretical and methodological perspectives,

ironically, obscure their own Marxist roots, seeking in particular to put distance between them and any hint of materialism or recognition of class conflict. Still, a growing number of cultural studies and communication scholars recognizing the impact of power on communication practices identify themselves as Marxists or at least see their work as indebted to the Marxist legacy. The international resistance to the globalization of market dynamics and international corporate decisions has been faintly and uneasily reflected in annual conferences of the Global Fusion Consortium and the Union for Democratic Communications, and in issue-themed conferences (for example, public broadcasting, Disney, media reform, and so on), as well as preconvention seminars on Marxism and communication studies at the National Communication Association Convention, which bring together hundreds of communication scholars and media workers concerned with democracy and communication, many of whom work from a Marxist or Marxist-informed perspective. Similar meetings also occur regularly in the United States and internationally in other disciplines: sociology, anthropology, political economy, history, education, labor studies, and others.

Yet, extended, informed publications focused on Marxist theory and the unique insights it affords contemporary studies of media and communication are largely unavailable in the United States. A review of rhetoric and mass communications textbooks reveals that the approach receives little or no attention in most undergraduate courses. Graduate studies in media, rhetoric, and cultural studies rely on a handful of selected translations of largely dated works by European theorists such as Louis Althusser, Antonio Gramsci, Pierre Bourdieu, Jürgen Habermas, and British cultural studies scholars—none of which clearly addresses American cultural and social realities. Few programs use Armand Mattelart, Nicholas Garnham, Göran Therborn, or other European Marxist scholars.

In short, contemporary political conditions and academic trajectories strongly suggest a need for a serious assessment of Marxism's significance for communication and media studies. This volume of essays is intended to open a conversation among scholars, students, media workers, the working class in all of its gender, ethnic, and national diversity, and the general public concerned with the future of communication and society. The selection presented here seeks to:

1. present some contemporary Marxist perspectives useful to communication and media studies;

2. identify and assess how various theoretical and methodological approaches have appropriated and/or misappropriated Marxist perspectives for understanding communication;
3. identify contemporary issues and problems in communication studies that might be better addressed and understood using Marxist research methods and theoretical insights (including, for example, dialectical and historical materialism, class hegemony, political economy, and material cultural studies);
4. demonstrate how a Marxist perspective can be usefully applied to specific case studies in communication, providing valuable insights and understandings that are not obtained using other approaches; and
5. consider the significance of a Marxist communication critique of existing institutional practices and dominant cultural norms, including its value for understanding and communicating the human condition and future social and political crises.

So what can Marxism offer to communication studies? The essays included here present many suggestions, which might be bundled in four topic areas, all of which presume social power: (1) language and ideology; (2) democracy and media; (3) international communication and globalization; and (4) social change, dialectics, and historical materialism as method. Nonetheless, even taken in conjunction with other works advocating a Marxist approach to communication studies, we do not yet have what could be considered a class analysis of communication.

In its most robust moments, this book argues that the field of communication studies should reassess its alignment with existing pluralist assumptions and affiliated agendas funded by market interests and proceed with a research and action program "of our own making" drawn from the insights and methods of historical materialism. At its more humble, the text encourages all to notice how the problems, concepts, and perspectives investigated by Marxism and Marxist scholars (including Gramsci, Bourdieu, Schiller, and others discussed in this book) have an astounding vibrancy in the face of recurring social conflicts, crises, wars, and natural disasters connected with the expanding global market system and its communication practices.

This book does not pretend nor intend to be the definitive statement on Marxism and communication: the range of opinions and understandings of Marxism is too diffuse to be collapsed into one work—the course of history, the outcome of political and social struggles, will be the arbiter on current

disagreements and the bearer of new tasks and perspectives. Several of the essays (for example, Giroux & Giroux) do not work explicitly from a Marxist frame or even make allusions to its traditions, yet all of the essays offer materially based insights about the societal whole that highlight social class and power relations. Hopefully, these offerings prompt further reflection for conscious action toward a better, more democratic society—a global society of our own making.

1

·ON THE MATERIAL AND THE DIALECTIC: TOWARD A CLASS ANALYSIS OF COMMUNICATION·

Lee Artz

Like any other theoretical or practical approach to the social and natural world, Marxism is full of contradictions, in which we ourselves, individually and as a social group, must grasp those contradictions as principles of knowledge and action (Gramsci, 1971, p. 405). It might be easier if Marxism provided simplistic categories for analysis, in the same way that Burkean rhetorical theory has a dramatistic pentad, Lloyd Bitzer's rhetorical situation provides four contextual ingredients for assessment and prediction, or Aristotlean rhetoric evaluates ethos, logos, and pathos. Of course, detractors and supporters alike (as well as "Marxisant" and post-Marxist revisors) often construct a reductionist model for ready dismissal or comprehension, but just as any serious rhetorical critic recognizes that shorthand expressions misrepresent and do injustice to rich and complex theoretical frameworks and their practical value, so too, a more intimate acquaintance with Marxism reveals a substantive, flexible, and irreplaceable methodology, not the fractured dogmatic schema regularly beaten up in journal literature reviews and countless classrooms across the United States.

Marxism has been contested, modified, and deformed, frequently distorted, overstated, and abused by enthusiastic practitioners and promoters—as true of any theory or method, especially one with such longevity and historical consequence. Two characterizations of Marxism have battled for supremacy. One can be described as deterministic, exemplified by the economic determinists of social democracy (for example, Kautksy) and various structuralists (for example, Althusser). The other renders Marxism subjectivist, privileging human agency beyond concrete class relations of force and historical conjunctures (from Sorel and Lukacs to Laclau and Mouffe and the Latin American *guerrillistas* of the 1960s and '70s). A more complete appreciation of Marxist methodology begins with a materialist conception of history that recognizes the dialectical contradictions in all of life. This materialist dialectic appears clearly in the most political concept in Marxism: class struggle. Social classes are brought into being by the relations of production in each social formation—relations that are not just economic as the reductionists assert nor socially arbitrary as the subjectivists would have it, but relations of production that are contradictory, contested, and complementary, relations that include social, cultural, and political practices, with a complex array of individual and collective religious, gender, ethnic, national, psychological, and experiential variations.

Moreover, despite claims by duplicitous detractors and zealous supporters, Marxism has no Biblical reference to resolve interpretations. Nor can Marxism, or any other theory or method, be appraised by the expression of one or another advocate: baking, bricklaying, or aeronautics cannot be judged simply by the efforts of an individual or even a collective, but only by the success or failure of efforts by the most resolute and skilled under applicable conditions. Aeronautics cannot be considered unscientific because a paper airplane won't fly. At the same time, repeated efforts by inventors to fly wearing birdlike wings demonstrates their enthusiastic, but limited, understanding of aeronautics. Likewise, Marxism as a method of investigation and guide to action must be continually tested, retested, and updated according to the concrete conditions confronted. This is not to argue that a theory or method cannot be evaluated, dismissing any specific inadequacy as ineptitude or the result of an inappropriate application. Rather there is a materialist dialectic between theory and application: just as we say that "a worker is only as good as the tools," we know that tools alone do not make a worker skilled; the worker, the tools, and the task at

hand all must be evaluated individually in their interaction. Marxism likewise must be evaluated by careful consideration of its methodological tools and practices, the methodological application, and the actual, material conditions of its application.

What follows is a series of observations that might inform a methodology based on a materialist dialectic. Although reordering these defining terms of Marxism reverses the primary linguistic term to dialectic, I do so to emphasize the materialist core of Marxism that has been discarded by those who envision flux without regard to actual. I suggest that a rigorous materialism is dialectic because it attends to the contradictions within and around all things, relations, and processes. Consistent materialism cannot be static or deterministic in regards to society, either, because a complete assessment of social relations and human interaction reveals the possibilities (and probabilities) for human agency and its historical determinates, but not the predetermination of history.

Materialism

At its philosophical, scientific core, materialism holds that there is an external condition of life that we do not create but that imposes itself on us (Engels, 1941; Timpanaro, 1980). Nature and its biological processes, and society and its cultural processes, preexist each of us and would exist without our individual presence. As a corollary, we are dependent on nature and other humans for survival; we could not exist without them. In other words, there is a reality outside of and prior to humanity.

This natural material world exists according to laws independent of our thought, language, and conceptualization. Gravity pulls objects together, whether Galileo discovers the law or the Inquisition accepts it. Evolution is not a matter of rhetorical excellence: species have appeared, receded, and been transformed according to natural selection and other more complex natural processes. The reach of the universe does not depend on our perception of it. Yet, although the material world exists with or without our approval, evidence of the material world is continually being tested and verified in practice. Indeed, all of our intellectual and ideological understandings are predicated on our material existence. Moreover, all thoughts, ideas, and concepts are materially real, in that they can be observed, measured and

evidenced in synapses, sounds, text, and images, but thoughts, ideas, and concepts that do not refer to or represent material things, relations, or processes are nonetheless fictional in their practical manifestation. The word *unicorn* has a material existence in its linguistic form, or even in its graphic depiction as a work of art or piece of performance. Yet, outside of the fictional world, unicorns do not exist. Klingons are powerful in the *Star Trek* world; they even have a language and culture on television; but no country or universe will ever be subjected to a Klingon invasion. In other words, thoughts, ideas, and concepts are ultimately real only insofar as they have a material expression or can be brought into being. Fictions, novels, lies are real in that they exist-in-themselves, but they are unreal in that they have no other existence outside of their utterance. Things that do not exist outside of language, verbal or nonverbal, have no actual, material existence and thus are not real, although belief in their existence may indeed prompt practical human activity that has serious material consequence. With or without the existence of a supreme being, the belief in God moves humans to actions in the name of God, but it is not God's existence that is manifest—it is the materiality of human action that matters. In other words, while we identify natural processes with abstract categories for our understanding and use (and humans have done so, at least since the Milesians of the seventh century B.C.), the processes themselves need no label to function.

The dialectic—a diachronic characteristic of the ever changing material world whereby contradictions arise in and through development of phenomena—concretizes materialism in action, allowing us to more fully interpret historical change, including changes in communication use and development. From the continual transformation of the universe to the changing social interactions of everyday life, the material basis of everything that exists moves dialectically—from the processual contradictions within things and among things.

Consequently, with the development of human life and our ability to alter the material conditions of our life, we have become authors and agents in the use of the material world for our own ends. "Between nature and the individual stands the structure of society based upon the mode of producing the necessities of life" (Novack, 1965, p. 24). Moreover, all natural and social progress is contradictory—every act of creation is an act of destruction, as Goethe once said. In other words, the objective, material world (including the forces and relations of production that mediate between nature and

humanity) provides both real limits as well as realizable opportunities for human action. The flux of history and humanity can be measured and recorded by how humans first form and then transform their own nature according to the actual material conditions and processes. This materialist analysis recognizes, allows, and encourages conscious action for altering our natural and social conditions, because materialism understands that all social relations "emanate from the social struggle for survival" (Novack, 1965, p. 19). A materialist approach to history, thus, is dialectical without one iota of dogmatism—for the truth lay in the actual, contradictory processes that cannot be fully understood except in their dialectic development because "all known historic conditions are circumstanced" (Labriola, 1966, p. 128).

The materialist dialectic is based on the conflicting movement of forces and relations in history, which has repeatedly demonstrated that the mode of production of life shapes and limits all other sociocultural phenomena and processes. A materialist analysis of these sociohistorical processes finds identifiable social classes in negotiation, alliance, and conflict over how social relations and the relations of production should be organized and mobilized. Marxism, in applying the materialist dialectic, has termed the historical process "class struggle." Whatever terms are used, however, the material conditions of social life have developed and demonstrated in practice that the process of social development has occurred according to the outcome of battles over resources, organization, and preferred human relations, including relations of production. In other words, because history and the social order depend on the productive forces we develop and the social relations that we construct in realizing the power of those productive forces, it follows that conscious practical human action is necessary to alter and improve upon existing productive forces and social relations. As Peter Singer (1980) explains the materialist conception of history, "History is the progress of the real nature of human beings, that is, human beings satisfying their wants and exerting their control over nature by their productive activities" (p. 57). So, although the productive forces always finally exert themselves, they do so "only through the actions of individual humans" (p. 58). The movement of humanity to resolve its dilemmas depends on the productive forces humanity has developed—medicine for illness and injury; cultivation, storage, shipment, and storage for nourishment; cultivation, production, and design for shelter; and education, recreation, science, and entertainment for culture—to allow us to overcome and adjust to the natural world and its impact on our very existence.

A materialist argues that it is thus impossible to understand communication in isolation from the larger social order in which it occurs, develops, and is battled over. In 2005, this means that one cannot meaningfully present communication theories or perspectives outside of global capitalism, its various nation-state formations, its economic, cultural, political, and ideological manifestations, and their existing and developing contradictions. Media reform, alternative media, and individual attempts at democratic communication practices that fail to contextualize their activity according to the class character of local, national, and international social relations will ineluctably be muted at best, or, more likely, be absorbed by the overarching norms of class society. As Elizabeth Fox (1988) and Rick Rockwell and Janus (2004) have demonstrated for Latin American and Central America, media reform has no traction without societal transformation. Under more favorable political conditions, media democracy in Nicaragua (from 1981 to 1990) (Artz, 1994) and media access in Venezuela in 2005 (see TeleSUR, at www.zmag. org/Venezuela_watch.cfm, for example) further substantiate the materialist dialectic: control of production, media and otherwise, precedes transformation of its social use.

This materialist approach to history and communication privileges the social over the individual, but it does not discount the role of individuals in history. Instead, the materialist dialectic recognizes that individual influence on events depends on the historical moment, the historical conjuncture of events. The outcome of historical social processes are not predetermined, but influenced, guided, and disrupted by the behavior and actions of masses of humans—at some moments they/we are inspired or deterred by the actions of just a few, or even one. Dialectically speaking, individual intervention always alters the material conditions of life, but which individual actions will change the inertia, the norm, the structure, and practice of society? That depends on the overall material relations of power at that moment. George W. Bush did not invent the invasion of Iraq—the impulse preceded him by at least a decade, the favorable political climate for his call arose from decades of ideological and cultural grooming by media and political parties in the United States, and ultimately his charge needed 9/11 to terrorize many Americans into accepting "preemptive" war. Hugo Chavez did not begin the Bolivarian revolution in Venezuela—his voice was raised at a moment when millions of Venezuelans (and Latin Americans) were searching and ready for alternative ways of being. In each case, and others

of historical note, the active political response of millions that was triggered by individual actions depended on the material conditions of those millions that preexisted any individual rhetor: similar settings and similar practices shared by social groups and classes of humans will spur similar responses and similar behaviors. Thus, throughout Latin America in the last ten years, political formations have migrated to the center left as Argentinians, Ecuadorans, Peruvians, Uruguayans, Brazilians, and others have had similar experiences with the Washington Consensus, privatization, and neoliberalism—leading to similar, albeit materially unique, social and national responses. Individuals have influenced these developments in each case, because the material conditions allowed for greater or lesser individual agency in history.

Communication Means and Communication Practices

Throughout history, different communication forms, from oral, written, and printed to aural, televisual, and other electronic modes, have affected our reception of messages. Different social practices encourage or impede all communication, interaction, social awareness, democratic participation, and knowledge construction. In other words, we cannot assume or accept that any particular medium materially predetermines the communication process or practice. Oral communication may be more accessible, more democratic, than other communication forms, but even the use of voice can be restricted, structured, or encouraged. A peasant can physically speak, but the feudal relations and threat of force by the noble dictates how and when the peasant will speak. Likewise, radio and television do not do anything: the sets must be turned on; programming is produced and broadcast according to prevailing social norms and practices; and the listener/viewer must decide if and how to watch the available programming.

Technologically, radio can receive and transmit. Radio can be democratic and participatory, information rich and easily accessible to the public; it can be bureaucratic and propagandistic, controlled by government censors and broadcasters; it can transmit background music, filled with commercials, and monopolized by deregulated profit-driven media giants. The use of any technology depends on how a particular societal order or social

group decides or accepts how to use it. In short, communication practices are the result of the dynamic interaction between communication means (media technology) and social practices (informed by social relations, power, and use).

Frequently, communication texts, especially those concerned with the mass media, focus on the advances of technology and consumer-based information access. However, attending primarily to the pleasure and promise of technology is like being wowed by bells, whistles, and shiny dials, overlooking the social substance and use of media technology. Privileging technology reduces humans to respondents, not agents, and misses possible alternative, democratic uses of media technology. This emphasis depends on a widely held assumption in media studies that consumer markets are a given, an almost natural condition of communication in the modern world. Many texts discuss media and mass communication practices within an ambiguous "free marketplace of ideas," where all citizens (defined as consumers) have equal access to information reception, production, and distribution: democracy amounts to popularity in the marketplace. Thus, any idea that has merit must naturally achieve commercial success—it's what the people want! Conversely, lacking widespread distribution and acceptance in society, nondominant ideas and little-known information are simply indications that the public has rejected them because such nonpopular ideas must lack merit or value. Even in texts that recognize media consolidation and the impact of advertising and public relations on information production and distribution, citizens are conceived of as individual consumers of information, who will seek out information to meet their own uses and gratifications, eventually creating a market for new ideas (for example, Folkerts & Lacy, 2001; Vivian, 2004). Public information, public interest, and cooperative, collective, citizen action receive scant attention in the midst of the celebration of new media products that promise new personal freedom and exciting cultural experiences.

High expectations for media and other technology have marked each invention and innovation in mass communication history. But none has singularly delivered individual liberation nor brought abundance to all of society, as promised. Indeed, the social upheaval that came with each transformation of mass communication practices (such as literacy, the penny press, or radio broadcasting) did not resolve social inequality or unrest, because the impulse for research, development, and promotion of particular media

practices most often corresponded to the communication needs of the politically, socially, and economically dominant classes. Of course, every media technology and communication practice is subject to the contradictions and conflicts that afflict society as a whole. The use and impact of any communication means or practice ultimately depends more on the material social relations between classes and the attending cultural and social norms than on the inherent nature of any particular technology. A television set in the living room doesn't "make" kids aggressive, even if it's left on 24/7. In the United States, networks and their advertisers decide the programming and messages sent, and audiences watch and interpret messages according to dominant social and cultural norms that encourage boys to be tough, girls to be nurturing, authorities to use any violent means necessary to catch the "perp," and stories to have happy endings with the status quo intact. In past studies, it was found that the cartoons that prompted aggressive behavior in American child viewers did not affect Japanese children in the same way—their popular culture was not awash in confrontation and coercion, social acceptance of violence, and encouragement of in-your-face individualism was not prevalent in the larger culture. In other words, media and communication and their functional consequences, in general, occur within particular social contexts. Media and communication both reflect and reproduce the practices and values of the society in which they function.

Ideas and the communication of ideas always occur in the context of relations of power, relations that exist at discrete, yet ongoing, historical moments. All ideas and the communication of ideas are produced, distributed, and understood within social relations that give rise to those ideas. Thus ideas and their communication are always in flux because social relations are always in the midst of being reproduced, contested, and modified or transformed. Language itself is the result of human interaction with nature, including other humans. The material conditions of life prompt humans to create language to express their connections. Inuit words for "snow" are plenty, but !Kung words for "snow" in Namibia are few. In contemporary society, ideas and their communication are related to how we interact with nature and each other, according to the complex realities of life in capitalist America—mostly "conditions not of our own making."

None of this is particularly profound. Linguists, cultural anthropologists, social constructionists, and semioticians have made similar claims. Yet, we still ask: What is the source of the social power that infuses language with

meaning or determines the specific use of a communication medium? What Marxism has to offer is a materialist analysis of linguistic and ideological power and media practices, an analysis that identifies the connections between communication practices and social relations within social formations. Following Marx and Engels, who were inspired by Morgan, Darwin, Adam Smith, Ricardo, and others, Marxists have recognized that social relations materially arise alongside relations of production: how humans organize their survival prompts, how they interact, how they express that interaction, and how they might reproduce or transform/overturn social relations that privilege existing relations of production, including the division of labor, the distribution of resources, and decision-making powers. A vital part of social relations is communication—the symbolic and practical means for organizing, understanding, and changing our social relations: interacting with each other, we communicate, we produce communication, we use communication, and we as communicators change in the process.

Social Product, Social Tool, Social Process

Social Product

Every communication practice is simultaneously a social product, a social tool, and a social process. Every dominant communication practice arises as the resulting social product of habitual social interaction. As a species, humans must collectively interact with nature and each other to sustain life. In the process, human interaction produces communication in the form of sounds, speech, words, language, and nonverbal codes. In English, the sign e is pronounced "ē." In Spanish, the sign e is pronounced "ā." The pronunciation of other signs, in these and other languages, follows ritualized practices of centuries of use in culturally specific languages. Likewise, groupings of these signs and sounds express words with meanings drawn from shared experiences. In our modern world, we produce and reproduce our way of life by exploiting nature in complex and often convoluted ways; we construct communication practices that roughly correspond to how our physical and social existence has been constructed. The use of computers, for instance, prompts vocabularies representing the associated practices of computer use: PC, download, hypertext, burn, and so on. Reflecting accepted

social practices and existing social relations, the English-language vocabu-
lary for women and blacks has a considerably longer list of derogatory
words than the vocabulary list for men and whites. The words in use, the
words we know, have been produced over time in and by societies that
have had white European males in power. A racist society will produce
racially biased vocabularies. Whether derogatory or favorable, meanings for
words associated with women, men, blacks, and whites are social products
communicating the corresponding social power of women, men, blacks,
and whites. Find a negative word to describe a British citizen. *Limey*? A list
of negative words for Italian, Polish, or Mexican citizens would be consid-
erably longer and considerably more derogatory. Why? It is not that the
English language can't be composed to insult English-speaking people.
Nor is it that dominant members of society gathered in secret to create
words of derision for their "inferiors." Rather, the practice of racial insult,
like all communication practice, is a social product. Because Britain was a
colonial superpower—in the eighteenth century, the sun never set on the
British empire—its language reflected its social and economic dominance.
Words were created that reflected existing social relations; words did not
appear that did not reflect those relations. Hence, words for Brits were/are
predominantly favorable in the English language; English-language words
describing subordinate nations and peoples reflected their actual subordi-
nate social position in the global relations of production of life.

Media technology is also a social product, not merely the invention of
creative genius. Gutenberg is credited with inventing the printing press,
but the press was in use centuries before in China and Korea. Even in Europe,
dozens of other artisans and mechanics assembled similar machines for
printing. More importantly, the scientific knowledge, mechanical principles,
and material prerequisites (such as paper, ink, solvent, metallurgy) were
the result of contributions of generations of thinkers and tinkerers. The
development of radio and television progressed in a similar fashion, the
social product of particular societies having needs, opportunities, resources,
knowledge, and other material prerequisites. Indeed, who can be dubbed
the "father" of radio remains in dispute: Heinrich Hertz, Guglielmo Marconi,
Edwin Armstrong, Lee DeForest, Reginald Fessenden? Each inventor worked
from the material and technical knowledge available at the time. Each con-
tributed to the collective effort, and several arrived at similar, yet unique,
conclusions. But radio transmission and reception was possible only as

their individual accomplishments progressed and were synthesized—often contentiously. And who "invented" television? The Utah farmboy Philo T. Farnsworth, or a host of other inventors? In any case, each studied the physics, electronics, and mechanics of centuries of scientific discovery that was systematically presented to him in his school curriculum—also the result of an advanced industrial society that set aside resources for public education. This is not to discount individual genius or creativity, but only to underscore that in these media, and all others, including film, photography, data transmission, satellite technology, and the Internet, technology was produced socially by thousands sharing knowledge, dividing labor tasks, and providing necessary time and resources for the development of each medium.

Social Tool

Socially produced and practiced, communication is also a social tool. Words produced by an agrarian society become tools for farmers to express and organize their agricultural activities. Words produced by a racist society become tools for maintaining race discrimination. Historically speaking, words arise through collective practice, but once produced word use becomes a social tool for organizing future actions and relations. Naming objects, persons, and relations not only identifies and defines them, but also expresses the social values, perspectives, and expectations favoring existing social relations, including preferences for those who have some influence over naming and defining. Thus, the dozens of Inuit words for "snow" not only reflect the categorizations produced, but indicate that Inuits use these words for noting distinctions that are significant for their daily life: thick snow, wet snow, light snow, changing snow, and so on can indicate weather patterns, seasonal changes, animal migrations, or conditions essential to survival. For most of contemporary North America, in contrast, distinctions in snow type are less significant. Given that weather has been mitigated by housing, heating, travel, and other cultural conditions, words for snow varieties—those linguistic tools for expressing meaning—are less prevalent and less important. From the natural world to the social and cultural world, words are used for signifying distinguishing characteristics and making evaluations. Words are social tools for marking who will be accepted and included and who will be identified as deviant and outside. Thus, those

who can name or influence word choice have the power to affect other social relations. In the 1500s, the conquistadors demanded that the colonized indigenous people in Central America speak Spanish or have their tongues cut off: to control the population, the conquerors felt compelled to control language as a tool of conquest. In the United States, it was illegal for black slaves to learn to read and write: slaveholders correctly understood that literacy could be a tool for liberation. Given U.S. dominance in the world, the expression and implementation of the word *terrorist* becomes a tool for evaluating nations, adjusting military policies, determining domestic civil liberties, and justifying incarceration of combatants and citizens. The word *terrorist* can be a tool for distinguishing actual threats or a tool used to intimidate political opponents: in 2004, the National Education Association (NEA), an organization of 400,000 public and private school teachers, was deemed "terrorist" by the Secretary of Education because the NEA challenged federal education initiatives.

In a similar way, media technology has been and is a social tool for those who control its use and application. Media technology improves the distribution of information, persuasion, and entertainment. Those who own or control media can influence what news and information will be disseminated, what social norms will be highlighted and valued, which persuasive messages will be transmitted. Media may be used to consolidate power, as the Catholic Church and European nation-states attempted to do with their use of the printing press; or media may be used to challenge and resist power, as Thomas Paine, Ben Franklin, and other colonialists did with their use of the printing press in colonial America in the eighteenth century. Authoritarian governments on every continent have attempted to use radio and television broadcasting for social control; in each case, from Bolivian miners to Mexican peasants, popular organizations have employed alternative, more democratic media for political mobilization and liberation. In the United States, radio began as a social tool of organization and affiliation by communities, universities, schools, and religious and political groups. With the 1934 Federal Communication Commission regulations, radio became a social tool for advertising and entertainment, as commercial interests were granted exclusive licenses for nationwide mass broadcast. The experience of the British Broadcasting Corporation (BBC) in England illustrates a different use for radio—public service, public information, nonprofit cultural entertainment. Whatever the myriad possibilities within any particular society,

including its rules, regulations, and norms, media always appear as social tools for the producers, directors, and decision makers of each medium. Whether it is which language can be spoken, what terms will be used to describe our fellow human beings, who can read and write, what passes for news criteria, or who has access to radio broadcast, those who influence and control communication practices wield a powerful social, political, and cultural tool.

Social Process

Understanding communication, materially, as always simultaneously a product and tool recognizes the changing, contradictory, and dynamic nature of communication as a social process. Communication is a shared and yet contested practice that must constantly be negotiated and reconstructed even as it expresses and organizes human understandings. As societies change, communication changes, and as communication changes in use by diverse contesting social groups, societies change. To be tan in the nineteenth century was a sign of underclass: manual laborers and hard workers got "farmer's tans"—darker skin indicated further social inferiority in keeping with the race relations of the time. Elites who lived more leisurely spent less time in the fields, used umbrellas at the beach, and relished their alabaster skin. Today, the situation is somewhat reversed. Tans often represent winter trips to resorts in Mexico or Florida or on the Riviera and suggest expendable income; paleness, in contrast, indicates that one has been laboring indoors during the "vacation" months. Simpler examples include words such as *bad*, which may mean "good," or *cool*, which can also mean "hot." The words we use change over time and in particular contexts, because all communication is fluid, changing, the outcome of social processes of battles over meaning and use. Certainly, communication shapes our perception of the world, yet we alter our perceptions and communication to achieve our own ends, which often conflict with existing, accepted meanings.

Conflicts over meaning are frequently inscribed in disparities between what is intended and what is understood, described by Stuart Hall (1990) as a social imbalance between encoding and decoding dominant, negotiated, alternative, or oppositional meanings. Dominant meanings are those preferred by the message source and generally in keeping with the norms and values of dominant society. Whenever preferred dominant readings of

particular messages are unclear or unacceptable, various publics or groups construct a negotiated meaning, based largely on the dominant interpretation painted with a particular experience, preference, or understanding. Occasionally, groups or individuals will consciously reject a dominant message as not in their interest and construct their own alternative understanding—gas-powered SUVs are seen as environmentally damaging, so one buys a hybrid compact car, which doesn't challenge Detroit or the fossil fuel industry but does present an alternative meaning for gasoline-powered transportation. On occasion, usually coinciding with a moment of serious social or political crisis, groups or individuals will respond to messages oppositionally—when segregated schools were no longer acceptable, the system of public education was rejected and politically challenged.

These multiple readings of meanings and messages produced in culture do not reside primarily in the discursive field, but indeed indicate that social groups are continually competing over resources other than media and communication, using communication as a catalyst for social change or a prop for the status quo. In other words, we may create our own worlds, but we do so in response to conditions that we confront. The NAACP was formed in 1905 as the National Association for the Advancement of Colored People. At the time, *colored* was the social product of a race-conscious society that denigrated "black" citizens. *Black*—as a social product of race-prejudiced society—was negative in most contexts: blackball, black sheep, and black mark on your record were undesirable. In contrast, white sheep, white lies, and white as snow were more favorable concepts. The meaning of *black* has its roots in archaic Indo-European sounds resulting from negotiations over humanly recognizable colors. Additionally, the social-political meaning of *black* has its roots in historically identifiable relations between racialized humans—largely in the European world and languages. Thus, *black* is a social product expressing human interaction according to the outcome of the contested significance of natural markers—skin color in chattel slavery European colonies. To be black in the United States was to be second-class and thus the communication of multiple negative synonyms for *black* would be expected in the symbol system of that society—symbols that kept black Americans "in their place." In the mid-twentieth century, even the leading black company in the United States made profits by selling bleaching skin cream. In short, *black* and *white* were communication terms produced according to existing social relations of inequality. In short order—almost

simultaneously—*black* became a social tool for maintaining discriminatory social relations based on racial difference. Despite centuries of conflict and resistance, and as long as race relations remained relatively static, *black* (and its more demeaning synonyms as epithets) carried a negative meaning in keeping with existing dominant social relations. Yet, as opponents of race inequality and segregation politically organized, as the civil rights and black nationalist movements gained power and prestige, social relations changed, social practices changed: *black* was transformed into a positive marker of identity: black power, black pride, black is beautiful. The social process of challenge and disruption to existing social relations, and their ensuing limited adjustment, resulted in a new linguistic social product: *black* now also expresses the changed, yet still contested and contradictory, relations of race (*race*: a word with meaning also produced by a particular society to express material social relations and practices, a word that is a social tool for categorizing humans for particular relations, a word that someday will undergo a social process of transformation, and hopefully disuse, as humanity progresses).

We are born into a world of communication created by existing and prior symbolic and socioeconomic activity. We learn and act and work with the language, knowledge, values, and meanings we receive, and then alter (or try to alter) that inheritance in response to our experiences, our interests, and our goals. The production and use of words, language, and images are created by those who came before us; we share and contest communication in the present and will accept, alter, or discard some practices in the future—all in the process of learning about, challenging, and changing our social conditions.

Media too have changed as competing groups and individuals have discovered and experimented with possible uses for each technology. Inventors and innovators have often been supplanted by more powerful, more organized agents, often orchestrating or relying on legal maneuvers to secure control of particular media. In the 1930s, RCA, NBC, and CBS used their economic and industrial power to influence the Federal Communications Commission to capture radio broadcasting for commercial interests and manufacture radios as receivers only. Within just a few years, from 1928 to 1935, nonprofit, educational broadcasters who once appeared on almost 40 percent of the radio dial were pushed to the frequency edges with less than 4 percent of airtime across the country (McChesney, 1993). In the process,

radio in the United States became less a medium of citizen mass communication and more a system for commercial broadcasting. Radio was prevented from becoming a means for democratic mass communication. Public service, educational, and democratically accessible radio was aborted as the airwaves were soon flooded with advertisements and mass entertainment produced by giant for-profit broadcasters. In other words, from a materialist dialectic, radio as a social product and social tool underwent a dramatic social process of transformation, from a means of horizontal, democratic communication by citizens to a medium for the vertical transmission of mass entertainment for consumers.

Mass communication practices, ideological frames, and the meanings of words and symbols are the products of changing cultural needs and norms that respond to and influence changing political and social relations. Participatory communication practices might serve as tools for developing community and democracy, while dominant media practices serve clear and identifiable economic interests, advertising, and even short-term political agendas and ideologies. Each emerging mass medium, from print to the latest media communications technology, has been contested as the tension between technological opportunity and unequal social relations posed questions over possible use. Marxism understands that historically the battle has been between competing social classes over the power to communicate, over the power to organize society.

Communication and Its Social Contradictions

Compare two expressions and their practical manifestations from two different societies involved in differing social-political trajectories (that reflect opposing socioeconomic priorities and social class interests): employee quality circles in the United States and *cogestion* (worker's co-management) in Venezuela. In the United States, many large corporations have company-led co-management teams to encourage workers to make suggestions for improving efficiency. Several companies have even initiated "communities of practice" that "govern themselves and choose their own leaders, often in contested elections" (Wessel, 2005, p. A2). For what purpose? To create "islands of democracy in a hierarchical capitalist sea" that will provide knowledge and expertise "for the benefit of shareholders" and society (p. A2).

In Venezuela, a similar term has a dramatically different application due to the political direction of the government and the political power of the mass movements. *Cogestion* still translates as "co-management" as in Europe and still "means making production more efficient." But, now it also means "getting rid of bureaucracy, mismanagement and corruption" (Martin, 2005). Managers are elected and may be recalled, and profits are distributed for social programs according to votes by worker's and citizen's assemblies (Jorquera, 2005). *Cogestion* politically translates as "worker's control." To make any sense, the linguistic translations of *co-management* must recognize the political processes that are the primary mediators of the larger conflicts between social forces seeking to either reproduce or transform the social formations of capitalism in the United States and Venezuela.

Likewise, the political consequence of the two "co-management" plans cannot be understood linguistically. A self-governing "community of practice" at Schlumberger, Ltd., an oil-field services company of 52,000 employees, cannot be cast as a "real democratic institution" simply because it holds contested elections: it is no "worker-run kibbutz" (Wessel, 2005, p. A2); it is a means for managing and motivating technical professionals for increasing company profits. In contrast, *cogestion* at CVG—the largest aluminum plant in Venezuela—is a different kind of co-management that redefines the political consequence of the term.

> There are regular meetings to discuss what is being produced, how it is being produced and what quantity and quality is being produced. So management is effectively in the hands of the workers. No significant decision is taken without the active participation of the workers. The process is also being opened up to the local community. Increasingly discussions are being held between factories and the local community about the role it plays in the local economy...they discuss what projects the company should be supporting in the local area. (Jorquera, 2005)

Two ideologies share a similar vocabulary, but their articulations stretch the linguistic boundaries in proportion to how their ideological practices (in management, production, and decision making) stretch the boundaries of political relations within the existing social formation. It is not linguistics or ideology writ small in Venezuela that worries North American capitalism. Rather it is the political consequence of an ideology in practice that threatens

to overturn the entire capitalist formation in Venezuela. As President Hugo Chavez declared on his weekly TV show, *Alo Presidente!*, the Venezuelan revolution is "a process in which new ideas and models are born, while old ideas die, and in the Bolivarian revolution it is capitalism that will be eliminated!" (Martin, 2005).

Marxism makes sense of these "rhetorical turns" as material manifestations of dialectical social contradictions active in and on capitalist institutions and in the more concentrated social contradictions in Venezuela. Ideas did not spring forth from the mind of Schlumberger's CEO Euan Baird or Venezuelan president Chavez. Their ideas occurred in the context of economic pressures (oil depletion and exploration, declining profit margins, reduced national budgets, imbalances in international trade, competition, deregulation, privatization) and political tensions (middle-class anxiety and volatility, worker demands for social and economic security, widespread dissatisfaction with neoliberal policies and politicians). Each offers leadership for multiple social class forces; each proposes solutions to urgent or emerging social and economic crises. A Marxist analysis would suggest that the degree of success of each will depend on how their linguistic/ideological offerings spur political actions by socially and politically powerful classes that can reproduce or transform the existing social relations.

The Presence of Class

Dominant modes of communication permeate the relations of production in every society. Contrary to the technological determinists, the means of communication—which do have technological parameters—do not have inherent social applications or consequences. Indeed, the use of any particular means of communication depends on how existing social relations develop and employ that technology—that is, on the outcome of negotiations, battles, or alliances among class forces within that society and how they decide to produce and reproduce life. These same means of communication may function differently whenever the social relations that determine their use are changed: radio in Nicaragua went from a military instrument of U.S. occupation, to a tool for business and trade reports, to a vehicle for mass entertainment and propaganda by the Somoza dictatorship, to a means of propaganda and mobilization by the Sandinista resistance, to a public forum

for participatory, democratic communication, locally and nationally (Artz, 1994). Whoever had power over the microphone determined the professional practices of the medium and the social function of its communication. As Robin Murray and Tom Wengraf (1979) write in explaining access to media, in class societies the dominant communication systems will operate to "confirm and enhance the power and cohesion of the dominant class and to confirm and control the fragmentation and subordination of the subordinated classes" (p. 185). In other words, "asymmetrical social relations" distort or restrict the possibilities for democratic communication and media use.

This observation understood narrowly is not solely the purview of Marxism. "Who must listen, who can speak, when and how, are questions always worth asking" (Murray & Wengraf, 1979, p. 185). What Marxism provides is the understanding that the determinants of public access to the means of communication depend on the political economy of the social formation, providing a theoretical stance for measuring democracy, identifying the social forces in contention, and explaining and predicting dominant communication practices according to which social classes have power or attain leadership in that society.

Here then is the value of Marxist insight: our understanding of the workings of communication and culture in society is improved by attending to social class relations. Accepted wisdom in most media, rhetoric, and other communication textbooks—as well as other academic social sciences in the United States—would have it that social class is an archaic concept, theoretically and materially. In mass media accounts, the significance of social class has been overcome by the workings of the pluralist democratic system, the leveling effect of affordable consumer goods, and everywhere superseded by identity politics or other more prevalent social divisions unrelated to the division of labor. Marxism rejects these surface readings of dynamic, complex social relations that define the material reality of capitalist society, the division of labor, and corresponding social relations and cultural practices. Positing social practice as the site of human agency (Kraidy, 2005) gains credence only when the material and historical class basis for social practice is identified.

Class characterizes the materialist analysis of communication because it encapsulates an important tenet of Marxist methodology: there really are rulers and ruled; classes really do exist in all modern societies. Admittedly, this claim requires much more than the following short presentation on

social relations and the production of life, but this brief should at least suggest the materialist approach being promoted.

Toward a Class Analysis of Communication

The Production of Life

Metal, wood, oil, and other raw materials are used by humanity for its survival and development, but as long as they remain underground or standing in the forest, they are useless. It takes human labor to transform natural resources into usable items (a fact consciously obscured by advertising and the culture industry, from Nike and Coors to Disney and Microsoft). A variety of techniques and practices have been employed over the thousands of years of human existence and in the process of expropriation of nature and production of things men and women have developed social relations that coincide with the organization of their productive activities. Indeed, one cannot speak of productive practices without speaking of social practices— as intimate parts of the same organic process. Societies have been formed through the combination of productive practices and their accompanying social relations, as varied as the multiple ways we have interacted with nature and each other: primitive communism, chattel slavery, feudalism, capitalism, and socialism being a few of the more well known.

Every society can be characterized by how its members enter into social relations for the production of life—relations that organize the harvest, discovery, expropriation, production, distribution, and use of resources, necessities, goods, and services for life; relations that also inform their cultural manifestations (for example, dance, art, music, vernacular speech, recreation, entertainment, cuisine, and so on). Advanced capitalist societies, such as the United States, have highly industrialized productive forces with the collective efforts of millions using available means of production to manufacture goods and services according to stratified social relations that distribute benefits, rights, and responsibilities hierarchically. Productive forces include the whole range of technical means available for exploiting nature and producing material goods for human use; means of production include natural resources (coal, wood, oil, water, and so on) and the instruments of production (tools, machinery, technology, transportation, electricity, and so on).

Human life is produced by the gathering of natural resources by human labor using various means of production. Hence, labor power—the human capacity to work—is the material prerequisite for the transformation of natural resources to usable things, because labor power is also what changes natural resources into progressively more advanced instruments of production. Capitalism is a social system in which the means of production are privately owned and operated for individual profit. Capitalism organizes labor power as wage labor—workers are paid for labor time and skill, but not their total productivity. Machinery and technology and the skill and experience embodied in machines and technology through science, knowledge, invention, and innovation improve the efficient use of labor power acting on nature by employing those instruments of production on nature. Contemporary American capitalism organizes the immense productive capacity of collective international labor into wage labor working with the latest technology and most advanced equipment available to produce commodities for corporate sale.

The social relations of production in the United States are not as advanced, progressive, or socially egalitarian as the productive forces and means of production would allow. Production is highly socialized; the labor process is collectively organized according to an extensive division of labor, increasingly on an international scale. Producers do not sew their own clothing, grow their own food, or build their own furniture. Instead, to meet the needs and desires of society as a whole, clothing, cereal, sofas, music, and most other socially useful items are mass produced in privately owned enterprises that involve thousands, if not hundreds of thousands of people in labor. Individuals with many different skills perform many different tasks: discovery, design, extraction, transport, manual labor, skilled machining, packaging, inspection, and maintenance of machinery. Producers "are not simply individual workers, side-by-side in a given enterprise," but workers who "have been made into a real 'collective' worker by the division and organization of labor" (Jalée, 1977, p. 12) and by the production of commodities for others sold for private profit. In the globalized capitalist system, even the smallest item destined for mass consumption requires a highly socialized, coordinated international productive effort.

In contrast to the highly socialized production process, neither the actual producers of goods nor citizens as a whole direct, control, or decide the goals or practices of production. Instead, the means of production—from

raw materials and factories to railroads, from oil and oil rigs to tankers—are privately owned, operated, and managed for individual private profit. Mineral deposits, forests, water, and even the air may be ostensibly "owned" by the public, and thousands of workers participate in the actual transformation of nature into material goods, but the decisions on when and how to use those resources, costs (including environmental and human consequences), and profits resulting from collective human effort are held privately. In other words, production is socialized, but the decisions over production are private. Moreover, the benefits from the collective knowledge and efforts of humanity are unevenly distributed among social groups and individuals.

The Production of Class Relations

This combination of advanced productive forces and private ownership of the means of production creates social relations that require millions of workers and managers, who own no productive resources beyond their own labor, to sell their labor power to capitalist owners in order to live. Thus, on one side, we have workers (including laborers, technicians, and engineers, for example), without whom no production would be possible, struggling to maximize their wages and salaries, often by working more hours. On the other side, there are capitalists, who own the means of production, without which no production would be possible, seeking maximum profits from their machinery and property by increasing the productivity of the labor power they employ. Importantly, for Marxism, these contradictory relations of production are not relations between individuals per se but are social relations between classes of individuals linked to each other by an insurmountable contradiction. "The contradiction between the private ownership of the means of production and the social nature of production" (Jalée, 1977, p. 13) provides the material ground for the production and negotiation of other corresponding, yet contradictory, social and cultural practices.

The primary social contradiction within capitalism is structurally expressed as an antagonism within productive relations—not simply personal relations but social relations between classes. From a Marxist perspective, social classes appear as a group of people who relate to production in similar ways and share a common location in the relations of production (Therborn, 1983, p. 39). The capitalist class owns the means of production but

rarely works there. The working class does not own the means of production but gives them material expression by physically using tools, machinery, and labor power (mental and manual) on raw materials and their products. In terms of production, the working class owns only its labor power, which must be sold to the capitalist for a wage, whereas the capitalist depends on the worker to create goods, which must be sold for a profit. Other classes can also be defined according to their relationship to the means of production. For example, the managerial middle class is excluded from ownership of the means of production and as an administrator is also generally excluded from actually using the means of production; instead its position is defined by organizing the productive process.

Of course, these broad categories are very rough outlines. In each case, more specific class groupings within a class can be recognized in relation to the overall social structure (Wright, 1985). Industrial workers have a different relationship to the means of production than do transit workers, retail clerks, or communication workers. Finance capitalists have a different relationship to the means of production than do industrial capitalists or small business owners. There are obviously multiple and complex differences between sections of classes and between the same classes in different conjunctural moments in different capitalist countries. Nonetheless, defining social class according to its relationship to the means of production and its position in the productive process provides an analytical lens for making sense of social, political, and cultural practices, including communication and media.

The material existence of these structurally situated classes is insufficient for explaining, predicting, or transforming social relations, however. Structures don't act; people do. As surmised from the above, the production of things coincides with the production of social relations that construct preferred social and cultural practices, including media practices, sport, entertainment, recreation, and so on. In other words, social class has a subjective human agency component: not only is social class a structural condition, but it also "is a process, is defined in relation to other classes" that are also in process, and "is historically contingent" (McNall, Levine, & Fantasia, 1991, p. 4).

The power of any class depends only in part on its relation to the means of production. It also depends partly on its relation to other classes and society as a whole—relations that change as classes change and struggle over time. Once capitalism became the predominant mode of production,

the capitalist class became the leading class economically, politically, and ideologically as emergent "nation-states" enforced the capitalist class's economic, political, and cultural rule. The social power of all other classes was decisively altered in the process. The nobility lost its feudal privilege and its political and cultural power, as well; the peasantry declined in number and significance; the working class grew rapidly. The feudal order positioned all classes in relationship to the land; the capitalist order positioned all classes in relationship to manufacture of commodities; international capitalism positions all classes in relationship to the global division of labor. The social significance and political and economic power of each class comes from the combination of its economic and social relationship to the structure of the means of production and its political and cultural relationship to other classes.

This dense narrative does not do justice to the complex concept of social class, which is essential to any complete understanding of communication practices, but for purposes of discussion, three conclusions might be drawn from the above account:

1. The social organization of the means of production provides a useful guide for identifying social class.
2. Based on the relationship to the means of production and to other classes and groupings, social classes have varying degrees and kinds of power.
3. The political power and social impact of each class depends on the outcome of its interactions (battles, alliances, and negotiations) with other classes.

These conclusions pose several questions: What is the relationship between social position and the political organization and power of any particular class? How does the social structure affect the capacity for subordinate class action? How do individuals and classes experience or understand the social structure and their class position?

Class Formation

Class structure does not determine class formations but only determines their probabilities (Wright, 1985, 1991); classes politically emerge from the

social relations and interactions within and between classes. Structured social relations limit possible class formations, but do not determine, such that "one cannot group anyone with anyone while ignoring fundamental differences, particularly economic and cultural ones. But this never entirely excludes the possibility of organizing agents in accordance with other principles of division" (Bourdieu, 1987, p. 8). Gender, race, ideology, and political action by government and other organized agencies also shape the political formation of classes and prompt and inform cultural practices, such that entertainment reflects patriarchy, sport reflects race prejudice. Even cuisine (which follows cultural development across space and time) has ideological impulses and overtones of class markers: upscale versus fast food; five-star versus drive-through...

In other words, class structure is simply the material context for other social processes (Wright, 1997, p. 9), such that social classes confront real limits on the material and political resources available for group action. Materialism finds that similar class structures allow for different class formations, as history has revealed (Cohen, 1990; Levine, 1988; Poulanzas, 1978). Stephens (1979) found that differences in organized working class political strength and action led to different class formations in seventeen Western capitalist nations after World War II, similar to Valocchi (1991). As Wright (1997) says, class formations are "created through the strategies of actors attempting to build collective organizations capable of realizing class interests" (p. 19). As actors become aware of their lived experience, they choose strategies based in large part on how their class position and activity has informed and framed their experiences. For Marxist communication scholars, the condition of social structure is an important material prerequisite for evaluating real and proposed social practices, including rhetorical, ideological, and other political messages. Communication that is more consciously cognizant of how groups and individuals are connected to the social structure will likely be more successful in constituting certain class formations. The materialist dialectic understands that humans may act to transform conditions, to make revolutions against social orders that fail to meet changing human needs.

The current class structure provides more immediate material and political resources to the dominant capitalist classes than it does to the subordinate working classes, because the current socioeconomic system, which is being globalized by transnational corporations and international trade

relations, can still provide for the relative material well-being of a majority of the working population in North America and Europe. Although social movements and class struggles have modified the political landscape in the United States, the judicial dispensing of structurally available material and political benefits to oppositional classes and groups has allowed capitalist class representatives to maintain the legitimacy of capitalism (and preemptively defend it militarily around the globe). However, the rapid adjustment to the world division of labor for private profit hurtles us toward major class conflict, most likely obscured by national resistance to international relations and Northern interventions, as is currently transpiring in Bolivia, Venezuela, Brazil, Chad, India, and elsewhere. These ruptures will create antagonisms within the United States, as resources for the working and middle classes will necessarily be diverted by the capitalist order to defend its interests globally, and national social classes will be repositioned in relation to their counterparts in other nations and regions. We are about to enter a new era of class confrontation and negotiation over what kind of world we will have.

The social and political process of class contradiction and class negotiation is expressed in Antonio Gramsci's concept of hegemony. Hegemony is the process of moral, philosophical, and political leadership that a social group attains only with the active consent of other important social groups (Artz & Murphy, 2000, p. 1). Hegemony is preconditioned on the social and economic power of the working class—without the continued support of the majority of working people, capitalist society would collapse and alternative social relations could be proposed, as happened in France 1968, Chile in 1970, Portugal in 1975, Nicaragua in 1979, Poland in 1980, the Soviet Union in the 1990s, and in Venezuela today, to name a few examples. Dominant classes that are too self-serving in their political, social, and economic leadership (or lacking the material resources to provide benefits to all) will inevitably confront serious challenges by other social groups. In North America and Europe, working and middle classes consent to capitalist hegemony because (absent alternatives) it provides some modicum of tangible material benefits, coherent political leaderships, and meaningful cultural practices. Hegemony does not just occur naturally; it must be constructed and institutionalized. In every stable hegemonic order, leaderships direct society through hegemonic institutions that help regulate, communicate, and popularize practices, norms, and values necessary for reproducing dominant social relations.

Hegemonic Institutions

The function of hegemonic institutions is to reproduce the social order and its relations of production, which include (1) everyday practices such as the work day, school day, and consumerist diversions, including hobbies, recreation, media, and other entertainments that are commodified (the singular profit-driven production of products); (2) the educational system, including an appropriate curriculum and organization, in class- and race-based public institutions and for-hire private institutions; (3) the legal system, including laws, enforcement, and incarceration for infringement on property and personal rights; (4) the political system, including the two-headed one-party system of representation, staged, nonissue election campaigns, deference to the executive administrators of the state, and the popularization of this "democratic" system via the media; and (5) the institutionalized cultural system, including sport, music, entertainment, recreation, and ideological practices that will reproduce the social order, such as religious rituals, nuclear family childrearing tasks, gendered fashion, commodified narrowcast media genres, charity, and other vehicles for promoting atomized hyperindividualism, spectatorship, deference to expert authority, and other norms that will obstruct or preclude group solidarity, democratic participation and access to communication, and any commitment to social justice. As Kate Crehan (2002) observes, "Those groups that have power act, often in extremely subtle ways, to stifle the emergence of understandings of the world that challenge their accounts of reality" (p. 146). This is more than a public relations function, although publicists certainly act to advance particular worldviews. As noted above, relations of production can never be understood only as economics or the material manufacture of goods. Rather, relations of production are understood in their totality, as a whole complex of coordinated, negotiated, and contradictory human activities that seek to reinforce social class positions relative to the mode of production in operation. The production of life includes activities that create and develop personal relations, institutional relations, and preferred and naturalized practices of work, as well as the ideological supports that explain and justify the social arrangements. The social order is not a neutral playing field in which "different, autonomous cultures happily coexist; they are fields of struggle, in which those espousing radically different conceptions of the world strive for primacy." At any one time, there are certain class groups that are hegemonic,

although that leadership is never total—"it is always, although to various degrees, a struggle in process" (Crehan, 2002, p. 146).

Media Hegemony

The relations of production of communication and media exist within the complex of the relations of production of life in each social order. Cultural practices are essential to the reproduction of the hegemonic order, which needs the assistance of the merger of common sense, folklore, and mass popular culture. Dominant classes and their representatives appropriate the means of communication for the production and dissemination of ideologies (in word and deed) that will reproduce their preferred relations of production of life, but they rely upon the creative offerings of subordinate classes and groups for inspiration. Hegemonic success often depends on how well the dominant classes and their representatives can incorporate contributions and challenges from subordinate classes into an ideology (in word and deed) that may modify but reinforce and protect the existing social relations of production of life.

Thus, the preferred mode of communication for a class society employs the available technology for applications appropriate for reproducing the existing relations of production, both in the productive practices and the symbolic output. Media, for instance, have historically been developed "only when the time was ripe—which shows that a technical innovation can prosper only if it meets a social need" (Escarpit, 1979, p. 195). Printing not only needed the material prerequisites for its technical development, as described above, but also the material class prerequisites, as book publishing went through several "mutations" in response to the needs and uses, first of the "international aristocracy," then of the "nascent capitalist industry" as the "popular book had a strong puritanical bias, and the stress lay more on its moral code than on its revolutionary value," later when "its efficiency as a social determinant" "played a part in the building of progressive opinion" of the emerging American capitalist democracy, and finally, "the inevitable consequences of capitalist industrialization" that turned books into simple commodities for sale to millions (Escarpit, 1979, p. 197). James Carey (2001) describes in some detail the rise of a journalism that met the needs of advertising, capitalist business and finance, and a newly urbanized working class

in the United States in the nineteenth century, which meant that the jour-
nalism of the penny press presented a style, timing, and content beneficial
to capitalist relations of production, including orienting the working classes
to the appropriate symbols, practices, and norms. In each instance, and still
today, the cultural production roughly followed the contours of the larger
political and economic needs of the dominant classes. As Armand Mattelart
summarizes, "Mass culture fulfills a need engendered by the political sys-
tem of representative democracy, which appeared along with the develop-
ment of capitalism" in the United States.... Just as the locomotive and the
telegraph accompanied capitalism's need to open up new markets, and find
new sources of raw materials, in order to permit the advance of its mode of
production, for a similar reason, the mass communication and mass culture
network accompanied the bourgeoisie's need for an opening towards other
classes" (Mattelart & Siegelaub, 1979, p. 3–23). This includes the recruitment
and ideological and technical training of creative workers and production
staff. Scriptwriters must turn their stories into marketable narratives for
commodity sale; artists must aspire to become the next "American Idol"; and
all must be convinced and pleased by the fairy-tale worlds of self-gratifica-
tion accorded to the consumption of consumer goods. Here, the functions
of mass culture correspond to the functions Gramsci (1971) accords hege-
mony, or class leadership: to organize "the 'spontaneous' consent given by
the great masses of the population to the general direction imposed on
social life by the dominant fundamental group; this consent is 'historically'
caused by the prestige (and consequent confidence) which the dominant
group enjoys because of its position and function in the world of produc-
tion" (p. 12).

Marxism does not fetishize the product, but sees the material basis for
production in the structure of relations and in the social and cultural prac-
tices accompanying those relations. Hence, a materialist analysis of any
text, discourse, or media practice would move beyond the instant semiotic
to the social semiotic arising from the relations of production. Marxism
does not fetishize the structure, but recognizes the likely practices fitting
those structures and the contradictions arising from those same practices
that conflict with the class interests of the subordinate groups. Thus, the
materialist dialectic—in contrast to Althusser's static structuralism that
always already "interpellates" actors through ideological and repressive state
apparati—sees social, cultural, and political practices as material expressions

of the materially existing contradictions between social classes, giving rise to reproduction, resistance, or revolution that can transform and replace the structure of social life. Marxism does not fetishize the practice, but sees public relations, advertising, organizational and political communication, journalism, and other communication practices as attending to the reproduction of capitalist relations of production. Communication has meaning only in the concrete, in the materially identifiable, dialectically contradictory historical conditions under which it occurs. Thus, for example, without connection to a social movement challenging capitalism and its various nation-state configurations, media reform will be still-born or even improve the persuasive appeal of capitalist ideologues—as documented in repeated studies on Latin American media (Fox, 1988). New communication practices—whether reciprocal as in Dianne Rucinski (1991) or democratic and participatory as in Bertolt Brecht (1981), Lee Artz (1994), and Guillermo Rothschuh (1986)—need new communication structures, which need new relations of production.

Material Power and Dialectical Interaction

Although relations of production create social relations that link social classes, the strength of one class is not directly proportional to the weakness of others: each class has its own strengths and weaknesses. Therborn (1983) identifies the power resources of three major classes in capitalism: the fundamental resource of the capitalist class is the *expanding market* and its ability to materially satisfy other classes; the resource of the middle class of small business people is its *autonomy*, or independence from employers, workers, landowners; the fundamental resource available to the working class is its *collectivity*—in action it can stop or unleash productive power, political power, and social change. Therborn argues that the capacity of each class to provide political leadership for organizing society and reproduce or transform the social order depends on its ability to deploy its intrinsic capacity to or against other classes. Thus, communication by and for capitalism promotes entertainment and consumption in order to economically and ideologically reproduce market values and practices. The communication of entrepreneurs stresses individuality—a value easily incorporated into the consumer culture. In contrast, a conscious working class communication would express

solidarity, community, collective social responsibility, decision making, and concern for humanity as a whole. Obviously, media technology would be and is used differently in promoting these differing class interests, values, and political resources. The daily practices of Clear Channel radio and U.S. television networks illustrate one use, one ideology; the practices of PBS or NPR suggest possible alternative uses; while dozens of U.S. community radio stations, Nicaraguan popular radio in the 1980s, and other international examples demonstrate more collectively democratic uses and transformative ideologies. The professional practices and organizational norms of communication in each case begin to make sense in light of a materialist conception of social class and social formation.

Communication practices always occur under particular social conditions and social formations, such that technology used/developed both reflects and is intended to reproduce that social formation, even as certain conditions of that formation change. In other words, private ownership of media can function with no government regulation or with considerable government regulation, including limits on time, audience, content, synergy, and even ownership share. Private ownership can be so limited under a capitalist social formation that public media dominate, as the BBC does in the UK. Yet, from one extreme to the other, dominant media practices reinforce and reproduce the capitalist formation by popularizing, normalizing, and promoting values and practices essential (or at least tolerable) to the capitalist system. Only during exceptional crises would such practices be replaced. Likewise, it is also an exception for private media to disregard its stated professional practices that obscure class relations or present existing social relations as natural, normal, and preferred. Of course, under extreme challenge, the capitalist private media will do its job of defending the social formation. Thus, the *New York Times* called for a U.S. boycott of UNESCO after the organization asserted that media and culture were public resources. The *New York Times* also found the means to support the U.S. war on Iraq, distorting its journalistic claims to balance, objectivity, and truth (Artz, 2004b). Even more revealing is the leading role of the Cisneros media group in Venezuela, which used its dominant media position to orchestrate demonstrations, strikes, and ultimately a coup against a democratically elected government. At least since 1999, Venevisión has established and implemented its own system of censorship, propaganda, and public exhortation to defend the interests of Venezuelan capitalism and its established norms of government, trade, and social welfare.

Media are subject to class power through the control mechanisms of ownership or direction, the professional practices influenced or determined by the control mechanisms, and the social function set by the control mechanisms. The mode of communication depends on the relationship between the means (media technology available for use) and the social conditions, including social relations within the formation. Without this vision, even the most insightful researchers stumble, as evidenced by leading cultural imperialism and hybridity theorists who ultimately shy from class analysis: Herbert Schiller (1976) writes of "dominating stratum" and "dominating centers" (p. 9) without identifying the class character of the dominant; Marwan Kraidy (2005) reclaims hybridity from "the free marketeers" to redefine it as "a social issue with human implications" because people are not merely "individuals who constantly recreate themselves by way of consumption," but he goes no further than finding agency in ill-defined, nonclass "translocal and intercontextual" social practices (pp. 151–52). Capitalism (national and international) may well have a variety of social relations and cultural forms, varying from bureaucratic and autocratic norms, to censorship, to more "enlightened" co-management, or even a more laissez-faire system of production all expressed in a variety of hybrid, transcultural, contradictory cultural practices. Yet, as Gramsci writes, the "kernel" of capitalist relations— private profit from expropriated surplus labor—is always protected. Thus one witnesses Rupert Murdoch and Roger Ailes at Fox or Michael Eisner at ABC/Disney closely attending to daily operations that include assuaging cultural refinements for diverse audiences, from China, Indonesia, and Latin America. Meanwhile, the equally profitable Mideast satellite network Al-Jazeera remains fairly independent from the owners, who are removed from daily operations, but nonetheless has a consistent self-described pan-Arab perspective.

These instances indicate the need to analyze the concrete relations and practices: How does communication occur and function? Who decides what and how? What tensions and contradictions exist and how are they resolved or intensified? What is the relationship between this communication or cultural practice and the rest of the social order—regulators, instigators, evaluators, spectators, facilitators, benefactors, and beneficiaries—and how does this communication practice reinforce, reproduce, challenge, or potentially transform those relations and why? For Marxism, communication has no fixed meaning, but it has actual material consequence as it occurs—both

materially in the products, the institutions, the actions related to communi-
cation and symbolically in the language, rituals, and meanings that are
loosely strapped to those material practices.

Disney feature animations are a case in point. The ideology of hierarchy,
individualism, and authority that are consistently narrated in Disney ani-
mations coincides with the social relations that Disney finds necessary to
produce, distribute, and export its products. Disney characters, dialogues,
and story lines invariably reject social responsibility, democracy, and group
solidarity in favor of the hero/heroine's self-interest, even when that self-
interest legitimates and advances monarchy, autocracy, and antidemocratic
diegeses (Artz, 2004a). The political economy of the Disney corporation illus-
trates those stories in practice: nonunion, underpaid workers, artists, and
technicians are encouraged to obey corporate orders to advance corporate
income, while multimillions are provided to CEOs and shareholders in the
corporate circle of life (Giroux, 1999). The narrative moral of Disney features
is not determined by the animation genre nor by the film or video medium;
rather Disney decides how the means of communication can advance its
product distribution and income flow in tandem with clothing, toys, games,
theme parks, cruise ships, and other branded merchandise.

In a slightly different example, journalism demonstrates how norms and
practices meet the needs and values of a social formation. The construction
of "objectivity" presented as nonpartisan relies on forms—credible sources,
balanced reporting, the inverted-pyramid style, headlines, column-one news,
editorial sections, and other standardized norms—that conform seamlessly to
the time and space requirements of the business cycle, advertising require-
ments, and corporate profit drives. Whenever these forms obstruct or con-
flict with the fundamental interests of the capitalist system, they are quickly
modified or discarded by the corporate media suddenly dedicated to the
"national interest," which apparently can be defended only by more partisan
political forms that can mobilize citizens against social forces that threaten
to transform the capitalist order or important parts of that order. Thus, we
have Venevisión, Nicaragua's *La Prensa*, Fox, the *New York Times*, and others
adjusting their practices to represent the ideological needs of the leading
social classes and their power.

Class power is diffuse, but nonetheless it has names and addresses. Media
conglomerates have significant interlocking directorships (Henwood, 1989)
ensuring the sharing of corporate goals, the review of tactics and plans

(such as embedding journalists during the U.S. war on Iraq), and reinforcing ideological stances (Herman & Chomsky, 1988). This is not conspiracy; rather it is the efficient implementation of a shared interest in a social system for the production of life based on private profit from wage labor, by administering political decisions and cultural practices that will reproduce existing social relations and norms; norms and relations that are essential to the smooth operation of the entire capitalist social formation in the United States and globally—for example, deregulation, privatization, commercialization, and citizen atomization through spectatorship, consumption, "family values," and deference to authority, among others.

This political leadership, this development of norms, is class power, power that is fronted by representing and representative individuals and groups. Whether Bush or Kerry, the U.S. war on Iraq was on the capitalist class agenda. FDR may have nationalized banking and industries, but even the National Association of Manufacturers understood that the "liberal" was saving the system from a worse fate, with a radicalizing, organizing working class on the horizon. When the representatives perform poorly for the class, they are isolated and removed under pressure from multiple class institutions, especially the media. Anastasio Somoza infringed on the interests and profits of Nicaraguan capitalists and thus lost his political base, exemplified by the opposition of *La Prensa*. Nixon failed to heed the advice of the capitalist think tanks, the prestige press, and the representative system: Watergate was resurrected by the elite media as the excuse to dump the liability. Politicians, party officials, government agents, and their publicists are recruited, screened, and well trained before they are allowed to administer the capitalist state (Domhoff, 1967, 1979; Therborn, 1980). With occasional and temporary exception, this truism holds for the workings of all major institutions in the United States, whether government or civil society: public schools and colleges, law enforcement, social services, national charities, media and culture industries, and other repressive and ideological apparatuses. If an individual deviates too far from the norm acceptable to dominant ideology, he/she is suddenly and severely castigated or shunned, usually before gaining public recognition, but even then the wolves will keep them in line—as during the McCarthy-era witch hunt, more recently in the instance of award-winning journalist Peter Arnett being fired after he openly opposed the U.S. war in Iraq, and in the case of the Dixie Chicks, who were publicly berated and boycotted by Clear Channel Communications

radio and others for their similar antiwar statements. The venues and instances of harassment and isolation are frequent and historically verified (see, for example, Zinn, 1980).

Mass Culture

Mass culture, often termed popular culture by the mass media, arose with the development of the conditions of capitalist production and now follow the latest economic practices: streamlined lean production, extreme commodification, centralization of decision making, risk aversion, homogenized market segmentation, globalization of standardized models (Artz & Kamalipour, 2004), and the exploitation of the labor and creativity of diverse communities. The tedious base/superstructure debate has been materially superseded: the media and culture industries are now base; media and entertainment are the leading U.S. exports. In this mix, the collective interests of humanity do not appear, except as anathema or threat to the social order (Chavez is criticized as a danger to Latin America because he diverts oil profits from shareholders to public education, public health, housing, and other human services). Mass culture reproduces very specific political and social norms. Mass culture promotes values, images, and practices that tend to reproduce dominant social relations (Dines & Humez, 1995)—even allowing for conflicting fact claims or alternative, but not oppositional, social practices. Mass culture assumes access to all, but access is limited to the reception of themes and values and the purchase of products—both of which reproduce the social relations of production of commodities. At the same time, because capitalist mass culture must appropriate genre, images, topics, and forms from subordinate classes, in order to both sell commodities and popularize consumerist ideologies, the content is often available for reappropriation and rearticulation by the subordinate—vaguely recognized as hybridity in international communication and cultural studies texts. A prime example is sport, which is unequivocally authoritarian, diversionary, and hegemonic in its cross-class appeal in the United States. Elsewhere (particularly in more repressive nations), sport has frequently allowed for resistive voices. Under the Franco dictatorship in Spain, Salazar in Portugal, Somoza in Nicaragua, and other military regimes around the world, soccer matches became a form of popular resistance. "In the absence of constitutional

liberties, such as the right of assembly, freedom of speech and opinion, as well as the impossibility of publicly authorized solidarity, the stadium became one of the only places where the collectivity could meet and express itself" (Mattelart, 1979, p. 49). Likewise, early rap music fulfilled a similar function in the U.S., where it became the "CNN of the black community" in the words of Chuck D, producer of rap group Public Enemy. In these realities of little or no access to public communication, products of mass culture may become "'free areas' that provide occasions for the expression of popular discontent" (Mattelart, 1979, p. 49). Ironically, whenever such expressions of resistance are unattached to social movements of the working class and the discontented, the capitalist producers of mass culture pick them as if fruit from a colonial banana republic, to be effaced of politics, reprocessed, and sold back to the subordinate as evidence of the "best of all possible worlds." For Marxism, political expressions from cultural activity can never be more than laments unless they are connected to the material power of organized political-social movements that can articulate new meanings, new practices, and new relations of production.

This becomes abundantly clear through the process of globalization of capitalist relations. Globalization is not a new historical process, but it is a new stage in the expansion of capitalism. It represents the urgent need for advanced capitalist nations to find new markets for their products and the simultaneous need for cheap labor. Although expanding the contradiction between overproduction and shrinking markets from the G8 countries to the rest of the world does not bode well for capitalism, "the globalization of the more insidious networks of cultural invasion was carried out when the need for a new international division of labor became evident to the ruling classes" (Mattelart, 1979, p. 48). For similar reasons, the hybridization of mass culture in respective national and domestic markets now accompanies international capitalism's need for cooperative national elites and compliant working classes as both producers and consumers of cheap cultural commodities—creating the actual conditions of what might be termed cultural imperialism.

The abuse heaped on the theory of cultural imperialism articulated by Schiller (1976) (Tomlinson, 1991) has been possible for the same reasons Marxism has been disparaged: insufficient clarity in meaning and reductive explanations suitable for political attack. Perhaps the biggest shortcoming of the cultural imperialism perspective is that it is not Marxist enough. It has

often been used "with ill-defined meaning," and "without intending to, many studies are devoted to, and actually re-validate the myth of imperialism's omnipotence and omniscience" (Mattelart, 1979, pp. 57, 58). Critics that identify widespread resistance to the North's cultural exports have it half-right: the increasing attempts at social control through cultural seduction in the mode of the Argentinian movie *Tie Me up, Tie Me Down*, where the "seducer" who restrains his "lover" is subsequently desired, is a fiction. The attempts by the metropolis of the North at domination, political, economic, military, or cultural, cannot be equated with success. Subordinate nations and classes within nations resist. Thus, recognizing the impetus and appearance of cultural imperialism (and for that matter resistance to domination) should not be confused with the ability to succeed in imposing or overcoming dominance. (Indeed, resistance by itself only mitigates power). Once again, materialist analysis could resolve the apparently deadlocked debate.

The missing half of the critique that salvages human agency from the reductionist notion of cultural imperialism's invincibility is that an exclusive focus on the limits of cultural imperialism too easily slides to a rejection of any structural conditions on subordinate cultural production. As if active audiences rule, as if free flow of information really were free flow, critics of cultural imperialism (for example, Straubhaar, 1984, 1991) fail to recognize the material conditions of mass cultural export: the dominant media empires of the North; the cooperative national and regional capitalist partners assembled in government institutions or in powerful joint ventures; the exclusion of subordinate classes from national media production and distribution; the actual appeal of the North's cultural products; and, perhaps most importantly, the reproduction of the Northern empire's *model* in domestic comprador production.

Marxism tracks a clearer path for understanding, explaining, and transforming the process of globalization than most current studies provide. In real history, as Gramsci (1971) writes, it is necessary "to take into account the fact that international relations intertwine with these internal relations of nation-states, creating new, unique, and historically concrete combinations. A particular ideology, for instance, born in a highly developed country, is disseminated in less developed countries, impinging on the local interplay of combinations" (p. 110). Hybridity is more than a diversionary answer to a cultural imperialism thesis cast reductively—it is the actual material of culture on the ground in specific locales at specific historical moments. This

issue is not the material existence of hybrid cultural forms—whether Brazil has become a net exporter of soap operas or whether Mexican producers appropriate WWE's popularization of wrestling into a children's cartoon for export to the United States—the issue is what concretely is the hybrid product or practice (Kraidy, 2005). Who produces? Who uses? What is the political and social consequence of the hybrid culture? Media are not free-floating entities; they have owners (and classes of owners), directors, programmers, and other media workers. Whatever the complexity of the translocal, classes are the impulse for production and the contradictory, refracting, polyvalent lens for interpretation. Marxism's insistence on working from the frame of relations of production of life, including social class power, would have us ask, What are the political contours of the cultural hybrid and which social relations of production are reproduced ideologically and in other material ways?

The materialist analysis requires both a macro and a micro analysis that can place the appearance of a specific telenovela, musical genre, lifestyle choice, or other cultural practice in the context of the totality of the relations of production, locally, nationally, and internationally at each historical conjuncture. Doing so, even cursorily, we find that while the North does not impose its cultural products on the South, its model predominates as national and regional ruling classes adapt the cultural successes of the North to vehicles more useful for distribution to subordinate classes in the South. Hence, *Who Wants to Be a Millionaire?* becomes a television hit in India as *So You Want to Be a Multi-Millionaire* in rupees (Crabtree & Malhotra, 2004), with questions drawn from India's history and popular culture. WWE has successfully expanded its empire by adapting its presentation to the cultural specificities of different nations from Mexico to Japan, while a local entrepreneur in Bolivia has amassed a cultural following with the production of indigenous women wrestlers replete in traditional dress. And the regional media powerhouse Brazil? Does it pose a counterpole to Western ideology because it is the leading producer of soap operas in the South (Straubhaar, 1984)? Telenovelas from Brazil are closer to the experience of Rio and São Paolo and hence other Latin American experiences, but their stylistic hybridity mutes their political potential: few positive images of the Brazilian working class, no political solutions that challenge Brazilian capitalism, and only slight hints of solidarity among the poor appear. Indeed, telenovelas excel at diversion from political conversation and the promotion

of consumerism throughout the countries of the South. As in the United States, advertising and ratings drive the telenovels, their narratives, their timing. The appearance of more controversial racial and sexual subjects may attract more viewers than an American import, but those subjects do little to challenge the Brazilian capitalist system and its relations of production—including the popular pastime of television viewing as spectators/consumers. The issue is not culture, it is the politics of culture.

The macro and the micro combine with a Brazilian accent to promote individualism, consumerism, spectatorship, and authority—the hybrid is robust, pleasures many audiences, and still serves international capitalism well (including through academic treatments that cannot see the forest of transnational capitalist media models taking root around the world). The cultural synthesis of communication and other social practices cannot be stripped from existing social relations, nationally or internationally, nor does a cultural synthesis negate the political power of the dominant. At best, cultural hybridity can be an impulse for and assistant to other social practices, including political action, which may transform the production of life, socially, culturally, politically, and economically.

The Material and the Dialectic

Consistent materialism is nuanced, tentative, and concrete. It is also dialectic, because material reality is dynamic—all that is comes into being, develops, and passes away. Complete materialist analyses must recognize the contradictions at work within every phenomenon, contradictions that must always and everywhere be present, because for anything to exist it must be materially active in production, reproduction, or degeneration.

Communication is no exception to this materialist tenet. Within every communication practice, system, or utterance there exist tensions reflecting contradictions among social class relations. The meaning of any particular word or act is constantly in flux, depending on the context, personal and political relations, and dominant interpretations that we accept or modify in practice. When we speak we enter into battle, as it were, by proposing or challenging the dominant meaning of each word uttered, and by extension take a position on existing relations of power. We recognize the continual reappearance of "rhetorical situations" that are marked with exigencies—urgent

problems subject to human resolution. Hence, all rhetorical utterances must occur under specific material conditions: real human agents, real human audiences, identifiable or defined problems, materially available discourses, and possible actions. Marxism indicates that each rhetorical situation also always occurs within a particular society, with all of its contradictory social relations, political practices, and cultural norms at work to one degree or another at that particular historical conjuncture. The rhetorical situation is not just a date, or a place, or an audience; it is that moment in history in which humans must respond to concrete conditions, and they must act in accord with or in opposition to dominant norms of behavior, belief, values, and relations of social class power. The "correct" response to 9/11 depends on the political consciousness of those hearing appeals for action. Discarding journalistic norms of objectivity and fact-checking were rhetorically apropos for capitalist partisan media in the United States at that moment, as was the partisanship of their Venezuelan counterparts at the moment of the capitalist coup against democracy, and of the British media at the moment of defense of colonial occupation in the Malvinas—if we recognize that capitalist media institutions exist not for some abstract dedication to the truth but as institutions that function to reproduce capitalist relations of production, preferably with the cloak of nonpartisan objectivity, but if necessary with the naked assertion of the right of market power to rule.

This is not a deterministic gloss. Rather it is the materialist recognition of the relationship between the mode of production of life in a given society, the flexible ideology constructed for the reproduction of that social order, the rhetorical flourishes that abound at moments of crisis, and the particular articulations that are necessary to those political forces that attempt to resolve the contradictions in favor of the existing structure by meeting the demands of its challengers. "These incessant and persistent efforts" by representatives and defenders of the existing social order form the terrain for possible social change, as oppositional forces "seek to demonstrate that the necessary and sufficient conditions already exist to make possible" transformations to the existing unsatisfactory social system (Gramsci, 1979, p. 108). The material conditions are thus always active, always unsettled, always subject to change. Yet, within these material conditions parameters exist. The task of materialist analysis is to "find the correct relation between what is organic and what is conjunctural…in the first case there is an overestimation of [structural] causes, in the second, an exaggeration of the voluntarist

and individual element" (Gramsci, 1979, p. 109). In other words, material-
ist analysis seeks to identify the dialectical processes and trajectories of the
various class forces and their relative political strength and relations of
power. Analyses of communication and media provide important indica-
tors of the relative strength and organization of various class forces as they
evolve, and thus may contribute to the communication and other actions
that can change the "conjunctural" situation.

Political economic analyses of media companies may or may not have
Marxist lenses. To be frank, case studies of media ownership, network prac-
tices, or even governmental regulation are insufficient to explain why and
how media practices occur. Such insights must be connected to a material-
ist dialectic—a historical analysis of the totality of the social relations of
production. Media power does not reside solely in shareholder investment
decisions or in production studios; rather it is connected to the tensions and
contradictions in the entire capitalist system. Although not expressed in
these terms, Glenda Balas's (2004) recounting of moments in the neutering
of public television in the United States indicates that proposals, controver-
sies, and broadcasting practices had more to do with the alignment of class
forces at each conjuncture and less to do with the articulated critiques and
proposals for broadcasting regulation. The articulation of public service or
public access had little purchase without the rhetorical power of a social
movement capable of disrupting the network's and the FCC's business as
usual. What Balas provides (that many more conscious political economic
accounts do not) is a diachronic appreciation of the changing social relations
through the prism of the FCC and public broadcast debates. Today, various
attempts at media reform fail to grasp the nature of the relations of produc-
tion of communication. Forty-five percent monopoly ownership, thirty-five
percent, or even less has little bearing on the commercial requirements and
practices of media in the United States. Political economy case studies reveal
much, but often say little, when they fail to put the history of media prac-
tices in class relief. Whether television or radio media are owned by six, ten,
or a thousand, if the media remain privatized, commercialized, and thus
dependent on advertising, the public, the majority in subordinate classes
and marginalized social groups, will still have little access to media pro-
duction. Unless and until organized movements of the working class, black
and Hispanic communities, women, youth, and other disenfranchised groups
seek their own communication means, the media will remain a vehicle of

entertainment and propaganda, because materially it is organically nourished and dependent on the market. The alienation of the audience from media programming does not occur just from the content, any more than alienation from the political system stems simply from the unattractive candidates—rather both result from the structural obstacles that create social relations of commodity exchange, and the accompanying disconnectedness among citizens and between citizens and their society, because workers, professionals, managers, and others are removed from decision making in media and politics. We make daily choices only in consumer goods, a singularly unsatisfying form of self-realization. Moreover, we ourselves have become commodities.

Dallas Smythe's "discovery" of audiences as commodities identifies a further ingredient in the relationship between communication and the mode of production of communication in its current capitalist formation. Program content must first fit the needs of advertisers, who demand receptive audiences for their commercials. Programs thus must conform in duration, frequency, narrative, and style to the requirements of advertisers. A fundamental prerequisite for commercial advertising is the production of the social need for consumption, triggered by a variety of production techniques but carried by an ideology of individual gratification at the expense of human solidarity and social responsibility: one must not look to the future and the consequences of production for profit, planned obsolescence, and overconsumption. Obesity is not a social problem, but a further opportunity for commodity sales to individual consumers persuaded to diet, exercise, or retrofit their clothing to plus sizes. Air pollution is not a social problem, but a further opportunity for commodity sales of air purifiers, asthma drugs, or hybrid vehicles to the environmentally conscious individual. Media will stop producing audiences only when they are controlled and managed by social classes opposed to human relations based on exchange and profit.

A Marxist political economy not only explains the history of class antagonisms, battles, and negotiated settlements, but also predicts media practices according to their position in the totality of social relations. Because the mediated production of communication exists within the totality of relations of production in any society, it necessarily functions primarily according to state intervention and regulation that seeks to reproduce dominant social class relations. (Internationally this is ensured through various regulatory agencies, such as the International Telecommunications Union,

which now admits corporations as members with rights accorded to nations [Thussu, 2000].) Thus, in the United States today, journalists, programmers, editors, and other media workers are confronted with a Patriot Act (supported by media owners) that compels their compliance in government investigation, restricts their reporting activities, and affects the behavior and attitude of their potential sources. Copyright laws impinge on public access to entertainment and information, restrict creative reconfigurations and educational activities, and serve the interests of private enterprise in publishing. The specter of school expulsions, library surveillance, and even imprisonment appears on the horizon of a stronger, more secure America. The standard textbook treatments of media activity have little to say about these very real, very material conditions of communication production and exchange.

For Marxism, communication is not static, not predetermined: it occurs from, and in opposition to active class forces. Thus, any analysis of media or communication in the United States today must consider the contradictions apparent in the new state regulations as capitalist class forces feel besieged internationally in trade, access to resources, and competition. Nothing that now exists, including dominant media practices, will be the same as capitalist class forces reorganize and adjust for maintaining their rule.

A materialist analysis that recognizes class interests indicates upcoming economic and social crises, political repressions, military occupations, massive resistance by subordinate classes, and countless opportunities for constructing a democratic social order. Communication and media of, by, and for the subordinate classes will be one of the determinants in the outcome of the coming world crises. Attention to the changing material conditions, including media and communication practices in the core of capitalism and its international peripheries, and mapping the trajectories, strengths, and conjunctural relations of force is the order of the day. The history of all working class struggles from the Paris commune to the Nicaraguan revolution and the movements in Brazil and Venezuela today reveals that transformation of capitalist society cannot occur without knowledge of the social relations that oppress and depress subordinate classes. To make change, one must understand change, and that begins with an awareness of the interrelationships between different classes and the material relations of the society. Hopefully, this book makes a contribution to preparing that assessment for practical action.

References

Artz, L. (1994). Communication and power: Popular radio in Nicaragua. *Journal of Radio Studies* 2: 205–28.

Artz, L. (2004a). The righteousness of self-centred royals: The world according to Disney animation. *Critical Arts: Journal of South-North Cultural and Media Studies* 18: 116–46.

Artz, L. (2004b). War as promotional "photo-op": The *New York Times'* visual coverage of the U.S. invasion of Iraq. In N. Snow & Y. Kamalipour (Eds.), *War, media, and propaganda* (pp. 79–91). Lanham, MD: Rowman and Littlefield.

Artz, L., & Kamalipour, Y. (Eds.) (2004). Bring 'em on! Media and power in the Iraq War. Lanham, MD: Rowman and Littlefield.

Artz, L., & Murphy, B. (2000). *Cultural hegemony in the United States*. Thousand Oaks, CA: Sage.

Balas, G. (2003). *Recovering a public vision for public television*. Boulder, CO: Rowman and Littlefield.

Bourdieu, P. (1987). What makes a social class? On the theoretical and practical existence of groups. *Berkeley Journal of Sociology* 32, 1–17.

Brecht, B. (1981). Radio as a means of communication: A talk on the function of radio. In A. Mattelart & S. Seigelaub (Eds.), *Communication and class struggle: 2. Liberation, socialism* (pp. 169–71). New York: International General.

Carey, J. (2001). The partisan press and the penny press. In L. Artz (Ed.), *Communication and democratic society* (pp. 77–82). New York: Harcourt.

Cohen, L. (1990). *Making a new deal: Industrial workers in Chicago*. New York: Cambridge University Press.

Crabtree, R., & Malhotra, S. (2004). In L. Artz & Y. Kamalipour (Eds.), *The globalization of corporate media hegemony*. Albany: State University of New York Press.

Crehan, K. (2002). *Gramsci, culture, and anthropology*. London: Pluto Press.

Dines, G., & Humez, J. M. (Eds.) (1995). *Gender, race, and class in the media: A reader*. Thousand Oaks, CA: Sage.

Domhoff, G. W. (1967). *Who rules America?* Englewood Cliffs, NJ: Prentice Hall.

Domhoff, G. W. (1979). *The powers that be: Processes of ruling class domination in America*. New York: Vintage.

Engels, F. (1941). Ludwig Feuerbach and the outcome of classical German philosophy. (C. P. Dutt, Ed. & Trans.). New York: International Publishers. (Original work published in 1888).

Escarpit, R. (1979). The mutations of the book. In A. Mattelart & S. Seigelaub (Eds.), *Communication and class struggle: 1. Capitalism, imperialism* (pp. 195–98). New York: International General.

Fox, E. (Ed.) (1988). *Media and politics in Latin America: The struggle for democracy.* Beverly Hills, CA: Sage.

Giroux, H. (1999). *The mouse that roared: Disney and the end of innocence.* Boulder, CO: Rowman and Littlefield.

Gramsci, A. (1971). *Selections from the prison notebooks.* (Q. Hoare & G. N. Smith, Trans.). New York: International Publishers. (Original work published in 1947).

Gramsci, A. (1979). Analysis of situations, relations of force. In A. Mattelart & S. Seigelaub, (Eds.), *Communication and class struggle: 1. Capitalism, imperialism* (pp. 108–12). New York: International General.

Hall, S. (1990). Encoding/decoding. In A. Gray & J. McGuigan (Eds.), *Studying culture: An introductory reader* (pp. 90–103). London: Arnold.

Henwood, D. (1989, March–December). [Series on media]. *Extra!* 2(5)–3(3).

Herman, E., & Chomsky, N. (1988). *Manufacturing consent: The political economy of the mass media.* New York: Pantheon.

Jalée, P. (1977). *How capitalism works.* New York: Monthly Review Press.

Jorquera, R. (2005, September). Venezuela: Notes on the Bolivarian revolution. Eh Din. Retrieved September 16, 2005, from http://www.panjab.org.uk/english/venezsit.htm.

Kraidy, M. (2005). *Hybridity, or the cultural logic of globalization.* Philadelphia: Temple University Press.

Labriola, A. (1966). *Essays on the materialistic conception of history.* (C. H. Kerr, Ed.). New York: Monthly Review Press. (Original work published in 1903).

Levine, R. (1988). *Class struggle and the New Deal.* Lawrence: University of Kansas Press.

Martin, J. (2005, September 2). Venezuela expropriates. ZNet. Retrieved September 16, 2005, from http://www.zmag.org/content/showarticle.cfm?SectionID=45&ItemID=8637.

Mattelart, A. (1979). Introduction. In A. Mattelart & S. Siegelaub (Eds.) *Communication and class struggle: 1. Capitalism, imperialism* (pp. 23–72). New York: International General.

Mattelart, A., & Siegelaub, S. (Eds.) (1979). *Communication and class struggle: 1. Capitalism, imperialism.* New York: International General.

McChesney, R. W. (1993). *Telecommunications, mass media, and democracy: The battle for control of U.S. broadcasting, 1928–1935.* New York: Oxford University Press.

McNall, S. G., Levine, R. F., & Fantasia, R. (Eds.) (1991). *Bringing class back in: Contemporary and historical perspectives.* Boulder, CO: Westview.

Murray, R., & Wengraf, T. (1979). Notes on communication systems. In A. Mattelart & S. Siegelaub (Eds.), *Communication and class struggle: 1. Capitalism, imperialism* (pp. 185–88). New York: International General.

Novack, G. (1965). *The origins of materialism.* New York: Pathfinder Press.

Poulanzas, N. (1978). *Class in contemporary capitalism*. London: Verso.

Rockwell, R., & Janus, N. (Eds.) (2003). *Media and power in Central America*. Urbana: University of Illinois Press.

Rothschuh, G. V. (1986). Notes on the history of revolutionary journalism in Nicaragua. In A. Mattelart (Ed.), *Communicating in popular Nicaragua* (pp. 28–36). New York: International General.

Rucinski, D. (1991). The centrality of reciprocity to communication and democracy. *Critical Studies in Mass Communication* 8(1): 184–94.

Schiller, H. (1976). *Communication and cultural domination*. New York: M. E. Sharpe.

Singer, P. (1980). *Marx: A very short introduction*. London: Oxford University Press.

Stephens, J. (1979). *The transition from capitalism to socialism*. New York: Macmillan.

Straubhaar, J. (1984). Brazilian television: The decline of American influence. *Communication Research* 11(2): 221–40.

Straubhaar, J. (1991). Beyond media imperialism: Asymmetrical independence and cultural proximity. *Critical Studies in Mass Communication* 8(1): 39–59.

Therborn, G. (1980). *What does the ruling class do when it rules?* London: Verso.

Therborn, G. (1983). Why some classes are more successful than others. *New Left Review* 138: 37–55.

Thussu, D. (2000). *International communication*. London: Arnold.

Timpanaro, S. (1980). *On materialism*. (L. Garner, Trans.). London: Verso. (Original work published in 1970).

Tomlinson, J. (1991). *Cultural imperialism*. Baltimore: Johns Hopkins University Press.

Valocchi, S. (1991). The class basis of the state and the origins of welfare policy in Britain, Sweden, and Germany. In S. G. McNall, R. F. Levine, & R. Fantasia (Eds.), *Bringing class back in: Contemporary and historical perspectives* (pp. 167–84). Boulder, CO: Westview.

Vivian, J. (2004). *The media of mass communication*. 7th ed. Boston: Pearson.

Wessel, D. (2005, August 25). Motivating workers by giving them a vote. *Wall Street Journal*, A2.

Wright, E. O. (1997). *Class counts: Comparative studies in class analysis*. NY: Cambridge University Press.

Wright, E. O. (1985). *Classes*. London: Verso.

Zinn, H. (1980). *A people's history of the U.S., 1492–present*. New York: HarperCollins.

·CHANGE HAPPENS: MATERIALIST DIALECTICS AND COMMUNICATION STUDIES·

Dana L. Cloud

Dialectics poses something of a problem for communication scholars. Marx has been read as denying the necessity of communicative political intervention in a revolutionary process assumed to be an automatic outcome of economic evolution. Rhetorical theorists such as Kenneth Burke (1959) have claimed a symbol-centered Marxism that eschews materialist class analysis on the assumption that the recognition of economic determinants of consciousness and culture underestimates the role of rhetoric in constituting identities and motivating action.

Influenced by both mainstream liberalism and poststructuralist thought, a number of communication theorists have put forward a series of unfortunate straw persons about the classical Marxist tradition and its approach to discourse: that it is mechanistic, positing a crude economic determination of all things cultural and political; that it maintains a simple-minded reflection model of truth; that it assumes a uniform identity among workers; that it is an unsubstantiated theory of history; and finally, that it is insensitive to rhetorical invention and practice (see Aune, 1994). Michele Barrett (1991), for example, argues that the Marxist tradition up through Althusserian

structuralism needs to be liberated from its economism and from the idea that classes exist as a priori identity positions. Ernesto Laclau and Chantal Mouffe (2001) charge classical Marxism with putting forward "the illusory prospect of a perfectly unitary and homogeneous collective will that will render pointless the moment of politics" (p. 2).

While some Marxists have expressed faith in spontaneous revolution, most critics of Marxist economism misunderstand the dialectical relationship between economics and consciousness, confusing dialectics with crude economic determinism. In the process, post-Marxist theory has vitiated our field of a key resource for the understanding of communication and social change. In this chapter I will argue that it is the understanding of dialectics on a real material basis that makes organized, purposeful political intervention on behalf of the working class possible in the first place. Unlike mainstream bourgeois liberalism and unlike the wave of poststructuralist reduction of all reality into discourse, dialectical materialism can explain the process of historical change.

Bourgeois thought takes the political and social status quo (that is, the desirability of capitalism, the market, and the drive for profits; the necessity of imperialism and the class divide; and so on) as given, fixed, and natural. Thus, U.S. State Department official Francis Fukuyama (1993) declared "the end of history" in 1989, writing, "A true global culture has emerged, centering around technologically driven economic growth and the capitalist social relations necessary to produce and sustain it" (p. 126; see also Fukuyama, 1999). Inspired by Hegel's faith in human transcendence of contradiction, Fukuyama's (1993) argument was that, in the absence of viable alternatives to liberalism, history, conceived of as the clash of political ideologies, is at an end (on Hegel, see p. 65). Fukuyama suggests that what reforms are left are constituted in granting cultural recognition to contesting groups within the existing liberal-capitalist framework. Oddly, structuralist and post-structuralist theories also regard history, understood as change propelled by the clash of contending classes and interests, as at an end. In other words, both pro-capitalist liberalism and post-Marxist theory envision a static social world that is either acceptable as it is or invulnerable to systematic challenge. For both, liberal capitalism resounds as "the final form of human government" (Fukuyama, 1993, front matter).

In contrast, Marxist dialectics is the theory, study, and practice of social change as it emerges from the contradictions that threaten to split capitalist society open. History cannot end so long as society's basic contradictions

remain in place. As Marx and Engels explained, and as Marxists since have elaborated, dialectics recognizes capitalism as giving rise to the forces that will undermine it—namely, the creation of an exploited but powerfully collectivized working class, alongside anarchic economic competition that drives the system to overproduction and crisis. In the 1873 afterword to the second German edition of *Capital*, volume I, Marx explains that the dialectic

> is a scandal and abomination to bourgeoisdom and its doctrinaire professors, because it includes in its comprehension and affirmative recognition of the existing state of things, at the same time also, the recognition of the negation of that state, of its inevitable breaking up; because it regards every historically developed social form as in fluid movement, and therefore takes into account its transient nature not less than its momentary existence; because it lets nothing impose upon it, and is in its essence critical and revolutionary. (par. 23)

In this passage Marx highlights the political and ideological import of dialectics in the context of other theories that, at the end of the day, counsel resignation to capitalist society.

However, permanent social stability is impossible in a system divided by class and thus prone to conflict among groups with contradictory material interests. Materialist dialectics is a mode of understanding that shows that epochal clashes between contending classes have propelled history forward; but the process is not simple, direct, or automatic. Materialist dialectics is also a way of understanding how people, through communication and other bodily action, take advantage of the historical opportunities afforded by contradiction and contention.

Here I will put forward a series of propositions about historical materialist dialectics that show the relevance of this concept to rhetoric and communication studies: (1) dialectics is a theory that can explain the process of historical social change; (2) dialectics is pragmatic and change-oriented; (3) dialectics is the real basis for working class agency; and, therefore, (4) dialectics is necessary to any real political challenge to capitalism (and thus to communication scholars and activists interested in fostering such a challenge). Essentially, I am arguing that the dialectical interrelationships among contending classes and between their experience and its contradictory ideological rendering pose opportunities for rhetorical, political intervention.

It has been the goal of socialist revolutionaries since Marx to inject the "political moment" of system analysis into what would otherwise remain a series of fragmented, short-term, and ideologically contained struggles. As Marx (1851–52) puts the issue in *The Eighteenth Brumaire of Louis Bonaparte*, "Men [*sic*] make their own history—but they do not make it just as they please; they do not make it under circumstances chosen by themselves, but under circumstances directly found, given and transmitted from the past" (ch. 1). Materialist dialectics is a way of understanding the given circumstances of capitalist society as the foundation of and constraint upon the process of social change.

Dialectics Is Explanatory

Put briefly, dialectics refers to the idea that change emerges out of clash and contradiction between mutually imbricated aspects of a social relationship. There are idealist formulations of dialectics, such as that of Plato, whose dialogues enact clash in the rarified realm of ideas, aspiring to what he regarded as ever higher truths, and that of Hegel, whose observation that the self-estrangement produced in relations of unequal power is crucial, but whose solution to estrangement once again involved transcendence of the sensuous, material, political world (see any of Plato's dialogues with the Sophists, including *Gorgias* and *Phaedrus*). Hegel (1894/1971) writes, "*The Absolute is Mind (Geist)*—this is the supreme definition of the Absolute. To find this definition and to grasp its meaning and burden was, we may say, the ultimate purpose of all education and all philosophy: It was the point to which turned the impulse of all religion and science: and it is this impulse that must explain the history of the world" (p. 18). In this passage, Hegel describes Mind as objective and the sensuous world as subjective and suspect. The idea is primary, and the world of lived experience only a copy.

In materialist dialectics, on the other hand, a material social base (relations of production and distribution of necessary goods) both structures and is conditioned reciprocally (though not in equal measure) by the cultural and political arrangements attendant a historical moment. While rejecting Hegel's idealism, Marx was drawn by Hegel's dialectics as an alternative to either static views of society or theories of linear progress. Whereas liberal-democratic, positivist, and utilitarian thinking regards history as the evolution

of society according to principles of evidence and reason, materialist dialectics describes the ways in which history unfolds, not as a series of great ideas or scientific reforms, but rather as a product of contending classes, possessing divergent structural interests. This is why Marx and Engels claimed to be "standing Hegel on his head"; theoretical thought is not a transcendence of history, but is itself grounded in the moments of its production (par. 17). Further, Marx (1844/1932) points out that the clash between noble and alienated *concepts* cannot challenge the material conditions of labor and privation in which people struggle for less philosophical gains. As Marx (1845) puts it in the famous passage from *The German Ideology*,

> This demand to change consciousness amounts to a demand to interpret reality in another way, to recognize it by means of another interpretation. The Young-Hegelian ideologists, in spite of their allegedly "world-shattering" statements, are the staunchest conservatives. The most recent of them have found the correct expression for their activity when they declare they are only fighting against "phrases." They forget, however, that to these phrases they themselves are only opposing other phrases, and that they are in no way combating the real existing world when they are merely combating the phrases of this world. (part I, section A)

In both Marx and Hegel, dialectics is the understanding of something in its entirety, as a unity of opposites. Tension between opposites yields the possibility of the emergence of something new. For example, in capitalism, capital and wage labor are just such opposites. Capital cannot exist throughout wage labor, for it is only through the exploitation of wage labor that capital can be reproduced and expanded. At the same time, however, the modern wage laborer is an invention of capitalism. The unity of the two is unstable, because it has built in the potential for its own destruction in the form of the potentially revolutionary struggle between labor and capital. Another totality described by materialist dialectics is the opposition between how people live and the ideas they hold in their heads—in other words, the contradiction between experience and ideology.

One side of a dialectical relationship may exert more weight than the other, but in the end it is the contradictions in the relationship between two different kinds of things that generate the possibility of change. Thus, in his *Summary of Dialectics*, V. I. Lenin (1914) described dialectics as a *struggle* of

opposites, of contradictions unfolding and defined dialectics as a method of understanding the whole of society as a unity of contradictory opposites and the dynamism of their reciprocal connections.

Lukács (1972/1951) explains this relationship in greater depth, arguing against mechanistic understandings of dialectics. About Lukács's formulation, Ivan Mésáros (1972) writes, "Only if one grasps dialectically the multiplicity of specific mediations can one understand the Marxian notion of economics. For if the latter is the 'ultimate determinant,' it is also a determined determinant: it does not exist outside the always concrete, historically changing complex of concrete mediations" (p. 72). Simply, materialist dialectics is a way of knowing and explaining *relationships* among different aspects of social life, a method for discovering the totality of interrelationships in which ideas and economics coexist.

Contrary to a theory positing indeterminate and fundamentally inexplicable social relations, dialectics is an explanatory theory of history and social relations; thus it is an epistemological theory that not only describes a state of affairs at any given moment, but also seeks to explain the emergence of that state of affairs out of historical conditions. The question remains whether history has vitiated the theory. To acknowledge that socialist revolution did not, on Marx's prediction, occur soon after 1848 (at which point bourgeois revolutions were sweeping Europe, fueling Marx's hopes) is not to declare dialectics dead. Dialectics is not a theory of spontaneous economically driven revolution; rather, it is a method of observing social changes from the local and limited to the global and momentous. Further, the failure of revolutionary movements themselves must be understood dialectically.

To wit, Stalin's rise to power did not happen in a vacuum or as a result of some essential tyrannical kernel of Bolshevism. Rather, during the civil war and imperialist invasions of Russia after the revolution, and after the failure of the German revolution, the Soviet working class was decimated. Ruthlessness born of austerity and panic replaced democratic decision making. The party became a shell of itself; where it had been rooted in democratic, mass workplace organizations, it became a rotten husk spitting forth the distorted fruit of state capitalism. This transformation exemplifies the utility of dialectics, explaining how one form of society's contradictions press it forward into something qualitatively different (see Cliff, 1955/1974; Trotsky, 1955). History, including the history of ideas, is tied inextricably to struggle over the ways in which society is organized at its most fundamental level.

Yet dialectical materialism is not only a method of explanation but also a guide to political intervention.

Dialectics Is Pragmatic, Instrumental, and Change-Oriented

Materialist dialectics is a theory of how people and all their ideas and activities get things done in the world, not merely a theory of how the world is. It is grounded in materiality and seeks to understand how concrete relations of economic distribution and labor are real and exploitative; how ordinary people and their bosses have divergent real interests, consciousness of which may generate struggle against immediate harms and, in some instances, against the class society as a whole system. For example, a series of general strikes and political demonstrations in Bolivia against the privatization of natural gas industries has forced a president to resign his office (see Lewis, 2005). Clearly, the workers and demonstrators understand something about their position in concrete social relations. Their understanding is born of both local elemental experience of austerity when natural resources fall into the hands of a few capitalists, and a theoretical consciousness of the system that produces such austerity. Without such an understanding of the totality of social relations rather than reacting against lived experience alone, the "political moment" of public struggle could not be realized.

Similarly, Boeing workers on strike in 2005 have given voice to decades of experience. In a 2005 public radio interview, Everett, Washington, union activists David Clay and Don Grinde (members of the International Association of Machinists and Aerospace Workers) explain their grievances and motivation to strike. Grinde says, "We've been struggling for 12 years to get our pensions fixed, get them to union scale standard that would provide a comfortable living for people so they wouldn't have to worry about how they're going to take care of their grandkids and family." Clay echoes Grinde's assessment, commenting also on workers' experience of continual mass layoffs and increasingly ruthless company behavior. "The recent layoffs cut thirty-three thousand workers, but the workload didn't diminish. Some people are doing the work of three or four people. And we're working quite a bit of overtime. What we've seen is that we're getting squeezed. They want to get every drop out of us and not bringing back the number of people we need."

For Clay and Grinde, the accumulation of such experiences has motivated explanation of and action against the company's efforts to cut into workers' standard of living. Both activists understand the larger picture of how the company's drive to profits depends upon increasing pressure on workers. Grinde notes, "[Labor cost is] making up only five percent of the cost of an airplane. They act like we're the total cost of the company, when we're small part, yet we make the majority of the money for the Boeing Company. How is that fair? They don't talk about bonuses, stock options, excessive salaries to CEOs. It's incredible. The new guy [new CEO James McNerney] gets $22 million in pensions, and he hasn't been here three months. And I've devoted a lifetime, we've all devoted lifetimes, to the company." In turn, this insight generates a commitment to union activism and broader class consciousness. Grinde comments,

> We're not out here for the machinists, we're out here for the working class, for everybody. All other union members, because once someone goes downhill that just lowers the bar and makes it worse for the next guy. So we're fighting against divide and conquer. They wanted to go after retiree benefits for new hires so they're constantly chipping away trying to find ways to divide the membership. It's taken us 20 plus years and we've finally figured that out and we're not going to allow that to happen whether it's a janitor, a machinist, or a military worker in Wichita, we're all going to take the same package and none of us are coming back for less. We're all in this together.

Three aspects of these unionists' discourse are significant for an understanding of materialist dialectics. First, the lived experience, over a period of decades, of intensifying exploitation alongside burgeoning corporate profits and executive compensation has clearly informed activists' consciousness of the nature of their situation. Second, the dialectical interplay of experience and ideas has led both workers to understand their place as part of a self-conscious class. Yet as activists, they also know that not all workers are in the same place with regard to class consciousness. They have taken on positions of leadership and organization in order to try to foster broader class consciousness among divided groups of workers. They thus become communicative agents in the process of building a politicized general struggle out of a localized strike for narrower gains.

Marxist dialectics explains this moment in terms of the "transformation of quantity into quality." This is a principle of dialectics more generally, but

in materialist dialectics it refers to how a number of small changes and experiences can accrue so as to overcome a threshold of material capability and/or consciousness. Thus, capitalism's dependence on socialized labor and the tendency in the system to production over and above the capacity that can be sold creates its own opposition in the formation of an antagonistic working class. In the first settled agricultural societies more and more individuals were able to accrue a surplus of what was produced. As such surpluses grew as a result of improved technologies of agriculture and storage, there became a need to justify the minority holding and controlling of such surplus and the need for an arbiter among groups with contending interests in keeping the surplus or appropriating it. Over time, the quantity of such incidents and situations produced the conditions for the emergence of a state, with laws, regulations, administrators, and ideologists (see Harmon, 1999, pp. 161–232). In this way, the quantity of accumulation pushed toward a qualitative change in the organization of society—namely, the transition to feudalism from the beginnings of settled agriculture.

In the same way, political and economic grievances stored over time may lead to generalized political anger. A number of "bread-and-butter" strikes at workplaces, where workers seek the local gains of higher wages and improved work conditions, may multiply in a situation like the one in Bolivia or like the one in Russia in February 1917, where a women's strike for bread, land, and peace spread to workplaces across the country to depose the tsar. The movement from localized class consciousness to a broader political analysis does not happen spontaneously or automatically in most cases, but requires mediation, communication among workers and political organizations that discovers the generalized nature of each individual's local situation.

But class is not itself a product of communication. Rather, class for Marx is the objective social relationship of various members of society to that society's means of production. Under capitalism, there are only two basic classes: the bourgeoisie, or ruling class, who own the means of production, and the proletariat, whose lack of property and of control over the means of production forces them to work as wage laborers for the bourgeoisie. While class position is more complicated and ambiguous for some intellectuals, civil servants, small business owners, and so on (the layer Marx called the petit bourgeoisie), it is objectively possible to identify a group's relationship to the means of production (see Wright, 1997; contrast Gibson-Graham, 2001). Thus, while Timpanaro (1975) acknowledges that the working class

is an abstraction with an ontological being, it has, epistemologically speaking, objective existence. It is obvious that around the world millions of people toil while a tiny proportion of society do not; a few reap the profits from the many, and very few people have the freedom to control the conditions or necessity of their work.

These realities define the objective existence of a working class position. Unlike women, minorities, gays, and other minoritized groups, workers (a category including the great majority of the world's women, oppressed minority groups, despised sexualities, and so on) are united by the fundamental reality of exploitation: the extraction of profit from labor. Sectors within the working class are oppressed differently and to different degrees on the basis of identity categories. Even so, members of the working class share a fundamental objective interest in overcoming exploitation. Challenging divisions (by race, gender, sexuality, and so on) among ordinary people is necessary to that project; thus, addressing the specific oppressions faced by ordinary people is necessary to developing identification based on interests.

Despite sharing fundamental interests, there is no guarantee that workers will automatically see their situation as collective or political. What agent encourages interpretation of lived experience to foster a dialectical transformation; what kind of discourse is needed for a "class in itself" (to employ Marx's phrase) to become a "class for itself"? Though originally articulated by Marx (1847, p. 211), this distinction was taken up by a succession of Marxists interested in the role of discourse, intellectuals, and political organizations (that is, parties) in the production of class consciousness and organization. For both communication theory and revolutionary activism, these are core questions—to which Marxist dialectics offers the only viable answer.

Dialectics Is Necessary to the Challenge to Capitalism

While class interests can be the real foundation upon which an anticapitalist antagonism can be built, their mere existence is insufficient to the task. Lukács, among others, rejected the idea that class consciousness is an automatic response to proletarian existence. Thus he criticized the Polish revolutionary Rosa Luxemburg for her insistence on the spontaneity of systematic consciousness and revolution (Marx, 1847, p. 279). Along these lines, Oskar

Negt and Alexander Kluge (1993) explain in *Public Sphere and Experience* that interests, grounded in lived experience, are the basis for but not the realization of a proletarian public, which is organized in discourse. In Marxist theory and socialist practice historically, the role of rhetorical catalyst is played by the political party or organization, which, emerging out of the working class itself, proceeds to recruit members, circulate ideas, and win adherence to a particular worldview and course of action (see Gramsci, 1971). Thus, the rhetorical mediation of real interests enables the formation of potentially instrumental political collectivities without resort to individualism, identity politics, or relativism.

Some revolutionaries, including Luxemburg and Karl Kautsky, regarded revolution as the mechanistic product of spontaneous class uprising (this belief in automatic class consciousness and revolutionary development led to different conclusions for Luxemburg, who remained a revolutionary but postponed the organization of a revolutionary party, and Kautsky, who embraced liberal reformism as an alternative to party organization; see Kautsky, 1924; see also Luxemburg, 1900). However, many other Marxists, including, on the whole, Marx and Engels themselves (but see Marx 1857–67, 1873, vol. 1, ch. 13), did not "see the need for revolution as self-evident" (see Aune, 1994, p. 14). Engels (1886), the usual target of this accusation, wrote, "In the history of society the actors are all endowed with consciousness, are men [*sic*] acting with deliberation or passion, working towards definite goals; nothing happens without conscious purpose, without intended aim" (part 4). Similarly, the Bolsheviks, including Lenin and Trotsky, demonstrated the necessity of organized political intervention in the process of revolutionary struggle because not all workers are automatically cognizant of their interests, the nature of the capitalist system, or their power to challenge it (see the first two volumes of Tony Cliff's biography of Lenin: Cliff, 1975/2004a, 1976/2004b).

It is a key insight for communication scholars and activists that there is a difference between a class as an objective entity and *class consciousness*, which is a rhetorically produced understanding of one's class position. As Oskar Negt and Alexander Kluge (1993) cogently explain, "Class and consciousness are real categories.... The Marxist tradition draws them together into a single term so as to outline a program. This program is concerned with the mediation between the coming into being of the proletarian context of living, along with its subjective, 'conscious' side," (p. 250) which is produced rhetorically in a proletarian public sphere (party or union).

Thus, there is a dialectical relationship between the immediacy of a worker's existence and the consciousness of her place in a system of social relations (see Lukács, 1972, p. 168). "Yet this antithesis with all its implications is only the *beginning* of the complex process of mediation whose goal is the knowledge of society as a historical totality" (Lukács, 1972/1951, p. 171). In other words, without contradiction, there is no struggle; without struggle, there is no progress (an allusion to Frederick Douglass, who in an 1857 essay wrote, "If there is no struggle, there is no progress"; see Douglass, 1857/2000). Finally, contradiction does not automatically or necessarily lead to struggle; mediation—between contradiction and struggle, class position and identity, experience and consciousness—is necessary.

Stuart Hall and others have argued that Gramsci rejected the idea of a pregiven class *identity* (see Hall, 1996a), and this is an accurate claim. What Gramsci did argue, however, is that workers share a pregiven, fundamental, and real *interest* in overcoming their exploitation that could be the basis for winning them to political organization and class struggle. Thus, in "Working Class Education and Culture," Gramsci explains that workers are not dupes, though they may require education conducted by and for them to "truly understand the full implications of the notion of 'ruling class'" (Gramsci, 2000, pp. 72, 190). For Gramsci, real working class education must debunk "ideologies aimed at reconciling opposing interests" in favor of "the expression of these subaltern classes" (Gramsci, 2000, p. 197).

Thus, the Marxist dialectic is rhetorically and argumentatively mediated while lapsing into neither idealism nor spontaneism. Neither a soulless machine of history nor a deus ex machina drives society inexorably toward transformation. What are the media (in the broad sense), then, for class consciousness and class will? In the Second International and in Lukács, the medium is the Socialist Party. Lukács has been charged with vanguardism, or the valorization of a narrow layer of revolutionary leadership that, by virtue of greater experience and knowledge, is in a position to lead workers' movements (see Aune, 1994, p. 68). Caution about elitist or individualistic leadership of working people's struggle is always appropriate. A number of activists and scholars are critical of a particular kind of vanguard, Leninist "democratic centralism" (a phrase describing the importance of debate followed by unified action based on a democratic decision). Cliff, a Trotskyist, has argued that critiques of democratic centralism confuse this principle with its distortions in the bureaucratic centralism of

Stalinist state capitalism (see Cliff, 1955/1974). However, a socialist party or organization, like other mainstream parties, organizes consciousness and leads political movements. It attempts to win public support and to vie for hegemony in the political realm. It employs rhetorical strategies of identification and attempts to move groups to take particular kinds of action.

Liberal-capitalist organizations (such as the Democratic Party) exert more top-down influence on ordinary people, having little or no basis in the real conditions of people's lives and often performing the role of convincing workers to identify and act against their own interests (in support of war and tax cuts for the wealthy, against the provision of social services such as universal health care, and so on). In contrast, groundedness in concrete social relations and workplace organizations makes a socialist party potentially the most democratic form of rhetorical mediation. Worried about the problem of imposing a political analysis on ordinary people "from the outside," Gramsci (1971) argued for organizations inclusive of organic intellectuals who belong to the working class but whose education and experience may push a struggle forward. In workplaces and in educational settings, organizers and educators can make arguments about the daily experience of work and how those experiences are connected to other workplaces, to experiences of family and consumption, and, eventually, to the requirements of capitalism as a system.

Because materialist dialectics offers a nuanced, anti-individualist, explanatory theory of material existence, contingency, critique, and practical action, it is odd that so many theorists post-Althusser have rejected dialectics in an endeavor increasingly pessimistic and disengaged from actual political practice. A number of cultural studies and poststructuralist theorists have claimed the tradition of materialist dialectics while attempting to rhetoricize or "go beyond" (deny accountability to?) it. As Perry Anderson (1979, pp. 24–48) and Terry Eagleton (1996) have explained, post–World War II critical theory was born of a series of defeats for revolutionary movements around the world, left trying to explain capitalism's resiliency and tenure (see also Wood, 1986/1998, who, like Eagleton, dates the retreat from class politics to the defeats of 1968). Understanding how ideological inducements to identify with capitalist imperatives is important; recognizing the ways in which capitalism has changed over time is also crucial.

However, to come to the conclusion that capitalism is so flexible and so reified that it cannot be challenged is to leave Marxism and the dialectic behind, and to resign oneself to either domination or the pleasures of small

rebellions on the terrain of culture. Further, to assume that the kind of discipline exerted by capitalism on its subjects is primarily or exclusively symbolic, ideological, cultural, or discursive is to reject materialism and the possibility of a real class basis for identification and struggle against capitalism.

Beginning with Williams's articulation of a "cultural materialism" and his rejection of the base-superstructure dialectic, cultural studies has on the whole focused entirely on political relations in discourse rather than economics. This trend is especially evident in the work of Stuart Hall, whose appropriation of Gramsci for critical race studies foreshadowed a later emphasis on the production of cultural subjects on a cultural stage (Hall's wording, 1996b, p. 467). Adorno and his colleagues located oppression in a discursive totality epitomized in mass popular culture. Thus Frederic Jameson (2000) situates Adorno in the Hegelian rather than the Marxist tradition, in Adorno's emphasis on alienation in culture and language and pessimism regarding the possibility of overcoming this alienation in a transcendent whole. Jameson himself identifies with this method, whose dialectics is "nothing more than the writing of dialectical sentences…. Dialectical thinking is thought about thought" (p. 73).

Structuralist Marxism, as represented by Louis Althusser, also foregrounds the discursive at the expense of economic agency. As Sue Clegg (1991) and Ellen Wood (1998) have noted, Althusser's obsession with the structures of language and consciousness both rejected economic struggle and negated any notion of the subject as political agent within a class. Ideological struggle replaces economic organization in Althusser's (1977) work: "The Ideological State Apparatuses may be not only the *stake* but also the *site* of class struggle" (p. 147). Alongside the structuralism of Althusser, the work of Michel Foucault has had an immeasurable influence on contemporary discourse theory. In the move from archaeological depth hermeneutics to genealogical analyses of discourses laterally conceived, Foucault becomes explicitly antidialectical.

The work of Foucault and a discourse-centered appropriation of Gramsci together give shape to the post-Marxist rejection of economic interests as a source of contradiction and consciousness. According to Laclau and Mouffe, we must jettison the idea of class interests and the reality of social classes, positing instead the constructs "interests" and "classes" without reference to the actual foundations of these constructs. In this formulation, the kind of social antagonism described by Marx between existing working and ruling classes must become a discursive articulation of forces on the basis of

contingent, constructed identities with no fundamental basis in reality. While I respect Laclau and Mouffe's commitment not just to any antagonism, but to *socialist* strategy, their theory cannot allow assessment of antagonisms on the basis of real fidelity to working class interests.

This trend reaches its logical conclusion in Gilles Deleuze and Felix Guattari's *A Thousand Plateaus*, in which the authors describe social change as an inexplicable shift in the commonsense axioms organizing society, across a space imagined as singular and flat, without contrast, depth, or contradiction. In the resort to immanence, poststructuralist thought in its clearest manifestations is marked by its profound suspicion of dialectics, in fact collapsing the key dialectical systems regarded as fundamental in a Marxist critique. Thus, in their influential book *Empire*, Michael Hardt and Antonio Negri (2000) describe society as a spatial totality; Empire is self-creating and operates as a form (following Foucault) of bio-power. As Alex Callinicos (2003) notes, *Empire* rewrites Marx as Foucault (p. 127). In arcane language, what this amounts to is a liberal reformist politics in which one contests Empire on its own terrain and without basis or hope for creating something in one's own interests, since all interests are constructs and what we imagine to be our interests are themselves forms of discursive discipline (see Hardt & Negri, 2000, p. xv).

Wood (1986/1998) writes that *Empire* could be taken as "a manifesto for global capitalism, written by a guru of globalization. Its object would be to present a picture of the world in which opposition to globalization and to capitalism itself would be futile, a world in which the best we can do is go with the flow, lie back and think of Nike" (p. 61). The work, she writes, "counsels surrender" (p. 63). Surrender is the end product of the collapse of materialist dialectics. Theories devoid of real bases for real antagonisms give up the dialectics between both the clash of contending classes and the tension between interest and consciousness. Theories that define capitalism out of economic existence likewise lose any real basis for resistance.

Conclusion: Change Happens

In the field of rhetorical studies, Ron Greene has put forward the poststruc-turalist position that capitalism has demonstrated such flexibility and reach as to become more or less invulnerable to systemic challenges. Ignoring revolutions, revolutionary movements, and labor struggles in Latin America

and around the world in the early 2000s, Greene (2004) advocates settling for the "excesses of joy" (p. 204) afforded (to some) by late capitalism and rejects the idea that struggle against capitalism could proceed on a materialist (Marxist) basis. Very much like Fukuyama (1993), Greene (2004) argues that postmodern capitalism—allegedly a dynamic, postindustrial world in which politics has become a matter of representation more than redistribution of material goods—has made socialist politics untenable; like Fukuyama, Greene endorses a politics of cultural recognition within an allegedly permanent capitalist social order. Both, in Marx's words, are "professors of bourgeoisdom."

This work and its poststructuralist theoretical underpinnings ignore one crucial fact: change happens. It is impossible to do away with dialectics, since the process of dialectical clash and social transformation is, in reality, ongoing. Where there is exploitation and oppression, ordinary people rise up to fight it. The dialectic presents itself as an opportunity to explain and intervene in the process of change. The recognition of the actual interests of the culturally diverse and discursively creative working class in a world still divided into classes is no more and no less than the ability to make practical judgments, on the basis of which there might be an actual organized, systematic, and powerful attempt to change the real world.

References

Althusser, L. (1977). Ideology and ideological state apparatuses: Notes towards an investigation. In L. Althusser, *"Lenin and philosophy" and other essays*. London: New Left Books.

Anderson, P. (1979). *Considerations on Western Marxism*. London: Verso.

Aune, J. A. (1994). *Rhetoric and Marxism*. Boulder, CO: Westview.

Barrett, M. (1991). *The politics of truth*. Stanford, CA: Stanford University Press.

Burke, K. (1959). *Rhetoric of motives*. Berkeley: University of California Press.

Callinicos, A. (2003). Tony Negri in perspective. In G. Balakrishnan (Ed.), *Debating empire* (pp. 121–43). London: Verso.

Clay, D., & Grinde, D. (2005, September 3, 7:30 A.M.). Radio interview. KEXP, Seattle.

Clegg, S. (1991). The remains of Louis Althusser. *International Socialism Journal* 53 (winter): 57–78.

Cliff, T. (1974). *State capitalism in Russia*. Retrieved August 1, 2005, from http://www.marxists.org/archive/cliff/works/1955/statecap/index.htm. (Original work published in 1955).

Cliff, T. (2004a). *Building the party: Lenin 1893–1914*. Chicago: Haymarket Books. (Original work published in 1975).

Cliff, T. (2004b). *All power to the Soviets: Lenin 1914–1917*. Chicago: Haymarket Books. (Original work published in 1976).

Douglass, F. (2000). West India emancipation speech delivered August 3, 1857 at Canandaigua New York. In P. Foner (Ed.), *Frederick Douglass: Selected speeches and writings* (pp. 358–68). New York: Lawrence Hill.

Eagleton, T. (1996). *The illusions of postmodernism*. Oxford: Blackwell.

Engels, F. (1886). *Ludwig Feuerbach and the end of classical German philosophy*. (Progress Publishers, Trans.). Retrieved July 2, 2005, from http://www.marxists.org/archive/marx/works/1886/ludwig-feuerbach/index.htm.

Engels, F. (1925). Old preface to anti-Dühring. *Dialectics of nature*. Retrieved June 24, 2005, from http://www.marxists.org/archive/marx/works/1878/05/dialectics.htm. (Original work published 1878).

Fukuyama, F. (1993). *The end of history and the last man*. 2nd ed. New York: Harper.

Fukuyama, F. (1999). Second thoughts: The last man in a bottle: Socialism and the end of human economy. *The National Interest* (summer). Retrieved September 20, 2005, from http://www.findarticles.com/p/articles/mi_m2751/is_56/ai_55015107.

Gibson-Graham, J. K. (2001). *Re-presenting classes: Essays in postmodern Marxism*. Raleigh-Durham, NC: Duke University Press.

Gramsci, A. (1971). The intellectuals. In Q. Hoare & G. N. Smith (Eds. & Trans.), *Selections from the prison notebooks* (pp. 3–23). New York: International Publishers. (Original work published in 1949).

Gramsci, A. (2000). Hegemony, relations of force, historical bloc. In D. Forgacs (Ed.), *The Antonio Gramsci reader: Selected writings, 1916–1935* (pp. 190–221). New York: New York University Press.

Greene, R. W. (2004). Rhetoric and capitalism: Rhetorical agency as communicative labor. *Philosophy and Rhetoric* 37: 188–206.

Hall, S. (1996a). Gramsci's relevance for the study of race and ethnicity. In D. Morley & K. H. Chen (Eds.), *Stuart Hall: Critical dialogues in cultural studies* (pp. 411–41). New York: Routledge.

Hall, S. (1996b). What is this "black" in black popular culture? In D. Morley & K. H. Chen (Eds.), *Stuart Hall: Critical dialogues in cultural studies* (pp. 465–76). New York: Routledge.

Hardt, M., & Negri, A. (2000). *Empire*. Cambridge, MA: Harvard University Press.

Harmon, C. (1999). *People's history of the world*. London: Bookmarks.

Hegel, G. F. (1971). *Philosophy of mind*. (A. V. Miller, Trans.). Oxford: Clarendon. (Original work published in 1894).

Jameson, F. (2000). T. W. Adorno. In M. Hardt & K. Weeks (Eds.), *The Jameson reader*. London: Blackwell.

Kautsky, K. (1924). *The labor revolution*. (H. G. Stenning, Trans.). Retrieved September 22, 2005, from http://www.marxists.org/archive/kautsky/1924/labour/index.htm.

Laclau, E., & Mouffe, C. (2001). *Hegemony and socialist strategy*. London: Verso.

Lenin, V. I. (1914). *Summary of dialectics*. Retrieved June 5, 2005, from http://www.marxists.org/archive/lenin/works/1914/cons-logic/summary.htm.

Lewis, T. (2005). The new surge in Bolivia's rebellion. *International Socialist Review* 41: 7–10.

Lukács, G. (1972/1951). *History and class consciousness*. Cambridge, MA: MIT Press.

Marx, K. (1845). *The German ideology*. Retrieved June 5, 2005, from http://www.marxists.org/archive/marx/works/1845/german-ideology/ch01a.htm#a1.

Marx, K. (1847). *The poverty of philosophy*. (Institute of Marxism-Leninism, Trans.). Retrieved June 5, 2005, from http://www.marxists.org/archive/marx/works/1847/poverty-philosophy/ch02e.htm.

Marx, K. (1851–52). *The eighteenth brumaire of Louis Napoleon*. (S. K. Padover, Trans.). Retrieved June 5, 2005, from http://www.marxists.org/archive/marx/works/1852/18th-brumaire/ch01.htm.

Marx, K. (1857–61). *Grundrisse der Kritik der Politischen Ökonomie/Outlines of the critique of political economy*. (M. Nicolaus, Trans.). Retrieved June 5, 2005, from http://www.marxists.org/archive/marx/works/1857/grundrisse/.

Marx, K. (1873). *Capital*. (H. Kuhls, Trans.). Retrieved September 22, 2005, from http://www.marxists.org/archive/marx/works/1867-c1/p3.htm#3b.

Marx, K. (1932). On Hegel's philosophy in general. *Economic and philosophical manuscripts of 1844*. (M. Mulligan, Trans.). Retrieved June 5, 2005, from http://www.marxists.org/archive/marx/works/1844/manuscripts/hegel.htm. (Original work published in 1844).

Mészáros, I. (1972). *Lukács' concept of the dialectic*. London: Merlin Press.

Negt, O., & Kluge, A. (1993). *Public sphere and experience*. (P. Labanyi, J. O. Daniel, & A. Oksiloff, Trans.). Minneapolis: University of Minnesota Press.

Plato. *Phaedrus*. Retrieved June 10, 2005, from http://classics.mit.edu/Plato/phaedrus.html.

Timpanaro, S. (1975). *On materialism*. London: Verso.

Trotsky, L. (1955). *Revolution betrayed*. Retrieved August 15, 2005, from http://www.marxists.org/archive/cliff/works/1955/statecap/index.htm.

Wood, E. M. (1998). *The retreat from class*. London: Verso. (Original work published in 1986).

Wright, E. O. (1997). *Classes*. London: Verso.

·MEDIA, CULTURE, AND SOCIETY: THE RELEVANCE OF MARX'S DIALECTICAL METHOD·

Deepa Kumar

Dialectical materialism, the method of analysis developed by Marx and Engels, is more relevant to media and cultural studies scholarship today for at least two reasons: the crisis of neoliberalism and the collapse of Stalinism. The failure of neoliberalism—that is, capitalism in its current avatar—is an uncontroversial fact. From Argentina, to Russia and Southeast Asia, and even New Orleans in the aftermath of hurricane Katrina, the inability of the neoliberal project to address the needs of the majority is plain to see. At the same time, there has also been a rise in struggle and movements that not only have articulated an opposition to globalization but have started to discuss and develop alternatives to the existing system. The workers and peasant demands in Bolivia, the factory occupation movement in Argentina, and the Bolivarian experiment under Chavez's Venezuela are just a few examples of the rejection of the status quo and the attempt to find alternatives. The time has come for critical scholarship to shake off the yoke of TINA (there is no alternative), and start to take seriously the bankruptcy of capitalism and the possibilities of a socialist alternative. This process is only

aided, I would argue, by the collapse of the Soviet Union and the shedding of the dead weight of Stalinism. This second historical factor—that is, the dissolution of Stalinism and bureaucratic centralism—has opened up a space from which to rethink the relevance of classical Marxism.

Through much of twentieth century, cultural theorists within the Marxist tradition have had to adapt and develop Marxist theory in response to Stalinism. For instance, the key theorists within the Frankfurt school were shaped by the failure of the Bolshevik revolution and rise of Stalinism. Within their own country they witnessed the betrayals of German social democracy during World War I, the failure of the German revolution, the rise of Hitler, and the rigidity of the German Communist Party under Stalinist domination. From these demoralizing events they drew the conclusion that this was the result of flaws within Marxism itself that needed to be addressed theoretically. In so doing, they drew from the work of philosophers like Kant, Fichte, and Hegel. The result was that Marxism acquired a distinctly idealist hue where the agency of the working class, and material struggle, was replaced by an emphasis on criticism and critical theory.

Scholars in the British cultural studies tradition, writing under conditions of rising struggle in the 1960s, would retain the centrality of the working class within Marxism. However, they too had to respond to Stalinism, and particularly to the events in Hungary in 1956 when a worker revolt was brutally suppressed by the Soviet Union. Several figures such as Edward P. Thomson and Raymond Williams would distance themselves from the Soviet Union after this. Yet, this break with the Soviet Union again meant a retheorization of aspects of Marxist theory (as opposed to a critical analysis of Soviet society from a Marxist position). In celebrating the working class, Williams and Thompson, at least in their early work, would bring a large dose of voluntarism into Marxist theory; that is, they would overemphasize agency and downplay structural limitations. As Stuart Hall (1994) notes, the "culturalist" tendency within British cultural studies would elevate human experience and culture-consciousness in contrast to the "structuralist" tendency that would elevate structural discursive limitations. Louis Althusser would even go so far as to suggest that history was a process without subjects. Both approaches are ultimately undialectical. When Marx argued that human beings make their own history (agency), he qualified this claim by stating that this history was made under conditions not of our

own choosing (structural limitations). Whereas culturalists overemphasize the former, structuralists overemphasize the latter.

The poststructuralist and postmodernist turn in cultural studies would then sever all ties to Marxism. Angela McRobbie (1992), in the concluding essay of the cultural studies anthology that emerged out of the 1990 conference at the University of Illinois, Urbana Champaign, would note that a "return to a pre-postmodern Marxism…is untenable because the terms of that return are predicated on prioritizing economic relations and economic determinations over cultural and political relations by positioning these latter in a mechanical and reflectionist role" (p. 719). Thus, Marxism itself would be viewed as reductionist with little evidence offered to validate this argument. In this chapter I set out to defend Marxism from the taken-for-granted, yet largely unsubstantiated, charge of reductionism and economism. I do so by focusing on dialectical materialism as method of analysis, to demonstrate that it is diametrically opposed to reductionism. It is my hope that a new generation of scholars will reject the recycled criticisms of Marxism prevalent in the academy and engage more seriously with the work of Marx and Engels. Contrary to McRobbie, I would argue that a return to pre-postmodern Marxism is not only possible today in context of a post-Stalinist world, but also a historical responsibility that neoliberal capitalism challenges us to bear.

Before beginning the discussion of dialectics, one more point is in order. There are passages in Marx's writings that, when taken in isolation from the rest of his work, can lead one to argue that Marxism is reductionist. One such passage that is often quoted by critics of Marxism can be found in the preface to *A Contribution to the Critique of Political Economy*, where Marx argues that

> In the social production of their life, men enter into definite relations that are indispensable and independent of their will, relations of production which correspond to a definite stage of development of their material productive forces. The sum total of these relations of production constitutes the economic structure of society, the real foundation, on which rises a legal and political superstructure and to which correspond definite forms of social consciousness. The mode of production of material life conditions the social, political and intellectual life process in general. It is not the consciousness of men that determines their social being, but, on the contrary, their social being that determines consciousness. (In Tucker, 1978, p. 4)

This passage implies that the mode of production or the economic base determines the political and legal superstructure in direct and unmediated ways, lending itself to an economistic understanding of the base and superstructure. However, as Derek Sayer (1979) has argued, although this quote can be used to substantiate the charge of economism, Marx's other writing can also be used to reject the reductionist account of the base-superstructure relationship. Sayer cites numerous passages from Marx that counter reductionism (see pp. 77–103). Marx's longtime collaborator, Friedrich Engels, also militated against charges of reductionism. In his letter to Bloch, he points out that

> According to the materialist conception of history, the *ultimately* determining element in history is the production and reproduction of real life. More than this neither Marx nor I have ever asserted. Hence if somebody twists this into saying that the economic element is the *only* determining one, he transforms that proposition into a meaningless, abstract, senseless phrase. The economic situation is the basis, but the various elements of the superstructure—political forms of the class struggle and its results, to wit: constitutions established by the victorious class after a successful battle, etc., juridical forms, and even the reflexes of all these actual struggles in the brains of the participants, political, juristic, philosophical theories, religious views and their further development into systems of dogmas—also exercise their influence upon the course of the historical struggles and in many cases preponderate in determining their *form*. There is an interaction of all these elements in which, amid all the endless host of accidents...the economic movement finally asserts itself as necessary. (In Borodulina, 1984, p. 294)

In other words, what Marx and Engels argued for was a method that was historically specific and that understood the dialectical relationship between various institutions and agents. It is this method that we see at work in Marx's various works, such as the analysis of the Paris commune or Engel's explanation of the condition of the English working class, and not the mechanical, reductionist caricature that critics purport. As David McLellan (1971) notes, "those critics of Marx who sometimes write as though Marx's summary of the 'guiding thread' of his studies in the preface to his *Critique of Political Economy* (1859) were a definite and exhaustive account of his views will have to do some wider reading. For such a brief summary as is contained in the preface can only be adequately interpreted by reference to the immense amount of background thinking and writing from which it

sprang" (p. 14). Before diving into this body of work, it is necessary to begin with Hegel to fully appreciate the materialist dialectic.

Hegel's Dialectic

The dialectical method as it exists in Marx finds its roots in the work of G. W. F. Hegel. Hegel wrote at a time when profound changes were shaking the very foundations of feudal Europe. The French Revolution and the rise of Napoleon were to have a deep impact on him, leading him to develop a philosophical method that incorporated the notion of historical change. For Hegel, change is the product of contradiction that all things bear within themselves. For instance, the acorn bears within itself the ability to become an oak, to become something different from what it is. The oak then is the negation of the acorn. The acorn by containing its own negation, therefore, is contradictory. It is this contradiction that allows things to grow and change. In the preface to *Phenomenology of Spirit*, Hegel critiques other philosophical systems for being one-sided in their understanding of the world. Rather than reject these philosophies, he shows that they can be incorporated into his own method as "moments" in the unfolding of the dialectic. He offers a metaphor by which to comprehend his dialectical method:

> The bud disappears in the bursting-forth of the blossom, and one might say that the former is refuted by the latter; similarly, when the fruit appears, the blossom is shown up in its turn as a false manifestation of the plant, and the fruit now emerges as the truth of it instead. These forms are not just distinguished from one another, they also supplant one another as mutually incompatible. Yet at the same time their fluid nature makes them moments of an organic unity in which they not only do not conflict, but in which each is as necessary as the other; and this mutual necessity alone constitutes the life of the whole. (Hegel, 1977, p. 2)

In other words, the truth is the whole and not any one part of it. Furthermore, it is through the *process* of development that the parts come to constitute the whole and when they do so they are different from what they were before; they negate themselves. Thus, for Hegel, a method of analysis that focuses simply on the bud misses the fact that the bud is a moment in the process of

change and will be transformed into a blossom and then a fruit. At each stage in its growth, we see not only a cancellation of the previous self, but also a part of the old that is preserved in the new. It is only through an understanding of the total process that the parts can be fully grasped. Thus, a dialectical approach is at its core antithetical to any form of reductionism because it understands the relationship between the part and the whole not as being reducible to each other, but as mutually conditioning or mediating each other.

In *Science of Logic* Hegel shows how concepts relate to one another and develop dialectically. He attempts to bring together and build a system that shows the interconnection between various ways of understanding the world, from the natural sciences to art, religion, culture, and other philosophical systems. He begins with the most basic contradiction between the notion of "being" and "nothing." The first concept he addresses is "being," which he points out is contained in everything that exists. The very first concept is a totality in itself in that all things that exist must be; they must have being. Yet, being contains within itself its opposite—nothing. He refers to this diad of "being" and "nothing" as the "unity of opposites" or the "identity of opposites." These two terms by themselves are static, but for Hegel they don't exist in isolation but rather are mediated by a third term, "becoming." In German, the word for "becoming" means both "ceasing to be" and "coming to be." In short, becoming incorporates both aspects of being and nothing. But it also supersedes or sublates (*aufheben*) both these terms and invokes motion. This process Hegel refers to as the negation of the negation. The book begins with this first negation and then develops various moments of this process until it arrives at the final concept, the absolute Idea. A series of seemingly dead and static concepts are given motion and movement through the process of contradiction and negation.

Tony Smith (1993), in his overview of the *Science of Logic*, explains that at the broadest level, Hegel made a distinction between the "principle" and the "principled." The "principle" is an explanatory system that seeks to understand the real world. The real world or that which is to be explained is termed the "principled." This differentiation may seem somewhat analogous to classificatory schema such as subject/object, signifier/referent, mind/body, all employed for the general purpose of distinguishing the concrete from the abstract or reality from thought. Prior to Hegel, the tendency among thinkers was to separate the two and to develop dualistic theories. For instance, Emmanuel Kant argued that there is an insurmountable wall

between the way things appear to human beings in our minds and the real world or the "thing-in-itself." He argued that even though objective reality produced the sensations within human beings from which concepts were derived, ultimately there was a gap between the two. Hegel rejected this dualism. For him, the relationship between the principle and the principled is not one of mutual exclusiveness; that is, the principle is not merely a subjective category but a component within the dialectic of subject and object. The principle does not merely explain the principled but captures the intelligibility of the principled and, as such, is united symbiotically with the principled. The principle is therefore ontological at the same time as it is epistemological. In this sense the epistemological question cannot be put to Hegel or Marx, as will become evident later, without invoking at the same time the ontological question. Concrete things acquire an identity through contradiction; therefore the "unity" that we perceive is a complex of opposites; it is, in Hegelian terms, a "unity of difference." The principled is therefore never a simple entity but a unified manifold. The principle that grasps the unity unifies the principled in thought, and the principle-principled dialectic becomes a "unity of unity in difference." In this sense contradiction is internal to the principle as well—it is its underlying logic. Hegel argues that to "consider a thing rationally means not to bring reason to bear on the object from the outside and so to tamper with it, but to find that the object is rational on its own account" (in Rees, 1998, p. 47). Or put another way, "this dialectic is not an activity of subjective thinking applied to some matter externally, but is rather the matter's very soul putting forth its branches and fruit organically" (p. 47). In short, subject and object are unified.

It follows, then, that Hegel understood history as reason/rationality being revealed to human consciousness. Hegel's system brought together the concepts and categories of analysis with the process of historical development. In *Philosophy of History*, Hegel (1956) argues that *Geist* or Spirit, by which he means the sum total of all human knowledge, manifests itself only in partial form in every society. And as society develops, human beings come to recognize the rational structure of society that previously was hidden from consciousness. John Rees (1998) summarizes Hegel's philosophical system as follows:

> Hegel's mature system sought to fuse logical categories of analysis with the real course of historical change. The contradictions of thought *are* the

contradictions of reality. The power of thought is the power to change real-
ity. What is true of the methods of thought is simultaneously true of the his-
tory of the world. The history of the world is the rationality of the human
mind working itself out in time. This is self-evidently an idealist method, but
equally self-evidently, it is also an historical method that seeks to explain the
totality of social change by examining the conflicts and contradictions at its
heart. It is, therefore, the birth of the dialectic in its modern form. (p. 33)

When Marx appropriated the Hegelian dialectic he preserved the concepts
of totality, contradiction, and change, but in doing so he absolved it of its
idealism and grounded it within material reality.

Marx's Dialectic

For Marx the starting point, or the simple category, wasn't "being," a philo-
sophical concept, but rather the reality in which human beings live. In the
materialist dialectic, even the simplest category stems from reality and as a
category embodies the complex mediations of which it is an instance.
Elaborating upon the differences between his dialectic and that of Hegels in
the afterword to the *Capital: Volume I*, Marx writes:

> My dialectical method is not only different form Hegel's, but is its direct
> opposite. To Hegel the life process of the human brain, i.e. the process of
> thinking, which, under the name of "the Idea" he even transforms into an
> independent subject, is the demiurges of the real world, and the real world
> is only the external, phenomenal form of "the Idea." With me, on the con-
> trary, the ideal is nothing else than the material world reflected by the
> human mind, and translated into forms of thought.... The mystification
> which [the] dialectic suffers in Hegel's hands, by no means prevents him
> from being the first to present its general form of working in a comprehen-
> sive and conscious manner. With him it is standing on its head. It must be
> turned the right side up again, if you would discover the rational kernel
> within the mystical shell.

Marx argued that Hegel fell into the error of considering the real as being
the result of self-coordinating and spontaneously operating thought; for
Hegel it was this process that generated the concrete. When Marx placed

Hegel on his head his goal was to develop dialectically an understanding of the world based on material reality—a liberating criticism first articulated by Ludwig Feuerbach in *The Essence of Christianity* (1841). However, in rejecting Hegel's idealism Marx did not lapse into materialist reductionism—that is, a position that posits that consciousness is wholly determined by material reality in a one-sided manner. Marx acknowledged that thought can become an objective force when material reality is shaped subjectively. Marx argued that through practice, human beings not only act upon the world and shape it but, in the process, are themselves shaped by the material world. Articulating the difference between the bee and the architect, he states that "the architect builds the cell in his mind before he constructs it in wax. At the end of every labor process, a result emerges which had already been conceived of by the worker at the beginning, hence already existed ideally" (Marx, 1976, pp. 283–84). In short, consciousness-in-action can and does shape material reality. However, the process of acting upon the world also shapes consciousness. For instance, the materials that an architect works with impact the realization of the ideal in her/his head.

In their early debates with the young Hegelians, Marx and Engels differentiated themselves from the idealists by arguing for the unity of subject and object, stressing the role of human activity and practice. Marx jotted down the outline of this materialist approach in "Theses on Feuerbach" (1845), but in *The German Ideology* we find a full exposition of the materialist conception of history. In contrast to Hegel, who sees history as the successive manifestations of the *Geist*, and Feuebach, who sees a passive static material reality, Marx argues that it is material conditions and practical human activity that are the motors of historical change. Tracing the evolution of human existence, he points out that the first historical act is the satisfaction of needs, alongside which is the production of the means by which these needs may be satisfied. His fundamental premise is that *individuals exist*, and therefore have to sustain their material existence. The satisfaction of these needs is dependent on the means of subsistence that human beings find in existence or the productive forces (left by older generations or otherwise), and this gives rise to the modes of production that a society may engage in a given epoch. Individuals also enter into social relations with each other in concordance with the modes of production. These social relations are mediated by the productive forces, which is the sum total of the material (labor, raw material, and so on) available for that social organization.

Historical materialism therefore starts out with the material circumstances that enable the sustenance of life and from there proceeds to explain human interactions and consciousness. As Marx put it,

> In direct contrast to German philosophy which descends from heaven to earth, here we ascend from earth to heaven. That is to say, we do not set out from what men [sic] say, imagine, conceive, nor from men as narrated, thought of, imagined, conceived, in order to arrive at men in the flesh. We set out from real, active men, and on the basis of their real life-process we demonstrate the development of the ideological reflexes and echoes of this life process.... Life is not determined by consciousness but consciousness by life. (In Borodulina, 1984, p. 23)

While Marx understandably stressed the role of material reality in shaping consciousness in his debates with idealist philosophers, he also acknowledged the mutually conditioning relationship between thought and reality. Thus, he would state that "circumstances make men just as much as men make circumstances" (in Tucker, 1978, p. 165).

In the *Grundrisse*, Marx explicates at some length his method of analysis and provides several examples of how it might be employed to study the world. For instance, he states that if one were interested in studying production, then one might start with the category of population. However, such a starting point would be a mere abstraction if it left out an understanding of the particulars that determine the category "population." Marx elaborates that population is a unity of differences and is a concrete beginning to the extent that it is a "combination of many determinations, i.e. a unity of diverse elements" (McLellan, 1971, p. 34). Hence, although "population" may seem like a coherent unity and the result of a synthesis, it is actually a starting point with multiple mediations. Like Hegel, even the simplest categories within the materialist dialectic contain aspects of the totality. However, unlike Hegel it is material reality that mediates these categories. Marx's method therefore involves the selection of a category, which, being historically specific, embodies a host of determinations at its very inception into a theory. As Marx would write,

> If we start out, therefore, with population, we do so with a chaotic conception of the whole, and by closer analysis we will gradually arrive at

simpler ideas; thus we shall proceed from the imaginary concrete to less and less complex abstractions, until we arrive at the simplest determinations. This once attained, we might start on our return journey until we finally came back to population, but this time not as a chaotic notion of an integral whole, but as a rich aggregate of many determinations and relations. (In McLellan, 1971, p. 34)

In short, the Marxist method involves unraveling and building upon the multiple determinations that even an apparently simple concept is marked by. A simple category such as "commodity" or "labor" is already an abstraction of the lived relations of the people of a society, and is a unity of mediations. For instance, "capital," when invoked as a category, bears the traces of and acquires relational meaning from wage labor, value, price, money, and so on. However, the concrete is not reached merely by the building of categories, as Hegel suggested. For Marx, thought and the concrete world are fused within a unity of difference. He points out that the simple category "can have no other existence except as an abstract one-sided relation of an already given concrete and living aggregate" (McLellan, 1971, p. 35). Incipient even within the simple category is the totality.

One might then ask, Where do categories come from? The framework for such a question stems from a dualistic analytics that separates "knowing" from "being," and both the Marxist and Hegelian epistemologo-ontological dialectic would reject such a separation for all the reasons mentioned earlier. Marx would respond to such a question by stating that sociohistorical conditions, and one's social position within that context, determine consciousness and therefore categories. For instance, Marx analyzes the point at which "labor" as an abstraction comes to be used by political economists. He argues that while labor has existed since antiquity, its realization in discourse as an abstraction is possible only when historical circumstances give rise to a condition where particular forms of labor lose their distinctiveness—that is, in the context of a society where individuals are able to move between different forms of labor. These conditions then allow theorists to talk about labor in general as opposed to "farm labor" or the particular labor of artisans. It is with the emergence of capitalism that such a concept as "abstract labor" can come into being, because unlike feudalism, which had a rigid and hierarchical division of labor, capitalism permits a degree of mobility between occupations. Thus, although the concept "labor" is an

antiquated one, its inception into a theory at the general level of abstraction is contingent upon historical conditions. To use the words of Marx, "This example of labor strikingly shows how even the most abstract categories, in spite of their applicability to all epochs—just because of their abstract character—are by the very definiteness of the abstraction a product of historical conditions as well, and are fully applicable only under those conditions" (in McLellan, 1971, p. 39). While a category can be spoken of in the abstract sense, the concrete provides it direction, and thus "the more simple category can serve as an expression of the predominant relations of an underdeveloped whole or of the subordinate relations of a more developed whole" (in McLellan, 1971, p. 36). In the materialist dialectic, the "whole" or the concrete totality is presaged even in the simplest and most abstract category.

So far we have discussed how Marx, while adopting a dialectical method from Hegel, transforms it from an idealist to a materialist analytic. While he preserves the notions of totality, change, and contradiction, each acquires a distinct materialist foundation. At this point, we need to examine in more detail the concept of "*aufheben*," which usually is translated into "sublate" or "transcend" in English. The concept in German provides more accurately the process of unity in conflict or the dialectical process whereby movement, interaction, and change take place. To use the words of Hegel (1969), "'To sublate' has a twofold meaning in the language: on the one hand it means to preserve, to maintain, and equally it also means to put an end to.... Thus what is sublated is at the same time preserved" (p. 107). *Aufheben* involves a process that on the one hand negates and on the other preserves; that is, in the conflict of opposites the negation of one results in part of it being preserved in the act of sublation. In Hegel the conflict of opposites and the contradiction between them is resolved by showing that they are simply different aspects of an underlying concept. Thus, as mentioned earlier, the term *becoming* is shown to mediate between the opposites "being" and "nothing." In other words, the seeming contradiction can be resolved by recourse to a more complex concept. Whereas for Hegel contradiction could be resolved in theory, for Marx contradictions are found in reality and can only be resolved in practice. In the *Economic and Philosophical Manuscripts*, Marx (1975) would write that in order to "supersede the *idea* of private property, the *idea* of communism is enough. In order to supersede private property as it actually exists, *real* communist activity is necessary" (p. 365). In short, the materialist dialectic calls for a concrete analysis of real

historical conditions based on the understanding that this reality is fraught with contradictions and that real human activity is needed for change. Methodologically, dialectical materialism recognizes human society as a complex totality that is mediated by multiple factors of which the economic ultimately sets the limits of what is possible. Far from being reductionist, the Marxist method enables us to understand the world in all its complexity and opens up the possibility for change.

Implications for the Study of Media and Culture

The starting point for a dialectical analysis of media and culture is the recognition that the media are contradictory institutions. They are contradictory both in terms of the content of media products and in the structure and organization of the media industry. While some countries still have state-owned media, by and large the mass media around the world are owned by giant conglomerates. This means that they are part of the economic base. But because the products of the industry are ideological/cultural they are also part of the superstructure (Meehan, 1986). As Eileen Meehan (1986) has argued in relation to television in the United States, "one must rethink television as constituted in contradiction as both culture industry and industrial culture" (p. 449). The economic imperatives of a for-profit media system set limits on the content of media products. The industrial logic pushes media producers to churn out programs that are usually modeled on past successes. Thus, formulas and stereotypes are mechanisms that the industry employs to cope with financial risk (Turow, 1997). At the same time, however, the media are forced to introduce innovation as a way to continue to entice audiences that have grown tired of old formats. This leads to programs that sometimes challenge the status quo. For instance, while television serves up a steady diet of shows that justify the criminal justice system, some shows like *Law and Order: SVU* provide a more complex understanding of crime and occasionally invite the audience to empathize with criminals by explaining the social contexts that cause crime. While Hollywood has churned out a vast array of films that internalize U.S. foreign policy, we also get films like *Three Kings* that ask us to view the 1991 Iraq war in more critical ways. In short, the range of products offered by the media are contradictory: some tend to reinforce the

dominant ideology, while others, arguably a smaller percentage, tend to challenge it.

In addition to contradictions across various media products, contradiction can also be found *within* most media texts. For instance, while a film like *Charlie's Angels* represents a step forward in the representation of women, in that the female protagonists are shown to be powerful, strong, and capable of activity in contrast to the usual passive role for women as damsels in distress in action thriller films, it also marks a step backward, not only because ultimately a man, Charlie, makes the key decisions but because the women's bodies are objectified in all the typical ways. The television series *Roots* was progressive to the extent that it cast African Americans as the key protagonists and asked audiences to identify with them; it was regressive in that it depicted slavery as the product of individual antagonists and obscured the social parameters of the system that would implicate many historical icons in the United States. Ultimately, the series was about individual triumph over adversity and a celebration of the American dream. Yet it also, perhaps for the first time in television history, cast black people as the heroes and some whites as the villains, reversing a long trend.

Media texts are contradictory, as all reality is contradictory. And contradiction allows for change within the totality of social relations. This change is the product of human beings resisting their conditions of oppression and exploitation. Thus, a show like *Roots* could be broadcast only after the civil rights and black power movements forced American society to confront racism. Strong female characters like Roseanne and Murphy Brown become possible only after the feminist movement challenges sexism. Shortly after the UPS strike of 1997, the game show *Wheel of Fortune* did a week-long tribute to workers. All the contestants on these shows were either union members or their families, and the major prizes were union-made and identified as such, with prominent displays of union labels. In my book *Outside the Box: Corporate Media, Globalization, and the UPS Strike* (2006), I use a dialectical method to explain why a normally antilabor media became more sympathetic to the working class. It was the product of numerous factors: the strike itself, the level of preparation by the union and by UPS, the struggle over ideas and representation, the state of working class consciousness, and others. Multiple factors coalesced to impact media and culture within the context of an economic struggle—and above all the interest of media producers to profit from their audiences.

In short, mass-mediated products are determined by various factors—the systems of ownership, the process of cultural production, the level of struggle, the state of consciousness in society at a given time, and so on. A dialectical method of analysis would involve studying all these factors within a concrete historical context so as to explain the multiple mediations that infuse a product of culture. There is nothing about this method that is reductionist or deterministic. Marxism offers hope for the possibility of change, without guaranteeing the outcome. As scholars of the media and culture, we have a twofold task—to explain and critique the state of culture and society, and then to act upon the world to change it. In taking up this challenge, classical Marxism as a guide to action has much to offer.

References

Borodulina, T. (Ed.) (1984). *Marx, Engels, Lenin: On historical materialism*. Moscow: Progress Publishers.

Hall, S. (1994). Cultural studies: Two paradigms. In N. B. Dirks, G. Eley, & S. B. Ortner (Eds.), *Culture/power/history: A reader in contemporary social theory*. Princeton, NJ: Princeton University Press.

Hegel, G. W. F. (1956). *The philosophy of history*. (J. Sibree, Trans.). New York: Dover Publications.

Hegel, G. W. F. (1969). *Science of logic*. London: G. Allen & Unwin.

Hegel, G. W. F. (1977). *Phenomenology of spirit*. (J. N. Findlay, Trans.). New York: Oxford University Press.

Kumar, D. (2006). *Outside the box: Corporate media, globalization, and the UPS strike*. Urbana-Champaign: University of Illinois Press.

Marx, K. (1975). Economic and philosophical manuscripts. *Early writings*. London: Penguin.

Marx, K. (1976). *Capital: Volume I*. London, Penguin.

Marx, K. *Capital: Volume I, 1873: Afterword to the second German edition*. Retrieved from http://www.marxists.org/archive/marx/works/1867-c1/p3.htm.

McLellan, D. (1971). Introduction. In D. McClellan (Ed.), *Marx's Grundrisse*. London: Macmillan.

McRobbie, A. (1992). Post-Marxism and cultural studies: A post-script. In L. Grossberg, C. Nelson, & P. Treichler (Eds.), *Cultural studies* (pp. 719–30). New York: Routledge.

Meehan, E. (1986). Conceptualizing culture as commodity. *Critical Studies in Mass Communication* 3: 448–57.

Rees, J. (1998). *The algebra of revolution: The dialectic and the classical Marxist tradition.* New York: Routledge.

Sayer, D. (1979). *Marx's method: Ideology, science, and critique in* Capital. Atlantic Highlands, NJ: Humanities Press.

Smith, T. (1993). *Dialectical social theory and its critics: From Hegel to analytical Marxism and postmodernism.* Albany: State University of New York Press.

Tucker, R. C. (Ed.) (1978). *The Marx-Engels reader.* New York: W. W. Norton.

Turow, J. (1997). *Media systems in society: Understanding industries, strategies, and power.* 2nd ed. New York: Longman.

·REVISITING THE POLITICAL ECONOMY OF COMMUNICATION·

Vincent Mosco

This chapter provides an overview of the political economy approach to communication studies. The chapter first defines political economy and describes its use in communication research. It then provides guidance for rethinking and renewing the assumptions and issues that the approach takes up.

The time is ripe for such a rethinking because transformations in the world political economy and in intellectual life have raised fundamental challenges. The former include the near death of state communism and the rise of radical Islam as a potent force in the world, the dominance of the United States on the world political stage, accompanied by turmoil created by globalization, the breakup of what unity once existed in the Third World, and the rise of social movements, particularly feminism, environmentalism, and neoconservatism, that cut across traditional political economic categories such as social class. Among the numerous intellectual challenges, cultural studies questions the emphasis that political economy places on the study of the communication business and the power of large communication companies to shape beliefs and values. On the other hand, an approach variously called policy science, public choice theory, and rational expectations

applies mainstream economics or what is known as neoclassical economic theory to many different kinds of social behavior. It stresses the widespread sharing of power among individuals, rather than, as in political economy, the concentration of power in a dominant social class.

What Is Political Economy?

Two definitions of political economy capture the wide range of specific and general approaches to the discipline. In the narrow sense, political economy is the study of the social relations, particularly the power relations, that mutually constitute the production, distribution, and consumption of resources, including communication resources. This formulation has a certain practical value because it calls attention to how the communication business operates—for example, how communications products move through a chain of producers, such as from a Hollywood film studio, to wholesalers, retailers, and, finally, to consumers, whose purchases, rentals, and attention are fed back into new processes of production. However, there is sufficient ambiguity about what constitutes a producer, distributor, or consumer that one needs to be cautious about using this definition.

A more general and ambitious definition of political economy is the study of control and survival in social life. Control refers specifically to the internal organization of social group members and the process of adapting to change. Survival means how people produce what is needed for social reproduction and continuity. In this reading, control processes are broadly political, in that they constitute the social organization of relationships within a community, and survival processes are mainly economic, because they concern processes of production and reproduction. The strength of this definition is that it gives political economy the breadth to encompass at least all human activity and, arguably, all living processes (Foster, 2002). Its principal drawback is that it can lead you to overlook what distinguishes human political economy, principally our consciousness or awareness, from general processes of survival and control in nature.

Another way to describe political economy is to broaden its meaning beyond what is typically considered in definitions, by focusing on a set of central qualities that characterize the approach. Political economy has

consistently placed in the foreground the goal of understanding social change and historical transformation. For classical political economists of the eighteenth and early nineteenth centuries—people such as Adam Smith, David Ricardo, and John Stuart Mill—this meant comprehending the great capitalist revolution, the vast social upheaval that transformed societies based primarily on agricultural labor into commercial, manufacturing, and, eventually, industrial societies. For Karl Marx, it meant examining the dynamic forces within capitalism and the relationship between capitalism and other forms of political economic organization, in order to understand the processes of social change that would, he contended, ultimately lead from capitalism to socialism. Orthodox economics, which began to coalesce against political economy in the late nineteenth century, tended to set aside this concern for the dynamics of history and social change, in order to transform political economy into the science of economics, which, like the science of physics, would provide general, if static, explanations. According to this view, economics would be able to explain precisely how buyers and sellers come together to set prices in the marketplace, but would not address those broad processes of social and economic change that create the conditions for setting prices. Contemporary political economists, occupying various heterodox positions distinct from what has become the economic mainstream, continue the tradition of classical political economy to take up social change and transformation, focusing now on such areas as the transition from an industrial to a service or information economy. The study of the mass media and communication technology plays an important role in this research because the industries encompassed by these fields of study are major forces in the creation of today's economy.

Political economy is also characterized by an interest in examining the social whole or the totality of social relations that make up the economic, political, social, and cultural areas of life. From the time of Adam Smith, whose interest in understanding social life was not constrained by the disciplinary boundaries that mark academic life today, through Marx, and on to contemporary institutional, conservative and neo-Marxian theorists, political economy has consistently aimed to build on the unity of the political and the economic by accounting for their mutual influence and for their relationship to wider social and symbolic spheres of activity. The political economist asks, How are power and wealth related? How do these influence our systems of mass media, information, and entertainment?

Political economy is also noted for its commitment to moral philosophy, understood as both an interest in the values that help to create social behavior and in those moral principles that *ought* to guide efforts to change it. For Smith, as evidenced in his *Theory of Moral Sentiments* (1759/1976), a book he favored more than the popular *Wealth of Nations* (1776/1937), this meant understanding values like self-interest, materialism, and individual freedom that were contributing to the rise of commercial capitalism. In contrast, for Marx (1973, 1976), moral philosophy meant the ongoing struggle between the drive to realize individual and social value in human labor and the push to reduce labor to a marketable commodity. Contemporary political economy tends to favor moral philosophical standpoints that promote the extension of democracy to all aspects of social life. This goes beyond the political realm, which guarantees rights to participate in government, to the economic, social, and cultural domains where supporters of democracy call for income equality, access to education, and full public participation in cultural production and a guarantee of the right to communicate freely.

Following from this view, social praxis, or the fundamental unity of thinking and doing, also occupies a central place in political economy. Specifically, against traditional academic positions that separate the sphere of research from that of social intervention, political economists, in a tradition tracing its roots to ancient practices of providing advice and counsel to leaders, have consistently viewed intellectual life as a form of social transformation and social intervention as a form of knowledge. Although they differ fundamentally on what should characterize intervention, from Thomas Malthus, who supported open sewers as a form of population control, to Marx, who called on labor to realize itself in revolution, political economists are united in the view that the division between research and action is artificial and must be overturned.

The political economy approach is also distinguished by the many schools of thought that guarantee significant variety of viewpoints and vigorous internal debate. Arguably the most important divide emerged in responses to the classical political economy of Smith and his followers. One set of responses, which eventually established contemporary economics, focused on the individual as the primary unit of analysis and the market as the principle structure, both coming together through the individual's decision to register wants or demands in the marketplace. Over time, this

approach progressively eliminated classical political economy's concerns for history, the social totality, moral philosophy, and praxis and transformed political economy into the science of economics founded on empirical investigation of marketplace behavior conceptualized in the language of mathematics. Broadly understood as neoclassical economics or simply, in recognition of its dominant position as today's orthodoxy, economics, it is a perspective that reduces labor to just one among the factors of production, which, along with land and capital, is valued solely for its productivity, or the ability to enhance the market value of a final product (Marshall, 1890/1961; Jevons, 1965).

A second set of responses to the classic political economy of Smith opposed this tendency by retaining the concern for history, the social whole, moral philosophy, and praxis, even if that meant giving up the goal of creating the science of economics. This set constitutes the wide variety of approaches to political economy. A first wave was led by a number of groups, including conservatives who sought to replace marketplace individualism with the collective authority of tradition (Carlyle, 1984), utopian socialists who accepted the classical faith in social intervention but urged putting community ahead of the market (Owen, 1851), and Marxian thinkers who returned labor and the struggle between social classes to the center of political economy. Subsequent formulations built on these perspectives, leaving us with a wide range of contemporary formulations.

Although economics occupies the center and center-right of the academic political spectrum, a neoconservative political economy thrives in the work of people like George J. Stigler (1988), James M. Buchanan (1999), and Ronald Coase (Coase & Barrett, 1968; Coase, 1991), recipients of the Nobel prize in economics, who apply the categories of neoclassical economics to all social behavior with the aim of expanding individual freedom. Institutional political economy occupies a slightly left-of-center view, arguing, for example, in the work of John Kenneth Galbraith (1985, 2004), who drew principally on Veblen (1899/1934, 1932), that institutional and technological constraints shape markets to the advantage of those corporations and governments large enough and powerful enough to control them. Institutionalists created the framework for studies, described below, documenting how large media companies can control the production and distribution of mass media products to restrict diversity of content, specifically by keeping out work that challenges pro-business views. Neo-Marxian

approaches, including those of the French Regulation School (Lipietz, 1988; Robles, 1994), world systems theory (Wallerstein, 2004), and others engaged in the debate over globalization (Veltmeyer, 2004; Sassen, 1998), continue to place social class at the center of analysis, and are principally responsible for debates on the relationship between monopoly capitalism, the automation and deskilling of work, and the growth of an international division of labor. Recent work has sought out common ground between institutional and neo-Marxian theories (O'Hara, 2000). Finally, social movements have spawned their own schools of political economy, principally feminist political economy, which addresses the persistence of patriarchy and the dearth of attention to household labor (Huws, 2003), environmental political economy, which concentrates on the links between social behavior and the wider organic environment (Foster, 2002), and a political economy that melds the analysis of social movements with the Italian autonomous Marxist theoretical tradition. Dyer-Witheford (1999) has made the most productive use of this tradition in communication studies.

The Political Economy of Communication

Communication studies has drawn on the various schools of political economic analysis, and it is useful to map the political economy of communication from the perspective of regional emphases. Although there are important exceptions and cross-currents, North American, European, and Third World approaches differ enough to receive distinctive treatment.

North American research has been extensively influenced by the contributions of two founding figures, Dallas Smythe and Herbert Schiller. Smythe taught the first course in the political economy of communication at the University of Illinois and is the first of four generations of scholars, linked together in this research tradition. Schiller, who followed Smythe at the University of Illinois, similarly influenced several generations of political economists.

Their approach to communication studies drew on both the institutional and Marxist traditions. A concern about the growing size and power of transnational communication businesses places them squarely in the institutional school, but their interest in social class and in media imperialism gives their work a definite Marxian focus. However, they have been

less interested than, for example, European scholars in providing an explicit theoretical account of communication. Rather, their work and, through their influence, a great deal of the research in this region has been driven more explicitly by a sense of injustice that the communication industry has become an integral part of a wider corporate order that is in their view both exploitative and undemocratic. Although Smythe and Schiller were concerned with the impact within their respective national bases, they both developed a research program that charts the growth in power and influence of transnational media companies throughout the world (Smythe, 1981; Schiller, 1969/1992, 1989, 1996, 2000; Maxwell, 2003).

Partly owing to their influence, North American research has produced a large literature on industry and class-specific manifestations of transnational corporate and state power, distinguished by its concern to participate in ongoing social movements and oppositional struggles to change the dominant media and to create alternatives (Artz & Kamalipour, 2003; McCauley et al., 2003; McChesney, 1999; Mosco, 1996; Schiller, 1999; Wasko, 2003). A major objective of this work is to advance public interest concerns before government regulatory and policy organs. This includes support for those movements that have taken an active role before international organizations, in defense of a new international economic, information, and communication order (Mosco & Schiller, 2001; Constanza-Chock, 2003).

European research is less clearly linked to specific founding figures, and, although it is also connected to movements for social change, particularly in defense of public service media systems, the leading work in this region has been more concerned with integrating communication research within various neo-Marxian and institutional theoretical traditions. Of the two principal directions this research has taken, one, most prominent in the work of Garnham (1990, 2000) and in that of Peter Golding and Graham Murdock (Murdock, 2000; Murdock & Golding, 2000), has emphasized class power. Building on the Frankfurt School tradition, as well as on the work of Raymond Williams (1975), it documents the integration of communication institutions, mainly business and state policy authorities, within the wider capitalist economy, and the resistance of subaltern classes and movements reflected mainly in opposition to neoconservative state practices promoting liberalization, commercialization, and privatization of the communication industries.

A second stream of research foregrounds class struggle and is most prominent in the work of Armand Mattelart (1986/1992, 1983, 2000).

Mattelart has drawn from a range of traditions including dependency theory, Western Marxism, and the worldwide experience of national liberation movements to understand communication as one among the principal sources of resistance to power. His work has demonstrated how peoples of the Third World, particularly in Latin America, where Mattelart was an advisor to the government of Chile before it was overthrown in a 1973 military coup, used the mass media to oppose Western control and create indigenous news and entertainment media.

Third World research on the political economy of communication has covered a wide range of interests, although a major stream has grown in response to the modernization or developmentalist theory that originated in Western, particularly U.S., attempts to incorporate communication into an explanatory perspective on development congenial to mainstream academic and political interests. The developmentalist thesis held that the media were resources that, along with urbanization, education, and other social forces, would mutually stimulate economic, social, and cultural modernization in the Third World. As a result, media growth was viewed as an index of development. Drawing on several streams of international neo-Marxian political economy, including world systems and dependency theory, Third World political economists challenged the fundamental premises of the developmentalist model, particularly its technological determinism and the omission of practically any interest in the power relations that shape the terms of relationships between First and Third World nations and the multilayered class relations between and within them (Melkote & Steeves, 2001; Mody, 2003; Pendakur, 2003).

The failure of development schemes incorporating media investment sent modernization theorists in search of revised models that have tended to include telecommunication and new computer technologies in the mix (Jussawalla, 1993; Jussawalla & Taylor, 2003). Political economists have responded principally by addressing the power of these new technologies to integrate a global division of labor. A first wave of research saw the division largely in territorial terms: unskilled labor concentrated in the poorest nations, semiskilled and more complex assembly labor in semiperipheral societies, and research, development, and strategic planning limited to First World corporate headquarters, to which the bulk of profit would flow. More recent research acknowledges that class divisions cut across territorial lines and maintains that what is central to the evolving international

division of labor is the growth in flexibility for firms that control the range of technologies that overcome traditional time and space constraints (Artz & Kamalipour, 2003; Sussman & Lent, 1998; Pellow & Park, 2002).

Rethinking Political Economy

Although most assessments of political economy, including its application to communication research, acknowledge its contribution to intellectual life and to political activism, these also raise concerns about the need to rethink and renew political economy in the light of recent upheavals. The philosophical foundations of a political economy approach to communication provide an important starting point. Drawing on recent critical literature that reflects on the state of the field, I advance basic epistemological and ontological principles (Murdock & Golding, 2000; Calabrese & Sparks, 2003; Mosco, 1996). The political economy of communication needs to be grounded in a realist, inclusive, constitutive, and critical epistemology. It is realist in that it recognizes the reality of both concepts and social practices, thereby eschewing idiographic approaches that argue for the reality of ideas alone and nomothetic approaches that claim that ideas are only labels for the singular reality of human action. Following from this, political economy is inclusive in that it rejects essentialism, which would reduce all social practices to a single political economic explanation, in favor of an approach that views concepts as entry or starting points into a variegated social field (Resnick & Wolff, 1987).

The choice of certain concepts and theories over others means that I give priority to these over others as useful means of explanation. They are not assertions of the one best, or only, way to understand social practices. Additionally, the epistemology is constitutive in that it recognizes the limits of causal determination, including the assumption that units of social analysis interact as fully formed wholes and in a linear fashion. Rather, it approaches social life as a set of mutually constitutive processes, acting on one another in various stages of formation, and with a direction and impact that can be comprehended only in specific research. Finally, the approach is critical because it sees knowledge as the product of comparisons with other bodies of knowledge and with social values. For example, my political economy is critical in that it regularly situates the knowledge acquired in research against alternative bodies of knowledge in, for example, neoclassical economics, pluralist

political science, and cultural studies. Furthermore, it measures political economic knowledge against the values that guide my praxis, including the social democratic values of public participation and equality.

An ontology is an approach to the meaning of being that, in general, distinguishes between seeing things as either structures or processes. Against the traditional approach to political economy that concentrates on such structures as the business firm and government, rethinking political economy leads to an emphasis on social change, social process, and social relations. This means that research starts from the view that social change is ubiquitous, that structures and institutions are constantly changing, and that it is therefore more useful to develop starting points that characterize processes rather than simply to identify relevant institutions. Studying media institutions is important, but it follows from an analysis of social process. Guided by this principle, I develop a substantive map of political economy with three entry processes, starting with commodification, the process of transforming use to exchange value, moving on to spatialization, the transformation of space with time, or the process of institutional extension, and finally to structuration, the process of constituting structures with social agency. Placing these processes in the foreground does not replace structures and institutions, something that would substitute one form of essentialism for another. Rather these are entry points that constitute a substantive theory of political economy, one preferred choice among a range of possible means to understand the social field. The next section takes up these substantive entry points, using them to suggest the boundaries of a political economic analysis.

Commodification

Commodification has long been understood as the process of taking goods and services that are valued for their use (for example, food to satisfy hunger, stories for communication) and transforming them into commodities that are valued for what they can earn in the marketplace (farming to sell food, producing drama for commercial television). The process of commodification holds a dual significance for communication research. First, communication practices and technologies contribute to the general commodification process throughout society. For example, the introduction of computer communication gives all companies, not just communication companies, greater control over the entire process of production, distribution, and exchange, permitting

retailers to monitor sales and inventory levels with ever improving precision. This enables firms to produce and ship only what they know is likely to sell quickly, thereby reducing inventory requirements and unnecessary merchandise. Second, commodification is an entry point to understanding specific communication institutions and practices. For example, the general, worldwide expansion of commodification in the 1980s, responding in part to global declines in economic growth, led to the increased commercialization of media programming, the privatization of once public media and telecommunications institutions, and the liberalization (that is, deregulation) of communication markets.

The political economy of communication has been notable for its emphasis on describing and examining the significance of institutions, especially businesses and governments, responsible for the production, distribution, and exchange of communication commodities and for the regulation of the communication marketplace. Although it has not neglected the commodity itself and the process of commodification, the tendency has been to foreground corporate and government institutions. When it has treated the commodity, political economy has tended to concentrate on media content and less so on media audiences and the labor involved in media production. The emphasis on media structures and content is understandable in light of the importance of global media companies and the growth in the value of media content. Tightly integrated transnational businesses, such as Time Warner, News Corp., and Sony, create media products with a multiplier effect embodied, for example, in the tiered release, which might start with a Hollywood film exhibited in theaters, followed in six months or so by the release of the DVD, shortly thereafter by a version aired on pay-per-view, then on pay cable, and, finally, perhaps aired on broadcast television.

Political economy has paid some attention to audiences, particularly in the effort to understand the common practice whereby advertisers pay for the size and quality (propensity to consume) of an audience that a newspaper, magazine, or radio or television program can deliver. This has generated a vigorous debate about whether audiences—in fact, that is, labor—sell their labor power—in effect, their attention—in return for whatever content is produced (Smythe, 1977; Murdock, 1978; Lebowitz, 1986). The debate has been useful because it has broadened the discussion beyond content and included all businesses—not just media companies—in the core of communication research. More recent political economy research has broadened

the analysis of audience research to examine audience history and the complex relationship of audiences to the producers of commercial culture, including the Internet (Butsch, 2000; Compton, 2004; Hagen & Wasko, 2000; Ross & Nightingale, 2003; Terranova, 2000).

The labor of communication workers is also being commodified as wage labor has grown in significance throughout the media workplace. In order to cut the labor bill and expand revenue, corporate managers have replaced mechanical with electronic systems to eliminate thousands of jobs in the printing industry as electronic typesetting did away with the jobs of linotype operators. Today's digital systems allow companies to expand this process. Print reporters increasingly serve in the combined roles of editor and page producer. Not only do they report on a story, they also put it into a form for transmission to the printed, and, increasingly, electronic page. Companies generally retain the rights to the multiplicity of repackaged forms and thereby profit from each use. Broadcast journalists carry cameras and edit tape for delivery over television or computer networks. The film industry is now starting to deliver digital copies of movies to theaters in multiple locations over communication satellite, thereby eliminating distribution of celluloid copies for exhibition by projectionists. Companies now sell software well before it has been debugged on the understanding that customers will report errors, download and install updates, and figure out how to work around problems. This ability to eliminate labor, combine it to perform multiple tasks, and shift labor to unpaid consumers further expands the revenue potential (Gibbs, 2003; Hardt & Brennen, 1995; McKercher, 2002; Sussman & Lent, 1998). Workers have responded to this by bringing together people from different media, including journalists, broadcast professionals, and technical specialists in the film, video, telecommunications, and computer services sectors, into trade unions that represent large segments of the communications workforce (McKercher, 2002).

Spatialization

The second starting point for rethinking the political economy of communication is spatialization, or the process of overcoming the constraints of space and time in social life. Classical political economists like Smith and Ricardo found it necessary to devote considerable attention to the problems of how to value the spaces taken up by land and our built environment. Furthermore,

their development of a labor theory of value was bound up with the problem of how to define and measure labor time. Marx (1973) came closer to spatialization when he noted that capitalism "annihilates space with time." By this he meant that business makes use of the means of transportation and communication to diminish the time it takes to move goods, people, and messages over space. Today, political economists would say that rather than annihilate space, business, aided by developments in communication and information technology, transforms space (Castells, 2001). People, products, and messages have to be located somewhere, and it is this location that is undergoing significant transformation, evidenced in, for example, upheavals in the international division of labor that has seen millions of jobs relocated to low-wage regions of the world, especially to China and India.

Spatialization builds upon ideas offered by geographers and sociologists to address structural changes brought about by shifting uses of space and time. The sociologist Anthony Giddens (1990) refers to the centrality of time-space distanciation in order to examine the decline of our dependency on time and space. He suggests that this process expands the availability of time and space as resources for those who can make use of them. David Harvey (1989) identifies time-space compression to suggest how the effective map of the world is shrinking, again for those who can take advantage of it. Manuel Castells (2001) calls our attention to the declining importance of physical space, the space of places, and the rising significance of the space of flows to suggest that the world map is being redrawn according to boundaries established by flows of people, goods, services, and messages.

Communication is central to spatialization because communication and information processes and technologies promote flexibility and control throughout industry, but particularly within the communication and information sectors. Spatialization encompasses the process of globalization, the worldwide restructuring of industries and firms. Restructuring at the industry level is exemplified by the development of integrated markets based on digital technologies and, at the firm level, by the growth of the flexible or "virtual" company, which makes use of communication and information systems to continuously change structure, product line, marketing, and relationships to other companies, suppliers, its own workforce, and customers.

Globalization and industrial restructuring mutually influence four major patterns of government restructuring. Commercialization establishes

state functions, such as providing post and telecommunications services, principally along business or revenue-generating lines. Privatization takes this a step further by turning these units into private businesses. Liberalization gives the state's approval to opening competitive markets. Finally, internationalization links the state to other states, thereby shifting economic and political authority to regional (NAFTA) and international (GATT) treaties.

The political economy of communication has traditionally addressed spatialization as the institutional extension of corporate power in the communication industry. This is manifested in the sheer growth in size of media firms, measured by assets, revenues, profit, employees, and stock share values. For example, communications systems in the United States are now shaped by a handful of companies, including U.S.-based firms General Electric (NBC), Viacom (CBS), the Walt Disney Company (ABC), and Time Warner (CNN). There are others, including non-U.S.-based firms such as News Corp. (Fox), Bertelsmann, and Sony. Political economy has specifically examined growth by taking up different forms of corporate concentration (Herman & Chomsky, 1988; Herman & McChesney, 1997; Bettig & Hall, 2003). Horizontal concentration takes place when a firm in one line of media buys a major interest in another media operation that is not directly related to the original business. The typical form of this is cross-media concentration or the purchase by a firm in an older line of media, say a newspaper, of a firm in a newer line, such as a radio or television station. But horizontal concentration also takes place when a media company buys all or part of a business entirely outside of the media (for example, when a broadcaster buys a hotel chain). Vertical integration is the amalgamation of firms within a line of business that extend a company's control over the process of production, as when a major Hollywood film production studio purchases a distributor of film. This is also referred to as forward integration because it expands a firm further along the production and distribution processes. Backward vertical integration took place when the *New York Times* purchased paper mills in Quebec, thereby expanding the company down the production process. In addition to demonstrating how media firms have developed into transnational conglomerates that now rival, in size and power, firms in any industry, political economists are addressing the development of flexible forms of corporate power evidenced in the joint ventures, strategic alliances, and other short-term and project-specific arrangements that bring together companies or parts of companies, including

competitors. These take advantage of more flexible means of communication to unite and separate for mutual interest (Wasko, 2003).

One consequence of spatialization is the development of global labor markets. Business can now take advantage of differential wages, skills, and other important characteristics on an international scale. Much of the early political economic work in this area concentrated on the spread of the computer and communication component manufacturing (southeast Asia) and data entry (the Caribbean) businesses into the Third World, where companies were attracted by low wages and authoritarian rule (Heyzer, 1986; Sussman, 1984). The scope of research has expanded to address what is now called outsourcing or business efforts to find sources of relatively low-wage but skilled labor, needed in such areas as software production and call center sales and services in the Third World (Economic Policy Institute, 2004). It also encompasses the developed world, where a prime example is the growth of U.S. film and video production in places like Toronto, Vancouver, and other parts of Canada where lower labor costs add to business profits (Magder & Burston, 2001).

Structuration

The third entry point for a renewed political economy of communication is structuration, a process given prominence in Giddens's (1984) work. Structuration amounts to a contemporary rendering of Marx's view that people make history, but not under conditions of their own making. Specifically, research based on structuration helps to balance a tendency in political economic analysis to concentrate on structures, typically business and governmental institutions, by incorporating the ideas of agency, social process, and social practice. Concretely, this means broadening the conception of social class from its structural or categorical sense, which defines it in terms of what some have and others do not, to incorporate both a relational and a constitutional sense of the term.

A relational view of social class foregrounds the connections, for example, between business and labor, and the ways in which labor constitutes itself within the relationship and as an independent force in its own right. This takes nothing away from the value of seeing class, in part, as a designation for the differences between the "haves" and the "have nots." The political economy of communication has addressed class in these terms by producing research that documents persistent inequities in communication

systems, particularly in access to the means of communication, and the reproduction of these inequities in social institutions (McChesney, 1999; Murdock & Golding, 2004). This has been applied to labor, particularly in research on how communication and information technology has been used to automate and deskill work, including work in the media industries (McKercher, 2002). It has also been used to show how the means of communication are used to measure and monitor work activity in systems of surveillance that extend managerial control over the entire labor process in precise detail (Parenti, 2003).

Rethinking the political economy approach means expanding on the categorical conception with, first, a relational view of class that defines it according to those practices and processes that link social class categories. In this view, the working class is not defined simply by lack of access to the means of communication, but by its relationships of harmony, dependency, and conflict to the capitalist class. Moreover, a constitutional conception of class views the working class as the producer of its own, however tenuous, volatile, and conflicted, identity, in relation to capital and independently of it (Dyer-Witheford, 1999). This research aims to demonstrate how classes constitute themselves, how they make history, in the face of well-researched analysis of the conditions that constrain this history-making activity.

Rethinking political economy also means balancing another tendency in political economy: when it has given attention to agency, process, and social practice, it tends to focus on social class. There are good reasons for this emphasis. Class structuration is a central entry point for comprehending social life, and numerous studies have documented the persistence of class divisions in the political economy of communication. Nevertheless, there are other dimensions to structuration that complement and conflict with class structuration, including gender, race, and those broadly defined social movements that, along with class, make up much of the social relations of communication. Political economy has made important strides in addressing the intersection of feminist studies and the political economy of the media (Meehan & Riordan, 2002; Byerly, 2004). It has also taken major steps in research on information technology, gender, and the international division of labor, which addresses the double oppression that women workers face in industries like microelectronics, where they experience the lowest wages and the most brutalizing working conditions (Huws, 2003; Pellow & Park, 2002). Communication studies has addressed imperialism extensively,

principally by examining the role of the media and information technology in the maintenance of control by richer over poorer societies. Race figures significantly in this analysis and more generally in the social process of structuration, as Oscar Gandy (1998) takes up in his multiperspectival assessment of race and the media. Racial divisions are a principal constituent of the multiple hierarchies of the contemporary global political economy, and race, as both category and social relationship, helps to explain access to national and global resources, including communication, media, and information technology (Sivanandan, 1989; Pellow & Park, 2002).

One of the major activities in structuration is the process of constructing hegemony, defined as what comes to be incorporated and contested as the taken-for-granted, commonsense, natural way of thinking about the world, including everything from cosmology through ethics to everyday social practices (Artz & Murphy, 2000). Hegemony is a lived network of mutually constituting meanings and values, which, as they are experienced as practices, appear to be mutually confirming. For example, although political economy addresses agents as social rather than individual actors, it recognizes the significance of the hegemonic process of individuation, which refers to the practice of redefining social actors, such as business executives and workers, as individual subjects whose value is connected to individual rights, individual expression, the individual exercise of political responsibility in voting, and individual freedom of consumption. Political economists of communication document the ways major mass media promote individuation and demonstrate how these actions isolate individuals from one another, from their social and class identities, and from those with the power to carry out individuation. Political economists also describe the ways some media, however marginalized, resist participating in the hegemonic process of individuation and suggest forms of collective and democratic expression (Downing, 2001). They conclude that out of the tensions and clashes within various structuration processes, the media come to be organized in full mainstream, oppositional, and alternative forms.

Challenges on the Borders

Rethinking and renewing political economy also requires one to look outward, at the relationship between the discipline and those on its borders,

situating political economy of communication between cultural studies and policy science.

The cultural studies approach is a broad-based intellectual movement that focuses on the constitution of meaning in texts, defined broadly to include all forms of social communication (Storey, 2003). The approach contains numerous currents and fissures that provide for considerable ferment from within. Nevertheless, it can contribute to the process of renewing political economy in several ways.

Cultural studies has been open to a broad-based critique of positivism (the view that sensory observation of a static reality is the only source of knowledge). Moreover, it has defended a more open philosophical approach that concentrates on subjectivity or on how people interpret their world, as well as on the social creation of knowledge. Cultural studies has also broadened the meaning of cultural analysis by starting from the premise that culture is ordinary, produced by all social actors, rather than primarily by a privileged elite, and that the social is organized around gender and nationality divisions and identities as much as by social class.

Although political economy can learn from these departures, it can equally contribute to rethinking cultural studies. Even as it takes on a philosophical approach that is open to subjectivity and is more broadly inclusive, political economy insists on a realist epistemology that maintains the value of historical research, of thinking in terms of concrete social totalities, with a well-grounded moral philosophy, and a commitment to overcome the distinction between social research and social practice. Political economy departs from the tendency in cultural studies to exaggerate the importance of subjectivity, as well as the inclination to reject thinking in terms of historical practices and social wholes. Political economy also departs from the tendency for proponents of cultural studies to use obscure language that belies the approach's original vision that cultural analysis should be accessible to those ordinary people who are responsible for creating culture. Finally, it eschews the propensity in cultural studies to reject studies of labor and the labor process in favor of examining the social "production" of consumption and the ensuing tendency among some in the cultural studies school to deny labor any value in contemporary movements for social change (Denning, 1996, 2004; James & Berg, 1996; Maxwell, 2001; Mosco, 2004).

Political economy can also learn from the development of a policy science perspective, whose political wing has tended to place the state at the

center of analysis and whose economic wing aims to extend the application of primarily neoclassical economic theory over a wide range of political, social, and cultural life (Buchanan, 1999; Stigler, 1988; Posner, 1992).

Political economy has tended to regard government as overly dependent on and determined by the specific configuration of capital dominant at the time and therefore benefits from an approach that takes seriously the active role of the state. Moreover, political economy shares with policy science the interest in extending analysis over the entire social totality, with an eye to social transformation. Nevertheless, political economy departs fundamentally from the policy science tendency to a pluralist political analysis that views the state as the independent arbiter of a wide balance of social forces, none of which has enough power to dominate society. Against this, political economy insists on the power of business and the process of commodification as the starting point of social analysis. Furthermore, political economy rejects the policy science tendency to build its analysis of the social totality, and of those values that should guide its transformation, on individualism and market rationality. Against this, it insists on social processes, starting from social class and labor, and on setting community and public life against the market and a rationality that, from a political economy perspective, actually reproduces class power (Lewis & Miller, 2003).

Conclusion

For many years political economy has made an important contribution to understanding social life. Adam Smith began a process of providing theoretical rigor to a two-thousand-year-old tradition of offering advice and counsel to the powerful on the affairs of state. Karl Marx turned this tradition on its head by using political economy to critically examine capitalism and to provide the analytical tools to envision and build alternatives to capitalism. Given the centrality of media and culture for the process of globalization, it is more important than ever to rethink and renew the political economy of communication in order to understand the social order that the proponents of globalization envision and to help build democratic alternatives.

References

Artz, L., & Kamalipour, Y. (Eds.). (2003). *The globalization of corporate media hegemony.* Albany: State University of New York Press.

Artz, L., & Murphy, B. O. (2000). *Cultural hegemony in the United States.* Thousand Oaks, CA: Sage.

Bettig, R., & Hall, J. L. (2003). *Big media, big money: Cultural texts and political economics.* Lanham, MD: Rowman and Littlefield.

Buchanan, J. M. (1999). *Public finance and public choice: Two contrasting visions of the state.* Cambridge, MA: MIT Press.

Butsch, R. (2000). *The making of American audiences, 1750–1990.* New York: Cambridge University Press.

Byerly, C. (2004). Women and media concentration. In R. R. Rush, C. E. Oukrup, & P. J. Creedon (Eds.), *Seeking equity for women in journalism and mass communication education* (pp. 246–62). Hillsdale, NJ: LEA Press.

Calabrese, A., & Sparks, C. (Eds.) (2003). *Toward a political economy of culture.* Lanham, MD: Rowman and Littlefield.

Carlyle, T. (1984). *A Carlyle reader.* Cambridge: Cambridge University Press.

Castells, M. (2001). *The Internet galaxy.* New York: Oxford University Press.

Coase, R. H. (1991). *The nature of the firm: Origins, evolution, and development.* Oxford: Oxford University Press.

Coase, R. H., & Barrett, E. W. (1968). *Educational TV: Who should pay?* Washington, D.C.: American Enterprise Institute for Public Policy.

Compton, J. (2004). *The integrated news spectacle: A political economy of cultural performance.* New York: Peter Lang.

Constanza-Chock, S. (2003). Mapping the repertoire of electronic contention. In A. Opel & D. Pompper (Eds.), *Representing resistance: Media, civil disobedience, and the global justice movement* (pp. 173–91). London: Praeger.

Denning, M. (1996). *The cultural front: The laboring of American culture in the twentieth century.* London: Verso.

Denning, M. (2004). *Culture in the age of three worlds.* London: Verso.

Downing, J. (2001). *Radical media.* London: Sage.

Dyer-Witheford, N. (1999). *Cyber-Marx: Cycles and circuits of struggle in high technology capitalism.* Urbana: University of Illinois Press.

Economic Policy Institute. (2004). *Offshoring.* Washington, D.C.: Economic Policy Institute. Retrieved July 12, 2005, from www.epinet.org/content.cfm/issueguide_offshoring.

Foster, J. B. (2002). *Ecology against capitalism.* New York: Monthly Review Press.

Galbraith, J. K. (1985). *The new industrial state.* 4th ed. Boston: Houghton Mifflin.

Galbraith, J. K. (2004). *The economics of innocent fraud*. Boston: Houghton Mifflin.

Gandy, O. (1998). *Communication and race: A structural perspective*. London: Edward Arnold.

Garnham, N. (1990). Contribution to a political economy of mass communication. In F. Inglis (Ed.), *Capitalism and communication: Global culture and the economics of information* (pp. 20–55). London: Sage.

Garnham, N. (2000). *Emancipation, the media, and modernity: Arguments about the media and social theory*. New York: Oxford University Press.

Gibbs, P. L. (2003). Alternative things considered: A political economic analysis of labor processes and relations at a Honolulu alternative newspaper. *Media, Culture, and Society* 25: 587–605.

Giddens, A. (1984). *The constitution of society: Outline of a theory of structuration*. Berkeley: University of California Press.

Giddens, A. (1990). *The consequences of modernity*. Palo Alto, CA: Stanford University Press.

Hagen, I., & Wasko, J. (2000). *Consuming audiences*. New Jersey: Hampton.

Hardt, H., & Brennen, B. (1995). *Newsworkers: Toward a history of the rank and file*. Minneapolis: University of Minnesota Press.

Harvey, D. (1989). *The condition of postmodernity*. Oxford: Basil Blackwell.

Herman, E. S., & Chomsky, N. (1988). *Manufacturing consent: The political economy of the mass media*. New York: Pantheon.

Herman, E. S., & McChesney, R. W. (1997). *The global media: The new missionaries of corporate capitalism*. London: Cassell.

Heyzer, N. (1986). *Working women in southeast Asia: Development, subordination, and emancipation*. Philadelphia: Open University Press.

Huws, U. (2003). *The making of a cybertariat: Virtual work in a real world*. New York: Monthly Review Press.

James, D. E., & Berg, R. (1996). *The hidden foundation: Cinema and the question of class*. Minneapolis: University of Minnesota Press.

Jevons, W. S. (1965). *The theory of political economy*. New York: A. M. Kelley.

Jussawalla, M. (Ed.). (1993). *Global telecommunications policies: The challenge of change*. Westport, CT: Greenwood Press.

Jussawalla, M., & Taylor, R. D. (Eds.). (2003). *Information technology parks of the Asia Pacific*. London: M. E. Sharpe.

Lebowitz, M. (1986). Too many blindspots on the media. *Studies in Political Economy* 21: 165–73.

Lewis, J., & Miller, T. (Eds.). (2003). *Critical cultural policy studies: A reader*. Oxford: Blackwell.

Lipietz, A. (1988). Reflections on a tale: The Marxist foundations of the concepts of regulation and accumulation. *Studies in Political Economy* 26: 7–36.

Magder, T., & Burston, J. (2001). Whose Hollywood? Changing forms and relations in the North American information economy. In V. Mosco & D. Schiller (Eds.), *Continental order?* (pp. 207–34). Lanham, MD: Rowman and Littlefield.

Marshall, A. (1961). *Principles of economics*. London: MacMillan. (Original work published in 1890).

Marx, K. (1976). *Capital: A critique of political economy*. Vol. 1. (B. Fowkes, Trans.). London: Penguin.

Marx, K. (1973). *The Grundrisse: Foundations of the critique of political economy*. (M. Nicolaus, Trans.). Harmondsworth, UK: Penguin.

Massey, D. (1992). Politics and space/time. *New Left Review* 196: 65–84.

Mattelart, A. (2000). *Networking the world, 1794–2000*. (L. Carey-Libbrecht & J. A. Cohen, Trans.). Minneapolis: University of Minnesota Press.

Mattelart, A., & Mattelart, M. (1992). *Rethinking media theory: Signposts and new directions*. (J. A. Cohen & M. Urquidi, Trans.). Minneapolis: University of Minnesota Press. (Original work published in 1986).

Mattelart, A., & Siegelaub, S. (Eds.). (1983). YES *Communication and class struggle, vol. 2: Liberation, socialism*. New York: International General.

Maxwell, R. (Ed.). (2001). *Culture works: The political economy of culture*. Minneapolis: University of Minnesota Press.

Maxwell, R. (2003). *Herbert Schiller*. Lanham, MD: Rowman and Littlefield.

McCauley, M., Peterson, E., Artz, L., & Halleck, D. D. (Eds.). (2003). *Public broadcasting and the public interest*. Armonk, NY: M. E. Sharpe.

McChesney, R. W. (1999). *Rich media, poor democracy*. Urbana: University of Illinois Press.

McKercher, C. (2002). *Newsworkers unite: Labor, convergence, and North American newspapers*. Lanham, MD: Rowman and Littlefield.

Meehan, E., & Riordan, E. (Eds.). (2002). *Sex and money: Feminism and political economy in the media*. Minneapolis: University of Minnesota Press.

Melkote, S. R., & Steeves, H. L. (2001). *Communication for development in the Third World: Theory and practice for empowerment*. 2nd ed. New Delhi: Sage.

Mody, B. (Ed.). (2003). *International and development communication: A twenty-first century perspective*. Thousand Oaks, CA: Sage.

Mosco, V. (1996). *The political economy of communication*. London: Sage.

Mosco, V. (2004). *The digital sublime: Myth, power, and cyberspace*. Cambridge, MA: MIT Press.

Mosco, V., & Schiller, D. (Eds.) (2001). *Continental order? Integrating North America for cybercapitalism*. Lanham, MD: Rowman and Littlefield.

Murdock, G. (1978). Blindspots about Western Marxism: A reply to Dallas Smythe. *Canadian Journal of Political and Social Theory* 2: 109–19.

Murdock, G. (2000). Reconstructing the ruined tower: Contemporary communications and questions of class. In J. Curran & M. Gurevitch (Eds.), *Mass media and society.* 3rd ed. (pp. 7–26). London: Arnold.

Murdock, G., & Golding, P. (2000). Culture, communications, and political economy. In J. Curran & M. Gurevitch (Eds.), *Mass media and society.* 3rd ed. (pp. 70–92). London: Arnold.

Murdock, G., & Golding, P. (2004). Dismantling the digital divide: Rethinking the dynamics of participation and exclusion. In A. Calabrese & C. Sparks (Eds.), *Towards a political economy of culture: Capitalism and communication in the twenty-first century* (pp. 244–60). Lanham, MD: Rowman and Littlefield.

O'Hara, P. A. (2000). *Marx, Veblen, and contemporary institutional political economy.* Cheltenham: Edward Elgar.

Owen, R. (1851). *Labor: Its history and prospects.* New York: Fowler & Wells. [Original work published 1848].

Parenti, C. (2003). *The soft cage: Surveillance in America.* New York: Basic Books.

Pellow, D. N., & Park, L. S. (2002). *The Silicon Valley of dreams.* New York: New York University Press.

Pendakur, M. (2003). *Indian popular cinema: Industry, ideology, and consciousness.* Cresskill, NJ: Hampton Press.

Posner, R. A. (1992). *Sex and reason.* Cambridge, MA: Harvard University Press.

Resnick, S. A., & Wolff, R. D. (1987). *Knowledge and class: A Marxian critique of political economy.* Chicago: University of Chicago Press.

Robles, A. (1994). *French theories of regulation and conceptions of the international division of labor.* New York: St. Martin's Press.

Ross, K., & Nightingale, V. (2003). *Media and audiences: New perspectives.* Buckinghamshire: Open University Press, McGraw-Hill.

Sassen, S. (1998). *Globalization and its discontents.* New York: New Press.

Schiller, D. (1999). *Digital capitalism.* Cambridge, MA: MIT Press.

Schiller, H. I. (1989). *Culture, inc.* New York: Oxford University Press.

Schiller, H. I. (1992). *Mass communication and American empire.* 2nd ed. Boston: Beacon Press. (Original work published in 1969).

Schiller, H. I. (1996). *Information inequality: The deepening social crisis in America.* New York: Routledge.

Schiller, H. I. (2000). *Living in the number one country.* New York: Seven Stories Press.

Sivanandan, A. (1989). New circuits of imperialism. *Race and Class* 30: 1–19.

Smith, A. (1976). *The theory of moral sentiments.* Indianapolis, IN: Liberty Classics. (Original work published in 1759.)

Smith, A. (1937). *An inquiry into the nature and causes of the wealth of nations.* New York: Modern Library. (Original work published in 1776).

Smythe, D. W. (1977). Communications: Blindspot of Western Marxism. *Canadian Journal of Political and Social Theory* 1: 1–27.

Smythe, D. W. (1981). *Dependency road: Communication, capitalism, consciousness, and Canada.* Norwood, NJ: Ablex.

Stigler, G. J. (Ed.). (1988). *Chicago studies in political economy.* Chicago: University of Chicago Press.

Storey, J. (2003). *Cultural studies and the study of popular culture.* Athens: University of Georgia Press.

Sussman, G. (1984). Global telecommunications in the Third World: Theoretical considerations. *Media, Culture, and Society* 6: 289–300.

Sussman, G., & Lent, J. A. (Eds.). (1998). *Global productions: Labor in the making of the "information society."* Newbury Park, CA: Sage.

Terranova, T. (2000). Free labor: Producing culture for the digital economy, *Social Text* 18: 33–58.

Veblen, T. (1934). *The theory of the leisure class.* New York: Modern Library. (Original work published in 1899).

Veblen, T. (1932). *The theory of the business enterprise.* New York: Scribner's.

Veltmeyer, H. (Ed.). (2004). *Globalization and anti-globalization.* Aldershot, Hampshire: Ashgate.

Wallerstein, I. (2004). *The uncertainties of knowledge.* Philadelphia: Temple University Press.

Wasko, J. (2003). *How Hollywood works.* London: Sage.

Williams, R. (1975). *Television, technology, and cultural form.* London: Fontana.

Zhao, Y. (2001). *Media, market, and democracy in China: Between the party line and the bottom line.* Urbana: University of Illinois Press.

· CONTRADICTIONS IN CAPITALIST MEDIA PRACTICES ·

Colin Sparks

There is an old and honorable tradition in the labor movement that if you want some applause, you attack the capitalist media. That is guaranteed to get your audience clapping. Left-wing activists of all stripes, even very moderate ones, hate and loathe the media. Every night they sit in front of the TV news boiling with rage as, one after another, strikers are pilloried, Muslims demonized, asylum seekers witch-hunted, and Blair and Bush go unchallenged in their most outrageous lies.

The mass media are so loathed because they are central to "official" politics. They are the main mechanisms through which powerful groups in society—capitalists, politicians, and even trade union bureaucrats—are able to reach the mass of the population. The information they provide and the opinions they promote are the ones that are most readily available to everyone. You have to hunt out socialist viewpoints; the capitalist way of looking at the world is marketed relentlessly.

The reaction of generations of socialists to all of this has been the simple but firm conviction that the bourgeois media are all capitalist propaganda, designed to keep the queen on her throne, the prime minister in Downing

Street, and the boss on his yacht in St. Tropez. We see the media as relent-
lessly antiunion, racist, sexist, and war-mongering. We are disposed not to
believe a word we read in the papers or hear on the telly. Our ideas of what
is "just a bit of fun" most certainly do not include many of the things that
pass for popular entertainment on television or in the press. We are dis-
gusted at the nationalist hysteria that helps to send young men and women
off to the hazards and horrors of war.

This seems very obvious to us, and it is certainly at bottom entirely cor-
rect to say that the bourgeois media strain might and main to reproduce the
capitalist order. There is a strong current of leftist studies of the mass media,
most famously the "propaganda model" developed by Edward Herman
and Noam Chomsky (1988), that is dedicated to demonstrating why and
how the mass media "inculcate individuals with the values, beliefs, and
codes of behaviour that will integrate them into the institutional structures
of the larger society" (p. 1). There is a large body of work that demonstrates
just how the mass media are integrated into the capitalist order, and the
claim that they routinely seek to reproduce the capitalist system of which
they are a part is uncontestable.

Thinking of the media as one reactionary mass will not, however, quite
do. For one thing, there are a few dissenting voices that are allowed into the
media. We come across people who are unquestionably *not* interested in
propping up capitalism in the most unlikely places. While it is certainly the
case that the vast majority of people who are licensed to sound off in the
mass media are more or less consciously committed to capitalism, there are
occasional voices that contradict them. What is more, there are observable
differences among the media themselves, even when they fully accept cap-
italism.

If the main aim of the propaganda model, and similar theories of the
media, is to demonstrate the alignment between the interests of capital and
the content of the media, they are not adequate to explain a central aspect of
contemporary reality: the media in a contemporary bourgeois democracy
are remarkable not for their crushing uniformity but their limited diversity.
In the case of the UK, the broadcasters religiously maintain a balance
between the representatives of the main political parties, and while the *Daily
Telegraph* or the *Daily Mail* speaks with the authentic Tory voice of capitalist
reaction, the "real" bosses' paper, the *Financial Times*, supported the Labour
Party at the last four general elections. What is more, there are times, for

example during the run-up to the invasion of Iraq, when some sections of the media seem to launch outright offensives against government policy.

These real complexities are seized upon by capitalist apologists to argue that the mass media are free and independent, that what they report is the truth and the whole truth, and that the rest of their content is just giving the public what it wants. Any Marxist study of the mass media therefore has to do at least two things. It has on the one hand to demonstrate that the media are integral parts of the system of class rule and, on the other, it has to account for the apparent anomalies of conflicting voices that are most certainly present in the immediately observable output of newspapers and broadcasting. To do these things we need to go into some detail about the ways in which the media work.

Marx was certainly right when he observed that the ideas of an age are the ideas of its ruling class, but there is a big difference between how these ideas were produced and disseminated in his day (the pulpit was at least as important as the press) and in a contemporary, developed imperialist society, where social life is saturated with vast quantities of words and images conveyed by the mass media. The mass media are relatively recent phenomena, and have historically been very closely linked to capitalism and the development of the state system. The way that they produce and embody the dominant ideas of the age is a function of the kinds of social organizations that they are, and of the society within which they operate. As capitalism has developed and changed, so too have the media. The nature and content of the media in a contemporary capitalist society are likely to be markedly different from those of the media in other epochs.

Media in a Bourgeois Democracy

If the media of the twentieth century are overwhelmingly the media of monopoly capitalism, they have nevertheless operated in many different political environments. There are considerable differences between the ways in which the mass media operate in a state capitalist society, a fascist society, a classical military dictatorship, and a bourgeois democracy. While it may be true that, in the end, in all of these examples the media are concerned with justifying the existing order, the ways in which they do so vary widely. In this chapter, we are concerned solely with the ways in which the

mass media work in established and relatively stable bourgeois democracies like the United States and the UK.

It is a characteristic of capitalist society that the ruling class is divided among itself. One of the essential features of capitalism as a system is that the capitalists compete with each other; otherwise the system would lose its undoubted dynamism. While all capitalists have common interests, like keeping wages down and having the unrestricted right to manage, different capitalists have divergent individual interests: for example, arms manufacturers want to make sure there is maximum expenditure on weapons, while educational publishers want maximum expenditure on school books. More generally, different sections of capital have different visions of the future of capitalism, which correspond to their different markets and the different productive techniques upon which they depend: to take one contemporary example, capitalists in the UK are divided over how closely the country should be integrated into Europe. Debates and disputes among different capitalists and different sections of capital are a central and irremovable aspect of capitalist society. In a bourgeois democracy these differences are open and public, and form a great deal of the agenda of legitimate political life. Bourgeois parties, like the Republicans and Democrats in the United States, are formed around these differences among sections of capital.

Newspapers and other media can and do adopt a wide range of positions, while remaining entirely within the framework of capitalism. Sometimes newspapers are directly linked to particular groups of capitalists, or to the political party they are held to favor, and carry material directly promoting their view of the situation. A good example of this phenomenon is the leading Italian newspaper *Corriere della Serra*, which is owned by the Agnelli family, whose holdings include Fiat as well as other media outlets. Such newspapers were common in the UK in the nineteenth century but died out by the middle of the twentieth (Lee, 1976, p. 168ff; Koss, 1990, p. 1095ff). In other cases, the links are more informal, as with the *Daily Telegraph* or the *Daily Mail* and the Conservative Party in Britain, or *El Pais* and PSOE in Spain. Sometimes, newspapers are primarily commercial operations without formal political connections, and for which political coverage is a minor concern compared with the real estate advertisements and sports coverage. In this latter case, which is a commonplace in the United States, newspapers may represent the full range of capitalist opinion, all the way from Republican to Democrat, within their pages. Explaining why capitalist media

adopt different positions in a bourgeois democracy is thus hardly difficult: the capitalist class is not united and of one mind. The newspapers and other media reflect these differences and promote the interests of one group or another. Marxists would expect to find a diversity of views among the capitalist media, not uniformity.

Capitalist Media: Working Class Audience

The audience for the mass media, however, does not consist primarily of capitalists, so any theory of the media has to do more than explain that capitalists argue among themselves, and that the media are one of the places where they wash their dirty linen. Only the most rabid media outlets, or perhaps those that have a private rather than a public mass circulation, actually acknowledge that they are speaking in the interests of one small section of the capitalist class, or even of the capitalist class as whole. Most media, even those like the *Financial Times* that acknowledge that real live capitalists are a central part of their audience, make the implicit claim to be speaking to and for "society" as a whole. Despite being the property of capitalists in particular, the content of the media addresses issues that are matters of concern for capitalism in general. A good example is the invasion of Iraq. This was undoubtedly in the direct interests of sections of capital: arms manufacturers, oil companies, construction companies with an eye on reconstruction contracts, and a host of other bourgeois vultures saw easy profits in military conflict. Other capitalists had no direct interest in the conflict, or stood to lose out if state spending was directed away from the commodities that they produce. This, however, was not the overt substance of the debate about war in mass media. On the surface at least, what the papers and broadcasting discussed was foreign policy, the national interest, the moral issues at stake, weapons of mass destruction, and whatnot. The debate was framed in terms of the needs of society as whole. What is more, the way they handled debates was different from one outlet to the next, and some of them at least were prepared to give space to antiwar views.

In order to understand this, we have to look in more detail at the ways in which different media operate. All the media we are considering are large-scale enterprises that are locked in to the central structures of capitalism and its state, but there are important differences in their structures. Some

media are dependent directly upon the market, while others, mostly in broad-casting, are funded by indirect means like taxation. Again, while some media are owned by individual capitalists, others are owned by public corporations, and some, again mostly in broadcasting, are in the end owned by the state. The structures of markets vary: some media operate in what are effectively monopoly circumstances, while others face very sharp competition.

In most developed countries today, newspapers operate as pretty straight-forward capitalist enterprises. The workings of the market are restricted in a number of ways, notably by subsidies, which are more widespread than is sometimes acknowledged: the British newspaper press, for example, enjoys exemption from the 17.5 percent valued-added tax (VAT) levied on most com-modities. Elsewhere, and notably in the Nordic countries, the subsidy system is more selective. In the Swedish case, for example, there has since the 1970s been in place a system designed to support weaker newspapers and to pro-mote diversity of ownership (Gustafsson & Hadenius, 1976).

Broadcasting, and television in particular, is often organized rather dif-ferently: the example of the BBC in the UK, which depends overwhelm-ingly on a tax for its revenues, and which is (indirectly) owned by the state, is the obvious example. Here ensuring the continuation of the "subsidy" from the state is the central economic reality governing the organization. Different media have different kinds of dynamics, and these are reflected in the ways in which they operate. They therefore need to be treated, in important respects, rather differently.

What they all have in common, however, is that they depend on reach-ing a wide audience, and in a capitalist society that means that, apart from a tiny number of very highly priced newsletters, they are obliged to address people who are not capitalists. This is true even of media like the *Financial Times* and the *Economist*, which are read by a much wider layer of people than those who are actually owners of capital. Most media that attempt to reach a mass audience are obliged to address a working class audience, because that is the predominant class position in a developed capitalist society. Unless they reach this audience, they will fail as businesses. This is a very powerful reason why the mass media cannot simply reproduce the capitalists' own view of the world. At the very least, they have to pres-ent the capitalists' view of the world in a form that will be palatable to people whose entire life is spent in conditions of exploitation and oppres-sion that are the direct result of capitalism. One of the things that helps is

acknowledging and confronting the problems and worries that the audience faces. Allowing a certain amount of room to expressions of discontent or dissent thus makes good economic sense.

The Economics of Competitive Media

The fact that the mass media are primarily big businesses gives them many features in common with other large enterprises. This sector is marked by a strong tendency toward concentration of ownership. This is sometimes restricted by government legislation, but to the extent that the logic of capitalism is allowed to proceed it takes place, if anything, more rapidly in the media than it does elsewhere, since the same factors operate at least as powerfully in this branch of production as in any other. If you are producing newspapers, it makes good capitalist economic sense to own as many newspapers as possible. You will be buying paper and ink, and all of the other commodities that you need, in large quantities, and thus you will be able to negotiate bulk discounts that are not available to your smaller competitors. If you are producing a television program, it makes good capitalist economic sense to own the production studios and the distribution system, and to show the same thing to as many people as possible. If you are producing a cartoon film aimed at children, it makes good capitalist economic sense to use the characters you have spent so much on creating as the basis for toys, T-shirts, books, computer games, drinks, videos, rides in theme parks, and all manner of other merchandise. These processes are hardly mysteries: they are usually called vertical and horizontal integration, and they are the commonplace of the economics of capitalism. The overall effect is a very strong tendency toward the concentration and centralization of capitalism.

There are, however, several important aspects of the media business that set it aside from many other branches of industry. The first is that much of the media operate in two markets at the same time. One market is pretty obvious and straightforward: we pay directly for many of the media we consume. When we buy a newspaper, or pay a subscription to cable or satellite services, we purchase a commodity in exactly the same way as when we buy a packet of cigarettes or chocolate bar at the corner store.

A newspaper is different in a very important respect from the other things you find in the same shop. If you buy a Hershey bar and eat it, no

one else can eat it: consumption destroys the use value of the commodity. If you buy a newspaper and read it, someone else in your household can read it after you without any problem at all: consumption does not affect the use value of the commodity, or at least not to anything like the same extent. Even more oddly, if you are watching the TV news, it does not matter directly to you whether anyone else is watching it, and it costs the TV company just as much to produce and broadcast the news whether you watch it or not. But in order to produce any newspaper or news program, it is necessary to make a very substantial investment. In the case of both, you need journalists and editors and other technical personnel, together with their equipment, in order simply to gather and produce the "news." In the case of a newspaper, you need paper, ink, presses, highly skilled printers, trucks and vans, and an efficient distribution staff. You need all of these things just to print and sell one copy of the paper. In the case of television, you need studios, cameras, editing suites, a myriad of technical and creative staff, telecommunications links, and transponders and all of their technical staff, just to get your program on the air, no matter how large the audience is. In other words, you have to make a huge investment in capital and labor that remains constant irrespective of the size of the audience. What are sometimes called the "first copy costs" are high in all of the mass media.

The cost of acquiring an additional reader or viewer, however, is very small indeed. The same news has to be gathered to sell one hundred or one million copies. To produce the second and each subsequent copy of a newspaper, you need a tiny bit more paper and ink and human labor. To reach additional viewers you need to have a network of transmitters and to use slightly more power, and a few more technical staff. The marginal cost of producing an additional copy of a newspaper, or providing a signal to another viewer, is very low. It therefore makes sense to design a product that sells as widely as possible, and if this was all there was to the business then things would be very simple indeed.

There is, however, a second market operating that has a different dynamic. In developed capitalist economies, one of the main ways that media raise revenue is through the sale of advertising space, or to put it another way, they sell the audience to the advertisers. When we watch a commercial free-to-air television program, we are part of a mass audience that the TV companies involved sell to Proctor and Gamble, or whomever. For many of the media—most local newspapers, UK national quality

papers, free-to-air commercial TV—the second source of revenue is very much more important than the first. It is estimated, for example, that in the United States advertising revenues made up between 80 and 85 percent of the revenues of newspapers in the decade to 2000 (Picard & Brody, 1997, pp. 26–30; Picard, 2004, p. 113). The consequences of operating in this "dual product market," although not unique to the mass media, have very important consequences for what sorts of things get produced. Depending upon the sort of market for which a product is designed, it will have very distinctive characteristics. In some cases, the desire to raise advertising revenue simply complements the audience-maximizing logic of subscription revenue. In others, however, it operates directly contrary to it.

The most obvious example of the way in which the pursuit of advertising revenue influences the nature of the media is the UK national daily press market (Sparks, 1999). This is divided into three sectors that are clearly distinct in terms of their news values, their physical size, their visual appeal, and so on. The five broadsheet newspapers are clearly differentiated from the five tabloids, and there is a clear difference, albeit a rather smaller one, between the two midmarket tabloids and the three red-top tabloids. These differences can easily be explained in terms of the economics of the press. First of all, this is a saturated market, which has been declining overall, admittedly rather slowly, for around the last fifty years. It is also one that is dominated by a small number of large companies, led by News International, which has more than 30 percent of national daily newspaper circulation. This is the sort of market that experiences what is known as "oligopolistic competition," which characteristically takes the form of product differentiation rather than outright price cutting.

In these conditions, it is not always the case that a company that owns a newspaper wants to maximize its audience. Whatever it may say in the Constitution, so far as advertisers are concerned all men are very definitely not created equal. Some advertisers, supermarkets or the manufacturers of soap powder, for example, are indeed interested in reaching the largest possible audience, and they will tend to advertise in media that provide the maximum reach—say, television and the popular press. Even the unemployed need to eat and wash their clothes, so they form a potential market for the advertised products. Other advertisers, those producing luxury cars, for example, are interested in reaching the relatively small number of people who are rich enough to buy their products. They have little or no

interest in reaching the unemployed, who certainly can't afford a brand-new Mercedes. The companies that own newspapers target different kinds of readers in order to sell their attention to different advertisers.

Quality papers have editorial content designed not to attract as many readers as possible, but to attract particular kinds of readers. The popular papers, on the other hand, have editorial content designed to attract large numbers of readers, which in practice means working class readers.

The attempt to reach specific kinds of readers and, with the development of multichannel television, viewers means that media products are highly differentiated according to what is known about the tastes and values of their target audiences. The content of *Loaded* is aimed at adolescent males, that of *Cosmopolitan* at rather more sophisticated adolescent and young adult females, and so on. Among the factors that differentiate media products is politics. The owners of different media properties know something about the political tastes and preferences of their target readers, and they produce news and commentary designed to be attractive to them. They tailor their coverage of politics in the same way as that of sport, or holidays, or personal finance, in order to attract and hold particular kinds of readers. There is a market for views that are critical of government policy, and even for views that are critical of capitalism. This is one very powerful reason why it is economically rational for media that are driven by the market to allow space to voices that are themselves very critical of the market. In a competitive market, as in the UK national press, it makes sense for newspapers to adopt partisan political positions in order to attract and win special groups of readers.

Monopoly Media

The other main situation confronting mass media in a capitalist society is when they have a degree of independence from market competition. This is the case today for the overwhelming majority of the U.S. newspaper industry. There are hardly any cities in the United States in which there is genuine competition between two different newspapers. It is also, historically, the position that British broadcasters enjoyed, since they did not compete for revenue up to the 1990s, and even today such competition is limited. In neither U.S. newspapers nor British television is competition the central driving reality of the media, as it is in the case of the British national press.

In these circumstances, a different logic prevails: the aim is to gain a general, as opposed to a niche, audience. A newspaper in a monopoly, or near monopoly, position will be interested in attracting the maximum number of wealthy customers, since they are the ones who are most attractive to advertisers. It will thus produce material that is attractive to elite groups within its market (in the jargon, it will tend to superserve the elite audience). But if this elite group is divided among itself, as it normally is in a capitalist society because of the conflicts built into the system, then it is sensible not to alienate any section of the elite. You want to produce a product that is attractive to as many elite groups as possible and that they feel addresses their concerns and reflects their values. Consequently, it makes sense to produce journalism that allows more or less equal representation to all sections of the elite audience: you quote the Democratic senator but you also quote the Republican representative. It is for this reason that the U.S. press is so different from the British, and more generally the European, press. Both are capitalist, but the British press is habitually partisan because it is aimed at a fraction of the total audience, while the U.S. press is impartial (between different groups of capitalists) because it is aimed at the whole of the (capitalist) elite. Where the capitalist class are united, against workers or foreign enemies, however, the monopoly press is just as partisan as its competitive cousin. The monopoly press comes closer to being partisan on behalf of the whole ruling class, while the competitive press is partisan on behalf of one section of the ruling class.

Broadcasting represents a slightly different version of the same situation. Up until the present, the big terrestrial broadcasters are essentially addressing mass audiences, so the room for market segmentation is much smaller. Cutting across this, however, is the fact that broadcasting is everywhere much more tightly under state control (either through ownership or regulation) than are newspapers. This control takes a number of different forms. In Europe, as opposed to the United States, control has often meant direct or indirect ownership by the state. This has ensured that political considerations have been much more important in determining the political alignment of broadcasters than have simple market factors.

There have been three main options adopted by the executive committee of the ruling class. The first is to use the media as the outright tool of government. This was the option favored by De Gaulle in France, and it continues to have a very considerable appeal to politicians in the former communist countries of central and eastern Europe (Kuhn, 1995). The second is

to partition broadcasting among the main political forces in society. Thus, up to the 1990s, the Italian state broadcaster had three TV channels: RAI Uno, controlled by the Christian Democrats; RAI Due, run by the Socialists; and RAI Tre, which was in practice the fief of the Communist Party (Padovani, 2005). The third version, adopted in the UK and a number of other northern European countries, involved finding ways of obliging the broadcaster to reflect the main currents of opinion within bourgeois politics.

In the former two cases, the broadcasters are partisan and known to be partisan, and these solutions correspond to situations in which the bourgeoisie, although obliged to operate in at least partly democratic conditions, are united in their opposition to a party that they believe, rightly or wrongly, represents a fundamental threat to their class interests. Historically, in both France and in Italy, that party was the orthodox Communist Party, which in both cases was a mass organization with a real prospect of power. The capitalist class finds the third option acceptable and appropriate when it believes, quite rightly, that forces like the Labour Party in the UK are no real threat to its interests. The situation with the BBC and similar broadcasters is therefore much more like that of the monopoly U.S. newspapers: it reflects a variety opinion, but that variety is contained within the narrow consensus of politicians who accept capitalism.

In the case of the BBC, this is a formal requirement written into the agreement with the government that grants it the permission to broadcast (Agreement, 1996, section 3.2c). The legal requirement reflects only the structural reality of the BBC's position. In a bourgeois democracy, it is normal and natural for the main broadcasting institution to reflect the spectrum of bourgeois opinion. To defy the government is to court disaster, but to exclude the main opposition parties is only to store up trouble for the future, when they in turn might be the government, with their hand on the purse strings. The BBC does, obviously and genuinely, attempt to balance between government and opposition, not because its leading journalists are nice fair people who like to allow both sides a fair hearing, but because to do otherwise is to endanger the whole basis of the organization. In its *Guidelines* on the war in Afghanistan, for example, the BBC says that "Enabling the national debate remains a vital task: the concept of impartiality still applies....We must reflect any significant opposition in the UK (and elsewhere) to the military conflict and allow their arguments to be heard and tested" (BBC Afghanistan, 2001).

Of course, such a situation is not without problems. The institutional necessity to balance among bourgeois parties is interpreted and implemented by people who sometimes take it much too seriously. There is a continual danger that the staff will take talk about balance, fairness, and impartiality at face value and try to reflect the real range of opinion. The war in Ireland has been the most outstanding example of this, where there have been a series of well-recorded struggles between journalists and others who thought that balance meant giving Republicans a chance to state their case, and those who understood the limits to fairness (Curtis, 1984; Miller, 1994). The invasion and occupation of Iraq provided a more recent and spectacular example, to which we will return below.

Overall, then, despite the differences among the situations of the various media in the distinct ways they are owned and the markets in which they operate, it is very much in the interests of their owners, and in the interests of bourgeois politics, for the mass media to reflect a diversity of opinions, even including some that are at least mildly critical of capitalism. When the ruling class is split, as it very often is, to a greater or lesser extent, all factions want to make sure that their ideas get a hearing. In the case of those media that are dependent upon the marketplace, there are powerful forces that make them ready to allow diverse, and even dissident, voices a hearing. In the case of those that are much more directly dependent upon political favor, the norms of bourgeois democracy imply that they permit the main forces proportional hearing.

Who Produces the Media?

If all of this is quite easy to understand, but it begs the question of how it happens. We cannot explain everything through ownership or the operations of the market. We need also to look at who actually takes the daily decisions and produces the programs and material. Big media necessarily employ hundreds, if not thousands, of people. They are characterized by a high degree of both social and technical division of labor. Like all other large organizations in a capitalist society, the media are characterized by hierarchy. Those at the top decide policy and give orders, while those further down are supposed to carry out what has been decided by their bosses. If they have any worries or doubts about exactly what they should do, they

are expected to, in a phrase beloved of BBC policy documents, "refer up" for a decision. The BBC helpfully publishes a long list of situations in which such referrals are mandatory (Mandatory Referrals, 2005).

Although power ultimately lies with the owners, for day-to-day running of such large organizations they habitually employ salaried managers, who have a great deal of operational power, provided they produce the audiences and the profits for which they are hired. These senior managers, and their immediate subordinates, are very closely tied to the capitalist class, and they may well have some access to capital themselves. On the other hand, there are those employed by the organization who are undoubtedly proletarian in the most direct and obvious sense. Printers in newspapers, for example, or set builders in television companies, are without question manual proletarians of the kind that would have been immediately recognizable to Karl Marx himself. Between the two extremes, there are any number of different groups and individuals who have a wide range of relationships to the means of production.

One example of the contradictory way in which people fit into property relations is the "independent producer" working for one of the main broadcasters. There are big independent production companies like Endemol or Hat Trick, which are properly capitalist enterprises in their own right. On the other hand, there are large numbers of people who have a tiny production company of their own, which is often little more than letterheaded notepaper, and who scrabble around to get a contract to produce the occasional program. If they get a commission, then they will hire other people to work on it, sometimes as workers and sometimes as subcontractors. If they don't get a commission, they will make a living by working on other people's commissions, or perhaps outside of the industry all together. Sometimes these people are small capitalists, sometimes they are independent artisans, and sometimes they are wageworkers.

There are similar complexities within groups that appear to be all doing the same sort of thing. Journalists are a good example. The vast majority of journalists, certainly those working on local papers and on most magazines, are rather poorly paid wageworkers. At best, their status and income is about the same as those of schoolteachers, and we would regard them as white-collar workers. On the other hand, journalists on big daily newspapers are very much better paid. But even these elite journalists are divided. On the one hand are those journalists undertaking routine tasks whose

pace and content is determined by others, notably the "subs" (desk editors) who actually produce the paper, but also many of the more junior writers. On the other are the senior staff, including particularly the most prominent writers, who will be much better paid, have many other opportunities for earning more through various kinds of freelance employment, and who play a significant role in determining the editorial line of a newspaper.

Media organizations thus contain within themselves diverging interests and the potential of serious class conflict both over pay and conditions and over much wider issues such as editorial content. In extreme cases, notably social revolutions, the class differences inside media organizations come to the fore. In Portugal in 1974, for example, some of the bitterest struggles were over the editorial direction of newspapers and broadcasters, where the senior staff were lined up with the counterrevolution while the majority of the production staff supported the left (Downing, 2001, pp. 237–65). In more or less stable bourgeois democracies, however, the hierarchy is a powerful mechanism of control. In particular, the possibility of very substantial financial rewards for those who are professionally successful acts as a strong incentive on journalists and other creative staff to toe the management line.

From the point of view of determining the editorial line of a newspaper, the content of a new bulletin, or the overall strategies of a television station, matters are rather more complex than they were in the days before the division of labor. Of course it is true that owners exert a fundamental influence on the direction of their media: they can do what they like with their personal property. Some owners clearly use this power on a regular and day-to-day basis. Rupert Murdoch, who intervenes regularly in the editorial direction of the *Sun*, is probably the best-known contemporary example of this type. Others are more relaxed and less involved in the day-to-day operations, as with the non-Murdoch broadcasters in the United States. But the views of owners are not formed in a vacuum. These people mix regularly with other capitalists and their higher servants, at business conferences and social events and in their personal lives. They partly help to form the common sense of the capitalist class, and partly come to reflect it. Their formal and informal contacts and discussions help them define what issues are important and what should be ignored as much as possible. So the line of a newspaper is not usually the simple reflection of the eccentric views of an individual. To the extent that a proprietor determines the editorial line of a newspaper or TV station, he or she is speaking as a member of a class as well as as an individual.

Of course, there have historically been many cases in which owners have been barking mad and their articulation of the interests of their class has been eccentric in the extreme. The press proprietor Robert Maxwell is a well-known recent case, but the Canadian-British press baron Lord Beaverbrook, who owned the *Daily Express* in the days when it was the best-selling British newspaper, was also a case in point. He often launched campaigns, including some very eccentric ones, but there was a connecting thread of extremely robust imperialism running through everything Beaverbrook did. He may have spoken eccentrically, but his guiding idea was one that was common to the vast majority of the capitalist class of his day: he stood for the British empire, and so did they. The fact that capitalists are social beings and thus do not form their views in a vacuum applies even more strongly to those large media organizations that are not owned by a single individual or family. The large-circulation popular paper the *Daily Mirror* is a good example. It is owned by a publicly traded corporation, Trinity Mirror, that is not the personal property of its chairman, Sir Victor Blank, or of chief executive Sly Bailey.

Even the most determined proprietor, whether individual or corporate, has to operate through other people. Bailey does not edit the *Daily Mirror*; she relies on a handpicked editor to do that job. (Editors, incidentally, usually fervently deny any proprietorial influence so long as they are in post, only to spill the beans in a pretty dramatic fashion once they have been fired.) The owners of media corporations do not necessarily agree with every last decision taken by the people they appoint to produce the content of their outlets. Indeed, they can sometimes be very critical of such decisions. A notable recent case was when Michael Green, the chairman of the TV company Carlton, expressed outrage at a documentary on Palestine directed by the Australian radical journalist John Pilger (Symons, 2002). Green, however, does not demand of his senior staff that they produce only programs of which he personally approves. Even in his rage, he knows that the important issue is not his personal politics but the need to win an audience, and that his employees are better qualified to make judgments about that than he is.

Editors are not usually members of the capitalist class, merely its very highly paid servants. But they, too, do not form their views as individuals but as social beings, who meet regularly, both formally and informally, with real live capitalists, not to mention senior civil servants, lawyers and judges, military officers, politicians, and other very senior journalists. They are less likely to display signs of incipient lunacy or criminality than proprietors,

since they can be disposed of very simply by firing if they show any signs of deviance. They are much more likely than eccentric proprietors to give a faithful rendering of the views of the circles they move in, and they often move among different roles in the upper reaches of the governing elite. William Rees Mogg was a good example of this: not only did he edit the London *Times* (in which capacity he published an editorial welcoming the Pinochet coup in Chile), but he sat on a vast range of public bodies, including a stint as the deputy chair of the board of governors of the BBC.

The same is true of the senior journalists who produce the key opinion-forming pieces and who set the "common sense" of the newspaper. They all have very close contacts with the people who run the country: these people, after all, are the sources of much of their material. Confident journalists working for elite outlets will often brag of this in their work. If one listens to the reporting of Andrew Marr, BBC political editor and identikit respectable senior journo, one will hear him constantly refer to what "senior ministers" have told him. So too Philip Stephens, political columnist for the *Financial Times* and Blairite flak, whose writing is full of explicit references to his close and frequent relations with the people who run the UK. While the rhetorical conventions of popular newspaper journalism forbid that sort of boasting, the fact is that the political editors of newspapers like the *Sun* and the *Daily Mail* will normally enjoy just as good relations with the political elite as do those of the posh papers, and sometimes even better. The same is true for other prominent journalists in any bourgeois democracy: it is a condition of them doing their jobs well that they spend as much time hobnobbing with the people who run their neck of the woods as they possibly can, since that is one of the best and easiest ways for them to get the sort of material that can be used to produce a story.

For their part, politicians and officials are keen to court editors and senior journalists because they see them as important in presenting and interpreting their policies to a wide audience. One good recent example of this was when, on the day she was appointed, the new editor of the *Sun*, Rebekkah Wade, was rung up, in succession, by Tony Blair, Gordon Brown, and David Blunkett, each of them eager to establish good relations with this powerful figure. As one journalist put it, "The speedy reaction of the prime minister, chancellor of the exchequer (Finance Minister) and home secretary (Interior Minister) reflects how much the Labour party has come to depend on the mass-market tabloid" (Burt, 2003, p. 11).

The editors and senior journalists are the crucial group in understanding how the mass media relate to the capitalist order. They mix frequently with actual capitalists and their other higher servants, and they are rewarded in the same sort of way. Indeed, very often they are themselves the sons and daughters of the ruling class and its higher servants, with the standard badges of rank acquired at private schools and elite universities. They are therefore very well positioned to act as sounding boards for the capitalist class as a whole, since they share many of its ideas and beliefs. They are by profession a section of the organic intellectuals of the ruling class. They are supposed to take the half-articulate needs and desires of the ruling class and translate them into a form that can be published to society.

But their position is a contradictory one. They are interested in reaching an audience. This audience, however, is very far from being homogenous. While the vast majority of it is, of necessity, working class, a significant proportion is not, being either capitalists or petit bourgeois. As we saw, not all of this audience is of equal interest to newspaper or other media because the media depend in large part on advertising to make their money. The ways in which they articulate the views of the ruling class are thus shaped to fit the particular audiences that they are addressing. If the research they so expensively commission tells them that a significant section of their readership has views that are critical of the existing order, then they are obliged to engage with those views. The capitalist media certainly put forward various views held within the ruling class, but they put them forward in such a way as to try to persuade their intended audience.

There are, however, very severe limits to the degree of freedom enjoyed even by the most senior media employees. If they step out of line, they can always be dismissed. Two recent British cases, one in the private sector, one in the public, illustrate this very clearly. Both involve the invasion of Iraq, which while supported by the government was opposed by the majority of the population.

The *Daily Mirror*, under its editor, Piers Morgan, took a very public anti-war, indeed increasingly anti-Labour, stand, and this was tolerated for over a year; but in May 2004, allegedly under pressure from shareholders, Morgan was forced out. The incident that provoked it was the *Mirror*'s publication of photographs showing British soldiers abusing Iraqi prisoners, which seem to have been forgeries. Morgan refused to apologize, on the grounds that while the pictures might have been fakes, incidents of abuse and torture were

certainly only too real. The board of Trinity Mirror then sacked him (Trihorn & O'Carroll, 2004).

The public-sector incident was more spectacular, since it involved the forced resignations of both the chairman of the board of governors of the BBC, Gavin Davies, and the director-general (chief executive officer in corporate terms), Greg Dyke. Both of these men were longtime supporters of Tony Blair, and their appointments had occasioned some criticisms of political interference. Neither was an opponent of the invasion, and Dyke wrote later that he was a marginal supporter of the decision. As director-general, however, he later wrote in his autobiography, "Our job was to report the events leading up to the war, and the war itself, as fairly as we could. It was certainly not the job of the BBC to be the Government's propaganda machine" (Dyke, 2005, pp. 251–52). Whether or not the BBC actually carried out this ringing statement of public-service journalism is a matter of debate, but it is certainly the case that the BBC gave some space to critics of the invasion and occupation, and that this infuriated the government. After a long struggle between the government and the BBC, the details of which need not detain us here, Davies and Dyke were forced out in January 2004, over a minor incident of disputed reporting.

The obvious lesson of these two stories is that while the nature and structure of the mass media in a bourgeois democracy do allow some degree of autonomy, particularly to senior figures, editors and journalists can always be sacked and replaced by more pliable figures when their activities are perceived to threaten the interests of the owners or the government. In the grand scheme of things, the invasion of Iraq, for all its political ramifications, has not yet produced a moment in which there has been a serious systemic threat to capitalism, but even this relatively minor crisis provided a vivid illustration of both the freedoms and the limits of bourgeois democracy.

Audience Responses

There are two contradictory views of the influence of the capitalist media. One is expressed in the common saying "You can't always believe what you read in the papers," which is reflected in public opinion surveys where journalists vie with politicians for bottom place in tables of trustworthiness (Worcester, 1994, p. 36). This view articulates a healthy popular skepticism

of official discourses and a readiness to interpret the media according to the experiences of the audience, and it is the agreed orthodoxy of academic media studies, in both its positivist and critical variants. The other view was expressed in the famous headline after the 1992 general election "It's the *Sun* wot won it" (Linton, 1995). According to this interpretation, the audience is indeed influenced by the content of the media, and that there- fore anyone who seeks political office needs to be on the right side of the media. This view, of course, is the accepted orthodoxy of all bourgeois politicians, and most notoriously of New Labour.

Both views rest on a partial truth. There is a mass of evidence that bears out common sense. People form their views of the world in complex ways. The mass media is one source of information and opinion, but there are many others, including family, workmates, education background, read- ing, and personal history. In particular, the media have to compete with personal experience. When the media are more or less the only source of information about some event or issue, they have a much better chance of defining the way that people think than when they are addressing some- thing about which people have other sources of information, most notably personal experience. A classic example of this was during the great UK miners' strike of the 1980s, when the ruling class was united in its desire to defeat the strike and the media overwhelmingly attacked the miners (Jones et al., n.d.). Studies of public opinion, for example about the role of the police, showed that there was a very sharp division in the country. People who lived in mining areas, which were more or less under paramilitary occupation by the police for nearly twelve months, tended to view the min- ers as victims of an assault by the state. People living outside mining areas tended to see the miners as aggressive and violent, and likely to attack the police. The difference in attitude, of course, was the result of the fact that the propaganda war was effective where people had no direct experience of the realities of the strike, but was completely ineffective where they did.

Media Power and Class Adjustment

It is hardly surprising that the mass media in a bourgeois democracy reflect a variety of different viewpoints. In doing so, they reflect the diversity of opin- ion within the capitalist class, and they shape their contents to meet what

they think are the needs and interests of their target audiences. When the capitalist class is divided, as it usually is about inessential matters, the media will reflect those divisions. When it is united, for example against a major strike, then the media will tend to speak with one voice. The media is able to reflect these differences so directly and subtly because the people who take decisions about what to print or broadcast are socially quite closely integrated with the ruling class and its upper servants. The media, however, are primarily businesses, so in the majority of cases they do not present the views of the capitalist class for the capitalists themselves but for their mass audience, which normally contains a very substantial number of wageworkers.

In order to do this, however, the media employ people who are neither capitalists nor closely tied to the capitalist class. Just like any other group of workers, the printers, camera operators, journalists, and producers who make the media have a variety of views, ranging from enthusiastic acceptance of capitalism through to outright rejection of the whole system. In "normal times," when the rule of the bourgeoisie is unchallenged, these personal views are not of central concern to the owners of the media. No doubt they prefer their employees to love them, but the hierarchical division of labor means that workers either follow orders or get fired.

In abnormal times, when the ruling class is challenged, things are very different. It is a characteristic of revolutionary crises that the ruling class, while desperate to remain in control, is deeply divided among itself over how to go forward. At the same time, their control over newspapers and broadcasting outlets is challenged from below in just the same way as it is in other factories and offices. At that point, the fact that it is wageworkers that produce the media becomes of central importance.

References

Agreement. (1996). *The BBC agreement: Programme content.* Retrieved August 29, 2005, from http://www.bbc.co.uk/info/policies/charter/pdf/agreement.pdf.

BBC Afghanistan. (2001). *War in Afghanistan: Editorial guidelines.* Retrieved August 20, 2005, from http://www.bbc.co.uk/guidelines/editorialguidelines/assets/meetings/war_guidelines_october02.doc.

Burt, T. (2003, January 18–19). A riches from rags story of a Murdoch cheerleader. *Financial Times*, p. 11.

Curtis, L. (1984). *Ireland: The propaganda war*. London: Pluto.

Downing, J. (2001). *Radical media: Rebellious communication and social movements*. Thousand Oaks, CA: Sage.

Dyke, G. (2005). *Inside story*. London: Harper Perennial.

Gustafsson, E., & Hadenius, S. (1976). *Swedish press policy*. Stockholm: Swedish Institute.

Herman, E., & Chomsky, N. (1988). Manufacturing consent: The political economy of the mass media. New York: Pantheon.

Jones, D., Petley, J., Power, M., & Wood, L. (N.d.). *Media hits the pits: The media and the coal dispute*. London: Campaign for Press and Broadcasting Freedom.

Koss, S. (1990). *The rise and fall of the political press in Britain*. London: Fontana.

Kuhn, R. (1995). *The media in France*. London: Routledge.

Lee, A. (1976). *The origins of the popular press, 1855–1914*. London: Croom Helm.

Linton, M. (1995). *Was it the Sun wot won it? Seventh Guardian Lecture, Nuffield College Oxford*. Oxford: Oxuniprint.

Mandatory Referrals. (2005). *BBC editorial guidelines: Mandatory referrals*. Retrieved August 29, 2005, from http://www.bbc.co.uk/guidelines/editorialguidelines/referrals/.

Miller, D. (1994). *Don't mention the war: Northern Ireland, propaganda, and the media*. London: Pluto.

Padovani, C. (2005). *A fatal attraction: Public television and politics in Italy*. Lanham, MD: Rowman and Littlefield.

Picard, R. (2004). The economics of the daily newspaper industry. In A. Alexander, J. Owens, R. Carveth, C. Hollifield, & A. Greco (Eds.), *Media economics: Theory and practice*, 3rd ed. (pp. 109–25). Mahwah, NJ: Lawrence Erlbaum.

Picard, R., & Brody, J. (1997). *The newspaper publishing industry*. Needham Heights, MA: Allyn & Bacon.

Sparks, C. (1999). The press. In J. Stokes & A. Reading (Eds.), *The media in Britain: Current debates and developments* (pp. 41–60). Basingstoke, Hants: Macmillan Press.

Symons, L. (2002, September 20). Carlton chief slams Pilger's attack on Israel. *Media Guardian*. Retrieved August 29, 2005, from http://media.guardian.co.uk/presspublishing/story/0,7495,795756,00.html.

Trihorn, C., & O'Carroll, L. (2004, May 14). Morgan sacked from *Daily Mirror*. *Media Guardian*. Retrieved August 29, 2005, from http://media.guardian.co.uk/presspublishing/story/0,7495,1217192,00.html.

Worcester, R. (1994, February). Demographics and values: What the British public read and what they think about their newspapers. Presentation. "End of Fleet Street" conference, City University Graduate Centre of Journalism, London.

·LOST IN TRANSLATION: THE DISTORTION OF *EGEMONIA*·

Fabiana Woodfin

In the brief history of its existence, Gramsci's theory of hegemony has run the gamut from praise to pillory. After its "discovery" as a theory of domination and revolution that had been tucked away in the depths of fascist Italy, *egemonia* underwent a process of "translation" that made it available for the first time to a broad international audience. Its translation into the English language, however, is of particular importance for the future of critical studies, since the translation and subsequent adoption of hegemony theory by inquiries into culture and communication also constitute a history of distortion, cooptation, and—in more extreme cases—betrayal of the Marxist project of radical social change that hegemony theory originally espoused. This chapter offers a history of distortion through illustrations of attempts to sanitize and de-Marxify hegemony theory, particularly through the theory's reception in American communication studies as part of English-language renditions of "cultural studies." Hegemony theory is the pièce de résistance of Gramsci's *Prison Notebooks*. In essence, it describes the process whereby one social group achieves and maintains power over subordinate

groups primarily through the latter's consent, secured through ideological processes rather than through direct coercion. Gramsci's theory of hegemony was meant to problematize and expand on Marx's view of ideology as "the ideas of the ruling class" (Marx, 1978b, p. 172) by explaining how it is that subordinate classes consent to practices and views that go against their own interests and perpetuate their subordination. Hence, Gramsci defined hegemony as "the 'spontaneous' consent given by the great masses of the population to the general direction imposed on social life by the dominant fundamental group; this consent is 'historically' caused by the prestige (and consequent confidence) which the dominant group enjoys because of its position and function in the world of production" (Gramsci, 1971, p. 12). Conversely, domination as direct force is "the apparatus of state coercive power which 'legally' enforces discipline on those groups who do not 'consent' either actively or passively. This apparatus is, however, constituted for the whole of society in anticipation of moments of crisis of command and direction when spontaneous consent has failed" (p. 12). Throughout the *Notebooks*, Gramsci often uses the term *direzione* (direction, leadership) as a substitute for *hegemony* to further distance it from notions of coercion and to further identify hegemony with the construction and organization of consent.

The true strength of hegemony theory lies in its more sophisticated understanding of the organization of domination by explaining how domination, particularly in highly developed capitalist societies, takes more subtle, yet powerful forms, often under the guise of intellectual and moral "leadership." As the concept has morphed in the context of British and then American cultural studies, however, it is hardly recognizable or valuable for understanding or overcoming domination and hence problematic for use in critical theory in general.

In order to trace the distortion of hegemony theory, a clarification of the roots of *egemonia* is required. This is not an attempt to recapture some "pure," original version of the theory, but to understand the evolution of the theory as a series of political choices of adaptation made by some of its chief proponents. As Peter Ives (2004) points out, "struggles over the origins of 'hegemony' are more fundamentally struggles over what 'hegemony' means, how we use it, and what we can accomplish using it in the future.... More telling than a concept's origins are its vicissitudes. These are ultimately questions of political theory and political strategy" (p. 18). Gramsci's social and political

thought was fundamentally rooted in historical linguistics, yet the extent to which Gramsci's interest in language shaped his philosophy remains severely undertheorized in the English-speaking world. Gramsci's concern with language has been largely ignored by Gramscian scholars. *Selections from the Prison Notebooks*, to date the most influential edition of Gramsci's prison notebooks in the English language, hardly contains any of his writings on the subject of language, which constituted a considerable portion of his prison writings and a theme that ran throughout.

Gramsci and Language

The roots of "hegemony" as an idea are to be found primarily in Gramsci's explorations of historical linguistics. Gramsci's life as a conscious Marxist can be said to have begun and ended with a passion for language. As a young university student, he proposed to write a thesis on historical linguistics— a project he abandoned only for his other passion: Marxist politics. The birth of the idea of hegemony from Gramsci's historical linguistics was traced by Franco Lo Piparo in his *Lingua intellettuali egemonia in Gramsci* (1979). Though Lo Piparo intended to shed light on the importance that language played for Gramsci's theoretical foundation and without which "even the central notion of 'hegemony' would not have emerged the same and, perhaps, would not even have formed" (De Mauro, 1979, p. v) (translation from Italian by the author), his work remains untranslated and largely unknown a quarter of a century later.

When young Gramsci arrived at the University of Turin in 1911 to undertake a program of study in historical linguistics, he entered the scene of one of the most acrimonious debates in the history of linguistics. Two linguistic schools of thought, the neogrammarian and the neolinguist, were engaged in a fierce battle over differing notions about how languages evolved.

The neogrammarians subscribed to a positivist linguistics that saw the study of language as a natural science meant to reveal fixed phonetic laws. Discounting any connection between language and other social aspects of human activity, they conceived of language as physiologically determined, doomed to a fossilized state by the anatomical configuration of its speakers. Language change was explained in terms of a physiological "imperfection" of the speakers rather than by their sociohistorical encounters.

From the neolinguist camp, Gramsci's professor and mentor, Matteo Bartoli, argued that linguistic change was instead attributable to the interactions of people speaking different languages, originating from different locations, and subscribing to different cultures. Bartoli's key contribution to neolinguistics was the concept of *fascino* (allure, prestige), with which he explained why one linguistic form could gain predominance over another. Most important, linguistic changes were not seen as arising through internal, spontaneous evolution (also known as parthenogenesis), as the neogrammarians believed, but through contact with other idioms and languages. How does one group truly conquer another? Bartoli asked his students. By armed coercion or by making itself received with *fascino*? Was the prestige of a dominant group's language truly inseparable from the prestige enjoyed by that group's culture, institutions, and worldview? It is those who "give things," Bartoli countered, who can also "give words" (Lo Piparo, 1979). Already at work in these early teachings was the seed of the idea of domination as an ideological process involving consent rather than armed coercion.

Bartoli and Gramsci owed much to the work of the nineteenth-century Italian linguist Graziadio Isaia Ascoli, whose seminal concept of *sostrato*, or substratum, would be instrumental in the development of Gramsci's theory of hegemony. *Sostrato* was a theory of "ethnic reaction," meant to explain the dynamics involved in one group's adoption of another group's language. Substratum was composed of two characteristics, or moments: "substratum language" was the native language of any group that adopted the language of another group; "substratum action" referred to the influence that the native language exercised upon the linguistic structure of the adopted language (Lo Piparo, 1979). With his theory of substratum, Ascoli had introduced two fundamental tenets of neolinguistics that would influence Gramsci greatly. First, linguistic phenomena develop in relation to social phenomena. Linguistic history is, in other words, the social, political, and cultural history of the speakers of a language. It is therefore not just languages that come into contact but also the cultures and institutions of which those languages are a vehicle. Second, linguistic contacts are never peaceful but are steeped in conflict. The history of a language is, like the political and cultural history of its speakers, a history of struggle. Yet, with substratum action, Ascoli seemed to suggest that even in language, domination is never complete, for substratum action does not suggest a total suppression or destruction of the subdued language. "The result of the conflict must be the formation of a composite

linguistic block (the new idiom) in which elements of the dominant language and elements of the dominated language come to influence each other reciprocally" (Lo Piparo, 1979).

Bartoli's *fascino* and Ascoli's *sostrato* would continue to form the backbone of the concept of hegemony that Gramsci worked out in his prison notebooks. For this reason, Lo Piparo correctly surmised some twenty-five years ago that any undertaking of Gramsci's theoretical work would greatly benefit by starting from the end of his work, from notebook 29, which is dedicated entirely to his thoughts on language. Because these writings were not made available in the English language until the 1985 publication of *Selections from Cultural Writings*, a good fourteen years after the arrival of the *Selections from the Prison Notebooks*, Gramsci's interests in language have been treated as peripheral to the general body of his political theory, rather than central to it. In a section titled "Language, Linguistics and Folklore," Gramsci investigated the tension between two kinds of "grammars"—"normative" and "immanent"—which are in dialectical opposition to one another. Normative grammar can best be understood as pressure from the top and as the prescription of a "standard" language, while immanent grammar is spontaneous, that which people speak without knowing it. Normative grammar is influenced by immanent grammar and to an extent includes certain aspects of various immanent grammars; but it is ultimately the more prestigious normative grammar that, through a process that is very political, is internalized by the speakers of the language. The transformation of multiple immanent grammars into a unitary whole was a metaphor for the incorporating process of hegemony. Most important, Gramsci believed that immanent and normative grammar could not be separated from each other. They are constituted in and of each other and form a larger, unitary whole.

That questions of language were for Gramsci inseparable from questions of cultural and political power cannot be overstressed. This connection gains greater clarity in the practice of translation, which was for Gramsci a highly political act. His belief lay in the very structure of the Italian language itself. In the transformation of a text from one language to another there are myriads of points where the translator is presented with a choice. This choice is evident in the very etymology of the word *translate*. In Italian, to translate, or *tradurre*, has the same Latin root, *tradir* (to hand over), as the words *tradition* and *betrayal*. In the Italian language there is still today a remarkable similarity between *traduzione* (translation), *tradizione* (tradition), and *tradimento*

(betrayal) (Ives, 2004). Thus, even within the etymological root of the word itself, *traduzione*, the conflictual nature of the process is revealed. In Italian, then, to "translate" a text means literally being presented with a choice either to stick as closely as possible to the original, and be loyal to "tradition," or to deviate from a literal translation in order to appeal to the audience, and hence to "betray" the original in some way. In contrast, this tension is all but absent from the English word, *translate*, which suggests instead an effortless lateral distribution (Ives, 2004).

That such a choice is political can better be understood by viewing linguistic translation, much as Gramsci did, as representative of social and political translation. Gramsci spoke, for instance, of "translating" the Russian Revolution into Italy and Europe. When Gramsci observed that the sociocultural conditions that had favored the Russian Revolution were unlike those of Western Europe, he was attempting to "translate" the different hegemonic makeups of the two societies, to understand and diagnose the possibilities for a communist revolution in the West. This becomes even more apparent when, in notebook 11, section 46, Gramsci (2001, p. 1468) translates Lenin as having said, "we have not been able to 'translate' our language into those of Europe." However, as Ives (2004) observes,

> Lenin did not actually employ the concept of translation to describe his dissatisfaction with the resolution passed by the Third Congress of the International in 1921, to which Gramsci alludes. Lenin actually wrote what is translated thus: "We have not learnt how to present our experience to foreigners." It is Gramsci who brings the concept of translation (*tradurre*) to Lenin's rather narrowly organizational comment.... "Translation" enables him to explain how the "presentation" of "our experience"—that of revolution—requires "translation" and not the mere transmission from one context to another. (p. 101)

Because the actual material conditions in the West presented a different political relationship between state and civil society, revolution would require a different theoretical understanding and strategic approach than it had in Russia. Revolution in the West had to be translated in a manner that took account of profound structural and superstructural differences between the two societies, rather than simply attempting a superficial transfer of isolated elements. Such an understanding of Gramsci's use of "translation" reveals a perennial choice that is a political choice of "restoration/revolution"

(Ives, 2004, p. 101), not only in the translation of languages but also in that of social formations, political processes, and historical epochs.

Gramsci and the Neo-Gramscians

Gramsci's discussions of "translation" will prove very useful for understanding the dynamics of his own translation into the English language and, more specifically, into British cultural studies, together with the ensuing political choices that such translations purveyed. As already noted, the first critical edition of Gramsci's prison notebooks to appear in English is the oft quoted *Selections from the Prison Notebooks,* published in 1971—the entire collection of the Gramsci's prison notebooks, in two volumes, did not appear in English until 1992 and 1996. The publication of the *Selections* was a landmark event for neo-Marxism, for even as it neglected the influence of language on Gramsci's thought, it brought to light other key elements of his philosophy.

One of the main themes that contributed to making Gramsci a success almost overnight with this audience was his aversion to the "determinism" and "economism" already permeating the orthodox Marxist camp of his day. The determinist position in Marxist philosophy reflected a largely positivist conception of society that saw historical change as governed by certain "natural" laws: capitalism contained specific contradictions, the "seeds of its own destruction," that, it was believed, would inevitably lead to its collapse. In order to triumph, socialism would hardly require political or cultural intervention. This conception of revolution did not require that human beings possess historical agency, encouraging a certain fatalism within socialist movements that functioned, according to Gramsci, much like the new opiate of the masses (Merrington, 1978). Within this deterministic framework, the economy assumed primacy to the point of virtual totality, dismissing the importance of the cultural and political activities of a society.

Recovering Marx and Engels's more materialist dialectic approach, Gramsci's philosophy of praxis opposed the economist's reductionist position: "The claim (presented as an essential postulate of historical materialism) that every fluctuation of politics and ideology can be presented and expounded as an immediate expression of the structure, must be contested in theory as primitive infantilism" (Gramsci, in Forgacs, 1988, p. 190). At a

time when the crisis of capitalism should have led to the triumph of social-ism, Germany and Italy had instead witnessed the rise of fascist govern-ments that, if anything, further institutionalized the support of a troubled capitalist economy. That this political turn had been possible was due, according to Gramsci, not merely to economic and political maneuvering, but also to cultural intervention. Mussolini and Hitler may have initially relied on the use of force and intimidation to gain power, but it was through cultural channels that they succeeded in subsequently maintaining such power. Ideological power thus became a central theme underlying Gramsci's analyses of language, culture, politics, law, and philosophy. What was imme-diately evident, then, even from the limits of the *Selections*, was that Gramsci's philosophy of praxis was his attempt to construct within Marxism a much-needed theory of the superstructures.

Gramsci's concept of hegemony served to tie culture to politics and the economy within his philosophy of praxis. While hegemony requires that the ruling group exercise economic dominance, this is not enough to maintain this group's superior position. Nor is direct coercion adequate to ensure its con-tinued ascendance. Even when a group has attained power it must continue to "lead" the subordinate groups such that its position appears natural, as the will of the people. For subordinate groups to support any social formation, their consent is crucial. This consent is organized through the superstructure, of which culture is a prominent component, and through the use of "pres-tige" and of "substratum action" in a dynamic process that foresees both com-promises and incorporation, often occurring simultaneously. Consequently, to see economy, as vulgar Marxism did, as the determiner of such processes would be to miss the point of hegemony entirely. The foregrounding of cul-ture is thus generally interpreted as Gramsci's chief deviation from classi-cal Marxism and his most important contribution to Western Marxism.

In developing his theory of the superstructures, Gramsci referred back to the early Marx of *The Eighteenth Brumaire* and the 1859 *Preface to A Contribution to the Critique of Political Economy*. Rather than seeing either base or super-structure as necessarily "determining" in the final instance, Gramsci preferred to think of hegemonic formations in terms of "historical blocs" where base and superstructure, just like his normative and immanent grammars, were perennially interlocked in dialectical relationship to one another. This conception, he argued, was "based on the necessary reciprocity between structure and superstructures, a reciprocity which is nothing other than the

real dialectical process" (Gramsci, 1985, p. 366). Gramsci's contribution, then, can be read as a necessary revision of "ideology" from the problematic view that ideology is produced solely by the ruling class and reflecting only its economic interests. That was the shape of the economic determinism Gramsci found so problematic and inaccurate because modern ruling classes promoted ideologies that incorporated the contributions and interests of working classes and other subordinate groups into a larger hegemonic common sense that advanced the leadership and domination of capitalism.

The various translations and interpretations in English that followed the 1971 *Selections* publication occurred in response to British Marxist "culturalists" grappling with the same issue of "determination." These translations can be roughly divided into two paradigmatic phases or tendencies, the first as a break *into* Marxism, the second as a break *away* from Marxism. Though each of these tendencies is characterized by an engagement with and problematization of the general issue of "determination," their representation here must of necessity be oversimplified. The purpose of this discussion is to outline the two major tendencies that have characterized such a trajectory, not to provide an exhaustive account of each stop along the way of the translation of *hegemony*. Furthermore, "translation" here is intended less in the literal sense of translating from one language to another (though this process certainly figures into the first phase) than in the broader, metaphorical sense. In this second sense, the theory of hegemony was continually reworked into a new model in order to serve the philosophical needs and political aims of its proponents, including those distancing themselves from Marxism.

The appearance of Gramsci's prison notebooks onto the British scene in the early 1970s seems hardly coincidental. Though the publication of the *Selections from the Prison Notebooks* was part of a broader importation of European texts being translated into the English language for the first time, most notably the works of Louis Althusser and other French poststructuralists, it must be stressed that the first importation of Gramsci into England was in no way random. Indeed, it could be seen as responding to the specific political needs of a British cultural studies emerging against the backdrop of a troubled New Left at a significant historical juncture.

The introduction of Gramsci into British cultural studies occurred in response to an attempt made by Raymond Williams to reclaim a Marxist tradition for cultural studies. In the grips of Cold War politics, this tradition had been all but appropriated by a defensive communist dogmatism from

whence Williams had labored to distance himself. "Williams could not hope to contest with reaction at all unless he dissociated himself from it," recalled E. P. Thompson (1961); "the follies of proletcult, the stridency and crude class reductionism which passed for Marxist criticism in some circles, the mixture of quantitative rhetoric and guilty casuism which accompanied apologetics for Zhdanovism—all these seemed to have corroded even the vocabulary of socialism" (p. 27). Williams nonetheless undertook the difficult task of defining an intellectual field without submitting to the polar ideologies of Cold War politics.

Eventually, he was to achieve a tentative compromise with the adoption of Gramsci. The official entry of hegemony theory into British cultural studies was declared by Williams in his "Base and Superstructure in Marxist Cultural Theory" (Williams, 1980), originally published in 1973. But in order to understand how it is that Gramsci was "translated" into this usage, some background knowledge on the theoretical dispute that occasioned his debut is necessary.

Twelve years prior, Thompson (1961) had issued a critique of Williams's new work, *The Long Revolution* (1961), a work that had been immediately hailed as an eminent text capable of providing a new direction for this emerging area of cultural inquiry. Williams's work was meant as a continuation of his previous *Culture and Society* (1958), which had set out to outline an adequate understanding of "culture" as "a whole way of life." This would remain the guiding definition in the field until *The Long Revolution*, where Williams countered the need to rework and expand his conception of culture from the analysis of the relation between intellectual and imaginative works to the traditions of their time: "Cultural history must be more than the sum of the particular histories, for it is with the relations between them, the particular forms of the whole organization, that it is especially concerned. I would then define the theory of culture as the study of *relationships between elements* in a whole way of life" (p. 46; emphasis mine). British society, contended Williams, was undergoing revolutionary changes that could not be explained solely by political and economic analyses but required analyses of cultural processes as well. Moreover, the process of this long revolution could not be understood so long as such analyses were treated as discrete areas of inquiry:

> we cannot understand the process of change in which we are involved if
> we limit ourselves to thinking of the democratic, industrial and cultural

revolutions as separate processes. Our whole way of life, from the shape of our communities to the organization and content of education, and from the structure of the family to the status of art and entertainment, is being profoundly affected by the progress and interaction of democracy and industry, and by the extension of communications. This deeper cultural revolution is a large part of our most significant living experience, and is being interpreted and indeed fought out, in very complex ways, in the world of art and ideas. It is when we try to correlate change of this kind with the changes covered by the disciplines of politics, economics and communications that we discover some of the most difficult but also some of the most human questions. (p. xii)

If for Williams the aim of cultural studies was "the study of relationships between elements in a whole way of life" (p. 46), then the aim of a theory of culture was to discover how such relations were organized within larger social formations. Hence, what Williams attempted, with *The Long Revolution*, was not to continue the literary-moral analysis of culture undertaken previously within the field, but to redefine British cultural studies by providing an anthropological theory of culture that sought to understand its position within the base-superstructure model.

Yet Thompson found Williams's methodology in *The Long Revolution* immediately objectionable, especially since it bore a direct relationship to the political intent of the field in general. Williams's admirable intention to redirect the field of cultural studies notwithstanding, Thompson contended that his attempt to develop a general theory of culture had nonetheless failed. The "Tradition" retraced by Williams came through a bit too polished, while the voices of dissent and indignation against the march of the gigantic process of industrialization had all but been purged from the account. In a blast of criticism that still resonates with the indignation Thompson must have felt, he charged Williams with being an apologist for the status quo, arguing that "men communicate affirmations as well as definitions, and in certain situations one may feel that indignation is a more appropriate response than discrimination" (p. 25). If one attempts to recount the history of a revolution, then "it is fair to suppose that it is a revolution *against* something (classes, institutions, people, ideas) as well as *for* something" (p. 25). But most prominently and problematically absent from Williams's chronicle was an accounting of revolution *by whom*.

What Thompson was essentially asking was this: If culture is "a whole way of life," *whose* way of life is it, *whose* traditions? Certainly, from

Williams's account, not those of the common people. In short, what Williams had neglected in his search for the Tradition was none other than the socialist tradition. Questions highly relevant to understanding the working class movement were never engaged. Williams's characters involved in this long revolution were "tricked up in their Sunday best," and his narrative of the bleakest moments in England's history somehow silent of the fact that "tens of thousands...[were] starved out of their 'whole way of life'...with millions starved out of theirs in Ireland" (Thompson, 1961, pp. 28–29). Yet "suffering," concludes Thompson, "is not just a wastage in the margin of growth: for those who suffer it is absolute" (p. 29). Thompson had just delivered the quintessential Marxist critique that was at the same time to serve as a challenge to Williams.

There does exist a tradition that accounts for this neglected history, he reminded Williams, and that is the Marxist tradition. What is more, Marx's theory of history, much like Williams's theory of culture, does not separate the realms of culture, politics, and economy, but sees them as inseparable elements of a whole. Thompson's critique took Williams to task on his definition of cultural studies: if it was to be "the study of the relationships between elements in a whole way of life," then it was, necessarily, a Marxist project.

This Marxist tradition was thus no less contested on the theoretical plain than in the public square, undermined as it has been by a history of vulgar determinations and facile reductionisms. But Thompson's question then remains, under many respects, still pressing today: "[I]s there a tradition there to which—despite all that has happened, all that must be revalued, and all the new evidence that must be taken in—we can return? Or must we start at the beginning again?" (p. 30). Within such a tradition, Thompson argued, it would be possible for cultural studies to define culture as an active process, "the process through which men make their history—that I am insisting upon" (p. 33). Culture thus emerges not as the tautology Williams had coined, culture as "a whole way of life," but, challenged Thompson, as "a whole way of struggle. And we are back with Marx" (p. 33).

Williams's response to Thompson's challenge was twelve years in coming, but when it appeared it demonstrated all the courage and spirit of self-renewal required to point cultural studies into a new, more fruitful direction. Williams's "Base and Superstructure" article (1980) constitutes a recovery of the Marxist tradition predicated on a rediscovery of the early Marx, the Marx of the preface to *A Contribution to the Critique of Political*

Economy (1978c)—the same that had grounded the theory of other Western Marxists, among them Gramsci. Instead of the mechanical base-determines-superstructure model, Williams preferred the proposition that social being determines consciousness, and he proceeded to specify the terms of his reclamation by redefining the entire base-superstructure model:

> We have to revalue "determination" towards the setting of limits and the exertion of pressure, and away from a predicted, prefigured and controlled content. We have to revalue "superstructure" towards a related range of cultural practices, and away from a reflected, reproduced or specifically dependent content. And, crucially, we have to revalue "the base" away from the notion of a fixed economic or technological abstraction, and towards the specific activities of men in real social and economic relationships, containing fundamental contradictions and variations and therefore always in a state of dynamic process. (Williams, 1980, p. 6)

What this passage also accomplished was to set the stage for the introduction of Gramsci into the project of British cultural studies. Williams in fact recommends adopting the notion of totality "only when we combine it with the other crucial Marxist concept of 'hegemony' " (p. 8). This first interpretation of *egemonia* thus emerges simultaneously with the dispute in British cultural studies over how best to break into Marxism. This translation is indistinguishable from the move to recapture the activities of human beings within their social constitutions and to rescue the dialectical relationship between being and consciousness. Breaking into Marxism was going to require an engagement with more complex theoretical frameworks for "culture" if a deeper understanding both of domination and emancipation was to be achieved, and this was the theoretical lacuna that Gramsci was brought in to fill. The "commonsense" ideology on whose back hegemony advances is lived at such depth that it explains the reality of domination much more clearly than the base-superstructure model previously did. Indeed, if ideology were merely an imposed set of beliefs and values, "or if it were only the isolable meanings and practices of the ruling class, or of a section of the ruling class, which gets imposed on others, occupying merely the top of our minds, it would be—and one would be glad—a very much easier thing to overthrow" (Williams, 1980, p. 9). Hegemony theory therefore constituted a more sophisticated account of domination insofar as it

underscored the pervasiveness of ideology while at the same time rejecting a total view of domination.

As a response, Williams's "Base and Superstructure" article met Thompson's challenge via a translated and already reworked hegemony theory, one expanded to distinguish between alternative and oppositional social movements, and between the temporal notions of residual and emergent social practices. Through this first theoretical "translation" of hegemony, Williams was able to counter Thompson's challenge with Marxism, yes, but a Marxist theory now better equipped to shift the focus of the determination debate within British cultural studies from one of base versus superstructure to one of being versus consciousness. This reinterpretation, expansion, and distortion of hegemony provided the field a negotiated Marxist foundation and invigorated the political project of the New Left in general.

Ultimately, Thompson had been less concerned with Williams's historical account for its own sake than with an account that could present the British New Left with future possibilities for political revival. Williams's response unmistakably aligned British cultural studies with the political project of the New Left, arming it with the theoretical grounding necessary for a confrontational perspective where struggle was finally given front stage in cultural inquiry. What Williams accomplished with his "Base and Superstructure" article was not only to amend the conformity of his previous position, but also, and most important, to redefine culture, as Thompson had urged twelve years before, as "a whole way of struggle." Cementing British cultural studies squarely in the radical tradition was the true triumph of Williams's "translation" of *egemonia*.

Unfortunately, this triumph would not last. As with any other idea, its fate was tied to the political context within which it was received and to which it was adapted. No sooner had the field worked out an acceptable break into Marxism than tensions within it created a rupture that would initiate a break out of Marxism. Hegemony theory was about to be translated yet again, this time with more unfortunate consequences.

This new tendency was perhaps already detectable in Stuart Hall's (1986b) historical rendition of the evolution of cultural studies along the lines of two master paradigms, which he identifies as the "culturalist" and the "structuralist" paradigms. After observing Williams's temporary abandonment of Marxism because of the unattractive base-superstructure

metaphor, Hall recounts the first direction taken up by cultural studies as the coming together again of Williams and Thompson along the lines of "determination":

> Here, then, despite the many significant differences, is the outline of one significant line of thinking in Cultural Studies—some would say, *the* dominant paradigm. It stands opposed to the residual and merely-reflective role assigned to "the cultural"…it conceptualizes culture as interwoven with all social practices; and those practices, in turn, as a common form of human activity: sensuous human praxis, the activity through which men and women make history. It is opposed to the base-superstructure way of formulating the relationship between ideal and material forces….It prefers the wider formulation—the dialectic between social being and social consciousness: neither separable into its distinct poles. (p. 39)

Hall is obviously referring to Williams's "Base and Superstructure" article. While Hall's discussion of the important structuralism-culturalism dispute within the field is not without its merits, it is also not without serious problems. To begin with, the manner in which Hall aligns this new paradigm along a rejection of the base-superstructure model appears as a general stance of opposition against Marxism. Hall characterizes *"the* dominant paradigm" not as a break into Marxism but as a stance of opposition to it. Instead of portraying this defining historical moment for British cultural studies as a rediscovery of Marx's being versus consciousness dialectic, Hall characterized the moment as an opposition to Marxism in general via the rejection of the base-superstructure metaphor. In reality, however, in that historical breaking into Marxism occasioned by the Williams-Thompson dispute, there was certainly more that was embraced from Marxism than was rejected, and on this Hall's account is silent.

Second, Hall characterizes the two positions in an already excessively reductionist manner. Not only had Williams already, some thirteen years earlier (1973), overcome the two positions Hall describes as such a neat binary opposition between a crude economic reductionism and a naive idealist humanism, but he had done so precisely with his break into Marxism. At one point, Hall identifies, among the strengths of structuralism, a reminder of the dialectic that human beings make their own history out of conditions not of their own making. Yet his reminder happens to constitute the central dialectic

of hegemony theory itself, and presents the major reason why Williams placed hegemony theory so centrally within the cultural studies project.

It is indeed unfortunate that Hall should have interpreted and inflated the culturalist-structuralist dispute as the defining "break" to have confronted cultural studies. What's worse, others within the field have followed his lead and typified the major tension within cultural studies as the culturalism-structuralism split (for example, Bennett, 1986; McGuigan, 1992; McRobbie, 1991; Turner, 1996). What is so grievous about this characterization is that it significantly narrows the field of discussion about the origins, evolution, and future possibilities of cultural studies in a manner that excludes the larger issue of the embrace or rejection of Marxism. Hence, Hall's "Two Paradigms" can be identified as a beginning in the tendency of British cultural studies to break out of Marxism.

Though Hall's work has in many respects been a beacon of innovation for cultural studies everywhere, not just in Britain, there are other ways in which Hall is, unfortunately, further implicated in this process of breaking out of Marxism. For instance, he adopted from Althusserian structuralism the concept of the "relative autonomy" of certain practices in opposition to the conception of correspondences and unities of systems of totality. This is related to another concept that Hall adopted, that of "articulation." Around the same time period as his "Two Paradigms" article, Hall (1986a) describes his use of the term:

> In England, the term has a nice double meaning because "articulate" means to utter, to speak forth, to be articulate. It carries that sense of language-ing, of expressing, etc. But we also speak of an "articulated" lorry (truck): a lorry where the front (cab) and back (trailer) can, but need not necessarily, be connected to one another.... The theory of articulation, as I use it, has been developed by Ernesto Laclau.... His argument...is that the political connotation of ideological elements has no necessary belongingness, and thus, we need to think the contingent, the non-necessary, connection between different practices—between ideology and social forces...and between different social groups composing a social movement, etc. (p. 53)

What Hall is describing here is no less than an antimaterialist (and hence anti-Marxist) disjoining of the two dialectical antipodes of Marxism, whether

one wishes to view it as base and superstructure, as being and consciousness, or as normative and immanent grammar. Those same "strongly coupled" elements he had urged keeping in dialectical relation in his "Two Paradigms" article are here severed with the slash of a word. One is left to wonder what happened to Gramsci, who had proved such an inspiration for Hall and whose theory of hegemony had been a "more refined" approach that had "properly restore[d] the dialectic between the unconsciousness of cultural categories and the moment of conscious organization" (Hall, 1986, p. 45). This was the same Gramsci who had "begun to point a way through this false polarization in his discussion of 'the passage between the structure and the sphere of the complex superstructures' " (pp. 45–46). That Gramsci, it turns out, had already been "re-translated," and would continue to be translated over and over by Hall, in such a way that would better serve new political needs by emphasizing "contingency," and "unnecessary connections" between dominating structures, particularly economic ones, and ideological superstructures. In one example of this "new and improved" Gramsci, Hall claims that Gramsci, in describing the dominating process of hegemony, "speaks of alliances of class strata, not of a unitary and unproblematic 'ruling class' " (p. 35). This translation is at the very least an attempt to sanitize a body of work committed to the overthrow of the ruling classes of Italy and Europe and the radical institution of a new social order. More problematic here is that Hall, in this interpretation of Gramsci, was relying on the *Selections from the Prison Notebooks*, in whose introduction the editors had specifically noted that Gramsci's increasing concern that prison censorship might bring his work to an end had led him to revise much of the material in his notebooks, "eliminating any surviving words or phrases…like the name of Marx or the word 'class' " (Hoare & Nowell-Smith, 1971, p. xi). Hall's particular reading of Gramsci is thus disconcerting, first because it is unlikely that he would have missed this information in his reading of the *Selections*, and second because Gramsci's self-censorship has become a widely known fact among Gramscian scholars.

 Attributing Gramsci with an aversion to class issues constitutes a translation practice that distorts rather than restores the intent of his work. This is further evidenced by another passage contained in the *Selections* in which Gramsci (1971) explains that "though hegemony is ethico-political, it must also be economic, must necessarily be based on the decisive function exercised by the leading group in the decisive nucleus of economic activity" (p. 160).

In other words, while hegemony unfolds through the superstructure, it still requires that the ruling classes maintain and employ economic power in order to preserve their dominance in a class-based society. Though available from the earliest days of Gramsci's translation into the English language, this passage is often overlooked in cultural studies theorists' attempt to distance themselves from discussions of class and economy (materially speaking, a move comforting to the social being of most academics).

This distancing was apparent as early as 1958, when Hall argued that under the current capitalist system known as consumer capitalism, the source of class consciousness had shifted from production to consumption, that the working class, in other words, now conceived of itself less in terms of what and how it produced than what and how it consumed, a shift that served to produce a new form of false consciousness, one rooted in "a sense of classlessness" (Hall, 1958). Yet, as Thompson was to contend, Hall failed to understand the historical context of class struggle, in which the working class had struggled against class power on economic, political, *and* cultural terrains for centuries, not just under consumer capitalism. Moreover, Hall's analysis displayed "a tendency to assert the absolute autonomy of cultural phenomena without reference to the context of class power: and a shame-faced evasion of that impolite, historical concept—the class struggle" (Thompson, 1959, p. 51). Hall, and others within the fields of communication and cultural studies, would later deploy Gramsci in their declaration of autonomy for culture.

Hall's interpretations of Marxism, including Gramsci's philosophy of praxis, are indeed perplexing, considering the substantial energy he has expended throughout his career to defend the continued relevance of Marxism against a post-Marxist stance—with which Laclau, incidentally, aligns himself—that has developed an increasingly *anti*-Marxist tone. Yet Hall's lead has served to further encourage a barrage of allegedly critical work that has ultimately served the interests of the anti-Marxist tendency he decries.

Once hegemony theory is sanitized of class consciousness, once it sees cultural practices no longer in an indissoluble relation to dominating structures but in a position of "relative autonomy" from those structures, then the door has just been swung wide open to a reductionism of another kind, one best understood as the glorification of resistance without power or political consequence.

The distaste with which cultural studies distanced itself from discussions of economy has been matched only by the delight with which much work in the field has latched on to "resistance." On the heels of Hall's adoption of "relative autonomy" and "articulation," Gramsci's theory of hegemony was translated yet again by an entire generation of culture and communication theorists who made reference not to Gramsci's political grammars but to an already problematic Hallsian translation of hegemony. Hence, the dialectical tension between structure and struggle that had glued hegemony together into a coherent theory of domination was literally wrenched apart in a move that can only be termed "divide and harmonize." The chief strategy through which this was accomplished and which this has engendered is an uncritical celebration of the consumption of popular culture products as an inflated spirit of resistance.

This tendency is most obvious in the works of communication theorist John Fiske. Though by no means the only champion of this "New Revisionism," his body of work can nonetheless be seen as having spearheaded this movement and is therefore examined here as a paradigmatic case. In his *Introduction to Communication Studies*, Fiske (1990) introduces Gramsci's relevance to the critique of ideology through an overly optimistic reading that immediately associates Gramsci with resistance: "The two elements that Gramsci emphasizes more than Marx or Althusser are resistance and instability" (p. 176). Gramsci's supposedly greater emphasis on resistance permits defiant popular tactics to always remain "finally unincorporable" (p. 185) by the dominant ideology. Such a reading ignores that the constant attempt to incorporate resistance within the dominant ideology is the very process whereby hegemony is perpetuated. While it is certainly true, as Williams had long pointed out, that no hegemonic process is ever total, since domination also presupposes occasional exclusion rather than complete incorporation of certain subaltern groups, believing resistance to be "finally unincorporable" by hegemony is to miss the point of hegemony entirely and to espouse an ironclad law of culture as the ameliorating shaper of history. Thompson's objection to asserting for culture an absolute autonomy should be recalled here. Though the point of Gramsci's theory of the superstructures was to counter the economic determinism of vulgar Marxism by attributing to culture a greater role within the formation of historical blocs, he would have opposed this attempt to regale culture with an equally deterministic tendency, on the grounds, once more, of its significance

for human agency. The excessive focus on consciousness and the neglect of structural critiques of class struggle also lead to political paralysis insofar as structural change is no longer seen as either possible or required, thus preventing the passage from theory to praxis so central to Gramsci's philosophy.

> Fiske's distortion of hegemony theory is in great part due to his exaltation of any antagonistic attitude as resistance capable of subverting the dominant social order. His ethnographic studies range from the disparaging audiences of a tabloid press that, by occasioning "sceptical laughter" and the "pleasures of not being taken in" constitutes "the historical result of centuries of subordination which the people have not allowed to develop into subjection" (Fiske, 2000, p. 355); to the subversive youth who, clad in ripped and faded jeans, resists designer co-optation (Fiske, 1989b); to the female consumers engaged in guerrilla warfare in the shopping mall, empowered as they are by "their competency in shopping operations, their familiarity with the terrain and with what they can get out of it," and who find in shopping malls the ideal terrain of resistance since "in our built environment there are few places designed for women…[and] in the shoppingtown, women have access to public space without the stigma or threat of the street" (Fiske, 1989a, pp. 22–23, quoting Ferrier). Never mind that believing women must still, in this day and age, be "protected" like children from the "stigma" and "threat" of the public space, rather than be encouraged to occupy it as concretely as their male counterparts, belies an enduring patronizing Victorianism even among allegedly emancipated intellectuals. The point is whether such practices should truly be considered resistance or whether they would more aptly be considered coping and escapism. Critical work should be able to make the crucial distinction between the two concepts, for ultimately its intellectual enterprise amounts to either recognizing and critiquing ideology, or celebrating it. Nicholas Garnham (1995) expressed this best when he observed that escapism, as escape from struggle and political engagement, was not something to be celebrated: "Escapism does little, it seems to me, to resist the structure of domination in which these subjects find themselves. In fact, escapism may (understandable as the practice is) contribute to the maintenance of that structure of power.…Surely the aim should not be to bow down in ethnographic worship of these cultural practices, but to create a social reality in which there are wider possibilities for the exercise of both symbolic and (in my view more importantly) material power" (p. 69).

Moreover, as inquiries into communication and culture become inquiries into patterns of consumption, they become increasingly indistinguishable from the marketing research required for the production of those goods necessary for the "complicated" consumption of an "alternative" lifestyle. And yet, any theory that presumes to investigate cultural phenomena should begin by examining the links between cultural practices, their commodification, and the distribution of power, and how such relations shape the development of hegemonic social formations. Put more bluntly, to what extent can the present ultratranslated version of hegemony still be considered a valid Marxist critique of capitalism rather than a recruitment tool for the savvy consumers Fiske parades as "resisting" subjects? In light of this appropriation of hegemony theory, it appears that capitalism and its intellectual discourse has attempted to co-opt the quintessential theory of co-optation.

An adequate *critical* theory of culture is therefore not only intrinsically political but also, as Hanno Hardt (1997) argues, inherently Marxist, for the most basic function of hegemony is "the reproduction of class and class relations in specific historical situations without total assimilation…of the dominated class, whose cooperation may be sought and won despite exclusionary practices" (p. 74). Insofar as analyses of communication and culture continue to dodge the economic forces that shape ideological practices, they continue to exclude the political.

This uncritical drift in cultural studies has, understandably, not gone without opposition from within the field, though some of this opposition has come in the form of a reactionary rejection of Gramscian theory altogether. David Harris (1992), for instance, subjects what he calls "gramscianism" to utter vilification, attributing the ultimate responsibility for the drift from class struggle to the "politics of pleasure" to some inherent shortcoming of Gramsci's theory of hegemony, rather than critically analyzing the political maneuvers that dictated the various translations of Gramsci within the British cultural studies context and, subsequently, within the English-speaking world in general.

Gramsci's theory of hegemony was never intended to serve as a "catch-all" solution to the problem of determination, though numerous of its proponents have certainly tried to adapt it to such use. The strength of hegemony theory lies in its placement of domination and resistance in material and dialectical relation to each other—under concrete, historical conditions, not in some reductionism favoring either one or the other. There is an entire

generation of culture and communication theorists who have studied Gramsci's hegemony according to Hall and Laclau. Few (Artz & Murphy, 2000), however, have arrived at an understanding of *egemonia* as Gramsci himself did, as the interplay of normative and immanent grammars. If they had, they would have understood structure and struggle as interlocked and inseparable, because each constitutes the other. Human beings are neither entirely constrained by structures of domination nor sufficiently free of those structures to make their own history. Moreover, dominating structures and possibilities for struggle against those structures are only conceivable against each other's backgrounds. They, too, like normative and immanent grammar, are inseparable because they are constituted in and of each other. The entire concept of "articulation," by separating struggle from structure, resistance from domination, broke hegemony of its vital dialectical essence and initiated the exodus from Marxism.

Ideas and theories no doubt are mutable. A diverse and conflicted body of work such as cultural studies could not and should not stick rigorously to some fictitiously "pure" version of a theory, which is precisely what characterizes dogmatism. But ideas are also perishable, especially when their critical tension is blunted by a radical anti-Marxism in which, equally unfruitful, one dogmatism is traded for another.

The history of the translation of Gramsci into the English language is also a history of political choices, distortions, and co-optation. Along the way, some theories of hegemony stripped away much of its critical substance. What was lost in those translations of *egemonia* was the Marxist project itself, the "ruthless criticism of everything existing" and the radical social transformation to which such criticism is committed. As Gramsci himself would have observed, this process has been less one of linguistic *traduzione*, of translation, than one of political *tradimento*—of betrayal. The history of hegemony theory surpasses its own confines, providing an admonitory illustration of the subjection of Marxist theories themselves to hegemonic forces that seek to blunt and sanitize what is most critical about them. The vicissitudes of hegemony theory are thus part of the larger history of the attempt to de-Marxify and defuse critical theory. The task now is as pressing as it was for Thompson almost half a century ago, when he reminded us that "a whole way of struggle" remained to be theorized. In such a project, Thompson's search for a method and tradition is as salient as ever. The development and advancement of the Marxist method must include the critical recovery of

the history of concepts and their reception. "Hegemony" is one such concept that can be retrieved, nurtured, adjusted, and applied in action.

References

Artz, L., & Murphy, B. (2000). *Cultural hegemony in the United States*. Thousand Oaks, CA: Sage.

Bennett, T. (1986). Introduction: Popular culture and "the turn to Gramsci." In T. Bennett, C. Mercer, & J. Woollacott (Eds.), *Popular culture and social relations* (pp. xi–xix). Milton Keynes: Open University Press.

De Mauro, T. (1979). Preface. In *Lingua intellettuali egemonia in Gramsci* (pp. v–xvi). Bari: Laterza.

Forgacs, D. (Ed.). (1988). *An Antonio Gramsci Reader*. London: Lawrence & Wishart.

Fiske, J. (1989a). *Reading the popular*. Boston: Unwin Hyman.

Fiske, J. (1989b). *Understanding popular culture*. Boston: Unwin Hyman.

Fiske, J. (1990). *Introduction to communication studies*. London: Verso.

Fiske, J. (2000). Popularity and the politics of information. In J. Hartley, R. E. Pearson, & E. Vieth (Eds.), *American cultural studies: A reader*. Oxford: Oxford University Press.

Garnham, N. (1995). Political economy and cultural studies: Reconciliation or divorce? *Critical Studies in Mass Communication* 12(1): 62–71.

Gramsci, A. (1971). *Selections from the prison notebooks of Antonio Gramsci* (Q. Hoare & G. N. Smith, Trans.). New York: International Publishers.

Gramsci, A. (1985). *Selections from cultural writings* (W. Boelhower, Trans.). D. Forgacs & G. Nowell-Smith (Eds.). Cambridge, MA: Harvard University Press.

Gramsci, A. (1996). *Prison notebooks* (J. A. Buttigieg & A. Callari, Trans.). J. A. Buttigieg (Ed.). New York: Columbia University Press.

Gramsci, A. (2001). *Quaderni del carcere*. V. Gerratana (Ed.). Torino: Einaudi.

Hall, S. (1958). A sense of classlessness. *Universities and Left Review* 5: 26–31.

Hall, S. (1986a). On postmodernism and articulation: An interview with Stuart Hall. *Journal of Communication Inquiry* 10(2): 45–60.

Hall, S. (1986b). Two paradigms. In R. Collins, J. Curran, N. Garnham, P. Scannell, P. Schlesinger, & C. Sparks (Eds.), *Media, culture, and society: A critical reader*. London: Sage.

Hardt, H. (1997). Beyond cultural studies: Recovering the "political" in critical communication studies. *Journal of Communication Inquiry* 21(2): 70–78.

Harris, D. (1992). *From class struggle to the politics of pleasure: The effects of Gramscianism on cultural studies*. London: Routledge.

Hoare, Q., & Nowell-Smith, G. (Eds.). (1971). Preface. In *Selections from the Prison Notebooks of Antonio Gramsci* (pp. ix–xv). New York: International Publishers.

Ives, P. (2004). *Gramsci's politics of language: Engaging the Bakhtin Circle and the Frankfurt School*. Toronto: University of Toronto Press.

Lo Piparo, F. (1979). *Lingua intellettuali egemonia in Gramsci*. Bari: Laterza.

Marx, K. (1978b). The German ideology. In R. C. Tucker (Ed.), *The Marx-Engels reader*. New York: W. W. Norton.

Marx, K. (1978c). Preface to *A contribution to the critique of political economy*. In R. C. Tucker (Ed.), *The Marx-Engels reader*. New York: W. W. Norton.

McGuigan, J. (1992). *Cultural populism*. London: Routledge.

McRobbie, A. (1991). New times in cultural studies. *New Formations, 13.*

Merrington, J. (1978). Theory and practice in Gramsci's Marxism. In New Left Review (Ed.), *Western Marxism: A critical reader*. London: Verso.

Thompson, E. P. (1959). Commitment and politics. *Universities and Left Review* 6: 50–55.

Thompson, E. P. (1961). The long revolution (part I). *New Left Review, 9.*

Turner, G. (1996). *British cultural studies: An introduction*. London: Routledge.

Williams, R. (1958). *Culture and society*. New York: Columbia University Press.

Williams, R. (1961). *The long revolution*. New York: Columbia University Press.

Williams, R. (1980). Base and superstructure in Marxist cultural theory. In R. Williams (Ed.), *Problems in materialism and culture: Selected essays* (pp. 31–49). London: Verso.

·THE CONVICTIONS OF REFLEXIVITY: PIERRE BOURDIEU AND MARXIST THEORY IN COMMUNICATION·

David W. Park

By the time of his death in 2002, Pierre Bourdieu had established himself as one of the great sociologists. His scholarly work continues to invigorate academia around the world and across the disciplines. Additionally, late in his life, he also emerged as one of the most noticeable intellectuals in the world, whose links to the antiglobalization movement in Europe made him something of a celebrity.

Because of his prominent status within and outside of academia, it is something less than controversial to suggest that Marxist theory in communication has something to gain through a consideration of Bourdieu's ideas and activist example. To integrate the ideas of a famous and widely cited (and safely deceased) scholar into the discussions carried on by those interested in Marxist theory in communication is perhaps not in and of itself a revolutionary pursuit. Despite this, I argue that an engagement with the ideas of Bourdieu can do much for those who hope to establish a more secure home for Marxist theory within the field of communication.

I pursue three main goals here. First, I will demonstrate some of the Marxist dimensions in Bourdieu's work. Though there is much danger of

overstatement in such a task, it is important to establish first that Bourdieu was indeed pursuing a project that was consistent with some of the most relevant assumptions of Marxist theory. Second, I will review how Bourdieu's ideas have been used in the field of communication, and how communication research has tended to absorb Bourdieu's ideas in a manner that plays down their Marxist potential. Finally, I will consider Bourdieu's career as a public intellectual in France, to draw lessons for Marxist scholars today.

The Marxist Dimensions of Bourdieu's Thought

Bourdieu possessed a protean imagination. His research and theoretical projects found him pursuing many different topics, using a wide array of methods, and making common cause with a number of theoretical outlooks. To assert that Bourdieu's work can be summed up as entirely "Marxist" would be an inaccurate simplification. David Swartz (1997) points out that Bourdieu's work can be regarded as "an ongoing polemic against" (p. 5) many different schools of thought, including Marxism. Bourdieu rejected most attempts to classify his own approach, instead preferring ambivalence toward many of the major traditions in sociology. In his own words, he intended to "think with Marx against Marx" (Bourdieu, 1990, p. 49), and to use a similar approach when dealing with other theorists' ideas. Instead of claiming Bourdieu wholesale for Marxism, I make the less dramatic assertion that we can often find in Bourdieu's ideas a meaningful engagement with Marxist ideas that points the way to critical scholarship. His incorporation of Marxist theory and his application of it provides insights regarding how to do Marxist scholarship and how to go beyond some of the usual problems such scholarship has experienced in the past.

I am not the first to point to Marxist dimensions of Bourdieu's work. Indeed, one of the earliest English-language appreciations of Bourdieu (along with DiMaggio, 1979) came from Nicholas Garnham and Raymond Williams, whose 1980 "introduction" to Bourdieu in *Media, Culture, and Society* explored Marxist themes in Bourdieu's writing. They note that one of the most important problems that Bourdieu addresses is that of reproduction, a primary concern of Marxism at its understanding of "the mode of production," "the mode of domination," and "crisis and revolution" (Garnham and Williams, 1980, pp. 210–11). Reproduction occupies a major role in *Outline*

of a Theory of Practice (1977), and takes on a more explicitly class-relevant tone in Bourdieu's voluminous writing on education (for example, Bourdieu & Passeron, 1979). Reproduction would continue to be a major theme for Bourdieu until his death.

Materialism is another theme in Bourdieu's thought that demonstrates his ongoing concern for Marxist ideas. Though he was no proper materialist, he was most skeptical of explanations of social behavior that emphasized agency, and even used Marx to shore up his own theory of social behavior, as when he noted that "the individual is always, whether he likes it or not, trapped—save to the extent that he becomes aware of it—'within the limits of his brain,' as Marx said, that is, within the limits of the system of categories he owes to his upbringing and training" (Bourdieu & Wacquant, 1992, p. 126). Bourdieu's concept of the *habitus* was offered in the spirit of combining the insights of Marxist materialism with culturist approaches associated with Max Weber and Emile Durkheim. This attempt to merge Marxist ideas with others is sometimes interpreted as a rejection of Marxist and structuralist modes of inquiry, with their characteristic materialist emphases. However, Bourdieu's concern for the material is deeper than this may indicate. Throughout Bourdieu's writings on knowledge, we find a continual concern for the material dimension of social action phrased in terms of "*le sens practique,*" or "practical knowledge." At least as early as *Outline of a Theory of Practice* (1977), we find Bourdieu building explicitly on Marx's *Theses on Feuerbach*, as Bourdieu sides with Marx's refusal to explain social processes simply "from a subjective point of view" (Marx, quoted in Bourdieu, 1977, p. 10).

An important starting place—and a telling materialist influence—in Bourdieu's approach to knowledge and culture is his take on the first two theses of Marx's appraisal of Feuerbach's defense of materialism. In the first, Marx declares that the "chief defect of all hitherto existing materialism…is that the thing, reality, sensuousness, is conceived only in the form of the object or of contemplation, but not as human sensuous activity, practice, not subjectively" (Tucker, 1972, p. 143). The second thesis ends with the conclusion that the "dispute over the reality or non-reality of thinking which is isolated from practice is a purely scholastic question" (Turner, p. 144). Here we find Marx rejecting idealism in a manner that would inform much of Bourdieu's work.

Ideas explicitly relying on, or cognate with, the *Theses on Feuerbach* can be found most clearly at work in Bourdieu's outline of the *habitus*, a conception

of the relation between the individual and society that stresses the practical dimension of individual experience. Bourdieu's emphasis, with Marx, was on critiquing the oft-encountered scholarly presupposition that ideas are somehow free-floating. As Bourdieu critiqued the Marxist-structuralist camp for their lack of attention to meaning and culture, we can also see in his brand of materialism a nugget of wisdom that is most applicable to the Marxist scholar in communication today: any effort to address a cultural formation that lacks attention to the structural and practical elements that underlie its legitimacy and sustainability will be vulnerable to charges that it is taking the social formation for granted. The relevance of this basic insight to Marxist scholars of mass communication is profound. Those who have followed in the footsteps of Herbert Schiller and Hanno Hardt know this terrain well. Their emphases on media structures, systems, and history have helped to define what Marxist scholarship can look like. More recent examples of scholars who have taken up the materialist approach to mass communication can be found in this volume.

Finally, it should also be recognized that, despite Bourdieu's tendency to frequently rely on Weberian or Durkheimian approaches, he generally presented his work as a "critique"—a word that Durkheim and Weber (with their preferences for value-neutrality) rarely used—a point observed by Garnham and Williams (1980) some twenty years ago. This critical perspective was particularly noticeable in *Distinction* (1984), *Homo Academicus* (1988), *The Weight of the World* (1999), *Acts of Resistance* (1998a), and *Firing Back* (2003). In keeping with Marx's aphoristic advice that "the point is to change" the world (quoted in Tucker, 1972, p. 145), Bourdieu did not regard the issues he studied as mere academic conundrums. His work called out for change, though his reflexivity often seemed to mask this call. He saw critique as a necessary part of all of the social sciences, at one point insisting that "social science necessarily takes sides in political struggles," because its job is to "[uncover] the social mechanisms which ensure the maintenance of the established order and whose properly symbolic efficacy rests on the misrecognition of their logic and effects" (Bourdieu, 1975, p. 101; quoted by Wacquant in Bourdieu & Wacquant, 1992). Clearly, Bourdieu's consistent devotion to reflexivity—which he claimed was the cause of his much-maligned writing style—was not sufficient to keep him out of political struggles. His long-lasting attempt to be both critical and reflexive can be viewed as a model of intellectual commitment, and not as

a mealy-mouthed avoidance of pressing political concerns, or a retreat to the ivory tower.

The point here is that Bourdieu's ideas involved major Marxist assumptions, and that this common ground between Bourdieu's approach and Marxism gives to contemporary Marxist communication scholars a productive theoretical mechanism that can be applied in a robust manner to a wide range of communication practices. Bourdieu's body of theory provides a vigorous prospect for broadening the Marxist approach. I suggest that we regard Bourdieu's ideas as tools that do not belong "naturally" in any theoretical camp, but are instead just waiting to be articulated, enlivened by whomever has the initiative to pick up on them. The common ground is there; yet, the Marxist framework advanced by Bourdieu has not been fully appreciated or much applied in communication studies.

Bourdieu's Legacy

The tendency to ignore or avoid Bourdieu's relationship to Marxism can be readily detected in scholarship about Bourdieu. For example, the widely read *Bourdieu: Critical Perspectives* (Calhoun, 1993) admirably recounts many of Bourdieu's main ideas. However, the perspectives covered therein often focus on working out the subtle machinations of the *habitus*, or the relational sense of meaning that Bourdieu put forth with his theory of the field, but with scant attention to Bourdieu's recognition of the material power of the sociopolitical order, including social classes. With the exception of Garnham's incisive chapter "The Cultural Arbitrary and Television," most of the insights on Bourdieu's ideas in Craig Calhoun's book concern more Durkheimian approaches to practice, and eschew the kind of structural analysis that Marxist scholarship frequently employs. Mentions of Marx are few and far between. In part, the book represents the attempts of many to fit Bourdieu into their theoretical programs, and this ultimately compresses the sense of Bourdieu the critic that might more fully have been acknowledged. Another widely read book about Bourdieu, Richard Jenkins's *Pierre Bourdieu* (1992), details how Bourdieu's ideas relate to structuralism, language, and reproduction. Once again, though, the picture of Bourdieu's ideas that emerges obscures Bourdieu's political and social critique, as well as his application of Marxism. David Swartz's *Culture and Power: The Sociology*

of Pierre Bourdieu (1997) is an excellent overview of Bourdieu's ideas, with some powerful ideas concerning Bourdieu's theoretical input on the role of the intellectual, but with no appreciation of Bourdieu's Marxist approach.

This sense that Bourdieu and Marxism have little to do with each other is particularly strong in the field of communication. Communication has been both slow and selective in picking up on Bourdieu's ideas. Jefferson Pooley (2004) has carefully examined the extent to which Bourdieu figures in modern communication research, and his analysis suggests that communication scholars rarely use Bourdieu. Pooley finds that Bourdieu is cited infrequently in communication scholarship, more likely to be cited by scholars outside the United States, and is most likely to be cited only in the context of work on taste. As Pooley (2004) points out, "nearly a third" of the papers he examined that did involve Bourdieu cite *Distinction*—and nothing else (p. 3). Instead of a robust approach to the media, we wind up with a relatively cautious use of Bourdieu, using only his broadest terms—like *habitus* or *le sens practique*—in a manner unlikely to give us the kind of conceptual leverage that critical scholarship demands. Those who hope for a critical Marxist use of Bourdieu have, so far, largely hoped in vain. While Nick Couldry (2003) has offered what appears to be an excellent starting point for applying Bourdieu, we still have a long way to go.

To blame these scholars who write about Bourdieu or attempt to extend his ideas into empirical domains without any Marxist emphasis for some alleged plot against Marxism is not the point here. If anyone were to be blamed for Bourdieu's distance from Marxism, it would be Bourdieu himself, for he quite intentionally distanced himself from Marxism and from political causes. Garnham (in Calhoun, 1993) suggests that Bourdieu's allegiance to Durkheimian tendencies can be isolated as one factor that prevented Bourdieu from being more open to the idea of change as a potential in social action.

In the final analysis, Bourdieu's ideas will not be delivered to Marxist theory on a plate. If we are interested in shaping them to our interests—and I have attempted to outline how this is possible—we must do so ourselves. Bourdieu was nothing if not prolific, and his ideas almost always involved a sense of tension. If the relative lack of attention to Bourdieu in communication means that Marxist angles have yet to be touched on, it also means that his ideas have yet to be entirely co-opted by any other factions within academe. This provides an opportunity for Marxist scholars to seize on a

theoretical approach that can address long-standing conceptual interests *and* refine the ideas that have already endured in Marxist scholarship.

Bourdieu as Public Intellectual: Merging Reflexivity and Commitment

The story does not end there, with an intractable frustration resulting from Bourdieu's oft-unwieldy theoretical mechanism and preference for reflexivity over simple answers, and a vague call for us to go get some Bourdieu in our lives. It is one thing to suggest that Bourdieu is available to us, but it would be much more helpful to say something about why we might bother making common cause with his ideas.

One useful application of Bourdieu's ideas and example concerns how intellectuals relate to the public. After all, it is significant that Bourdieu's last years found him well established as a very critical and very public scholar, who addressed issues that are major contemporary concerns of Marxist activists. We can (and, I hope, will) debate the finer points of Bourdieu's internal contradictions and differential commitment to Weber, Durkheim, and Marx for years. No matter what lingering doubts Bourdieu may have had about Marxist critique and about the role of the popular expert were apparently outmatched by his own sense of political commitment. He was eulogized as "France's foremost public intellectual after the passing of Foucault" (Calhoun & Wacquant, 2002); this reputation came from his dedication to numerous causes, and from his association with other major European intellectuals, including Gunther Grass, Hans Haacke, Eric Hobsbawm, and Edward Said. Though accounts do vary, the public-ness of his political stances does seem to have increased markedly toward the end of his life. As a successful critical public intellectual, a champion of many radically progressive causes, and a theorist of intellectuals, Bourdieu's ideas and example can be instructive to those whose sense of commitment leads them to consider how Marxist ideas can be put across to the public.

Swartz (2003) outlines six explanatory factors that account for Bourdieu's move to engage the public late in life. First among these was Bourdieu's career trajectory. As Bourdieu moved from a peripheral to a central location in the French intellectual field, he earned both security as an academic and enhanced public stature. Second, changes in the intellectual field—in

particular, the lack of competition for the role of the "total intellectual" in France—in the 1980s and '90s supported Bourdieu's public move. Third, the growing influence of the mass media in France made a public move both feasible and powerful. Fourth, the failures of the French socialists in power in the 1990s created a struggle over economic policy and its effect on the working classes—to which Bourdieu had much to say. Fifth, the French cultural legacy of critical intellectuals made Bourdieu's ascendance to the position of France's most prominent intellectual seem relatively appropriate; Bourdieu stepped into the position that had earlier been occupied by such luminaries as Foucault and Sartre. Finally, the unifying issue of globalization brought Bourdieu's ideas together with the interests of those for whom he argued. In Swartz's analysis, Bourdieu's assumption of the role of France's most influential public intellectual is something that was made possible by Bourdieu's insistence on accumulating symbolic capital in his profession, developing this capital as if in wait, and then going public only when he had accumulated a store of symbolic capital and found an issue—globalization/neoliberalism—to which he could apply this capital (Swartz, 2003). This may strike some as an overintentionalized version of how Bourdieu played his hand in this game, but it is entirely consistent with Bourdieu's perennial concern for reflexivity. It is plausible to suggest that Bourdieu was not simply swept up by commitment, but was instead a canny commentator as he became a media figure, concerned at all times with the structure of the field in which he operated.

For Marxist communication studies, one lesson to be drawn from this is that the public intellectual role can be an important part of critical scholarship, though it must also be understood that this should not become simply a call for more public intellectuals. Bourdieu understood quite well how his own position in the field of intellectuals would inform whatever the media did with him. Even at the peak of his fame near the end of his life, he was aware that the public intellectual cannot directly control her or his connection to the public. To enter into the mediated game of commentary that Bourdieu (1998b, p. 57) describes in *On Television* is to enter into a game that one cannot control. This should not inspire fatalism about the potential for Marxist representatives to compete for media space, but it should definitely point to the need for a sense of the kinds of compromises that any such effort may entail. Seen in this light, C. Wright Mills's (1958) call for us to act as "public intellectuals" who "ought to feel responsible for the formulation

and the setting forth of programs, even if in the beginning they are for only a few thousand readers" (pp. 135–36), gives us little sense of the contemporary media processes at work in the task of becoming public intellectuals. Bourdieu's circumspection regarding his own place in the public intellectual field reminds us, as Todd Gitlin (1980) has pointed out, that the public representatives of oppositional movements are not in charge of their own mediated fronts. For us, today, this means that becoming "public intellectuals" is a goal that should be pursued only with a strong sense of reflexivity concerning what processes will engulf these public intellectuals when the cameras are turned on them.

Bourdieu's example of an intellectual not fully dependent on corporate media also provides a strong example of how professionalism can be successfully integrated into a critical, public stance. This is important because professionalism has been posited as antithetical to both public outreach and critical scholarship. Much literature on the place of the intellectual opposes professionalism to the public interest, or to critical potential. We can find this sense of professionalism in Gramsci's distinction between organic and traditional intellectuals. The " 'traditional' professional intellectuals, literary, scientific, and so on," occupy a class position that, though concealed, can be tied to "historical class formations" (Gramsci, 1971, p. 3), and therefore make them unlikely heroes for any Marxist movement. In a similar manner, Mills (1953) denounces the professionalization of the humanities and social sciences, denouncing the professor as "a member of a petty hierarchy, almost completely closed in by its middle-class environment and its segregation of intellectual from social life" (p. 131). Russell Jacoby picks up on these ideas in his *The Last Intellectuals* (1987), where he asserts that professionalism in academia has blunted the potential for critical perspective and insulated would-be intellectuals from the public. Jacoby (1987) describes how New Left intellectuals "became professors who neither looked backward nor sideways; they kept their eyes on professional journals, monographs, and conferences" (p. 140). These are but a few examples. The point is that professionalism has been routinely targeted as a cause for the left's ills.

Bourdieu complicated this widely agreed-upon notion that professionalism involves a necessary sacrifice of critical perspective as well as a turn away from the general public. His ideas—and his example—on this score are worth close examination. Bourdieu was consistent in his view that a

critical scholarship, or what he called a "committed scholarship," could play a major role in shaping political struggles. He saw no inherent contradiction in his call for "total commitment to internationalism and full adherence to scholarship" (Bourdieu, 2003, p. 25). Bourdieu's (1998b) description of scholarship often hinged on the idea of autonomy, which is "achieved by constructing a sort of 'ivory tower' inside of which people judge, criticize, and even fight each other, but with the appropriate weapons—properly scientific instruments, techniques, and methods" (p. 61). Though fully aware of the problems that come from a professional autonomy without commitment—as could be found in the biologist who concerns herself only with professional ends in the development of a bioweapon—Bourdieu was also wary of the call to "go public" associated with figures such as Mills. The field of the media is arranged such that what Bourdieu called "heteronomy—the loss of autonomy through subjection to external forces—begins when... someone who is not recognized as a historian (a historian who talks about history on television, for instance) gives an opinion about historians—and is listened to" (p. 57). Put simply, the process of reaching the public through the media subjects even the well-intentioned intellectual to processes outside of her or his control. For Bourdieu, the professions remained an important source of autonomy that could be of use to those who hoped to assemble a critical project. To favor going public over maintaining professional scholarly standards was, for Bourdieu, a sacrifice of autonomy for heteronomy, a surrender to the demands of the media market. He described how professionalism need not be seen as something that weakens one's commitment, but could indeed be used as an institutional resource. Of course, the media are not the only source of heteronomy in the intellectual field; Bourdieu (1996) was quick to point out that university sponsorship and the subordination of education to business also sapped the autonomy of the would-be critical scholar (pp. 344–45). Still, in a grand sense, Bourdieu leads us to suspect not the professionals so much as those who claim to be free-floating social actors. Bourdieu's assertion that the professions can play an important role in the creation of critical movements allows us to view institutions as potential tools (though not panaceas) for—and not just obstacles to—social movements.

A final point to be made here relates to one of the major critiques of Marxist theory: that Marxist scholars fail to account for themselves in their own description of social processes. Bourdieu's approach to the intellectual

field offers to Marxism a chance to make reflexivity a strength, and not a blind spot. The place of the intellectual in Marxism was a favorite theme of Alvin Gouldner's. Gouldner outlines quite clearly how Karl Marx and other Marxists maintained a view of social conflict that only occasionally took note of the role to be played by intellectuals. This was an important omission, of course, because they were themselves the intellectuals in this scenario. As Gouldner (1979) describes it, "Marxism has always lived a double life, vaunting theory, arguing that emancipation from the present cannot be achieved without it, yet suspecting and sneering at theor*ists*" (p. 75; emphasis in the original). Gouldner outlines a "false consciousness" in Marxism itself consisting in part of a sense that the working class will free itself, "whereas they will succeed in doing this only under the political leadership and cultural tutelage of the cultural bourgeoisie" (p. 76). Whether or not we accept all of what Gouldner has to say about Marxist theory, he does an exceptional job of addressing the role of the intellectual in move-ment politics. The self-effacement of the intellectual has been an enduring component of Marxist theory and practice. This is something more than a purely theoretical problem, as this elision leaves Marxist intellectuals uncer-tain about how exactly they should relate to the public, and also leaves them vulnerable to what are by now some familiar potshots from those opposed to Marxist ideas. When radical scholars and activists in the United States gain any significant entry into public culture, the response by the capitalist media accentuates the real or supposed distance between the intellectual and the people in whose interest she or he presumes to comment. "What does this intellectual know," goes the line, "given their position in the ivory tower and their promotion by alternative media?" There are numerous good answers to this anti-intellectual question, but we remain vulnerable to critiques like this as long as we fail to account for ourselves in our own theories.

Bourdieu's ideas offer a way to extend and reply to Gouldner's critique of this Marxist blind spot that leaves the left vulnerable to these attacks. Bourdieu's focus on reflexivity led him to address the uses of "the people" as a stake in the games played by intellectuals and politicians. Bourdieu (1990) describes how the strategy of claiming to speak for the people "per-mits those who can lay claim to a form of the proximity with the dominated to set themselves up as holders of a sort of pre-emptive right over the 'peo-ple' and, thereby, of an exclusive mission" while also "allow[ing] them to

accept or to lay claim to everything that separates them from their competitors at the same time as concealing…the break with the 'people' that is implied by gaining access to the role of spokesperson" (p. 152). This insight is particularly relevant to Marxism, an intellectual approach that emphasizes the historical power and responsibility of the working class majority. The most obvious application of this would be that Marxists—and in particular those Marxist scholars who attempt to take on a public role—should be aware of their own claimed links to the public. The tendency of Marxist intellectuals to presume to be able to speak for "the people" (so-called workerism) leaves them vulnerable to the obvious anti-intellectual critique that their intellectual status nullifies their ability to speak for anyone outside the ivory tower. In a more general sense, we can see how academic intellectuals who write for a broad, popular audience describe their own writing as writing "for" the general audience, as if their own attempt to go public represents something that is being done first and foremost in the interests of the people. Bourdieu warned us of the anti-intellectual populism at the root of these approaches to going public; Marxist scholars and intellectuals would do well to address this.

Obviously, this idea that one speaks for the people is by no means unique to Marxism; intellectuals from almost all parts of the political spectrum rely implicitly on a power to speak for the people. Bourdieu's sense that intellectuals (leftist and otherwise) wrongly laid claim to speaking for the people did not mean that he advised a retreat from the public. Particularly toward the end of his life, he seemed inspired by his own belief that "intellectual discourse remains one of the most authentic forms of resistance to manipulation and a vital affirmation of the freedom of thought" (Bourdieu, 1998a, p. 11); he had a vigorous belief in the potential of intellectuals to help in the struggle for justice. For his own field of sociology, he called for an effort to "maintain…[and] even to raise the requirements for the *right of entry*—the entry fee—into the fields of production," and also to "reinforce the *duty to get out*, to share what we have found, while at the same time improving the conditions and the means for doing so" (Bourdieu, 1998a, p. 65; emphasis in the original). These were not the words of someone who would advise retreat.

Late in his life, Bourdieu arrived at his most explicit statements on the matter of what is to be done. He offered an outline of intellectual

commitment in *Acts of Resistance*, where he suggested that scholars and intellectuals "create…a structure for collective research, interdisciplinary and international, bringing together social scientists, activists, [and] representatives of activists" (Bourdieu, 1998a, p. 56). One goal of this collective structure would be to "invent new forms of communication between researchers and activists, which means a new division of labor between them" (p. 57). Scholars in this context would be able to help "nonprofessionals to equip themselves with specific weapons of resistance, so as to combat the effects of authority and the grip of television, which plays an absolutely crucial role" (p. 57). This was not a program for demagoguery, as the structures Bourdieu envisioned were collective in nature. Bourdieu (1996) was insistent that "[c]ultural producers will not find again a place of their own in the social world unless, sacrificing once and for all the myth of the 'organic intellectual' (without falling into the complementary mythology of the mandarin withdrawn from everything), they agree to work collectively for the defense of their own interests" (p. 348). Of course, this is a lofty goal. It is relevant to the Marxist study of communication because its aim and precepts have so much in common with those of Marxist inquiry.

What makes this approach useful to us now is how it helps us to enunciate more fully a sense of what intellectuals (academic and otherwise) can do within Marxism. The attention that Bourdieu placed on the intellectual challenges us to move beyond the consoling myths of antiprofessionalism, of speaking truth to power, and of being stand-ins for "the people." Marxist scholars should look to Bourdieu's example for a model of how to integrate professional and intellectual achievement into a concerted effort to build new networks and structures that lead to greater intellectual autonomy from hegemonic institutions and greater intellectual connection to popular social movements. It is not a rejection of the professions and an embrace of the idea of "the people" that will help us to work for a socialist, democratic world. The strategy should be one that leads us to apply Bourdieu's concern for reflexivity in understanding the fields in which we struggle, develop the political tools that can give us more independence from capitalist class structures, and to reach out in solidarity with the working class and its allies. This is what Bourdieu did, and this is what will allow us not just to interpret the world, but to change it.

References

Bourdieu, P. (1975). The specificity of the scientific field and the social conditions of the progress of reason. *Social Science Information* 14(6): 19–47.

Bourdieu, P. (1977). *Outline of a theory of practice.* Cambridge: Cambridge University Press.

Bourdieu, P. (1984). *Distinction: A social critique of the judgement of taste.* Cambridge, MA: Harvard University Press

Bourdieu, P. (1988). *Homo academicus.* Stanford, CA: Stanford University Press.

Bourdieu, P. (1990). *In other words.* Stanford, CA: Stanford University Press.

Bourdieu, P. (1996). *The rules of art.* Stanford, CA: Stanford University Press.

Bourdieu, P. (1998a). *Acts of resistance.* Cambridge: Polity Press.

Bourdieu, P. (1998b). *On television.* New York: The Free Press.

Bourdieu, P., et al. (1999). *The weight of the world.* Stanford, CA: Stanford University Press.

Bourdieu, P. (2003). *Firing back.* New York: The Free Press.

Bourdieu, P., & Passeron, J-C. (1979). *The inheritors: French students and their relation to culture.* Chicago, IL: University of Chicago Press.

Bourdieu, P., & Wacquant, L. J. D. (1992). *Invitation to reflexive sociology.* Chicago: University of Chicago Press.

Calhoun, C. (Ed.) (1993). *Bourdieu: Critical perspectives.* Chicago: University of Chicago Press.

Calhoun, C., & Wacquant, L. J. D. (2002). "Everything is social": In memoriam Pierre Bourdieu (1930–2002). *Footnotes* 30(5): 10.

Couldry, N. (2003). Media, symbolic power, and the limits of Bourdieu's field theory. London School of Economics and Political Science. Retrieved December 2, 2004, from http://www.lse.ac.uk/collections/media@lse/mediaWorkingPapers/ewpNumber2.htm.

DiMaggio, P. (1979). Review essay: On Pierre Bourdieu. *American Journal of Sociology* 84: 1460–74.

Garnham, N., & Williams, R. (1980). Pierre Bourdieu and the sociology of culture: An introduction. *Media, Culture, and Society* 2: 209–23.

Gitlin, T. (1980). *The whole world is watching.* Berkeley: University of California Press.

Gouldner, A. (1979). *The future of intellectuals and the rise of the new class.* New York: Continuum.

Gramsci, A. (1971). *Selections from the prison notebooks* (Q. Hoare, & G. N. Smith, Trans.). New York: International Publishers.

Jacoby, R. (1987). *The last intellectuals.* New York: Farrar, Straus, and Giroux.

Jenkins, R. (1992). *Pierre Bourdieu.* London: Routledge.

Mills, C. W. (1953). *White collar*. New York: Oxford University Press.

Mills, C. W. (1958). *The causes of World War III*. New York: Simon & Schuster.

Pooley, J. (2004). *Lost in translation: Pierre Bourdieu in the history of communication research*. Paper presented at the meeting of the International Communication Association, New Orleans, LA.

Swartz, D. (1997). *Culture and power: The sociology of Pierre Bourdieu*. Chicago: University of Chicago Press.

Swartz, D. (2003). From critical sociology to public intellectual: Pierre Bourdieu and politics. *Theory and Society* 32: 791–823.

Tucker, R. C. (Ed.) (1972). *The Marx-Engels reader*. 2nd ed. New York: W. W. Norton.

·TOWARD A POLITICAL ECONOMY OF CULTURE: CAPITALISM AND COMMUNICATION IN THE SIXTEENTH CENTURY·

Lora Taub-Pervizpour

My title takes its cue from a recent publication of immense significance to scholars interested in the relationship between Marxist theory and critical research in communication. *Toward a Political Economy of Culture: Capitalism and Communication in the Twenty-First Century* (Calabrese & Sparks, 2004) should do much to instigate renewed and ruthless attention to "the role played by the means of communication in the modern world" (p. 1). The volume brings together essays from leading political economists of communication whose research has been unrelenting in laying bare the insidious workings of deregulation, privatization, liberalization, and commodification that have so reconfigured the landscape of communication and culture during the last decades of the twentieth century. At such a moment, it may seem counterintuitive to turn our attention away from these millennial developments to the role of communication in the early modern world. Yet, as I will argue in this chapter, our ability to grasp the relationship between capitalism and culture requires some considerable historical reckoning.

In this chapter I draw attention to some of the problems in our historical understanding of the role of culture and communication in the capital

accumulation process. My argument is not against analysis of new developments in the political economy of culture, indeed, I recognize the pressing need for just the kind of analysis Andrew Calabrese and Colin Sparks bring together. I argue, however, that to understand the indisputably and increasingly central place of communication and culture in the capitalist mode of production, we should look at the history of that relationship. Our understandings of "new" developments are constrained by a widespread historical shortsightedness. As Bernard Miège (2004) cautions in the fifth chapter of *Toward a Political Economy of Culture*,

> We should not be afraid to consider these changes as one stage in a longer period and should avoid falling prey to illusions of brutal ruptures, qualitative leaps, and structural upheavals that herald radical innovations. However decisive certain technological and information changes may seem, we should nevertheless beware of taking them for indications that a new era has come upon us. These changes merely serve to reaffirm the dominant mode of production by introducing communication into it in all its diverse forms all the more forcefully. (p. 93)

In his call to situate analysis of "new" media developments within the wider historical and social contexts that have shaped them, Miège suggests that even the latest changes in communication and information need to be understood in relation to the system of capitalist production that they service. But how long is this period? What history of the dominant mode of production will be useful here, and at what point in that history do capitalism and communication intersect? These are some of the fundamental questions I aim to open up in this chapter.

Political economists of communication have done much to debunk claims, gaining steam in the 1970s and widely taken for granted today, that we are living at a moment of epochal transformation. Nicholas Garnham (2001), Graham Murdock (2004), Robert McChesney, Ellen Meiksins Wood, and John Bellamy Foster, Jr. (1997), Miège (2004), and many others have brought extraordinary and varied evidence to bare against such claims that we are living in a fundamentally new era, whether one prefers to call it "postmodernity," "the information age," or "the information society." These scholars have argued the flaws in the prevailing periodization of the recent history of capitalism—industrial versus information, modern versus postmodern.

Their arguments demonstrate what is at stake in properly specifying the historical character of purportedly "new" developments. Meiksins Wood (1997) considers the fundamental political significance in periodizing the history of capitalism into modernity and postmodernity.

> Of course it is important to analyze the neverending changes in capitalism. But periodization involves more than just tracking the process of change. To propose a periodization of epochal shifts is to say something about what is essential in defining a social form like capitalism. Epochal shifts have to do with basic transformations in some essential constitutive element of the system. In other words, how we periodize capitalism depends on how we define the system in the first place. The question then is this: what do concepts like modernity and postmodernity tell us about the ways in which the people who use them understand capitalism? (p. 28)

While communication scholars have taken on issues of periodization in the recent history of capitalism, still largely unnoticed is another issue of periodization, with equally considerable consequences for our understandings of capitalism and culture. I refer here to the periodization of the early history of capitalism, and the crucial relationship of culture to early capitalist development. Systematic analysis of our received understandings of capitalism's beginnings, and the place of communication and culture in powering its early formation, is absolutely crucial to our ability to grasp and explain how the contemporary system works.

This work begins by bringing into contact important contributions from scholars working on both sides of the Atlantic, both within and beyond the field of communication, and both within and outside explicitly Marxist frameworks of analysis. And it begins from a revised understanding, emerging from one of the most consequential debates in contemporary Marxism, of the origins of the transition from feudalism to capitalism.

In England between the mid-sixteenth and early-seventeenth centuries, dramatic entertainment was transformed from a set of itinerant rag-tag practices into an institutionalized capitalist culture industry. I should underscore that it is not my primary concern to investigate how early modern drama represented or thematized the impact of emerging capitalism on human relationships. Literary critics have brought these themes into exhaustive view. At issue is the formation of new means of communication and

cultural production and the role that institutionalized theater played as a social force in the ascending world of capitalism. I do not dismiss the powerful role of the theater in projecting a particular vision of social power, but the theater was not only an ideological agent in reinforcing—or contesting—emerging relations of capitalism. Crucially, as commercial institutions, theater played a decisive role in the material expansion of capitalism in early modern England.

I propose here a historical basis for understanding the relationship between capitalism and culture much broader than current research in communication assumes. As early modern dramatists negotiated the growing incursions of capital into the conditions and practices of script production, the dramas themselves registered those tensions. Plays were a principle site for exploring and exposing the social fissures wrought by emergent capitalism precisely because plays were themselves produced within the unsettled social relations of that system. London drama, as Douglas Bruster (1992) has noted, "became intensively preoccupied with the moral and social connotations of what modern historians have retrospectively labeled 'nascent capitalism' and the 'market society' " (p. 14). Where we find plays calling into question the imprint of capitalism on human relationships, we also find playwrights, players, and a vast cast of theatrical laborers themselves negotiating the incursions of capital into the labor of drama.

No analysis of early capitalist development has taken into account the role of culture generally, and drama in particular, as a leading edge of this political economic formation. Of greater relevance to us here, however, is the fact that this early history of capitalist cultural production has yet to be registered within fields of communication research explicitly concerned with the relationship between capitalism and culture. Indeed, the historiography of capitalist, commercial culture is restricted almost exclusively to the twentieth century. While the burgeoning expansion of capital into realms of communication and cultural production during this period demands careful focus, the historical antecedents of capital's sprawling dominion remain largely unresearched.

Two decades ago, Raymond Williams (1985) asserted that "large-scale capitalist economic activity and cultural production are now inseparable" (p. 136). More recent scholarship, especially that collected in *Toward a Political Economy of Culture*, abundantly demonstrates this point. But in what historical period, it must be asked, does cultural production begin to fuel wider

networks of capital? When does culture entwine with the long and uneven development of capitalism and assume its vital place in the wider mode of production? Is it that communication, as one leading political economist of communication has contended, "was only incorporated into the heart of the capital accumulation process in the twentieth century"? (McChesney et al., 1997, p. 7).

The early twentieth century is widely taken as the period in which "communication became integrated into the capital accumulation process" (McChesney et al., 1997, p. 5). Representing this conceptualization, McChesney has asserted that "for most of industrial capitalism's first century, much of what is now considered the communication industry was not part of the capital accumulation process. Much, perhaps most, entertainment and even some journalism were conducted outside of the market or were explicitly subsidized for noncommercial purposes" (p. 5).

Without losing sight of the vibrant alternatives to commercial culture that have been historically sustained in the face of capital's formidable challenges—and brought powerfully to light through McChesney's research—a growing historiography of capitalist culture has coalesced around the related fields of American studies, U.S. cultural history, and the history of communication, calling this periodization into serious question. Scholarship focused on the nineteenth century demonstrates the struggles within a vast range of cultural forms and activities in the United States as they intersected and served wider dynamics of capitalist economic activity: dime novels, newspapers, cinema, opera, theater, burlesque, museums, amusement parks, dance halls, parks, fairs, city parades, and even broadcasting and telecommunications. Well before the twentieth century, this work demonstrates, culture and communication were already becoming key sites for cultivating and expanding capitalist class relations, marked, to be sure, by contestation.

Our historical rethinking of the commodification of culture must extend further still, to scholarship across the Atlantic, to the influential work of British Marxist historians. Vital empirical and theoretical connections justify this transatlantic crossing. Many cultural forms popularized in nineteenth-century America actually originated in England, where capital accumulation in cultural production established a much earlier foothold. The mobility of London's premiere stage performers across the Atlantic was made possible by, and directly fueled, English capitalist cultural production. Moreover, there are certainly considerable theoretical insights to be gained in more

carefully considering the work of British Marxist historians, scholarship that has not yet been adequately integrated into the critical political economic analysis of culture and communication. Of course this scholarship is immeasurably influenced by the theoretical insights of Stuart Hall and Raymond Williams, most obviously, but their contributions to the central issue of periodization have received scant attention, Schiller's (1994) research on information commoditization being a formidable exception.

Hall (1977) decisively situates the eighteenth century as the proper historical starting point for understanding and analyzing capitalist cultural production. In that period, according to Hall, "the institutions of a culture rooted in market relationships begin to appear" (p. 339). In his formulation, culture figured prominently "with and alongside" the system of agrarian capitalism rooting its way into English society. Hall's emphasis on the leading force of capitalist development in agriculture, as we shall see, was absolutely correct, but, as Schiller points out, the historical roots of agrarian capitalism and its links to cultural production are much deeper than even Hall's eighteenth-century periodization accounts for.

Similar historical uncertainties trouble the work of other British Marxist historians, including Williams, Peter Burke, and Leo Lowenthal. Again let me be clear that theoretical contributions of their work to the political economy of communication and culture are well established. Of concern here, however, is the historical ground on which their theoretical insights rest. On this point, they were uncharacteristically imprecise. Williams was less decisive than Hall in adopting the eighteenth-century periodization, wavering loosely between the sixteenth and eighteenth centuries. Importantly, Williams faced particular difficulty wrestling to fit drama within the inherited eighteenth-century framework.

In *The Country and the City* (1973), Williams traces the historical transformation of rural England from an "organic community" associated with a feudal mode of production into fields of capitalist enterprise. The later formation he equated with "the crisis of seventeenth-century England" (pp. 11–12). Williams identifies in seventeenth-century plays articulations of the pressures of new commercialism upon older customs rooted in the organic community (pp. 27–28). Usefully extending our historical perspective back into the seventeenth century, Williams, like Hall, emphasized the eighteenth century as the origins of "the long revolution" in culture and communication. His own investigations of drama, however, suggest that

this periodization is misguided. When does the long revolution begin? When does capitalist production interlock with the constitutive sites and practices of culture to which Williams so carefully attended?

Again it is in his analyses of drama that Williams confronts the problems of his own periodization. He never reconciled the historical evidence on drama with the received view privileging the eighteenth century.

If we take a long enough period, it is easy to see a fundamental transformation in English country life. But the change is so extended and so complicated, to say nothing of its important regional variations, that there seems no point at which we can sharply distinguish what it would be convenient to call separate epochs, as noted by Raymond Williams (1973, p. 35). Rejecting any historical model reducing the relationship between feudalism and capitalism to a clear line of demarcation, Williams nonetheless shied away from the full implications his research on drama had on the historical conceptualization of capitalist development in cultural production. Paradoxically, his return again and again to the eighteenth and nineteenth centuries truncated the long revolution he labored to explain. More than any other theorist of culture and communication working within a Marxist framework, Williams was consistent in his approach to the study of culture as constitutive of the whole social process. Why then would he settle for a view that changes in practices of cultural production plodded along two centuries behind the emergence of capitalist economic activity elsewhere? He had no alternative historical formulation from which to work.

The major problem here, in the work of Hall and Williams, and the subsequent research informed by them, is that the received periodization does not take into account one of the most significant historiographic revisions and debates in contemporary Marxism. Emerging in the last decades of the twentieth century, a massive body of historical research revealed that the capitalization of agricultural production began not in the eighteenth century, but fully two centuries earlier. This radical historiographic shift, unregistered by the work of Hall, Williams, and others, requires some explanation, if we are to construct, as Schiller (1994) argues we must, a more solid historical basis for contexutalizing and critiquing culture's place in the dynamic of capitalist expansion.

In one of the most consequential debates in Marxist historiography in recent decades, the so-called Brenner debates, prominent historians have effectively dismantled any historical basis for locating capitalism's origins

in the eighteenth century, either in English agriculture or industry. A more compelling account of the early history of capitalism has emerged that has yet to be incorporated into the study of English cultural development, but more important, for our purposes, has not received due attention from scholars whose research aims to understand the role of communication and culture in capitalist society. We have missed, therefore, nothing less than the early grounds upon which the contemporary commodification of cultural production is taking place.

Historian Robert Brenner (1987) led the charge to reject the dominant view of capitalism as an eighteenth-century industrial formation, in light of mounting evidence documenting the emergence of agrarian capitalist relations no less than three centuries earlier. Summarizing this historiographic shift, Schiller (1994) writes that in the late fifteenth century, "the crucial triadic relationship between landless wage laborer, capitalist tenant, and commercial landlord powered its way into English agriculture" (p. 108). According to the new formulation established by Brenner and others, the eighteenth century marked the *consolidation*, not the origins, of this crucial class relationship.

It is impossible in the space of this essay to do justice to Brenner's position, or the numerous responses the publication of his pathbreaking book, *The Agrarian Roots of European Capitalism*, provoked. Briefly, Brenner argued that radical changes in the organization and production of agriculture occurring in the late fifteenth and early sixteenth centuries comprised an agricultural revolution. English capitalism, according to Brenner and other historians (Meiksins Wood, 1991; Dobb, 1963) was "rooted in the transformation of agrarian class or property relations" (Brenner, 1987, p. 323). According to this revised view, agrarian capitalism laid the ground for and was the key to capitalist industrialization during the eighteenth century. Rather than viewing the Industrial Revolution as the springboard for capitalist expansion in Europe and beyond, Brenner argues instead that agriculture and industry were "mutually interdependent, mutually self-developing." Agriculture prompted widespread migration off the land and into industry, provided an increase in real wages and discretionary income for both the middle and lower classes, both of which fed growth in the home market. "Industry fed on agriculture and stimulated in turn further agricultural improvement," a process Brenner characterized as "an upward spiral that extended into the industrial revolution" (1987, pp. 326–27).

Communication scholars committed to research that aims to understand, explain, critique, and even challenge the role of culture and communication within capitalist class society cannot ignore the theoretical and practical implications of this historical reframing for our scholarship. These crucial historiographic revisions should seriously inform our understandings of the dynamics of more recent transformations and movements in the development of late capitalism. Schiller (1994) rightly argues, "A revised historical basis is absolutely necessary for an adequate account of the contested making of meaning within capitalist class society. This projected endeavor, of momentous import and daunting scope, defines a crucial general boundary of current scholarship" (p. 110). A full decade has passed since Schiller identified this boundary, but those historical and conceptual limits remain largely intact. Toward the goal of pushing that boundary a bit further, I now turn to some of the evidence from sixteenth-century theatrical production attesting to the fact that culture was a leading edge of early capitalist development.

Restructuring agricultural production around capitalist class relations fed urbanization as those who Christopher Hill (1991) has called the "victims of agricultural change" were wrenched from their plots of land and "took to the road in search of survival in some great city" (p. 49). London was their primary destination, swelling the city's pool of available wage labor. Between 1500 and 1650, London's population increased approximately tenfold, accounting for nearly 7 percent of the country's population, slightly over 2 million at the turn of the century (Meiksins Wood, 1991, p. 98; Clay, 1984, pp. 197–213). By the 1520s, London's population had increased to sixty thousand, and a century later it was nearly ten times that size, making it the largest city in Europe by the end of the seventeenth century, larger than either Paris or Rome (Clay, 1984, p. 107).

London was also becoming the largest distributive center for both imported and domestic goods (Meiksins Wood, 1991, p. 98). Distinctively, these goods were increasingly manufactured in workshops and factories outside of the home, a marked shift in the historical conditions and locations of labor and production. Home-produced wares were steadily replaced by goods manufactured outside of networks of the domestic economy and within the circuits of commodity production. Among the consumer goods produced for both local consumption and export were knitted woolen

stockings and caps, felt hats, iron cooking pots and frying pans, knives, swords, blades, daggers, nails, pins, glass bottles, gloves, earthen pots, copper wares, and specialized farm products such as saffron and hops (Thirsk, 1978, p. 2).

Developing alongside of and fueled by this burgeoning sphere of capitalist production and consumption was an entertainment industry with theater at its center. Theater historian Walter Cohen (1985) rightly argues that "although the city in itself by no means sufficed to bring forth a public theater, no other locale provided the economic and demographic conditions necessary for the successful interaction of investor, actor, dramatist, and audience" (p. 163). (Though success, as we shall see, was crucially dependent on one's position within this class relationship.) Theaters drew audiences from the city's sundry social divisions: apprentices, wage-earning laborers, the idling class, merchants, and nobles. Well-heeled out-of-towners came to London for a variety of consumer pleasures, including theater. They shopped in the largest markets for clothes, jewelry, glass, Mediterranean fruits, wine, and other products. They conducted banking and sought legal services. And for many wealthy visitors, London was the preferred "marriage market," where the privileged classes cultivated favorable relations for their sons and daughters. The theaters were one important arena for such pursuits (Clay, 1984, p. 205). The construction of the first permanent playhouses were integral to the changing material and social landscape of London as it powered its way to the center of early modern capitalism.

To one Londoner in this period, no arena of social life was unscathed by the emerging new social order. In 1601, John Wheeler wrote in *A Treatise on Commerce*:

> all the world choppeth and changeth, runneth and raveth after Marts, Markets and Merchandising, so that all things come into Commerce, and pass into traffice (in a manner) in all times, and in all places: not only that, which nature bringeth forth, as the fruits of the earth, the beasts, and living creatures, with their spoils, skins and cases, the metals, minerals, and such like things, but further also, this man maketh merchandise of the works of his own hands, this man of another man's labor, one selleth words, another maketh traffic of the skins and blood of other men, yea there are some found so subtle and cunning merchanges, that they persuade and induce men to suffer themselves to be bought and sold. (Wheeler, 1601/1977, pp. 6–7)

Wheeler takes note of aspects of the period largely ignored by subsequent generations of economic historians: the commodification and marketing of entertainment. "One selleth words" may refer to the hearty trade in cheap ballads, pamphlets, and chapbooks. But indisputably the largest market for "words" was the theater. "That light commodity of words," as playwright Thomas Dekker referred to drama, was sold daily (except for Sundays, and during Lent and outbreaks of plague) by at least a half dozen competing London playing companies and reached a larger audience than printed matter, since spectatorship did not depend on literacy. Increasingly, a trip to one of the city's public playhouses was becoming London's most popular entertainment pursuit.

Changes in the conditions of playgoing accompanied the capitalist reorganization of dramatic entertainment. The new playhouses introduced a more calculated and controlled system of admissions than itinerant players previously utilized. Before the permanent playhouses, players performed in market spaces, inn and churchyards, taverns, and other public venues, where custom was to pass a hat through the crowd to gather whatever earnings the spectators offered up. Such custom offered little guarantee of income and invited risk of theft. In the newly rationalized process of admissions introduced with the permanent playhouses, playgoers gained access to the theater only after paying a fixed price according to their seat (the cheapest admission was a penny).

Just how large was the market of playgoers in London? In his authoritative work on playgoing, Andrew Gurr (1996) makes a "conservative estimate" that during the seventy-five-year period in which public playhouses operated in early modern London, some 50 million paying playgoers passed through playhouse doors (p. 59). In 1595, when approximately 150,000 people lived in London, combined attendance for all theaters was probably close to 600,000 (Harbage, 1962, pp. 37–38). In 1620, as many as 25,000 people attended the playhouses weekly and 15 to 20 percent of Londoners who lived near the theaters might be considered "regular playgoers" (Foakes, 1985, p. 12). Access to the standing space directly in front of the stage known as the "pit" was just cheap enough that even porters, servingmen, and apprentices could muster the cost. While even those earning the most meager wages might visit the playhouses occasionally, the one-penny pit was surely beyond the reach of London's vast ranks of penniless poor. Jean Howard (1993) is insightful in pointing out the hyperbole of the antitheatrical tracts of the period warning

that habitual playgoing would surely stir the city's "masterless" and "idle vagrants" to riot and rebellion. London's most destitute would not have had the means to support the habitual playgoing in which they were allegedly engaged (p. 30). Extant references to specific persons entering play-houses between 1576 and 1642 allows us to identify some of those who comprised the early modern playgoing public: sailors, servingmen, tinkers, tailors, shoemakers, butchers, feltmakers, prostitutes, merchants, courtiers, artisans, Inns of Court men, gallants, gentrymen and women, noble lords, dukes and duchesses, citizens and their wives and daughters (Gurr, 1996, pp. 191–204).

The remarkable rate of playgoing caught the attention of preacher T. W., who delivered a sermon at St. Paul's in 1577 enjoining the gathered crowd to "Look but upon the common plays in London, and see the multitude that flocketh to them and followeth them: behold the sumptuous Theatre houses, a continual monument of London's prodigality and folly (quoted in Chambers, 1923, p. 197). With the social and moral agenda they promoted, antitheatricalists like T. W. clearly had reason to embellish. They were not "objective" witnesses, and their tracts must be read in the context of an ongoing campaign to shut the new theaters down. Still, T. W.'s account of the massive number of playgoers is echoed frequently throughout the period in a range of sources, not all of them opposed to playhouses, players, or playgoing.

By adversaries and advocates alike, London's new playhouses were frequently characterized as markets in miniature. Stephen Gosson, who wrote plays before turning his pen to antitheatrical tracts, linked the theater to London's Royal Exchange, which operated like a stock market, where merchants conducted affairs of domestic and international commerce. Playwright Thomas Dekker thematized the relationship more favorably in *The Gull's Horn-Book* (1609). In a chapter titled "How a gallant should behave himself in a Play-house," Dekker describes the theater as a poet's royal exchange, where playwrights' muses had become merchants.

The relationship between drama and the market in early modern London is of great interest to the political economy of culture, but efforts to understand and explain this relationship have been made primarily by literary scholars concerned above all with the textual articulations of this relationship. Most accounts have sought to trace "a perceived correspondence between economic commodification and representation" (Pye, 1994, p. 501).

While communication scholars will find in this effort some parallel to analyses of contemporary media representations, this is not the primary concern of political economy. No analysis of early modern theater has centered upon the capitalist reorganization of labor within dramatic production. It is here, ultimately, that the relationship between drama and the market is materialized in its historically specific form, at the point of greatest interest to a political economy of culture within the capitalist mode of production.

The profit motive driving the rise and expansion of commercial drama in early modern London has been well recognized by leading theater historians. While lingering ties of royal patronage still exerted themselves at some points of the production process, and remained symbolically and legally important, the key point is that players no longer received houseroom or wage off their lord. Players were newly among the ranks of London's wage laborers, playing for wages controlled by a playhouse owner and gathered from a paying, playgoing public.

In a now classic study, *Drama and Society in the Age of Jonson*, L. C. Knights (1937) mapped the social and economic foundations of Renaissance drama and provided a model of the relationship between drama and society that has been perpetuated in more recent scholarship. In the first few chapters of his book, Knights surveyed the broad social changes in Elizabethan London, essentially noting the diffusion of a capitalist mode of production, distribution, and consumption across a broad range of wares: coal, iron, copper, salt, glass, and soap, to name a few. Having established the "context," Knights then turned to Jonson's plays, which he argued promoted a critique of bourgeois acquisitiveness and individualism. The model perpetuates the familiar bifurcation between society and culture, between "the base" and "the superstructure," a model so soundly discredited by Williams. In exploring the "social and economic bases" of drama, Knights looked at the commodification of nontheatrical spheres of production—the manufacture of coal and iron, for example—and failed to recognize how the very same commodification process was radically restructuring dramatic production. Indeed, because dramatic production depended upon a vast range of industries and labors newly entwined in networks of capitalist production, this site of cultural production may rightfully be identified as a spearhead of capitalist expansion in early modern England. But this view was missed by Knights, and subsequent generations of theater historians, who have continued to focus on the ways that drama "reflected" or "mirrored"

changes happening "in society"—as if culture exists somewhere outside of this broader social milieu.

A noteworthy effort to break from this dualism is Jean Christophe Agnew's influential study, *Worlds Apart: The Market and the Theatre in Anglo-American Thought, 1550–1750*. For Agnew (1988), the early modern stage comprised "a laboratory of and for the new social relations of agricultural and commercial capitalism" (p. xi). Agnew's laboratory is the stage itself, where plays explored ways of negotiating a shifting social world under the sway of the expanding logic of capitalism. According to Agnew, it was a period in which markets were losing their "fixedness" in time and space and becoming formless, elusive, as a national market overtook local commerce. The importance of these representations as mediations for playgoers attempting to make meaning in a changing society is not in question here. But the links to the theater were not purely—nor principally—metaphorical. While Agnew is concerned with the "crisis of representation" capitalism wrought onstage, it is the crisis *backstage*, in the reconfiguration of social labor, that makes the playhouses so central to the early history of capitalism (and hence of vital importance to a political economy of culture). Indeed, as sites of cultural production, the early modern playhouses reveal quite fully the inextricable links between base and superstructure that Williams labored to underscore.

The materiality of early modern theater is given more attention by Douglas Bruster (1992), who argues against Agnew's focus on the metaphorical relationships between the market and theater. Bruster's work "begins with the premise that the theater was, a priori, a market, that it was, primarily, a place of business—and, as a business, part of a complex of centralizing institutions" (p. 10). There is no need to deny the stage its social vision—but the point is to remember the social forces shaping such vision. Bruster moves in the right direction when he argues that "the economic foundation of the playhouses…established a map of interests that must be charted alongside, if not before, a similar sketch of more explicitly ideological concerns" (p. 10).

Helpfully, Bruster's material theater moves us away from the recently fashionable emphasis on the "marginality" of early modern playhouses. In *The Place of the Stage: License, Play, and Power in Renaissance England*, Steven Mullaney (1995) emphasizes the geographic and social marginality of playhouses. According to this popular view, the very location of the theaters at

the outer boundaries of the city in an area known as the Liberties allowed the theater to perform a subversive role in early modern society and politics. In Mullaney's words,

> When popular drama moved out into the Liberties to appropriate their ambivalent terrain for its own purposes, it was able to do so only because the traditions that had shaped and maintained those Liberties were on the wane. A gap had opened in the social fabric, a temporary rift in the cultural landscape that provided the stage with a place on the ideological horizon, a marginal and anamorphic perspective on the cultural dynamics of its own time. (p. 136)

Were playhouses sites of cultural rebellion and ideological subversion? Whose interests were challenged, and whose were asserted, in the playhouses? Such questions need to be pursued not only in relation to the entertainment staged, but above all in reference to the social relationships that produced and controlled dramatic commodities. Mullaney's and other postmodernist readings of early modern drama overstate the subversive power of dramatic entertainment at the expense of any recognition of the capitalist class interests reorganizing its production during this period.

The importance of early modern drama to an historically informed political economy of culture is best revealed when we see the theater not mainly as a site of business, but as a site of *labor*. While the scholarship on early modern theater generally equates the physical permanence of the new playhouses with a new "professionalism" and "stability" for players, the newly developing capitalist conditions of production rendered the labor of playing precarious in new, decisive ways. What was gained, and what was lost, as players' itinerant practices were newly centralized in London and brought under the control of theater landlords? It seems to me a mistake to identify the new theaters as hallmarks of stability for dramatic laborers. Surely, the commodification of playing destabililized traditional forms and practices of dramatic production in the process of institutionalizing others. As sites of production, theaters were sites of struggle, and those struggles were not confined to dramatic representations on stage. As the central institutions of early modern cultural production, marked by the imposition of a wage system on labor previously organized along other lines, early modern playhouses did much more than "reflect" capitalist

transformation. Cultural production was at the very heart of the commodi-fication process taking hold of early modern London.

While my argument here necessarily draws on research well beyond the boundaries of communication scholarship, it should be clear that my purpose in doing so is to open up for study a historical moment in cultural production that bears implications for efforts within communication to grasp and theorize the role of culture in capitalist class society. This essay offers some preliminary evidence "that will link commoditization of cul-tural production to that long moment of transition, and to the social relations that circumscribed and defined it" (Schiller, 1994, p. 109). In working toward a political economy of culture there must be some serious effort to account for those sites of communication and culture where commoditization estab-lished an early hold. Early modern cultural production was a leading venue for extending capitalist class relations as it was reorganized along lines that directly served the wider achievements of capital in this historical transi-tion. Such knowledge casts serious doubt over the periodization of cultural commodification that still prevails in much communication research, even within critical political economy. Grasping the early history of cultural commodification in the sixteenth century is crucial to understanding this process and its diffusion in the twenty-first century.

References

Agnew, J. C. (1988). *Worlds apart: The market and the theatre in Anglo-American thought, 1550–1750.* Cambridge: Cambridge University Press.

Aston, T. H., & Philpin, C. H. E. (Eds.) (1985). *The Brenner debate: Agrarian class struc-ture and economic development in pre-industrial Europe.* Cambridge: Cambridge University Press.

Brenner, R. (1987). *The agrarian roots of European capitalism.* London: Cambridge University Press.

Bruster, D. (1992). *Drama and the market in the age of Shakespeare.* Cambridge: Cambridge University Press.

Calabrese, A., & Sparks, C. (2004). *Toward a political economy of culture: Capitalism and communication in the twenty-first century.* Lanham, MD: Rowman and Littlefield.

Clay, C. (1984). *Economic expansion and social change: England, 1500–1700.* Cambridge: Cambridge University Press.

Chambers, E. K. (1923). *The Elizabethan stage*. Oxford: Oxford University Press.

Cohen, W. (1988). *Drama of a nation: Public theater in Renaissance England and Spain*. Ithaca, NY: Cornell University Press.

Dobb, M. (1963). *Studies in the development of capitalism*. New York: International Publishers.

Foakes, R. A. (1985). *Illustrations of the English stage, 1580–1642*. Stanford, CA: Stanford University Press.

Garnham, N. (2001). Information society theory as ideology: A critique. *Studies in Communication Sciences* 1(1): 129–66.

Gurr, A. (1996). *Playgoing in Shakespeare's London*. Cambridge: Cambridge University Press.

Hall, S. (1977). Culture, the media, and the "ideological effect." In J. Curran, M. Gurevitch, & J. Woollacott (Eds.), *Mass communication and society* (pp. 315–48). London: Edward Arnold.

Harbage, A. (1962). *Shakespeare's audience*. New York: Columbia University Press.

Hill, C. (1991). *Change and continuity in seventeenth century England*. New Haven, CT: Yale University Press.

Howard, J. (1993). *Stage and social struggle in early modern England*. New York: Routledge.

Knights, L. C. (1937). *Drama and society in the age of Jonson*. London: Chatto.

McChesney, R., Meiksins Wood, E., & Bellamy Foster, J. (Eds.) (1997). *Capitalism and the information age: The political economy of the global communication revolution*. New York: Monthly Review Press.

Meiksins Wood, E. (1991). *The pristine culture of capitalism*. New York: Verso.

Meiksins Wood, E. (1997). Modernity, postmodernity, or capitalism? In R. McChesney, E. Meiksins Wood, & J. Bellamy Foster (Eds.), *Capitalism and the information age: The political economy of the global communication revolution*. New York: Monthly Review Press.

Miège, B. (2004). Capitalism and communication: A new era of society or the accentuation of long-term tendencies? In A. Calabrese, & C. Sparks (Eds.), *Toward a political economy of culture: Capitalism and communication in the twenty-first century*. Lanham, MD: Rowman and Littlefield.

Mullaney, S. (1995). *The place of the stage: License, play, and power in Renaissance England*. Ann Arbor: University of Michigan Press.

Murdock, G. (2004). Past the posts: Rethinking change, retrieving critique. *European Journal of Communication* 19(1): 19–38.

Pye, C. (1994). The theater, the market, and the subject of history. *English Literary History* 61(3): 501–22.

Schiller, D. (1994). From culture to information and back again: Commoditization as a route to knowledge. *Critical Studies in Mass Communication* 11(1): 117–40.

Thirsk, J. (1978). *Economic policy and projects: Development of a consumer society in early modern England.* New York: Clarendon Press.

Wheeler, J. (1977). *A treatise on commerce.* New York: Arno. (Original work published in 1601).

Williams, R. (1973). *The country and the city.* London: Paladin.

Williams, R. (1985). *Marxism and literature.* Oxford: Oxford University Press.

·COMMUNICATION AND CONTRADICTION: LIVING HISTORY AND THE SPORT PAGES OF THE *DAILY WORKER*·

Susan C. Leggett

We need to know this [radical sport] history because it is a living history—which is precisely what makes it so threatening.... By speaking out for the political soul of the sports we love, we do more than just build a fighting left that stands for social justice. We also begin to impose our own ideas on the world of sports—a counter morality to compete with the rank hypocrisy of the pro leagues. These are ideas that can embrace and cheer competition. That can appreciate the artistic talents of athletes and the strategy of coaches and players alike.
 —Dave Zirin, "Storming the Castle," Edge of Sports

Journalist David Zirin's (2005) collection of essays, *What's My Name, Fool? Sport and Resistance*, addresses readers with an energy more typically reserved for the newly converted. Zirin's writing is a call-and-response for citizen-fans to take the lessons of radical sports history not only to the playing fields of U.S. schools, playgrounds, to stadiums but also to streets across the country. In short, he calls for an all-out "storming the castle" of an institution—sport—taken hostage by the imperial interests of capital. For Zirin, this "storming the castle" is a refusal to remain ignorant of

the political contexts in which sport exists, it is to witness the heroism of athletes as a practicing journalist, it is to speak truth to power as an athlete.

By redirecting our conversation about sport to its origins in sanctioning social stability and initiating social change to storm the castle is to bring history alive. Just how mass media attends to sport is part of "remembering to forget" sport's relationship to nation building, racism, and sex/gender discrimination. For Zirin the journalist, the potential for change through a radical sport movement lives still amid the advertisements and industry practices that generate ruthless class relations, exploitive gender relations, decimated cityscapes, and false promises of social mobility. Citizen-fans speak out and unite.

For communication, the texts of what Sut Jhally (1989) calls the sport/media complex offer little in the form of resistance. Indeed, analysis of specific texts dealing with the deployment of sport/war metaphors during the Gulf Wars (Sabo & Jansen, 1994; Schechter, 2005) and intensified citizen surveillance at sport events such as the Super Bowl (Moore, 2001) make visible the connections sport has with dominant institutions. Sport texts offer systems of representation that celebrate and articulate the dominant values sustaining capitalism. In naming these relationships it is tempting to argue that sport and media themselves are so fully enmeshed in the state apparatus that they are unlikely, even impossible, spaces in which to find meaningful critiques of capitalism and its predatory practices. Yet, in the face of massive mobilization of the forces of capital to create a sport empire that services its cannibalistic needs for consumption and empire building, we know that athletes speak out, journalists speak out, citizens speak out. Zirin's Web page *Edge of Sports* is a testimony to those athletes whose actions bespeak a contemporary social justice agenda. *Edge of Sports* is also a testimony to what could be in contemporary sport journalism, in part by remembering what journalism forgets.

For communication, the potential of sport lives hidden deep in sport as a cultural form. While communication claims interest in historical memory, the discipline has yet to imagine and theorize sport and as a site for articulation and the recruitment of fans and athletes to membership in radical movements. The discipline of communication is silent on the living history of what is characterized by Harvey Levenstein (1974) as "probably the most important single publication in the history of radical journalism in the

United States" (p. 226), the *Daily Worker*, Communist Party, United States of America (CPUSA). The *Daily Worker* came to embody the cultural, social, political—and financial—challenges of recruiting new members to the CPUSA. If, as George Lipsitz (1990) writes, "[c]ultural forms create conditions of possibility, they expand the present by informing it with memories of the past and hopes for the future; but they also engender accommodation with prevailing power realities" (p. 16). Communication must now focus its efforts on such work.

By looking back at Marxist critiques of sport and looking forward with tools forged from Marxism, perhaps communication scholarship may articulate the complexities of the relationships as yet unknown radical movements will have with the social and cultural fields their potential members inhabit. Ultimately, the reflection offered in this chapter adopts the position that the virtual silence in communication about the sport column in the *Daily Worker*, newspaper of the Communist Party USA from 1924 to 1958 (Levenstein, 1974), results from a disciplinary emphasis on a dehistoricized analysis of media texts at the expense of analysis of social relations. An examination of the *Daily Worker* offers two lessons to communication: (1) retell the origin stories of sport and communication and (2) embrace contradiction in the living history of the *Daily Worker*.

Lesson 1. Retell the Origin Stories: Communication and Sport

If history comes alive in the telling of origin stories that refuse to sever production from reception, an examination of the social forces that have the power to sanction one story over another is instructive. Communication and sport each have their own origin stories that both obscure and reveal the promise of sport experience.

Sport continues to occupy a contradictory and complex position in American social and cultural life. Sport has functioned to solidify and to reproduce the social order (for example, Bairner, 2001; Wakefield, 1997). At the same time, sport has functioned as a space where athletes and journalists have a vibrant history of engagement, if not always voluntary, with progressive social and political agendas. We know that despite very real structural obstacles and personal consequences, athletes and journalists

have individually and collectively spoken out against war, racial discrimination, class oppression in the United States, and gender oppression.

From the refusals of Muhammad Ali, Tommie Smith and John Carlos, and Mahmoud Abdul Rauf to support imperialist invasions abroad and apartheid practices at home, sport contains moments where the symbols of radical political protest are made visible. Lesbians and straight women have found community, strength, and even safety in sporting contexts (Cahn, 1994; Festle, 1996; Griffin, 1998). Professional sport became a venue for African Americans to cross the color line. Irish and other immigrants understood sport as a vehicle for social mobility and a sense of belonging in America, as well as a context in which to maintain connections with communities of origin (Bairner, 2001; Reiss, 1995). Sport has even functioned in the Trobriand Islands as a space where identifies are refashioned and reclaimed through cricket in the face of colonial oppression (Kildea & Leach, 1979).

While marginalized populations have found in sport a home for solidarity and for progressive athletes to voice dissent, we also know that institutionalized sport has functioned aggressively to solidify the social order. Sport as an institution and set of practices that severs community and politically charged roots has not escaped Marxist critique.

As early as the 1930s, critics of sport, inspired by Marx's critique of capitalism and its social relations, argued that in its inception sport was antithetical to the goals of social justice and revolution. At base, sport was an institution based in class relations of capitalism. The rise of modern sport— what we recognize as sport today—at the turn of the twentieth century parallels the intensification of the state and economic apparatus of empire building. The bodies of athletes become commodities to produce surplus value for a small capitalist class of team owners. Moreover, sport deflects the attention of the masses to trivial matters, not politically engaged activities that might revolutionize class relations (Brohm, 1978). In short, theories of sport born from Marxism examine closely the creation of surplus value, processes of commodification and empire building, as well as the social fields to which sport is connected.

Collectively, then, sport becomes entangled in the "opiate argument." That is, sport is a tool to subdue and redirect the attention of working people to politically insignificant activities. These premises have been deployed to make critical sense of sport across multiple disciplines, including communication.

The origin story of sport as told by Sut Jhally (1989) characterizes critiques of sport as falling into two categories: ritual/ideological analysis and compensatory fulfillment. In telling this story, Jhally has argued that an analysis of the sports/media complex must go beyond the analysis of the ideological workings of content. The ideological workings of content in commodity form need to be examined, according to Vincent Mosco (1996), because "in addition to its ability to produce surplus value (thereby behaving like all other commodities), it contains symbols and images whose meaning helps to shape consciousness" (p. 147). However, again according to Mosco, content is "too often treated as instrumental to (in some political economy) or autonomous from (in structuralism and post structuralism) ideology" (pp. 147–48). Such dis-integration is largely the case in communication research on sport texts (Jhally, 1989). To refashion research about sport media, communication must examine the social relationships and social fields inhabited by members of radical and progressive groups.

Just as specific athletes and moments in history have claimed sport as resistive terrain, with the publication of Jhally's *Cultural Studies and the Sport/Media Complex* (1989) scholars have wanted to claim sport, and what Jhally calls the sport/media complex, as such terrain where it is possible to "fight for definitions of the social world" (Jhally, 1989, p. 71), where sport and media are posited as spaces where the "contradictions of capitalism" might be revealed.

Surely, examination of resistance to the reproduction of social inequality invigorates critiques of sport and media. Especially prominent in extant research are content critiques of violence, critiques of the portrayals of women, racial minorities, and nationalistic fervor evinced in media content. Especially absent, however, are examinations of lived experiences of citizen-fans and their relationships to the military-industrial complex and processes of globalization. There are some notable exceptions (Sabo & Jansen, 1994; McBride, 1995; Foley, 1990). There are also models for conducting the detailed economic analyses required to trace the relationships between capitalist imperatives and the arena of sport and media (for example, McAllister, 1998; Bellamy, 1998; McChesney, 1989).

Admittedly, though, the texts of sport and media are irresistible as objects of analysis. They embody the stunning technological achievements in media. They display astonishing and breathtakingly beautiful human performances. True, these artifacts can be spaces to read back into production processes.

Analysis of text, however, remains insufficient. Keenly aware of the tremendous cultural and social power of sport, Jhally (1989) suggests a research program for sport and media that includes, but does not prioritize, textual analysis. Drawing from Richard Johnson's circuit of culture model, Jhally argues that we can understand the power sport commands by examining the production and the commodity contexts of sport, the processes through which sport media messages are encoded; the texts produced; reader decoding of sport media texts; and social relations and lived experiences where scholars must examine "how people live their lives and the constraints and possibilities imposed by wider social, cultural, political and economic movements" (Jhally, 1989, p. 90). Thus, texts in analyses drawing upon the legacy of Marxism are crucial as commodities, as commodities that produce surplus value and as commodities that assume ideological significance in their valorization of the priorities of capital.

General concerns about an overemphasis in communication on the texts of sport and media aside, the *Daily Worker* remains conspicuously, and somewhat ironically, absent from studies of sport and media, even those adopting Marxist theoretical or radical perspectives. The *Daily Worker*, for example, is included in a 1974 collection of radical press but not in recently published collections of revolutionary press (for example, Streitmatter, 2001) or in recent collections of radical media (Downing, 2001). While it is not incumbent (or possible) for such collections to address each form of such press, the *Daily Worker* is a social artifact of what is arguably the most important radical movement of the 1930s and '40s (Levenstein, 1974). It is to the contradictions evinced in the sport pages of the *Daily Worker* that communication must turn.

Lesson 2. Embrace Contradiction: Living History and the *Daily Worker*

How might sport and coverage of sport act as a powerful cultural form to mobilize class consciousness or, at the very least, offer a critique of the forces exacerbating inequality and compromising human dignity? Vincent Mosco (1996) asks us to examine dissent and resistance by asking two deceptively simple questions, "How is it organized and how is it expressed?" (p. 167). Situated as the voice of the Communist Party USA, the *Daily*

Worker functioned as a voice of dissent and challenge to forces of capital exploitation.

Beginning in 1924, the *Daily Worker* was at once inside and outside the production apparatus of contemporaneous commercial dailies (Buhle, 1992; Levenstein, 1974). Funded by the CPUSA and its supporters, the *Daily Worker* did not rely on advertising, as was becoming more common by the 1930s (McChesney, 1989). The sport column initiated in the *Daily Worker* in 1936, however, stands out too in its reliance on the emergent codes and conventions of sport coverage in commercial dailies of the 1930s. An emphasis on contests, sport heroes, football scores, Army versus Notre Dame game previews, and the like might make this aspect of the paper a less enticing artifact to analyze precisely because it follows conventions of dominant modes of sport coverage. Still, if we are interested in the relationship between theory and practice we are bound in communication to ask, Why would a paper of a radical group cover sport? Why would the *Daily Worker* cover sport in a fashion that does not in and of itself draw upon Marxist critiques of capitalism so prevalent elsewhere in the paper at the time? Why would the sport column not illuminate the contradictions lived by working people during the years of the *Daily Worker* publication? In fact, given Marxist critiques of sport in circulation at the time, why would the *Daily Worker* address sport at all?

The *Daily Worker* most certainly did cover sport and it did so as a priority. Situated among *Daily Worker* stories announcing increases in milk prices, strike violence perpetrated by police, and dangerous working conditions, and assertive articles critiquing U.S. foreign policy. The paper regularly covered racial apartheid as practiced in the U.S. such as the arrest and trial of the Scottsboro Boys. (Not coincidentally, the *Daily Worker* was the only white-dominated press to cover this issue.) Yet, even given the gravity of these political and social issues, the sport pages take up approximately one eighth of the paper.

The most radical sport coverage centered on race relations, and the *Daily Worker* confronted racism in American sport both in its articles and through the activism of its staff, most especially sports writer Lester Rodney (Silber, 2003). The *Daily Worker* is recognized for its role in breaking the color line in baseball (Silber, 2003; Rusinack & Lamb, 2001). Not only did the *Daily Worker* cover black athletes and racial injustice, but Rodney himself dedicated his efforts to pressure major league baseball to break the color line (Silber, 2003).

Mark Naison (1979) examines what initially appear to be contradictions between the hopes of radical movement for worker solidarity and its sport coverage. At this historical moment these contradictions offer lessons in theory and practice to the discipline of communication. The organizational and institutional struggle within the *Daily Worker* provide opportunities to examine the ways the CPUSA operated as a radical movement and the ways the paper articulated the contradictions and lived experience of workers under capitalism.

Naison argues that when the *Daily Worker* (and other communist publications, such as the *Young Worker*) critiqued sport as an "opiate of the masses," drawing directly from Marxist critiques, readers and potential party members, quite simply, did not respond. Such coverage and critique left workers unsatisfied and the CPUSA still seeking membership. In essence, Naison suggests, workers did not in fact want to be cast as living outside the capitalist class in the context of sport fandom or to become critics of the developing and newly opening arena of professional sports. The CPUSA understood well the power of sport as a site where the capitalist class and industrialists wanted to inculcate new immigrants and second-generation Americans with values consonant with capitalism. At the same time, the CPUSA was faced with accepting a lack of new membership or maintaining the more strict Marxist critique of sport.

Professional sport became simultaneously an important part of building a worker movement (especially among young workers) and a site of potential communist organizing. This contradictory position can be partially resolved by recognizing the party's larger pragmatic strategy of joining with others who did not share the desire for radical economic and social reform to support programs such as the New Deal and to join the fight against fascism in Spain. Naison (1979) argues that what some critics regarded as capitulation to the cultural forces of the bourgeois was a strategy for recruiting new members. Only assertive and strong recognition of the working class's interest in boxing, racing, and participation in team sports might provide the CPUSA inroads into shaping attitudes of working class.

The CPUSA recognized that the party simply could not address sport in the same fashion, as radically, as it addressed other issues to working people. Sport historians have argued that American workers and immigrants found meaning and community in these activities. Further, the CPUSA actively recruited workers for participation in sport leagues developed as

alternates to the YMCA, or industrial leagues that were clearly designed to inculcate values supporting the interests of capital (Bairner, 2001; Naison, 1979) In some sense, then, it is possible to argue that the CPUSA did not deploy the radical potential of its own movement in this forum. To do so was to lose the potential alliance and membership of the working class.

A historical analysis of live experience of workers and sport in both industrial leagues and in communist leagues provides important context for communication researchers seeking to understand the relationship between social fields, means of production, and the appropriation of leisure time by the interests of capital. Communication can examine what must be named as the commodification of the sport experience even in the context of the newspaper of the CPUSA. While the paper as a whole did not operate along the same principles as commercial dailies of the time, the necessity to appeal to the consciousness of workers, to the spaces where workers lived, was a reality of political organizing.

The *Daily Worker*, then, challenges and teaches us not to celebrate media from radical groups unconditionally—but rather to examine the compromises and realpolitik of movement building. More important, it teaches us that the forces of capital are so powerful, its predatory capacity so thorough, that we must engage the theoretical apparatus of Marxism now to understand the staying power of sport as definitive in the social and cultural relations of competing and contesting classes.

In short, while we might argue that the radical potential of the *Daily Worker* breaks down to some extent on the sport pages, it surely does not in the practices of journalists like Lester Rodney. It is that discontinuity that demands our attention. In journalistic practice we must link past, present, and future—as David Zirin does. As communication scholars, we must seek out those discontinuities in other radical media to better understand movement building in its cultural contexts with the aim of human liberation.

References

Bairner, A. (2001). *Sport, nationalism, and globalization: European and North American perspectives.* Albany, NY: SUNY Press.

Bellamy, R. (1998). Professional sports organizations: Media strategies. In L. Wenner (Ed.), *Media, sports, and society* (pp. 120–33). Newbury Park, CA: Sage.

Brohm, J. M. (1978). *Sport: A prison of measured time*. London: Ink Links.

Buhle, P. (1992). *Daily Worker* (and successors). In M. J. Buhle, P. Buhle, & D. Georgakas (Eds.), *Encyclopedia of the American left* (pp. 178–82). Urbana: University of Illinois Press.

Cahn, S. (1994). *Coming on strong: Gender and sexuality in twentieth-century women's sport*. Cambridge, MA: Harvard University Press.

Downing, J. (2001). *Radical media: Rebellious communication and social movements*. Thousand Oaks, CA: Sage.

Festle, M. (1996). *Playing nice: Politics and apologies in women's sports*. New York: Columbia University Press.

Fighting Words: Selections from twenty-five years of the Daily Worker. (1949). New York: New Century Publishers.

Foley, D. (1990). *Learning capitalist culture: Deep in the heart of Tejas*. Philadelphia: University of Pennsylvania Press.

Griffin, P. (1998). *Strong women, deep closets: Lesbians and homophobia in sports*. Champaign, IL: Human Kinetics.

Jhally, S. (1989). Cultural studies and the sport/media complex. In L. Wenner (Ed.), *Media, sports, and society* (pp. 71–93). Newbury Park, CA: Sage.

Kildea, G., & Leach, J. (1979). *Trobriand cricket: An ingenious response to colonialism*. Video. (Available from Ronin Films.)

Levenstein, H. (1974). The *Worker/Daily Worker*. In J. Conlin (Ed.), *The American radical press, 1880–1960* (pp. 224–43). Westport, CT: Greenwood Press.

Lipsitz, G. (1990). *Time passages: Collective memory and American popular culture*. Minneapolis: University of Minnesota Press.

McAllister, M. (1998). College bowl sponsorship and the increased commercialization of amateur sports. *Critical Studies in Mass Communication* 15: 357–81.

McBride, J. (1995). *War, battering, and other sports: The gulf between American men and women*. Amherst, NY: Humanity Books/Prometheus.

McChesney, R. (1989). Media made sport: A history of sports coverage in the United States. In L. Wenner (Ed.), *Media, sports, and society* (pp. 49–69). Newbury Park, CA: Sage.

Mosco, V. (1996). *The political economy of communication*. Thousand Oaks, CA: Sage.

Naison, M. (1979, July–August). Lefties and righties: The Communist Party and sports during the Great Depression. *Radical America*, pp. 47–59.

Reiss, S. (1995). *Sport in industrialized America, 1850–1920*. Wheeling, IL: Harlan Davidson.

Rusinack, K., & Lamb, C. (1999). A sickening red tinge: The *Daily Worker*'s fight against white baseball. *Cultural Logic*: An Electronic Journal of Marxist Theory and Practice 3 (1). Retrieved August 25, 2005, http://eserver.org/clogic/3-1&2/rusinack&lamb.html.

Sabo, D., & Jansen, S. (1994). The sport/war metaphor: Hegemonic masculinity, the Persian Gulf War, and the new world order. *Sociology of Sport Journal* 11(1): 1–17.

Schechter, D. (Director). (2005). *Weapons of mass deception*. Video. (Available from Cinema Libre.)

Silbur, I. (2003). *Press box red: The story of Lester Rodney, the communist who helped break the color line in American sports*. Philadelphia, PA: Temple University Press.

Streitmatter, R. (2001). *Voices of revolution: The dissident press in America*. New York: Columbia University Press.

Wakefield, W. (1997). *Playing to win: Sports and the American military, 1898–1945*. Albany, NY: SUNY Press.

Zirin, D. (2005). *What's my name, fool? Sports and resistance in the United States*. Chicago, IL: Haymarket Books.

·CORPORATE CULTURE VERSUS PUBLIC EDUCATION AND DEMOCRACY: A CALL FOR CRITICAL PEDAGOGY·

Henry A. Giroux and Susan Searls Giroux

Although critical pedagogy has a long and diverse tradition in the United States, its innumerable variations reflect both a shared belief in education as a moral and political practice and a recognition that its value should be judged in terms of how it prepares students to engage in a common struggle for deepening the possibilities of autonomy, critical thought, and a substantive democracy. We believe that critical pedagogy at the current historical moment faces a crisis of enormous proportions. It is a crisis grounded in the now commonsense belief that education should be divorced from politics and that politics should be removed from the imperatives of democracy. At the center of this crisis is a tension between democratic values and market values, between dialogic engagement and rigid authoritarianism.

Faith in social amelioration and a sustainable future appears to be in short supply as neoliberal capitalism performs the dual task of using education to train workers for service-sector jobs and produce lifelong consumers. At the same time, neoliberalism feeds a growing authoritarianism steeped in religious fundamentalism and jingoistic patriotism encouraging intolerance

and hate as it punishes critical thought, especially if it is at odds with the reactionary religious and political agenda pushed by the Bush administration. Increasingly, education appears useful to those who hold power, and issues regarding how public and higher education might contribute to the quality of democratic public life are either ignored or dismissed. Moral outrage and creative energy seem utterly limited in the political sphere, just as any collective struggle to preserve education as a basis for creating critical citizens is rendered defunct within the corporate drive for efficiency, a logic that has inspired bankrupt reform initiatives such as standardization, high-stakes testing, rigid accountability schemes, and privatization.

Neoliberalism has become one of the most pervasive and dangerous ideologies of the twenty-first century. Its pervasiveness is evident not only by its unparalleled influence on the global economy, but also by its power to redefine the very nature of politics and sociality. Free-market fundamentalism rather than democratic idealism is now the driving force of economics and politics in most of the world. Its logic, moreover, has insinuated itself into every social relationship, such that the specificity of relations between parents and children, doctors and patients, teachers and students has been reduced to that of supplier and customer. It is a market ideology driven not just by profits but also by an ability to reproduce itself with such success that, to paraphrase Fred Jameson, it is easier to imagine the end of the world than the end of neoliberal capitalism. Wedded to the belief that the market should be the organizing principle for all political, social, and economic decisions, neoliberalism wages an incessant attack on democracy, public goods, the welfare state, and noncommodified values. Under neoliberalism everything is either for sale or is plundered for profit: public lands are looted by logging companies and corporate ranchers; politicians willingly hand the public's airwaves over to powerful broadcasters and large corporate interests without a dime going into the public trust; the environment is polluted and despoiled in the name of profit making just as the government passes legislation to make it easier for corporations to do so; what public services have survived the last thirty years are now being gutted in order to lower the taxes of major corporations (or line their pockets through no-bid contracts, as in the infamous case of Halliburton); schools more closely resemble either jails or high-end shopping malls, depending on their clientele, and teachers are forced to get revenue for their school by hawking everything from hamburgers to pizza.

Under neoliberalism, the state now makes a grim alignment with corporate capital and transnational corporations. Gone are the days when the state "assumed responsibility for a range of social needs" (Steinmetz, 2003, p. 337). Instead, agencies of government now pursue a wide range of "'deregulations,' privatizations, and abdications of responsibility to the market and private philanthropy" (p. 337). Deregulation, in turn, promotes "widespread, systematic disinvestment in the nation's basic productive capacity" (Bluestone & Harrison, 1982, p. 6). As the search for ever greater profits leads to outsourcing that accentuates the flight of capital and jobs abroad, flexible production encourages wage slavery for many formerly of the middle class and mass incarceration for those disposable populations (that is, neither good producers nor consumers) at home. Even among the traditionally pro-union, pro-environment, pro-welfare state Democratic Party, few seem moved to challenge the prevailing neoliberal economic doctrine that, according to Stanley Aronowitz (2003), proclaims "the superiority of free markets over public ownership, or even public regulation of private economic activities, [and] has become the conventional wisdom, not only among conservatives but among social progressives" (p. 21).

Tragically, the ideology and power of neoliberalism is not confined to U.S. borders. Throughout the globe, the forces of neoliberalism are on the march, dismantling the historically guaranteed social provisions provided by the welfare state, defining profit making as the essence of democracy, and equating freedom with the unrestricted ability of markets to "govern economic relations free of government regulation" (Aronowitz, 2003, p. 101). Transnational in scope, neoliberalism now imposes its economic regime and market values on developing and weaker nations through structural adjustment policies enforced by powerful financial institutions such as the World Bank, the International Monetary Fund (IMF), and the World Trade Organization (WTO). The impact on schools in postcolonial nations is particularly bleak, as policy reforms financially starve institutions of higher learning as they standardize—with the usual emphasis on skills and drills over critical thinking or critical content—the curricula of primary schools.

Secure in its dystopian vision that there are no alternatives, as England's former prime minister Margaret Thatcher once put it, neoliberalism obviates issues of contingency, struggle, and social agency by celebrating the inevitability of economic laws in which the ethical ideal of intervening in the world gives way to the idea that we "have no choice but to adapt both our hopes

and our abilities to the new global market" (Aronowitz, 1998, p. 7). Situated within a culture of fear, market freedoms seem securely grounded in a defense of national security, capital, and property rights. When coupled with a media-driven culture of panic and the everyday reality of insecurity, surviving public spaces have become increasingly monitored and militarized. Recently, events in New York, New Jersey, and Washington, D.C., provide an interesting case in point. When the media alerted the nation's citizenry to new terrorist threats specific to these areas, CNN ran a lead story on its impact on tourism—specifically on the enthusiastic clamor over a new kind of souvenir as families scrambled to get their pictures taken among U.S. paramilitary units now lining city streets, fully flanked with their imposing tanks and massive machine guns. The accouterments of a police state now vie with high-end shopping and museum visits for the public's attention, all amid a thunderous absence of protest. But the investment in surveillance and containment is hardly new. Since the early 1990s, state governments have invested more in prison construction than in education; prison guards and security personnel in public schools are two of the fastest-growing professions. Such revolutionary changes in the global body politic demand that we ask what citizens are learning from this not-so-hidden curriculum organized around markets and militarization. As that syllabus is written, we must ponder the social costs of breakneck corporatization bolstered by an authoritarianism that links dissent with abetting terrorism.

In its capacity to dehistoricize and naturalize such sweeping social change, as well as in its aggressive attempts to destroy all of the public spheres necessary for the defense of a genuine democracy, neoliberalism reproduces the conditions for unleashing the most brutalizing forces of capitalism. Social Darwinism has risen like a phoenix from the ashes of the nineteenth century and can now be seen in full display on most reality TV programs and in the unfettered self-interest that now drives popular culture. As social bonds are replaced by unadulterated materialism and narcissism, public concerns are now understood and experienced as utterly private miseries, except when offered up on *Jerry Springer* as fodder for entertainment. Where public space—or its mass-mediated simulacrum—does exist it is mainly used as a highly orchestrated and sensational confessional for private woes, a cutthroat game of winner-take-all replacing more traditional forms of courtship, as in *Who Wants to Marry a Millionaire*, or as advertisement for crass consumerism, like MTV's *Cribs*.

As neoliberal policies dominate politics and social life, the breathless rhetoric of the global victory of free-market rationality is invoked to cut public expenditures and undermine those noncommodified public spheres that serve as the repository for critical education, language, and public intervention. Spewed forth by the mass media, right-wing intellectuals, religious fanatics, and politicians, neoliberal ideology, with its merciless emphasis on deregulation and privatization, has found its material expression in an all-out attack on democratic values and social relations—particularly those spheres where such values are learned and take root. Public services such as health care, childcare, public assistance, education, and transportation are now subject to the rules of the market. Forsaking the public good for the private good and representing the needs of the corporate and private sector as the only source of sound investment, neoliberal ideology produces, legitimates, and exacerbates the existence of persistent poverty, inadequate health care, racial apartheid in the inner cities, and the growing inequalities between the rich and the poor (Henwood, 2003; Phillips, 2003; Krugman, 2003).

Central to neoliberal ideology and its implementation is the ongoing attempt by right-wing politicians to view government as the enemy of freedom (except when it aids big business) and discount it as a guardian of the public interest. The call to eliminate big government is neoliberalism's grand unifying idea and has broad popular appeal in the United States because it is a principle deeply embedded in the country's history and tangled up with its notion of political freedom—not to mention the endless appeal of its clarion call to cut taxes. And yet, the right-wing appropriation of this tradition is racked with contradictions, as they outspend their liberal rivals, drive up deficits, and expand—not shrink—the largely repressive arm of big government's counterterrorism-military-surveillance-intelligence complex.

Indeed neoliberals, Republican and Democrat, have attacked what they call big government when it has provided crucial safety nets for the poor and dispossessed, but they have no qualms about using the government to bail out the airline industry after the economic nosedive that followed the 2000 election of George W. Bush and the events of 9/11. Nor are there any expressions of outrage from free-market cheerleaders when the state engages in promoting various forms of corporate welfare by providing billions of dollars in direct and indirect subsidies to multinational corporations. In short, the current government responds not to citizens, but to

citizens with money, bearing no obligation for the swelling ranks of the poor or for the collective future of young people.

The liberal democratic lexicon of rights, entitlements, social provisions, community, social responsibility, living wage, job security, equality, and justice seems oddly out of place in a country where the promise of democracy—and the institutions necessary for its survival over generations—have been gutted, replaced by casino capitalism, a philosophy suited to lotto players and day traders alike. As corporate culture extends even deeper into the basic institutions of civil and political society, buttressed daily by a culture industry in the hands of a few media giants, keep free free-market ideology is reinforced even further by the pervasive fear and insecurity of the public, who have little accessibility to countervailing ideas and believe that the future holds nothing beyond a watered-down version of the present. As the prevailing discourse of neoliberalism seizes the public imagination and the corporate culture dominates in media and public life, there is no vocabulary for progressive social change, democratically inspired visions, critical notions of social agency, or the kinds of institutions that expand the meaning and purpose of democratic public life. In the vacuum left by diminishing democracy, a new kind of authoritarianism, steeped in religious zealotry, cultural chauvinism, xenophobia, and racism, has become the dominant trope of neoconservatives and other extremist groups eager to take advantage of the growing insecurity, fear, and anxiety that result from increased joblessness, the war on terror, and the unraveling of communities.

As a result of the consolidated corporate attack on public life, the maintenance of democratic public spheres from which to launch a moral vision or to engage in a viable struggle over institutions and political vision loses all credibility—as well as monetary support. As the alleged wisdom and common sense of neoliberal ideology remains largely unchallenged within dominant keep pseudo-public spheres, keep working class critique and collective political struggle become more difficult. Of course, there is widespread resistance to neoliberalism and its institutional enforcers such as the WTO and IMF among many intellectuals, students, and global justice movements, but this resistance rarely gets aired in the dominant media and if it does it is often dismissed as irrelevant or tainted by Marxist ideology. The U.S. government is driven by an arrogance of power and inflated sense of moral righteousness mediated largely by a false sense of certitude and keep never-ending posture of triumphalism. As George Soros (2004) points

out, this rigid ideology and inflexible sense of mission allows the U.S. administration to believe that "because we are stronger than others, we must know better and we must have right on our side. This is where religious fundamentalism comes together with market fundamentalism to form the ideology of American supremacy" (p. 1).

As public space is increasingly commodified and the state becomes more closely aligned with capital, politics is defined largely by its policing functions rather than as an agency for peace and social reform. As the state abandons its social investments in health, education, and the public welfare, it increasingly takes on the functions of an enhanced security or police state, the signs of which are most visible in the increasing use of the state apparatus to spy on and arrest its subjects, the incarceration of individuals considered disposable (primarily people of color), and the ongoing criminalization of social policies. Nowhere is this more visible than in the nation's schools. Part of the reason for the continuing crisis in American public schooling is due to federal cuts in education ongoing since the Reagan administration. The stated rationale for such a shift in national priorities is that American public schools are bureaucratic, wasteful, and altogether ineffectual—the result of a "big government" monopoly on education. As a result of such inefficiency, the public school system poses a threat to national security and U.S. economic dominance in the world market. To be sure, some public schools are really ailing, but the reasons for this, according to David Berliner and Bruce Biddle (1996), authors of *The Manufactured Crisis*, have to do with the grossly unequal funding of public education, residential segregation, the astonishingly high poverty rates of U.S. schoolchildren relative to most other industrialized nations, coupled with inadequate health care and social services.

Preferring the former diagnosis of general ineptitude, the current administration insists that throwing money at schools will not cure public school ills and will no longer be tolerated. Rather than address the complexity of educational inequalities disproportionately impacting poor and minority students, the Bush administration has sought solutions to troubled public schools in the much-touted No Child Left Behind (NCLB) legislation, which afforded certain key advantages to constituencies in favor of privatization, all the while appearing sympathetic to the plight of poor and minority youth. Not only do they maintain the advantages accorded white students who perform better on average than black and Latino students on standardized tests, the proposed school reforms were also very business friendly.

Renamed "No Child Left Untested" by critics, the reform places high priority on accountability, tying what little federal monies schools receive to improved test performance. For additional financial support, public schools are left no other meaningful option than engaging in public-private partnerships, like the highly publicized deals cut with soft drink giants that provide schools with needed revenue in exchange for soda machines in cafeterias. And clearly, media giants who own the major publishing houses will benefit from the 52 million–strong market of public school students now required to take tests every year from the third grade on.

The impact of NCLB also proved highly televisable, visibility now a key factor in the art of persuading a public weaned from political debate in favor of the spectacle. Thus the media provide routine reportage of school districts' grade cards, public—often monetary—rewards given to those schools that score high marks on achievement tests, liquidation of those that don't. Media preoccupation with school safety issues, moreover, ensure highly publicized expulsion, sometimes felony incarceration, of troublemakers, typically students of color. In short, accountability for teachers and administrators and zero tolerance for students who commit even the most minor infractions are the new educational imperatives. All of which demonstrates that the federal government is "doing something" to assuage public fears about the nation's schools that it largely created through financial deprivation and policies favoring resegregation. As a result, financially strapped schools spend precious resources on testing and prep materials as well as new safety measures, such as metal detectors, armed guards, security cameras, and fencing, in accordance with NCLB. In addition to draining public schools financially, both high-stakes testing and zero-tolerance policies have served to push out or kick out black and Latino youth in disproportionate numbers, as has been extensively documented by Henry Giroux (2003) in *The Abandoned Generation*, William Ayers and colleagues (2001) in *Zero Tolerance*, and Gary Orfield and Mindy Kornhaber (2001) in *Raising Standards or Raising Barriers?* As democracy becomes a burden under the reign of neoliberalism, civic discourse disappears or is subsumed by a growing authoritarianism in which politics is translated into unquestioning allegiance to authority and secular education is disdained as a violation of God's law.

Market fundamentalism increasingly appears at odds with any viable notion of critical education, and appears even more ominous as it aligns

itself with the ideologies of militarism and religious fundamentalism. The democratic character of critical pedagogy is defined largely through a set of basic assumptions, which holds that knowledge, power, values, and institutions must be made available to critical scrutiny, be understood as a product of human labor (as opposed to God-given), and evaluated in terms of how they might open up or close down democratic practices and experiences. Yet, critical pedagogy is about more than simply holding authority accountable through the close reading of texts, the creation of radical classroom practices, or the promotion of critical literacy. It is also about linking learning to social change, education to democracy, and knowledge to acts of intervention in public life. Critical pedagogy encourages students to learn to register dissent, as well as to take risks in creating the conditions for forms of individual and social agency that are conducive to a substantive democracy. Part of the challenge of any critical pedagogy is making schools and other sites of pedagogy safe from the baneful influence of market logics—ranging from the discourses of privatization and consumerism, to the methodologies of standardization and accountability, to new disciplinary techniques of surveillance, expulsion, and incarceration aimed at the throwaways of global capital, principally poor youth and youth of color.

Resisting such a radical challenge to democratic principles and practices means that educators need to rethink the important presupposition that public education cannot be separated from the imperatives of a nonrepressive and inclusive democratic order and that the crisis of public education must be understood as part of the wider crisis of politics, power, and culture. Recognizing the inextricable link between education and politics is central to reclaiming the sanctity of public education as a democratic public sphere, necessarily free of the slick come-ons of corporate advertisers, capitalist ideology, or, for that matter, JROTC. Central, too, is the recognition that politics cannot be separated from the pedagogical force of culture. Pedagogy should provide the theoretical tools and resources necessary for understanding how culture works as an educational force, how public education connects to other sites of pedagogy, and how identity, citizenship, and agency are organized through pedagogical relations and practices. Rather than being viewed as a technical method, pedagogy must be understood as a moral and political practice that always presupposes particular renditions of what constitutes legitimate knowledge, values, citizenship, modes of understanding, and views of the future.

Moreover, pedagogy as a critical practice should provide the classroom conditions that provide the knowledge, skills, and culture of questioning necessary for students to engage in critical dialogue with the past, question authority and its effects, struggle with ongoing relations of power, and prepare themselves for what it means to be critical, active citizens in the interrelated local, national, and global public spheres. Of course, acknowledging that pedagogy is political because it is always tangled up with power, ideologies, and the acquisition of agency does not mean that it is by default propagandistic, closed, dogmatic, or uncritical of its own authority. Most important, any viable notion of critical pedagogy must demonstrate that there is a difference between critical pedagogical practices and propagandizing, critical teaching, and demagoguery. Such a pedagogy should be open and discerning, fused with a spirit of inquiry that fosters rather than mandates critical modes of individual and social agency.

We believe that if public education is a crucial sphere for creating citizens equipped to exercise their freedoms and competent to question the basic assumptions that govern democratic political life, teachers in both public schools and higher education will have to assume their responsibility as citizen-scholars by taking critical positions, relating their work to larger social issues, offering students knowledge, debate, and dialogue about pressing social problems, and providing the conditions for students to have hope and believe that civic life matters, that they *can* make a difference in shaping it so as to expand its democratic possibilities for all, including the overwhelming majority of the population who are working class and, increasingly, people of color. It means taking positions and engaging practices currently at odds with both religious fundamentalism and neoliberal ideology. Educators now face the daunting challenge of creating new discourses, pedagogies, and collective strategies that will offer students the hope and tools necessary to revive the culture of politics as an ethical response to the demise of democratic public life. Such a challenge suggests struggling to keep alive those institutional spaces, forums, and public spheres that support and defend critical education, helping students come to terms with their own power as individual and social agents, exercise civic courage, and engage in community projects and research that are socially responsible, while refusing to surrender knowledge and skills to the highest bidder. In part, this requires pedagogical practices that connect the space of language, culture, and identity to their deployment in larger

physical and social spaces. Such a pedagogy is based on the presupposition that it is not enough to teach students to break with accepted ideas. They must also learn to directly confront the threat from fundamentalisms of all varieties that seek to turn democracy into a mall, a sectarian church, or a wing of the coming incarcerating state, a set of options that must be understood as an assault on democracy.

There are those critics who in tough economic times insist that providing students with anything other than work skills threatens their future viability on the job market. While we believe that public education should equip students with skills to enter the workplace, it should also educate them to contest workplace inequalities, imagine democratically organized forms of work, and identify and challenge those injustices that contradict and undercut the most fundamental principles of freedom, equality, and respect for all people who constitute the global public sphere. Public education is about more than job preparation or even critical consciousness raising; it is also about imagining different futures and politics as a form of intervention into public life. In contrast to the cynicism and political withdrawal that media culture fosters, a critical education demands that its citizens be able to translate the interface of private considerations and public issues, be able to recognize those antidemocratic forces—including corporate and political structures and practices—that deny social, economic, and political justice, and be willing to give some thought to their experiences as a matter of anticipating and struggling for a better world. In short, democratic rather than commercial values should be the primary concerns of both public education and the university.

If right-wing reforms in public education continue unchallenged, the consequences will reflect a society in which a highly trained, largely white elite will command the techno-information revolution while a vast, low-skilled majority of poor and minority workers will be relegated to filling the McJobs proliferating in the service sector. In contrast to this vision, we strongly believe that genuine, critical education cannot be confused with job training. If educators and others are to prevent this distinction from becoming blurred, it is crucial to challenge the ongoing corporatization of public schools while upholding the promise of the modern social contract in which all youth, guaranteed the necessary protections and opportunities, was a primary source of economic and moral investment, symbolizing the hope for a democratic future. In short, for public education to have

meaning for the future of humanity, it must come to grips with class society, reestablish its obligation to young people, and reclaim its role as a democratic public sphere.

Our insistence on the promise of critical pedagogy is not a call for any one ideology on the political spectrum to determine the shape of the future direction of public and university education. But at the same time, it reflects a particular vision of the purpose and meaning of public and higher education and their crucial role in educating students to participate in an inclusive democracy—a vision that must be informed with a critique of capitalist society and a recognition of the working class majority and its necessary contribution to a more democratic world. Critical pedagogy is an ethical referent and a call to action for educators, parents, students, and others to reclaim public education as a democratic public sphere, a place where teaching is not reduced to learning how either to master tests or to acquire low-level jobs skills, but a safe space where reason, understanding, dialogue, and critical engagement are available to all faculty and students. Public education, in this reading, becomes a site of ongoing struggle to preserve and extend the conditions in which autonomy of judgment and freedom of action are informed by the democratic imperatives of equality, liberty, and justice. Public education has always, though within damaged traditions and burdened forms, served as a symbolic and concrete reminder that the struggle for democracy is, in part, an attempt to liberate humanity from the blind obedience to authority and that individual and social agency gain meaning primarily through the freedoms guaranteed by the public sphere, where the autonomy of individuals becomes meaningful only under those conditions that guarantee the workings of an autonomous society. Critical pedagogy is a reminder that the educational conditions that make democratic identities, values, and politics possible and effective have to be fought for more urgently at a time when democratic public spheres, public goods, and public spaces are under attack by the capitalist market and free-market ideological fundamentalists who believe that corporations in top competitive form can solve all human affliction and that dissent is comparable to aiding terrorists—positions that share the common denominator of disabling a substantive notion of ethics, politics, and democracy.

We live in very dark times, yet as educators, parents, activists, and workers we can address the current assault on democracy by building local and global alliances and engaging in struggles that acknowledge and transcend

national boundaries, while demonstrating how these intersect with people's everyday lives. Democratic struggles cannot underemphasize the special responsibility of intellectuals to shatter the conventional wisdom and myths of neoliberalism with its stunted definition of freedom and its depoliticized and dehistoricized definition of its own alleged inevitability. As the late Pierre Bourdieu (1998) argued, any viable politics that challenges neoliberalism must refigure the role of the state in limiting the excesses of capital and providing important social provisions. In particular, social movements must address the crucial issue of education as it develops both formally and informally throughout the cultural sphere because the "power of the dominant order is not just economic, but intellectual—lying in the realm of beliefs" (Bourdieu & Grass, 2003, p. 66), and it is precisely within the domain of ideas that a sense of utopian possibility can be restored to the public realm. Pedagogy in this instance is not simply about critical thinking but also about social engagement, a crucial element of not just learning but politics itself.

Most specifically, democracy necessitates forms of education and critical pedagogical practices that provide a new ethic of freedom and a reassertion of collective identity as central preoccupations of a vibrant democratic culture and society. Such a task, in part, suggests that intellectuals, artists, unions, and other progressive individuals and movements create teach-ins all over the country in order to name, critique, and connect the forces of market fundamentalism to the war at home and abroad, the shameful tax cuts for the rich, the dismantling of the welfare state, the attack on unions, the erosion of civil liberties, the incarceration of a generation of young black and brown men and women, the attack on public schools, and the growing militarization of public life. As the credibility of capitalism declines, exacerbated by the periodic crises of the U.S. administration, the time has come to link the matters of economics with the crisis of political culture, and to connect the latter to the crisis of democracy itself. We need a new language for politics, for analyzing where it can take place, and what it means to mobilize alliances that have the power to reorganize society more democratically.

References

Aronowitz, S. (1998). Introduction. In Paulo Freire, *Pedagogy of freedom*. Lanham, MD: Rowman and Littlefield.

Aronowitz, S. (2003). *How class works*. New Haven, CT: Yale University Press.

Ayers, W., Ayers, R., & Dohrn, B. (Eds.) et al. (2001). *Zero tolerance: Resisting the drive for punishment*. New York: The New Press.

Berliner, D., & Biddle, B. (1996). *The Manufactured Crisis*. New York: Addison Wesley.

Bluestone, B., & Harrison, B. (1982). *The deindustrialization of America: Plant closings, community abandonment and the dismantling of basic industry*. New York: Basic Books.

Bourdieu, P. (1998). *Acts of resistance: Against the tyranny of the market*. New York: The New Press.

Bourdieu, P., & Grass, G. (2003). The progressive restoration: A Franco-German dialogue. *New Left Review* 14: 63–77.

Giroux, H. (2003). *The abandoned generation*. New York: Palgrave McMillan.

Henwood, D. (2003). *After the new economy*. New York: The New Press.

Krugman, P. (2003). *The great unraveling: Losing our way in the new century*. New York: W.W. Norton.

Orfield, G., & Kornhaber, M. (2001). *Raising standards or raising barriers?* New York: Century Foundation Press.

Phillips, K. (2003). *Wealth and democracy: A political history of the American rich*. New York: Broadway.

Soros, G. (2004). The U.S. is now in the hands of a group of extremists. *Guardian/UK*. Retrieved January 26, 2005, from www.commondreams.org/views04/0126-01.htm.

Steinmetz, G. (2003). The state of emergency and the revival of American imperialism: Toward an authoritarian post-Fordism. *Public Culture* 15(2): 323–46.

·FROM THE WEAPON OF CRITICISM TO CRITICISM BY WEAPONS: CRITICAL COMMUNICATION SCHOLARSHIP, MARXISM, AND POLITICAL ACTIVISM·

Steve Macek

Ideas can never lead beyond the old world order but only beyond the ideas of the old world order. Ideas cannot carry out anything at all. In order to carry out ideas men [sic] are needed who can exert practical force.

—*Karl Marx and Friedrich Engels*

Probably the single most important thing a radical academic can do is to blur the line between thinking about social change and acting on it.

—*Cynthia Peters*

Over the past two decades, the fields of communication, media studies, and rhetoric have been marked by an explosion of "critical," even self-consciously "radical" research and teaching, much of it informed by—or at least in dialogue with—Marxist theories of ideology, class politics, and capitalism. The nation's largest professional association of communication scholars, the National Communication Association, publishes two journals explicitly devoted to critical research and papers openly adopting a Marxist-inflected perspective are well represented at its annual convention. The same is true

of conferences sponsored by the International Communications Associa-tion, the Society for Cinema and Media Studies, and the Rhetoric Society of America. The works of Karl Marx and of Western Marxists like Antonio Gramsci, Theodor Adorno, and Louis Althusser are now required reading for graduate students in communication and media studies programs around the country. Marxist concepts like "hegemony," "ideology," "class," and "the dialectic" occasionally even receive mention in standard media communication and rhetoric textbooks. The fact that a respected press like Peter Lang is publishing the present anthology is itself a testament to the caché enjoyed by Marxist ideas in academic circles.

Yet despite the considerable influence of certain aspects of Marxist the-ory on scholarly discourse in communications, much of that discursive out-put has willfully ignored one of Marxism's cardinal insights: namely, the need for intellectuals to actively participate in and learn from real political struggles. "Philosophers have only interpreted the world in various ways," wrote Marx (1885/1983b) in his oft-cited eleventh thesis on Feuerbach; "the point, however, is to change it" (p. 158). This remark was not meant to dis-miss the importance of serious intellectual work, as is sometimes assumed. Far from it. While Marx (1885) insisted that "the mode of production of material life determines the social, political and intellectual life process in general," he also argued that it is precisely through politics and intellectual life that people become aware of the class conflict at the core of the capital-ist mode of production and by means of such ideological forms that they "fight it out" (p. 160). No effort at constructing a viable alternative to the barbarism, exploitation, war, and mass poverty that besets humanity in the twenty-first century can hope to succeed without an accurate understand-ing of capitalism, its logic, its history, and its characteristic social contradic-tions. At the same time, Marxist theory teaches us that it is impossible to develop such an understanding without becoming actively involved in movements for radical social change.

In what follows, I argue for what I take to be a classical Marxist position on the relationship of intellectuals and theorizing to political and social struggle and attempt to spell out its relevance for critical communication scholarship. After reviewing the classical historical materialist view of intel-lectuals and their political function, I examine the key reasons why many nominally Marxist (or, at least, critical) scholars in the field of communications eschew open political activism and how the distance of academic theorizing

from political practice distorts critical communication scholarship. I go on to make an argument for integrating critical communication research with concrete struggles for social justice and suggest possible avenues for bridging the academic–activist divide.

The Classical Marxist Position on Intellectuals and Politics

The political and social theories of Marx and his collaborator Engels are often taught in American universities as though they developed solely as a result of scholarly study and debate, as yet another contribution to some timeless, ongoing dialogue among the great figures of Western thought. Yet, this approach to Marx and Engels's shared work contradicts both the analysis of the social function of intellectuals implicit in the doctrine of historical materialism and their own impressive record of concrete political engagement. Indeed, their ideas only really make sense in the context of that record of engagement and struggle.

August Nimtz's recent book *Marx and Engels: Their Contribution to the Democratic Breakthrough* (2000) convincingly demonstrates that the two "were first and foremost political activists, and not simply 'thinkers'" and that they "were the leading protagonists in the democratic movement of the nineteenth century" (p. vii). Marx and Engels first came to political consciousness as participants in the crusade for democratic reform in the autocratic Prussian-dominated German empire. Early on in their intellectual partnership, they rejected the idea that theorizing and social criticism alone could accomplish the democratic social change they both craved. In the *German Ideology*, they chastised their contemporaries, the idealist Young Hegelians, for believing that the real chains holding humanity down consisted of "conceptions, thoughts, [and] ideas" and mocked them for "fighting against '*phrases*,'" forgetting that "to these phrases they themselves are only opposing other phrases, and that they are in no way combating the real existing world when they are merely combating the phrases of this world" (Marx & Engels, 1844/1978, p. 41). The task of overthrowing bourgeois rule—which in either its liberal or authoritarian, imperial form disenfranchised and oppressed the vast majority—would require more than empty phrases. As Marx famously put it, "the weapon of criticism cannot,

of course, replace criticism by weapons; material force must be overthrown by material force. But theory also becomes a material force when it has been gripped by the masses" (Marx, 1845/1975b, p. 182).

Marx and Engels put these insights into action by organizing a party of socialist workers and agitators, the League of Communists, and by drafting *The Communist Manifesto* (1848/1998) as a statement of the league's outlook and aims. But their involvement with practical politics went far beyond this. As publishers of the *Neue Rheinische Zeitung* and as leaders of the most militant faction of Cologne's proletariat, they helped to foment and direct the democratic insurgency of 1848–49 in Germany and for their trouble were hounded into exile by the repressive Prussian state. This experience formed the touchstone for all their subsequent reflections on class politics (see Nimtz, 2000, chs. 3–4). It reinforced their commitment to a vision of "socialism from below" and proved to them that the emancipation of the working classes could be won only by the working classes themselves, rather than bestowed on them by benevolent bourgeois leaders or enlightened intellectuals (for more on the concept of "socialism from below," see Draper, 1966). Given that Marx's research at the British Museum eventually revealed that the wave of revolutions that swept Europe in the 1840s had been sparked by a commercial crisis emanating from England and subsided as the crisis was resolved (Nimtz, 2000, p. 108), the experience of 1848 also underscored for them the importance of understanding the economic foundations of political events.

Though Marx was to spend several years in relative isolation from the "real movement" while writing *Capital*, he saw even this solitary, seemingly esoteric theoretical labor as preparation for the next revolution (Nimtz, 2000, pp. 153–54). Thus, when popular demands for democracy and social justice again pushed Europe to the verge of revolutionary upheaval in the 1860s, he and Engels plunged into political organizing once more by founding the International Working Men's Association, the first international association of proletarians involved in the fight for democracy. It was as a member of the IWMA that Marx helped to coordinate international working class opposition to the Franco-Prussian war—the first significant transnational antiwar movement in history—and mounted a defense in the press of the socialist Paris commune that sprang up in its wake.

For Marx and Engels, then, intellectual activity and concrete political action, theoretical and practical work, were necessarily connected; each informed the other. Despite their harsh critique of the idealist conception of

the heroic role of intellectuals in history, Marx and Engels nonetheless allowed that intellectuals could play a small but important part in the coming communist revolution. Historical materialism holds that the working class is the only political force capable of abolishing capitalism, and that by liberating themselves, they will simultaneously free humanity as a whole. Yet, as Marx (1847/1995) argued in *The Poverty of Philosophy*, the mere fact that workers under capitalism experience common living conditions and common sorts of exploitation does not mean that they necessarily share a common class consciousness and a common understanding of their material interests in overturning the capitalist system. This consciousness, he maintained, would be formed primarily "in struggle," through the countless successes and setbacks involved in collectively fighting for democracy and control over wages and working conditions. That Marx thought intellectual agitation could hasten the precipitation of revolutionary class consciousness among the working class is fairly obvious (although some have implied that historical materialism—with its stress on capitalism's objective social contradictions as the motor force of history—renders politics and agitation superfluous; see Laclau & Mouffe, 1985). In the *Manifesto*, for instance, he and Engels (1848/1998) write of "a portion of the bourgeois ideologists" who raise "themselves to the level of comprehending theoretically the historical movement as a whole" (p. 47) and align themselves with the proletariat, with the clear implication being that this aids in the dissemination of communist ideas and proletarian class consciousness. If Marx had believed that all intellectual agitation was inherently ineffectual, he would not have devoted so much of his time and effort to producing books, theories, analyses, pamphlets, and polemics. In fact, both he and Engels saw the incisive analysis of capitalism laid out in *Capital* as "a scientific victory" for the party of the working class, a club to wield against their enemies, and a recruiting tool for the revolutionary socialist cause (Nimtz, 2000, p. 189). But, as a historical materialist, Marx never made the mistake of overvaluing the importance of such intellectual endeavors to the overall political struggle, a struggle the outcome of which he correctly foresaw would be decided by weapons and masses and not by critics and scholars.

In the years following the founding of the First International, the unity of theory and practice embodied in Marx and Engels's writings and political activities became a model for the generations of Marxist intellectuals who carried on their legacy. Every major contributor to the classical tradition of

historical materialism—Karl Kautsky, V. I. Lenin, Leon Trotsky, Nikolai Bukharin, Rudolf Hilferding, Rosa Luxemburg, Georg Lukács, Antonio Gramsci, C. L. R. James, to name only a few—combined theoretical activity with intense involvement in the day-to-day politics of "the real movement." Lenin, Trotsky, and Bukharin held key positions in the Bolshevik party and played leading roles in the 1917 revolution and the early Soviet government. Kautsky and Luxemberg were leading, if bitterly opposed, personalities in the German Social Democratic party (the SPD), in its heyday arguably the largest mass political party in Europe. Hilferding was twice minister of finance in SPD governments during the Weimar Republic (Anderson, 1979, p. 17). Lukács was "a Deputy Minister of Education in the Hungarian Soviet Republic of 1919 and fought with its revolutionary army on the Tisza front against the Entente attack on it" (Anderson, 1979, p. 30). Gramsci was a cofounder of the Italian Communist Party and briefly served as its representative to the Comintern in Moscow, and, quite famously, he spent eleven years in a fascist jail for his political commitments (Boggs, 1984, pp. 8–10). Even C. L. R. James—best known for his cultural criticism, his writings on cricket, and his history of the Haitian revolution—worked to recruit black Americans to the Trotskyist movement, established the Pan-Africanist African Service Bureau, and became a leader in the national independence movement of his native Trinidad (see Buhle, 1989).

Of this group, Gramsci devoted the most energy to theorizing the function of intellectuals in politics and society in general. In his *Prison Notebooks*, he famously postulated that the ruling class in capitalist societies maintain their rule through a combination of the "consent" of subordinate classes and naked "coercion" in cases where that consent wavered. Furthermore, he stressed that in modern capitalist nations with liberal-democratic institutions—like Italy in the 1920s—the dominant classes win popular consent to their power in large part through the exercise of "hegemony" defined as "intellectual and moral leadership." Given these realities, Gramsci insisted that the socialist movement in the advanced capitalist countries would have to undertake a protracted campaign of education and organizing in order to wrest political and cultural leadership from the bourgeoisie. Intellectuals, he argued, would be instrumental in this campaign. Drawing a distinction between "traditional" intellectuals who "put themselves forward as autonomous and independent of the dominant social group" (Gramsci, 1988, p. 303) and "organic intellectuals" who emerge from and serve their class of origin, Gramsci hoped that the working class would not simply

"assimilate and 'conquer' the traditional intellectuals" but also succeed "in elaborating its own organic intellectuals" (pp. 304–5).

Yet in spite of his analysis of the centrality of intellectuals to the construction and reproduction of hegemony, Gramsci never abandoned the classical Marxist position on the primacy of praxis. Like Marx and Engels in *The German Ideology*, he viewed the traditional intellectuals' disdain for political involvement and their blindness to their own location in the capitalist division of labor as the ultimate source of their theoretical errors. Thus, he observed that "the whole of idealist philosophy can . . . be defined as the expression of that social utopia by which intellectuals think of themselves as 'independent,' autonomous, endowed with a character of their own, etc." (Gramsci, 1988, p. 303). Against the delusional idealism fashionable among the professoriate of his day, Gramsci contended that "the mode of being of the new intellectual can no longer consist in eloquence, . . . but in active participation in practical life, as constructor, organizer, 'permanent persuader' and not simple orator" (p. 321).

Despite their many differences, the canonical thinkers of historical materialism—Marx, Engels, Gramsci, Lenin, Trotsky, and Luxemberg—concurred on this one basic point: Marxist intellectual production in the absence of regular contact with the working class and their struggles runs the risk of degenerating into self-important irrelevance or obscurantism. A partisan connection to the organizations, deliberations, and actions of real (proletarian) social movements makes it more likely that Marxist research and theorizing will ask the right questions, address the movements' main concerns, and—ultimately—generate knowledge useful for the cause of working class emancipation. In short, involvement in and accountability to a movement keeps Marxist theorists honest and focused on collective and political, rather than careerist or self-serving, goals. As Lenin put it, "Correct revolutionary theory assumes final shape only in close connection with the practical activity of a truly mass and truly revolutionary movement" (as cited in Anderson, 1979, p. 105). Unfortunately, this is a point that seems to be lost on quite a few practitioners of critical communication studies.

The Quietism of the Tenured Radicals

Many, if not most, critical communications scholars in the United States—including some whose work is explicitly indebted to Marx and Marxist

theory—avoid the sort of public, partisan political activism that has long been de rigeur for Marxist intellectuals. While it is certainly not my place to name names or pass judgment on particular individuals, the problem of critical scholarship's general disconnect from radical activism is real enough and has been readily acknowledged by some of the icons of critical communication studies (Hardt, 1998, pp. 59–61; McChesney, 1995). Some critical scholars refrain from activism on the grounds that engaging in such "real world" politics would be unprofessional and would compromise their intellectual independence or objectivity. Some see their politics as "expressed solely and sufficiently through teaching and publishing" (Smith, 1997, p. 132). Others dismiss political action as hopeless by pointing to "a litany of the left's failures" (Stabile, 1997, p. 215). Still others complain that they lack the time and energy to commit to grassroots activist projects.

Some academic radicals confine their involvement with politics to the production of papers, essays, and books on highly specialized topics, often written in dense, difficult jargon, tailored to narrow, highly educated audiences, and usually published in low-circulation scholarly journals or delivered as presentations at professional conferences. As James Petras (2001) has pointed out, many self-identified left-wing academics "crave recognition from their bourgeois colleagues" and tend to be obsessed with awards, titles, institutional identities, and other symbols of prestige (p. 57). They frequently prefer "citing bourgeois sources over left sources" and use bourgeois scholarship as their primary framework of reference, thereby perpetuating "the invisibility of left researchers" (p. 55). Very little of their research and writing is aimed at the general public or oriented toward bringing about democratic social change, much less social revolution. Even when they do write about dissident political causes or the resistance of the oppressed, they do so as sympathetic outside observers rather than as committed participants. As a rule, they don't plan or attend protests, take part in popular political meetings, walk picket lines, engage in civil disobedience, assist with organizing drives, provide material support for left institutions (magazines, parties, bookstores, and so on), or even speak at public forums. Despite all the rhetoric about civic engagement one hears from liberals in academia these days (see, for example, Mindich, 2005; Putnam, 2000), collective political action seldom breaks out. For instance, the 2005 international conference of the Society of Scholarship on Learning and Teaching and Learning (SoTL) was held in Vancouver, British Columbia,

during the province-wide strike of public school teachers. It never occurred to the six hundred–plus attendees, or at least it was never broached by the conference, that SoTL might make even a small statement of support for smaller class sizes, curriculum development, or quality of education in British Columbia.

Such avoidance of activism (in the form of statements of solidarity)—even among faculty whose explicit theoretical commitments would seem to contradict a quietist stance—is perfectly understandable in light of the institutional realities under which most contemporary academics labor. In fact, what is striking is that, despite these harsh realities, so many academic intellectuals do engage in radical politics—in the antiwar movement, in environmental struggles, in solidarity movements supporting revolutions throughout the global South—and do speak out against injustice here and around the world.

From a materialist perspective, higher education in America exists mainly to meet the requirements of government and big business "for trained personnel and new scientific knowledge" (Aronowitz, 2000, p. 16). The modern, social scientific discipline of communications itself arguably grew out of military and government-sponsored research on propaganda that took place during World War II and the early years of the Cold War. True, colleges and universities at their best have provided sites for genuine dialogue and debate, for the expression of dissident ideas, and for the collective pursuit of knowledge, while smaller public schools and community colleges have provided educational opportunities to working class students who would not otherwise have access to them. But, as Stanley Aronowitz (2000) has argued, there is very little question among most trustees, college presidents, and provosts that the universities they manage "must remain a source of knowledge that serves the corporate order, and, more broadly, the national interest in economic growth" (p. 50). Indeed, many schools explicitly acknowledge as much in their mission statements. As a consequence, teaching in these institutions, when it is not an afterthought, is focused on equipping students with skills that will be useful in the labor market (for example, discipline, punctuality, obedience, ability to communicate in a "professional manner," and so on). Hiring and evaluation procedures for faculty—especially at institutions in the upper echelons of the academic system—reward individuals who are able to attract funding from corporations or the government and who refrain from ruffling the feathers of senior university administrators or wealthy alumni

donors (Aronowitz, 2000, p. 53). Indeed, at both private and public universities, faculty members are actively encouraged to contract themselves out to corporations, and, in turn, businesses endow chairs, make research grants, and even fund whole departments in exchange for exclusive control over the "intellectual property" resulting from faculty research (Soley, 1995). In short, American colleges and universities are, and have been for quite some time, pro-corporate enterprises, integral parts of the great "military-university-industrial" complex that is late capitalism. Faculty activism directed against the socioeconomic system these institutions embody and serve is understandably not welcomed (and is likely to be labeled "unprofessional" and even "disruptive").

To make matters worse, the current neoliberal onslaught on public goods and nonmarket values analyzed by Henry and Susan Giroux elsewhere in this volume is pushing higher education (and K–12 education) to become even more accommodating to the market and business interests. In the past two decades, public colleges and universities have come under increased pressure (from state governments and boards of trustees) to "privatize," "downsize," and "corporatize," sacrificing any commitment to public service in the process (Aronowitz, 2000, p. 64). Access to higher education is becoming increasingly rationed by class. In 1980, the maximum Pell Grant paid for 77 percent of the average cost of tuition, fees and on-campus room and board at a public four-year college or university; by 2003, it covered only 41 percent of that cost (Dickeson, 2004, p. 5). Meanwhile, state funding for public universities has dwindled from an average of $6,874 per student in the early 1980s to $5,721 today, even as tuition has continued to rise. As a result, a little over 50 percent of high school graduates from low-income families attend college as compared to 90 percent of high school graduates from high-income families (*Access Denied*, 2001, p. 5). Fiscal austerity, combined with the incursion of corporate management tactics into the realm of university administration, has also made life more difficult for all but the most fortunate professors. Class sizes are increasing, tenure lines and salaries are being cut, and more than half of all courses at four-year universities are being covered by graduate students and temporary, low-paid adjuncts (Aronowitz, 2004, pp. 74–74; see also Nelson, 1997). Moreover, departments and courses with low enrollments—no matter how valuable to the pursuit of knowledge and to the broader community—are being "downsized" with increasing regularity (Luce, 2005).

The economic uncertainty facing individual academics, and higher education more generally, no doubt works to dissuade many from activism, let alone political speech or publicly accessible and useful research. In the paranoid atmosphere that prevails in the contemporary neoliberal university, faculty members are so nervous about keeping their jobs (and under such stress as a result of the pressures placed on them by the realities sketched out above) that political engagement simply seems too risky.

Needless to say, the latest round of vituperative right-wing attacks on left-wing scholars and on the very idea of academic freedom has only exacerbated the sense of exposure and vulnerability among progressive academics. Despite our relatively minor, relatively tentative toehold in American higher education, both liberals and radicals in the academy find themselves increasingly under assault from the better organized, better funded forces of the right like Campus Watch, Accuracy in Academia, and David Horowitz's Students for Academic Freedom, who would like nothing more than to expel us from the ivory tower altogether.

The current crusade against "leftists" and "liberal bias" on America's campuses has its origins in the "political correctness" scare of the 1980s, which painted college Republicans, religious conservatives, and white men as victims of speech codes, affirmative action policies, and curricular reforms supposedly foisted on them by "tenured radicals" bent on brainwashing their students. Professors who incorporated discussions of class, sexism, and racial oppression into their teaching of subjects like history, literature, and film were vilified in the media and received hate mail and threatening phone calls (Wilson, 1995, p. 76); in at least one case, a left academic was denied tenure solely on the basis of his radical politics (Wilson, 1995, p. 38). Lavishly funded by right-wing foundations, supported by right-wing think tanks, and relentlessly promoted by conservative columnists and media pundits like George Will, John Leo, and Dinesh D'Souza, the PC campaign succeeded in turning public opinion against colleges and universities, and put progressives in the academy on the defensive (Messer-Davidow, 1995; Wilson, 1995).

Since the Bush administration's post-9/11 announcement of a seemingly limitless "war on terror," the masterminds of the PC panic have turned their attention to relentlessly rooting out "unpatriotic" professors who dared to criticize the U.S. invasions of Afghanistan and Iraq. In November 2001, the American Council of Trustees and Alumni—a group founded by Lynne

Cheney, wife of Vice President Dick Cheney and a longtime crusader against left-wing influence on colleges and universities—released its notorious study, *Defending Our Civilization: How Our Universities Are Failing America and What Can Be Done about It*, which purported to show that progressive students and faculty had responded to the terror attacks by pointing "accusatory fingers, not at the terrorists, but at America itself" (Martin & Neal, 2001, p. 1; see also Berkowitz, 2002). Shortly thereafter, members of Columbia University's Middle East and Asian languages and cultures department came under fire for allegedly intimidating Jewish students with their classroom criticisms of Zionism and their advocacy for the right of Palestinian self-determination (Sherman, 2005). Then, in 2005, right-wing politicians and media outlets like Fox News began pressing for University of Colorado president Elizabeth Hoffman to fire ethnic studies professor Ward Churchill for an essay he wrote comparing people working at the World Trade Center in the service of the impoverishment and exploitation of Third World nations to Nazi war criminal Adolph Eichman (Gabbard, 2005, p. 14). As a consequence of such pressures, the university launched a wide-ranging, McCarthy-esque inquiry into Churchill's publication record in search of alleged academic improprieties. Not coincidentally, red-turned-reactionary David Horowitz and his organization Students for Academic Freedom unveiled his Academic Bill of Rights at around the same time. This proposal, which became the basis for legislation introduced into more than twenty state legislatures, calls for ideological and political balance in both the teaching of controversial subjects and the hiring of faculty; though Horowitz has touted the measure as way of fostering intellectual diversity and lively debate on college campuses, both its supporters and detractors see it as an affirmative action policy for right-wing scholars and conservative ideologies supposedly marginalized in contemporary higher education (Gabbard, 2005, p. 15).

After what has happened to high-profile scholars like Churchill and the members of Columbia's MELAC department, it is no wonder that academics who adopt a critical, even Marxist perspective in the classroom and in their scholarly writing often avoid taking part in militant or radical politics—although there are notable exceptions. Agitating too vocally against the World Trade Organization, organizing in support of revolutionary regimes like those in Venezuela or Cuba, or even just taking part in a demonstration calling for the immediate withdrawal of U.S. troops from Iraq could

jeopardize the career of even the most promising junior professor. Consequently, even in interdisciplinary subfields like cultural studies and women's studies that have their roots in the radical politics of the 1960s, it is not uncommon for younger scholars to be entirely divorced from and unfamiliar with the realities of day-to-day political organizing (Macek, 2001; Messer-Davidow, 2002). Indeed, in many American colleges and universities today, you can find self-described Marxist intellectuals who have never connected with the movements they profess to support, never seen the inside of a union hall, and never stood up publicly or risked anything on behalf of the working class or the cause of social justice.

Idealism Redux: The Intellectual Consequences of Isolation from Political Practice

The capitulation of critical communication scholars to the academy's taboo against political engagement colors (and corrupts) much of what passes for "cutting edge" work in the field communication studies. It has led, in some cases, to a mindless celebration of spontaneous, undirected, anarchic popular resistance against capitalist structures of oppression and a simultaneous denigration of efforts at building a serious, organized, class-based challenge to the existing social order. Above all, though, it has resulted in an idealist overvaluation of the power of "discourse" and of the political significance of intellectuals, theory, and cultural production.

Consider, as a case in point, the enormously influential work of popular culture theorist John Fiske (who not long ago retired from a faculty position in communications at the University of Wisconsin). Since the 1980s, Fiske's writings on contemporary American media and popular culture have had an inordinate influence on the disciplines of cultural studies and mass communications—defining for one generation of students after another what it means to analyze popular culture as social communication—and are utterly symptomatic of the political bankruptcy of some of the main tendencies in contemporary critical scholarship.

Fiske famously predicated his own approach to the media and popular culture on a rejection of earlier Marxist theories of the corporate media and the cultural industry. In his view, such theories fail "to recognize the intransigence of the people in the face of this system . . . their refusal of the position

of the compliant subject in bourgeois ideology that is so insistently thrust upon them" (Fiske, 1989b, p. 162). Far from being "cultural dopes" subject to the commercial media's ideological manipulation, he claims that ordinary people in fact treat the media's texts "as a cultural resource to be raided or poached"; for Fiske (1987), what matters is not the built-in ideological slant of a sitcom or TV news broadcast, but the fact that TV's narrative strategies are "surprisingly ineffective . . . in imposing their structure and associated meanings upon viewers" who always "decode" these messages in ways that affirm their own (inherently subversive or oppositional) values (p. 302). Whether he is discussing teenage followers of Madonna, popular responses to TV news broadcasts, or fans of professional wrestling, Fiske always finds signs of popular resistance and opposition where a Marxist would see only credulity, conformity, and obeisance to the dominant ideology. Under his gaze, television becomes "a semiotic democracy" (Fiske, 1987, p. 236) and youths who intentionally tear their jeans are engaging in "a refusal of commodification" (Fiske, 1989b, p. 15). He even, absurdly, construes the phenomenon of female "Jell-O wrestling" in certain Chicago bars as a threat to "the category of the masculine" because it shows "women taking traditionally male roles" (Fiske, 1989a, p. 98). Even if we grant that media consumers routinely engage in this sort of resistance, there is no evidence whatsoever that such resistance contributes to the counterhegemonic project or helps build a countervailing power capable of challenging the existing social order. Indeed, resistance *on its own* may even prove valuable to the status quo, indicating points of contradiction that need to be renegotiated. Resistance is only a first response that needs to be organized, mobilized, and politicized, or it risks leading to co-optation or demoralization.

Notably, in spite of all his talk about ordinary people's tactics of resistance to what he vaguely calls "the power bloc," Fiske seems positively hostile to the sort of mass movements, systematic ideologies, and disciplined socialist organizations that alone could transform mere resistance into a revolutionary transformation of the status quo. Again and again, when analyzing the politics of popular culture, he unself-consciously repeats several of the New Right's cherished myths about the activist left. For instance, echoing one of Rush Limbaugh's favorite accusations, he claims that "the left has generally failed to win the support (or votes) of the people whose interests they support, and with whom they wish to be aligned" (Fiske, 1989b, p. 162). He complains that the left's critique of consumerism is "demeaning"

to ordinary people and "all too easily appears puritanical" (Fiske, 1989b, pp. 162–63). Moreover, he contends that "against the right-wing rhetoric of individual freedom, the left tends to use one of social conscious and justice, a rhetoric that has little appeal to popular consciousness or pleasure" (Fiske, 1989b, p. 165). As Graeme Turner (1992) has observed, Fiske's "view of the popular becomes so optimistic, so celebratory, that there seems little need to worry about the function of representation in reproducing the status quo" (p. 221).

The methodological and conceptual problems with this sanguine approach to mainstream media and popular culture are far too numerous (and far too serious) to deal with in depth here (for more detailed criticism of Fiske's theories, see Budd, Entman, & Steinman, 1990). Suffice it to say, though, that the entire way Fiske talks about cultural resistance is fundamentally misguided. His interpretation of popular culture valorizes what are typically isolated, individual gestures of defiance or discontent; he seems to think that if you add up enough individuals with deviant viewpoints engaged in enough acts of "textual poaching," you will end up with progressive political change. Yet, as history makes clear, political and social change is a product of collective, not individual, action; it is the achievement of consciously organized classes mobilized around material interests. A pro wrestling fan cheering for "the bad guy," a teenager watching MTV, a child playing video games—these are not the sort of "acts" that, even if we grant that they might express some subjective animosity toward the status quo, are particularly conducive to the construction of bonds of solidarity. And if cultural resistance does not, somewhere down the line, contribute to the formation of real (class) allegiances that can be mobilized in struggle, it is not clear that they are all that politically meaningful. Fiske's fundamental misunderstanding of the political stakes involved in the consumption of popular culture would have been inconceivable for someone with experience as an active participant in political and social movements. In a sense, Fiske's distance from the realm of practice leads him into the mistake of treating struggles over meaning that take place in and through cultural commodities *as if* they were the same thing as the collective, more openly political battles being waged by unions, left-wing parties, and social movements.

Fiske is not the only left academic guilty of such nonsense. Unfortunately, communication and rhetoric programs these days seem awash in fashionable poststructuralist, postmodernist theories that, as Dana Cloud (in press)

points out, "emerge out of an historical moment of political and intellectual pessimism on the Left and express deep skepticism about the possibility of mobilizing people against real oppression" (p. 5).

Typical in this regard is the "new materialist rhetoric" proposed by Ron Greene (1998, 2004) in his articles "Another Materialist Rhetoric" and "Rhetoric and Capitalism." Drawing on the analysis of globalization advanced in Michael Hardt and Antonio Negri's book *Empire* (2000), Greene suggests that Marxist communication and rhetorical theory has been thrown into question by fundamental changes in the capitalist mode of production and by the poststructuralist discovery of the mysterious, demiurgic powers of "discourse." He contends that "postmodern capitalism"— marked by decentralized, globalized chains of production and the centrality of "immaterial labor"—has rendered class-based political organizing obsolete (Greene, 2004, p. 197). Of course, as an immaterialist, Greene makes no reference to the material reality of 2.5 billion workers, hundreds of thousands of whom of whom are currently in working class struggles from Ecuador and the Philippines to British Columbia. Ironically, while he does not recognize real communication laborers creating and assembling telecommunications hardware and software, Greene wants his own theory of rhetoric as "communicative labor" to "provide an escape route from theorizing rhetorical agency as a model of political communication" (Greene, 2004, p. 189). The vision of rhetorical agency he goes on to elaborate sounds strikingly similar to Fiske's omnipresent "resistance." Rhetorical agency, Greene (2004) insists, is "everywhere," and communicative labor "generates a productive excess impossible to calculate and control" (pp. 203–4). For him, liberation is not something that has to be fought for, by organized collectives and real communities; rather it is immanent to the very nature of communication itself, is capable of emerging at any moment, and is the source of "productive excess and joy" (p. 204). While Greene's description of contemporary world capitalism—which is borrowed wholesale from Hardt and Negri—is certainly inaccurate and incomplete (for a more thorough critique, see Aune, Cloud, & Macek, in press), his flawed vision of agency is politically even more dangerous. If true, Greene's take on rhetorical agency would obviate the need for organizing, for rational analysis as a guide to political action, for the laborious task of mobilizing allies and marshalling resources. But a sober reading of history—such as that provided by the Marxist classics—gives the lie to such anarchic pipe dreams; the record

shows that history is made only through the efforts of organized classes struggling within the parameters set by a given historical situation and a definite mode of production (see Harman, 1998, for a host of examples). Any attempt to construct a viable challenge to capitalism on the basis of Greene's muddled theory would be doomed to failure. As with Fiske's optimistic vision of popular culture, it is highly unlikely that a theorist actively involved in concrete political struggles would make such crude mistakes. Indeed, one could argue that Greene's celebration of "communicative labor" as eluding capitalist control holds up the daily routine of contemporary academic intellectuals—writing articles, using computers, sending e-mail, talking around the seminar table—as the paradigm for emancipatory political action. As such, it sounds very much like the "social utopia of the intellectuals" that Gramsci rightly attacked as the wellspring of all idealism.

I single out Fiske and Greene here not because I consider their work particularly egregious or because I think they are somehow personally iniquitous but because their theories are representative of a broader trend in critical communication scholarship. Judging from the articles published in journals like *Critical Studies in Media Culture, Communications and Critical/Cultural Studies*, and *Philosophy and Rhetoric*, their attacks on Marxism and their idealist notions about politics represent a major tendency within the discipline. As a consequence, the focus of much critical communication research has shifted further and further away from the kinds of questions that might illuminate the obstacles facing left activists. The fact that so many critical communication scholars refrain from concrete, partisan political struggle no doubt has something to do with this.

What Is to Be Done?

From a Marxist perspective, to fully contribute to building a better world, critical communication scholars have no choice but to become (more) politically engaged. The notion that our teaching, research, and the esoteric debates that consume so much space in our specialized journals are inherently political or even subversive is delusional, as is the idea that the hierarchical, privileged, fundamentally pro-capitalist institutions we serve are inherently benign. The divorce between the academy and real-world politics has encouraged irrelevant, often misguided analysis both of the ways

communication maintains oppressive social structures and of the various ways it can aid in overturning them. Of course, political activism by itself does not guarantee theoretical or critical insight (see DeLuca & Peeples, 2002, for an example of activist scholarship that embraces the worst kind of poststructuralist idealism), but without political engagement theory and criticism too easily deteriorate into scholasticism. While it is true that critical communication scholars and other progressive academics find themselves increasingly subject to ideologically motivated witch-hunts and relentless economic pressures, this is no reason to sever our ties to the radical social movements that represent the most important means for changing the world. We need to cultivate and strengthen politically independent and democratically organized social movements. Either we embrace and identify with those movements or we will become increasingly isolated, increasingly useless to the progressive causes we support, and increasingly vulnerable to intimidation by the Horowitzes of the world. So, to borrow Lenin's question, what *exactly* is to be done? How should critical communication scholars go about bridging the enormous chasm between the ivory tower and the grassroots?

To begin with, as Peters (2005) has suggested, we should "start by following the Zapatista mandate to be an activist where you are" (p. 46). For instance, it is obvious that Marxists in communications need to organize within our departments, on our campuses, and in our discipline to turn back the right's current assault on academic freedom. This is a matter of simple self-interest, if nothing else. Groups like the American Association of University Professors and ad hoc organizations like Defend Dissent—formed in reaction to the persecution of Ward Churchill—have done some excellent work on this front, responding to conservative meddling in higher education on the op-ed pages of newspapers, in faculty senates, and in state legislatures. Yet resistance to the right's war on the academy could and should be radicalized. We need to make the case for preserving and expanding academic freedom as a way of ensuring a cultural space for dissent, debate, and independent thought, not only for tenured faculty, but for adjuncts, graduate students, undergraduates, and society as a whole. Perhaps even more important, we ought to argue for the preservation of academic freedom on the grounds that the university is one of the few sites left in our society where the objective, verifiable truth about the market and its devastating impact on human life can be articulated without fear of censorship.

Likewise, we should actively support faculty, adjunct, and graduate student unions and defend the right of all university employees to organize. We need to stand up for academically solid and socially crucial programs like labor studies that are increasingly being targeted for elimination by budget-conscious (and politically sensitive) administrators (Luce, 2005, p. 4). We need to defend affirmative action in both admissions and faculty hiring. Even more important, we should work to expand access to quality, affordable higher education for working class students (by, for instance, supporting the Labor Party's campaign for free tuition for all to two- and four-year public colleges and universities; see Reed, 2004).

We also need to foster an atmosphere conducive to student activism on our campuses, and, to the degree possible, in our classrooms. Radical student organizations need faculty mentors and defenders who will stand up to hostile administrators and hostile members of faculty on their behalf. They need faculty speakers and sponsors for their campus events as well as our other resources and financial support.

At the same time as we become more active on campuses ourselves and more supportive of student activism, we should seek to include real-world evidence and experience from beyond campus. Experiential learning, service learning, and internships in many college curricula should include opportunities for students to work with and on issues of social justice, labor and civil rights, environmental issues, and globalization. For instance, Virginia Commonwealth University professor Mark Wood asks his students to combine their study of radical perspectives on human rights and economic justice with attendance at meetings of a local coalition trying to pass a living wage ordinance in the city of Richmond. As he explains it, "these projects require students to engage theoretically *and* practically with the real problems of society and in so doing learn invaluable skills and develop invaluable capacities that cannot be learned or developed in the classroom alone" (Wood, 2005, p. 228). Moreover, by breaking down the barriers between critical theory and political practice, such projects teach students important lessons about the real meaning of critical theory's constituative interest in liberation.

Solidarity may begin in the workplace—which, for most critical communication scholars, means our colleges, universities, disciplines, and professional organizations—but it shouldn't end there. As Carol Stabile (1997) quite correctly points out, "our larger goal must be to dismantle the very

notion of an 'academic' left and to break down the divide that artificially separates us from other workers, to learn to speak not as individuals, but as representatives of a broader struggle for a democratic society" (p. 218). Activism that confines itself to the socially insulated universe of most colleges and universities will certainly not accomplish this. Of course, I am not suggesting here that critical communication scholars flock, en mass, to the countless tiny socialist grouplets, parties, and sects that dot the landscape of the American left. That may be the best context in which to pursue radical anticapitalist activism for some (including for some contributors to this volume). Following an observation Hal Draper made back in 1971, my own view is that what the left in the United States needs at the moment is not a membership-based, democratic-centralist, Leninist party but a proliferation of nonmembership-based, regional or local Marxist propaganda and education organizations—what Draper calls "political centers"—that support radical tendencies within existing social movements and help to prepare the ground for the emergence of such a party (see Draper, 1971). But whether critical communication scholars choose to connect with the class struggle through radical political parties, through "political centers," or directly through various progressive single- or multi-issue social change organizations, connect they must.

It goes without saying that academics' research and writing skills, specialized knowledge base, and public credibility can be enormously useful to social movements. Even radical scholars who do not involve themselves directly in political activism have worked to counter mainstream propaganda and to provide movement activists with information and analysis they need to criticize and understand the existing social order (for example, Chomsky, Jensen, McChesney). Yet because most radical academics habitually write for fellow academics, activists outside the university often find it difficult to find, access, and make use of scholarship that could enhance their organizing. If university-based intellectuals want their work to matter to social movements, they need to seek out and build relationships with movement activists, frame their research agendas with an eye to activists' interests, and write with them in mind.

Luckily, in the field of critical communication scholarship, we have abundant examples of precisely this sort of collaboration. For over fifteen years, sociologists William Hoynes and David Croteau have collaborated with the media activist organization Fairness and Accuracy in Reporting to

produce media monitoring studies that have exposed the narrow spectrum of mostly elite, mostly conservative views featured on TV news and public affairs programming (Hoynes, 2005, p. 100). This sort of research, Hoynes explains, "can provide activists with a more in-depth critique when they send critical letters, e-mails, or make phone class to their local media, and, just as important, the circulation of results can serve as an opportunity to encourage activists to talk back to the media" (p. 105).

An even more impressive instance of activist-academic collaboration was the role played by critical communication scholars in the battle over the Federal Communication Commission's recent bid to relax media ownership regulations. In 2002, media critic and University of Illinois professor Bob McChesney helped to found Free Press, an organization devoted to involving the public in the fight for a more democratic, more equitable media system. In 2003, Free Press joined forces with groups like the Newspaper Guild, AFTRA (the broadcaster's union), MoveOn.org, the National Association of Black Journalists, and the National Organization for Women to coordinate a campaign to stop an FCC proposal that would have allowed giant media conglomerates to grow even bigger (see McChesney, 2004, ch. 7). Over the course of this campaign, some 3 million messages were delivered to Congress and to FCC commissioners opposing further consolidation of media ownership. Although FCC chair Michael Powell convened only one official hearing on the proposed new regulations (held in the conservative town of Richmond, Virginia), communities like Chicago, Seattle, Philadelphia, Atlanta, and San Francisco held their own hearings, some of which were attended by liberal commissioners Jonathan Adelstein and Michael Copps (McChesney, 2004, p. 275). Over Memorial Day weekend, fourteen towns and cities saw demonstrations decrying the FCC's bid to further loosen media ownership rules; protests dogged Powell whereever he went and disrupted the June 2 meeting at which the FCC narrowly voted to ratify the new regulations (McChesney, 2004, p. 285). The outcry was so great, in fact, that Congress actually voted to rescind some of the new regulations.

In November 2003, a Free Press–sponsored conference on media reform attracted some two thousand participants, and the follow-up conference in May 2005 drew even more. And the issues that helped to spark the movement—the destructive influence of giant media conglomerates on the political process, the rotten quality of capitalist journalism, the racism and sexism so evident on TV, the damage commercialism does to children and the

environment—continue to energize activists today. Throughout this fight, the analysis of media scholars like McChesney, Edward Herman, Susan Douglas, Robert Jensen, Siva Vaidhyanathan, Sut Jhally, and Lawrence Lessig—presented in books, popular articles, public speeches, and video documentaries—provided grassroots media democracy activists with both intellectual ammunition and inspiration. Indeed, Free Press has even created an ironically named "Academic Brain Trust," a network of scholars who "lend their expertise to activists locally, nationally and globally," to strengthen the connection between media research and the media reform movement (*Academic Brain Trust*, 2005).

While from a Marxist perspective there are problems with Free Press's focus on lobbying efforts designed to influence media policymakers in Washington and with the reformist bent of some of its signature campaigns, there is no question that the organization has discovered effective ways of connecting critical communication research to political action, and has figured out how to mobilize enormous numbers of people to fight for a more democratic, more equitable media system. (And that, in and of itself, is a valid reason for self-identified Marxists to stay within the organization, to help build it and to attempt to radicalize it from within.) We can all learn from Free Press's example.

Yet critical communication scholars' involvement in radical social movements should not be confined to simply providing them with advocacy research or acting as spokespeople in the media. That sort of research and public relations work does not necessarily entail immersion in the life of a movement. In whatever causes we join, we academics ought to do our share of the necessary "invisible labor" of political organizing—photocopying, phone banking, running meetings, managing the logistics of demonstrations, fundraising, gathering signatures on petitions, and so on. We ought to be involved in meetings and decision-making processes (without, of course, seeking to dominate them). This is not to suggest that we should be reluctant to put our skills as researchers and communicators at the service of the movements and organizations we support, only that in doing so we should be careful not to reproduce the privilege, prestige, and sense of entitlement that normally comes with being associated with a college or university.

At the end of the day, there are plenty of ways scholars can, as Peters puts it, "blur the line between thinking about social change and acting on it" (Peters, 2005, p. 53). The possibilities, like the injustices wrought by the

capitalist system itself, are virtually endless. Support local strikes and labor actions. Attend a public meeting about police brutality. Publicize an anti-war demonstration. Launch a letter-writing campaign directed against a reactionary columnist in the local paper. Help build a local chapter of the Greens, the Labor Party, the International Socialist Organization, or effort politically independent from the two-party capitalist system. It isn't glamorous, and it can certainly be dangerous to one's professional career, but participating in collective struggle beyond the walls of the library and the classroom is the only way to learn about the true, oppressive nature of the existing social order; it's also the only way of learning how to replace it (see Stabile, 1997, p. 217).

Conclusion

For a Marxist, the ultimate test of academics' forays into politics—and of intellectual activism more generally—is the degree to which they advance the interests of the working class and the struggle for a democratic world (which necessarily entails the end of capitalism). Determining whether, in fact, our attempts to bridge the gap between theory and practice actually accomplish this can of course be tricky. Marxists must tread a thin line between ideological inflexibility, on the one hand, and opportunism and reformism, on the other. As the *Communist Manifesto* points out, our aim should not be to impose our abstract, theoretically pure ideals and utopian dreams onto the social movements we join. Rather, our objectives should "spring from the existing class struggle, from a historical movement going on under our very eyes," and we should "always and everywhere represent the interests of the [proletarian] movement as a whole" (Marx & Engels, 1848/1998, p. 51). This will be impossible to do if we are sitting on the sidelines.

References

Academic brain trust: Connecting scholars to media activists and policymakers. (2005). Retrieved October 14, 2005, from http://academicbraintrust.org.
Access denied: Restoring the nation's commitment to equal educational opportunity. (2001). Washington, D.C.: Advisory Committee on Student Financial Assistance.

Anderson, P. (1979). *Considerations on Western Marxism*. London: Verso.

Aronowitz, S. (2004). *How class works: Power and social movement*. Ithaca, NY: Yale University Press.

Aronowitz, S. (2000). *The knowledge factory: Dismantling the corporate university and creating true higher learning*. Boston: Beacon Press.

Aune, J., Cloud, D., & Macek, S. (In press). "The limbo of ethical simulacra": A reply to Ron Greene. *Philosophy and Rhetoric*.

Berkowitz, B. (2002, November). The campus crusades. *Z Magazine* 15: 12–15.

Boggs, C. (1984). *The two revolutions: Gramsci and the dilemmas of Western Marxism*. Boston: South End Press.

Budd, M., Entman, R., & Steinman, C. (1990). The affirmative character of U.S. cultural studies. *Critical Studies in Mass Communication* 7: 169–84.

Buhle, P. (1989). *C. L. R. James: The artist as revolutionary*. London: Verso.

Cloud, D. (In press). *The Matrix* and critical theory's desertion of the real. *Communication and Critical/Cultural Studies*.

DeLuca, K., & Peeples, J. (2002). From public sphere to public screen: Democracy, activism, and the "violence" of Seattle. *Critical Studies in Media Communication* 19(2): 125–51.

Dickeson, R. (2004). *Collision course: Rising college costs threaten America's future and require shared solutions*. Indianapolis, IN: Lumina Foundation.

Dillon, S. (2004, October 16). At public universities, warnings of privatization. *New York Times*, p. A12.

Draper, H. (1966). The two souls of socialism. *New Politics* 5(1): 57–84.

Draper, H. (1971). Toward a new beginning—on another road: The alternative to the micro-sect. Retrieved October 12, 2005, from http://www.marxists.org/archive/draper/1971/alt/index.htm.

Fiske, J. (1987). *Television culture*. New York: Methuen.

Fiske, J. (1989a). *Reading the popular*. Boston: Unwin Hyman.

Fiske, J. (1989b). *Understanding popular culture*. Boston: Unwin Hyman.

Gabbard, D. (2005, June). Neoconservatism and the academic Bill of Rights. *Z Magazine* 18: 14–16.

Gramsci, A. (1988). Prison writings, 1929–1935. In D. Forgacs (Ed.), *An Antonio Gramsci reader* (pp. 189–402). New York: Schocken Books. (Original work published in 1947).

Greene, R. (1998). Another materialist rhetoric. *Critical Studies in Media Communication* 15: 21–41.

Greene, R. (2004). Rhetoric and capitalism: Rhetorical agency as communicative labor. *Philosophy and Rhetoric* 37: 188–206.

Hardt, H. (1998). *Interactions: Critical studies in communication, media, and journalism*. Lanham, MD: Rowman and Littlefield.

Hardt, M., & Negri, A. (2000). *Empire*. Cambridge, MA: Harvard University Press.

Harman, C. (1998). *A people's history of the world*. London and Sydney: Bookmarks Publications.

Hoynes, W. (2005). Media research and media activism. In D. Croteau, W. Hoynes, & C. Ryan (Eds.), *Rhyming hope and history: Activists, academics, and social movement scholarship* (pp. 97–114). Minneapolis: University of Minnesota Press.

Laclau, E., & Mouffe, C. (1985). *Hegemony and socialist strategy*. London: Verso.

Luce, S. (2005). Labor studies under siege. *Against the Current* 118: 4.

Macek, S. (2001, Winter). Containing cultural studies: The departmentalization of an anti-disciplinary project. *Janus Head*, pp. 142–58.

Martin, J., & Neal, A. (2001). *Defending civilization: How our universities are failing America and what can be done about it*. Washington, D.C.: American Council of Trustees and Alumni.

Marx, K. (1975a). Contribution to the critique of Hegel's philosophy of right. In *Karl Marx–Fredrick Engels, collected works, volume 3: 1843–1844*. New York: International Publishers. (Original work published in 1844).

Marx, K. (1975b). The holy family. In *Karl Marx–Fredrick Engels, collected works, volume 4: 1845–1846*. New York: International Publishers. (Original work published in 1845).

Marx, K. (1995). *The poverty of philosophy*. New York: Prometheus Books. (Original work published in 1847).

Marx, K. (1983a). Preface to a contribution to the critique of political economy. In E. Kamenka (Ed.), *The portable Karl Marx* (pp. 158–61). (Original work published in 1859).

Marx, K. (1983b). Theses on Feuerbach. In E. Kamenka (Ed.), *The portable Karl Marx* (pp. 155–58). New York: Penguin Books. (Original work written in 1845, first published in 1885).

Marx, K., & Engels, F. (1978). *The German ideology: Part one*. New York: International Publishers. (Original work published in 1844).

Marx, K., & Engels, F. (1998). *The communist manifesto*. London: Verso. (Original work published in 1848).

McChesney, R. (1995, November). *Is there any hope for cultural studies?* Paper presented at Across the Disciplines and beyond Boundaries: Tracking American Cultural Studies Conference, University of Illinois, Urbana-Champaign.

McChesney, R. (2004). *The problem of the media: U.S. communication politics in the twenty-first century*. New York: Monthly Review Press.

Messer-Davidow, E. (1995). Manufacturing the attack on liberalized higher education. In A. Callari, S. Cullenberg, & C. Biewner (Eds.), *Marxism in the postmodern age* (pp. 526–36). New York: Guilford Press.

Messer-Davidow, E. (2002). *Disciplining feminism: From social activism to academic discourse*. Durham, NC: Duke University Press.

Mindich, D. (2005). *Tuned out: Why Americans under forty don't follow the news*. Oxford: Oxford University Press.

Nelson, Cary. (1997). *Manifesto of a tenured radical*. New York: New York University Press.

Nimtz, A. (2000). *Marx and Engels: Their contribution to the democratic breakthrough*. Albany, NY: SUNY Press.

Peters, C. (2005). Knowing what's wrong is not enough: Creating strategy and vision. In D. Croteau, W. Hoynes, & C. Ryan (Eds.), *Rhyming hope and history: Activists, academics, and social movement scholarship* (pp. 41–56). Minneapolis: University of Minnesota Press.

Petras, J. (2001, March). Left intellectuals and the desperate search for respectability. *Z Magazine* 14: 54–59.

Putnam, D. (2000). *Bowling alone: The collapse and revival of American community*. New York: Simon and Schuster.

Reed, A. (2004, January). Majoring in debt. *The Progressive* 68: 1–4.

Sherman, S. (2005, March 25). The Mideast comes to Columbia. *The Nation* 280(13): 18–24.

Smith, J. (1997). Faculty, students, and political engagement. *Social Text* 51: 131–42.

Soley, L. (1995). *Leasing the ivory tower: The corporate takeover of academia*. Boston, MA: South End Press.

Stabile, C. (1997). Pedagogues, pedagogy, and political struggle. In A. Kumar (Ed.), *Class issues* (pp. 208–20). New York: New York University Press.

Turner, G. (1992). *British cultural studies: An introduction*. New York: Routledge.

Wilson, J. (1995), *The myth of political correctness: The conservative attack on higher education*. Durham, NC: Duke University Press.

Wood, M. (2005). Another world is possible. In L. Gray-Rosendale & S. Rosendale (Eds.), *Radical relevance: Toward a scholarship of the whole left* (pp. 213–37). Albany, NY: SUNY Press.

Lee Artz teaches media studies at Purdue University Calumet in Indiana, where he is director of the Center for Instructional Excellence. A former steel-worker and machinist, Artz has published book chapters and journal articles on media practices, social change, and democratic communication. He is author of *Cultural Hegemony in the United States* (2000) and co-editor of *The Media Globe: Trends in International Communication* (2006), *Bring 'Em On! Media and Politics in the Iraq War* (2004), *The Globalization of Corporate Media Hegemony* (2003), *Public Media and the Public Interest* (2002), and *Communication and Democratic Society* (2001).

Dana L. Cloud teaches communication studies at the University of Texas, Austin. She has published one book, *Control and Consolation in American Culture and Politics: Rhetorics of Therapy* (1998), and has a second book in progress on dissident unionists at Boeing. She has also published numerous book chapters and articles in leading journals about historical materialism in communication studies, the critique of poststructuralist discourse theory, the U.S. labor movement, as well as writing on globalization, race and gender in the media. A longtime member of the International Socialist

Organization, Cloud has been involved in anti-war, labor, and global justice movements and in struggles for the rights of GLBT persons, women, immigrants, and people of color.

Henry A. Giroux holds the Global TV Network Chair in the Department of English and Cultural Studies at McMaster University in Canada. His most recent books include *Take Back Higher Education* (with Susan Searls Giroux) (2004), *The Terror of Neoliberalism* (2004), *Border Crossings* (2005), *Schooling and the Struggle for Public Life* (2005), *Beyond the Spectacle of Terrorism* (2006), and *America on the Edge* (2006)

Susan Searls Giroux teaches English and cultural studies McMaster University. She is the co-author of *The Theory Toolbox* (2003) and *Take Back Higher Education* (2004) and is managing editor of *The Review of Education/Pedagogy/ Cultural Studies*.

Deepa Kumar teaches in the Department of Journalism and Media Studies at Rutgers University. She is a critical media studies scholar and does research in the areas of media and social class, and media, war and imperialism. She is the author of the book *Outside the Box: Corporate Media, Globalization, and the UPS Strike* (2006). She has written several book chapters and articles for journals such as *Media, Culture and Society*, *Television and New Media*, and *Feminist Media Studies*, among others. She has also been active in the anti-war, labor, and social and economic justice movements.

Susan C. Leggett teaches communication at Westfield State College in New York. Her research examines how media institutions, messages, and technologies open up or constrain possibilities for social change. She is co-author (with Michael Morgan) of *Mainstream(s) and Margins: Cultural Politics in the 90s* (1996). With Lora Taub-Pervizpour she is currently writing the book *Critical Communication and Community in an Era of Digital Capitalism*.

Steve Macek teaches media studies, urban and suburban studies, and speech communication at North Central College in Naperville, Illinois. He is the author of *Urban Nightmares: The Media, the Right and the Moral Panic over the City* (2006), and his articles on media culture, politics and critical theory have appeared in leading academic journals as well as the popular press. He is active in the peace and justice, anti-corporate globalization and media reform movements.

Peter McLaren teaches courses in urban schooling and policy studies in the Graduate School of Education at UCLA. He is the author, co-author, editor or co-editor of approximately forty books and monographs. Several hundred of his articles, chapters, interviews, reviews, commentaries and columns have appeared in dozens of scholarly journals and professional magazines since the publication of his first book, *Cries from the Corridor*, in 1980. His books include *Marxism Against Postmodernism in Educational Theory* (with Dave Hill, Mike Cole, and Glenn Rikowski, 2003); *Che Guevara, Paulo Freire, and the Pedagogy of Revolution* (2000); *Revolutionary Multiculturalism: Pedagogies of Dissent for the New Millenium* (1997); and *Life in Schools: An Introduction to Critical Pedagogy in the Foundations of Education* (4th ed, 2002).

Vincent Mosco is Canada Research Chair in Communication and Society at Queen's University. Mosco is the author of numerous books, articles and policy reports on the media, telecommunications, computers and information technology. His most recent book *The Digital Sublime: Myth, Power, and Cyberspace* (2004) won the 2005 Olson Award for outstanding book in the field of rhetoric and cultural studies. He is co-editor (with Dan Schiller) of *Continental Order? Integrating North America for Cybercapitalism* (2001) and *The Political Economy of Communication: Rethinking and Renewal* (1996) which has been translated into Chinese, Spanish, and Korean. In 2004 Professor Mosco received the Dallas W. Smythe Award for outstanding achievement in communication research.

David W. Park teaches at Lake Forest College in Illinois. His research concerns intellectuals and the media, the history of mass communication research, and online audio delivery formats.

Colin Sparks is professor of media studies and director of the Communication and Media Research Institute at the University of Westminster. He is a long-standing member of the Socialist Worker's Party in Britain, writing for *Socialist Worker*, and is former editor of the magazine *Socialist Review*. He is a member of the editorial board of several journals including *International Socialism*. He has written extensively on a range of media topics, including journalism and popular culture, and media and social change in the former communist countries. He is currently completing a book on the media, globalization and imperialism.

Lora Taub-Pervizpour teaches media studies and communication at Muhlenberg College, Pennsylvania. Her research on the relationship between capitalism and culture in the early modern period provides a historical foundation for her work on children and new information technology in the context of twenty-first century digital capitalism.

Fabiana Woodfin is a Townsend Discovery Fellow at the University of California, Berkeley, where she is pursuing a Ph.D. in Italian Studies. She has written for publications in journalism and mass communication. Her research interests broadly span Gramscian studies and critical theory to encompass the politics of language and culture in post-unification Italy.

·INDEX·

Sut Jhally & Justin Lewis
General Editors

This series publishes works on media and culture, focusing on research embracing a variety of critical perspectives. The series is particularly interested in promoting theoretically informed empirical work using both quantitative and qualitative approaches. Although the focus is on scholarly research, the series aims to speak beyond a narrow, specialist audience.

ALSO AVAILABLE

- Michael Morgan, Editor
 Against the Mainstream: The Selected Works of George Gerbner

- Edward Herman
 The Myth of the Liberal Media: An Edward Herman Reader

- Robert Jensen
 Writing Dissent: Taking Radical Ideas from the Margins to the Mainstream

To order other books in this series, please contact our Customer Service Department at:
 (800) 770-LANG (within the U.S.)
 (212) 647-7706 (outside the U.S.)
 (212) 647-7707 FAX

or browse online by series at:
 WWW.PETERLANG.COM